Aphrodite

Jacksonville May 26 99

For Mano

Love ⸚

Suzanne

BOOKS BY ISABEL ALLENDE

The House of the Spirits
Of Love and Shadows
Eva Luna
The Stories of Eva Luna
The Infinite Plan
Paula
Aphrodite

Aphrodite

A Memoir of the Senses

Isabel Allende

DRAWINGS
Robert Shekter

RECIPES
Panchita Llona

Translated from the Spanish by
Margaret Sayers Peden

HarperPerennial
A Division of HarperCollinsPublishers

Credits

Creative Director: *Lori Barra, TonBo designs*
Designer: *Nathalie Valette*
Production: *Jan & Eric Martí, Command Z*
Imaging: *Shane Iseminger*
Photo Research: *Carousel Research, NY*
Fay Torres-yap, Elizabeth Meryman, Leslie Mangold, Laurie Platt Winfrey

Art credits appear on pages 317–318.

Excerpt from *Srngarakarika* from *Plaisirs d'Amour: An Erotic Guide to the Senses* by Elizabeth Nash.
Copyright © 1995 by CQ Editions. Reprinted by permission of HarperCollins Publishers, Inc.
The Perfumed Garden translated by Sir Richard Burton, published by Park Street Press,
an imprint of Inner Traditions International, Rochester, VT 05767. Copyright © by Charles Fowkes.
Excerpt from "Ode to the Plum" (Oda a la Ciruela) from *Tercer Libro de Odas,*
"Ode to Conger Chowder" (Oda al Caldíllo de Congrio) from *Odas Elementales,* and
excerpt from "Soneto XII" from *Cien Sonetos de Amor* are reprinted courtesy of Pablo Neruda.
"Death by Perfume" from *The Pillow Boy of the Lady Onogoro,* copyright © 1994 by Alison Fell,
reprinted by permission of Harcourt Brace & Company.
Excerpt from "Hymn to Cellulite" by Enrique Serna, reprinted by permission
of Grupo Editorial Planeta.
Excerpt from *Delta of Venus, Erotica,* copyright © 1977 by The Anais Nin Trust,
reprinted by permission of Harcourt Brace & Company.

A hardcover edition of this book was published in 1998 by HarperFlamingo,
an imprint of HarperCollins Publishers.

HarperCollins books may be purchased for educational, business, or sales promotional use.
For information please write: Special Markets Department, HarperCollins Publishers, Inc.,
10 East 53rd Street, New York, NY 10022.

First HarperPerennial edition published 1999.

. .

The Library of Congress has catalogued the hardcover edition as follows:

Allende, Isabel.
 [Afrodita. English]
 Aphrodite : a memoir of the senses / Isabel Allende; drawings by
Robert Shekter; recipes by Panchita Llona; translated from the Spanish by
Margaret Sayers Peden. — 1st. ed.
 p. cm.
 ISBN 0-06-017590-7
 1. Aphrodisiacs—Literary collection. I. Title.
PQ8098.1.L54A6713 1998
863—dc21 97-40274

. .

ISBN 0-06-093017-9 (pbk.)

99 00 01 02 03 /Q 10 9 8 7 6 5 4 3 2 1

I dedicate these erotic

meanderings to playful lovers

and, why not?

also to frightened men and

melancholy women

Her breath is like honey spiced with cloves,

Her mouth delicious as a ripened mango.

To press kisses on her skin is to taste the lotus,

The deep cave of her navel hides a store of spices

What pleasure lies beyond, the tongue knows,

But cannot speak of it.

Srngarakarika, Kumaradadatta, twelfth century

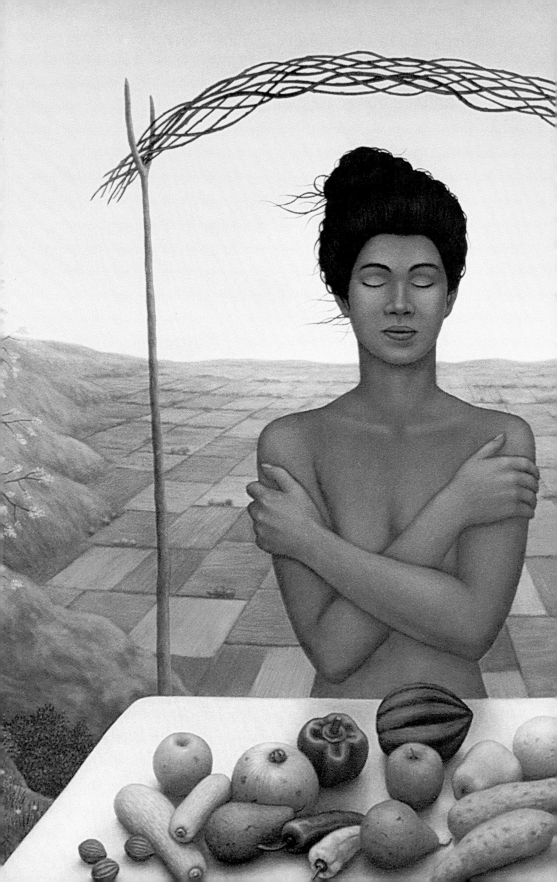

Introduction

AND *RONDO CAPRICCIOSO*

The fiftieth year of our life is like

the last hour of dusk,

when the sun has set and one turns

naturally toward reflection.

In my case, however, dusk incites me to sin,

and perhaps for that reason,

in my fiftieth year I find myself reflecting

on my relationship

with food and eroticism; the weaknesses

of the flesh that most tempt

me are not, alas,

those I have practiced most.

I repent of my diets, the delicious dishes rejected out of vanity, as much as I lament the opportunities for making love that I let go by because of pressing tasks or puritanical virtue. Walking through the gardens of memory, I discover that my recollections are associated with the senses.

My Aunt Teresa, she who was slowly turning into an angel and died with buds of embryonic wings upon her shoulder blades, is linked forever with the scent of violet pastilles. When that enchanting lady came to visit, her gray dress discreetly highlighted by a lace collar and her snow-crowned head, we children would run to meet her and she, with ritual precision, would open a pocketbook worn slick with age—always the same one—and take out a small painted tin box from which she chose a mauve candy to hand to each of us. Ever since then, when the unmistakable scent of violets floats upon the air, the image of that sainted aunt, who stole flowers from others' gardens to take to dying inmates of the poorhouse, floods back into my heart, intact. Forty years later, I learned that the scent of violet was the cachet of Josephine Bonaparte, who trusted blindly in the aphrodisiac power of that evanescent aroma, a scent that suddenly assaults the senses with a nearly nauseating intensity only to disappear without a trace, then return with renewed ardor. Before their amorous encounters, the courtesans of ancient Greece used violet to perfume their breath and erogenous zones, because when blended with the natural odors of perspiration and feminine secretions, violet alleviates the melancholia of the eldest men and torments the young beyond endurance. In the Tantra, the mystical and spiritual philosophy that exalts the union of opposites at all levels, from the cosmic to the infinitesimal, and in which man and woman are mirrors of divine energies, violet is the color of female sexuality, which is why it has been adopted by some feminist movements.

For me, the penetrating odor of iodine stirs images not of wounds or surgeries, but of sea urchins, those strange creatures of the deep inevitably related to my initiation into the mystery of the senses. I was eight when the rough hand of a fisherman placed the tongue of a sea urchin in my mouth. When I visit Chile, I seek the opportunity to go to the coast and taste freshly caught sea urchins once more, and every time I am flooded by the same mixture of terror and fascination I felt during that first intimate encounter with a man. Those ocean creatures are inseparable in my mind from that fisherman, with his dark sack of shellfish streaming seawater, and my awakening sensuality. That is how I remember all the men who have

passed through my life—I don't want to boast, there aren't that many—some by the texture of their skin, others by the flavor of their kisses, the smell of their clothing, or the sound of their murmuring voice, and almost all of them are associated with some special food. The most intense carnal pleasure, enjoyed at leisure in a clandestine, rumpled bed, a perfect combination of caresses, laughter, and intellectual games, has the taste of a baguette, prosciutto, French cheese, and Rhine wine. With any of these treasures of cuisine, a particular man materializes before me, a long-ago lover who returns, persistent as a beloved ghost, to ignite a certain roguish fire in my mature years. That bread with ham and cheese brings back the essence of our embraces, and that German wine, the taste of his lips. I cannot separate eroticism from food and see no reason to do so. On the contrary, I want to go on enjoying both as long as strength and good humor last. Thence the idea for this book, which is a mapless journey through the regions of sensual memory, in which the boundaries between love and appetite are so diffuse that at times they evaporate completely.

To justify yet one more collection of recipes or erotic instructions is not easy. Every year thousands are published, and frankly, I don't know who buys them, because I have never known anyone who cooks or makes love from a manual. People who work hard to earn a living and who pray in secret, like you and me, improvise in casseroles and bedroom romps as best we can, using what we have at hand, without brooding over it or making too much fuss, grateful for our remaining teeth and our enormous good fortune in having someone to embrace. All right, then, so why this book? Because the idea of poking about a bit in aphrodisiacs seems amusing to me and I hope it will be to you as well. In these pages I intend to approximate the truth, but that will not always be possible. What, for example, can one say about parsley? Some things scream for a little creativity . . .

Since time immemorial, in order to stimulate amorous desire and fertility, humanity has called upon substances, tricks, magic acts, and games that serious and virtuous people hasten to classify as perversions. Fertility will not interest us here—everyone else, you will have noticed, already has too many children—we're going to concentrate on *pleasure*. In a book on magic and love philters stacked among many similar tomes on my desk are formulas from medieval and even earlier times, some of which are practiced to this day, such as sticking pins in an unfortunate, still living toad and then burying it amid muttered incantations on a given Friday

night. Friday, it seems, is woman's day. The other six fall to men.

I found, too, a spell for trapping an elusive lover still practiced in certain rural areas of Great Britain. The woman kneads flour, water, and lard, sprinkles the dough with her saliva, then places it between her legs to endow it with the form and savor of her secret parts. She bakes this bread and offers the loaf to the object of her desire.

Long ago, philters of blood—often *elixir rubeus* or menstrual blood—and other bodily fluids were fermented in the hollow of a skull by the light of the moon. If the skull belonged to a criminal who had died on the gallows, so much the better. There are a surprising number of aphrodisiacs of this nature, but we are going to concentrate on those that could be dreamed up in normal minds and kitchens. In these times, there are very few women who have time to muck about kneading dough or have access to a human head.

The ultimate purpose of aphrodisiacs is to incite carnal love, but if we waste all our time and energy in preparing them we won't have much left for luxuriating in their effects. That is why you won't find any long-winded recipes here, except in a few unavoidable cases such as our orgiastic dishes. We have also consciously omitted recipes that necessitate cruelty. Can anyone who spends the day concocting a stew made of canary tongues actually concentrate on erotic games later? Spending my savings on a dozen of those delicate little birds, then mercilessly tearing out their tongues, would kill my libido forever. Robert Shekter, the creator of the satyrs and nymphs slipping through the pages of this book, was a pilot in the Second World War. His worst nightmares are not of bombings and corpses, however; no, rather of a distracted duck he brought down with his shotgun. When he went over to it, he saw it was still flapping its wings, and he had to wring its neck to prevent further suffering. He's been a vegetarian ever since. It seems that when the duck was shot it fell into a vegetable garden, flattening a head of lettuce, so he won't touch lettuce either. It is extremely difficult to prepare an erotic meal for a man with such limitations. Robert would never have collaborated with me on a project that included tortured canaries.

You will not find shark fins, baboon testicles, and other like ingredients here, because they don't turn up in neighborhood supermarkets. If you need to go to such extremes to pique your libido or fire your desire to make love, we suggest you consult a psychiatrist—or find a new partner.

Our sole focus will be on the sensual art of food and its effects on amorous performance, and the recipes we offer contain products that can be ingested without peril of death—at least in the short term—and are delicious besides. Broccoli, therefore, is not included. We limit ourselves to simple aphrodisiacs, like oysters passed from your lover's mouth to yours, following an infallible recipe of Casanova, who used this method to seduce a pair of naughty novitiates, or the smooth paste of honey and ground almonds that Cleopatra's lucky lovers licked from her intimate parts, in the process going out of their minds, along with modern recipes that contain fewer calories and cholesterol. We do not offer any supernatural potions, for this is a practical book and we know how difficult it is to find paws of koala, eye of salamander, and urine of a virgin—three species on the endangered list.

The road of gluttony leads straight to lust and, if traveled a little farther, to the loss of one's soul. This is why Lutherans, Calvinists, and other aspirants to Christian perfection eat so poorly. Catholics, on the other hand, who are born resigned to the concept of original sin and human frailty and who are purified by confession, free to go and sin again, are

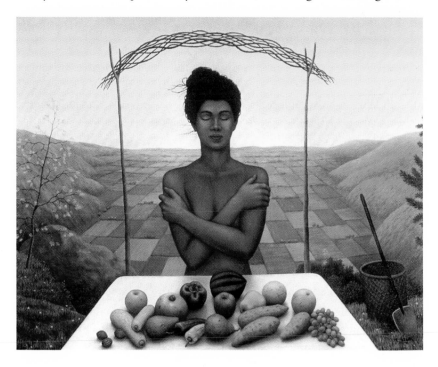

much more flexible in regard to the groaning board, so much so that the expression "a cardinal's tidbit" was coined to define something delicious. Lucky for me that I was brought up among the latter group and can devour as many treats as I wish with no thought of hell, only of my hips, although it has not been equally easy to shake off taboos relating to eroticism. I belong to the generation of women who married the first person with whom they "went all the way," because once their virginity was history, they were used goods on the matrimonial market, even though usually their partners were as inexperienced as they and seldom qualified to distinguish between virginity and prudery. If it weren't for the Pill, hippies, and women's lib, many of us would still be captives of obsessive monogamy.

In the Judeo-Christian culture, which divides the individual into body and soul, and love into profane and divine, anything having to do with sexuality, other than its reproductive function, is abominated. That demarcation was carried to the extreme when virtuous couples made love through an opening in the woman's nightgown embroidered in the form of a cross. Only the Vatican could imagine something that pornographic! In the rest of the world, sexuality is a component of good health; it inspires creation and is part of the pathway of the soul. It is not associated with guilt or secretiveness because sacred and profane love issue from the same source and it is supposed that the gods celebrate human pleasure. Unfortunately, it took me some thirty years to discover this. In Sanskrit the word that defines the joy of the creative principle is similar to the word for sensual bliss. In Tibet copulation is practiced as a spiritual exercise, and in Tantrism it is a form of meditation. The woman straddles the man, who is seated in the lotus position; they erase all thoughts from their mind, count their breaths, and lift their souls toward the divine, as their bodies join with tranquil elegance. Now, that makes you want to meditate.

Robert Shekter actively participated in the development of this project with his drawings, Panchita Llona with her recipes, and Carmen Balcells as agent. Participating passively were some fifty authors whose texts I consulted without asking their permission and whom I have no intention of mentioning, because bibliographies are a bore. Copying one author is plagiarism; copying many is research. And many of my friends participated innocently, all those who to please me lent themselves to testing the recipes and telling me their experiences, even though they were convinced that this book would never see the light of day.

Out of pure poetic inclination, it occurred to Robert Shekter to package the book with a CD of erotic music and to divide the topics into the Four Seasons, after Vivaldi, but that turned out to be more confusing than we could handle. Panchita tried to create her dishes while keeping in mind the produce of the seasons, but when Robert also asked her to give them musical names, she told him to shove off. It seems that most musical terms are in Italian, and you can't call a burrito with chilis *allegro ma non troppo*. So if in these pages you find some Italian musical phrase or other that may have been overlooked, don't pay any attention: it's a mere artist's caprice. The idea of the CD faced a similar fate because we couldn't agree about what constitutes erotic music. Panchita leaned toward Ravel's *Bolero*, Robert toward Bach, and I voted for the sound of an organ grinder that drifted in through the window one summer afternoon when . . . But that's another story.

Robert is a scientist. He did not allow me any novelist's tricks; he demanded precision. I had to show him the mountain of books I used in my research, and we had to evaluate the aphrodisiac power of Panchita's recipes using a method of Robert's invention. We called on volunteers of both sexes and diverse races, subjects over forty years old, since even a cup of chamomile tea turns on the young, which would have skewed our statistics. After inviting our guests to dinner and observing their conduct, we took painstaking measurements and noted down the results. They were quite similar to those I had obtained years ago when I was working as a journalist and had to write a report on the efficacy of black magic in Venezuela. Subjects who knew they were the target of voodoo rites began to rave and expel demonic humors; pimples erupted in their throats and their hair fell out. In contrast, subjects who remained in happy ignorance went on as prosperously as before. In the case of this book, friends who as they enjoyed the aphrodisiacs were informed of their power confessed to delicious thoughts, winged impulses, fits of perverse imagination and secretive behavior, while those who knew nothing about the experiment devoured their fare without visible change. Twice it was enough to leave the manuscript on the table, with the title in full view, for the aphrodisiac to take effect; table companions began nibbling each other's ears even before we served dinner. From which I deduce that, as in the case of black magic, it is a good idea to notify the participants. That way you save time and effort.

Once we had our plan, each of us got to work, and to the degree that nymphs, satyrs, and other mythological creatures streamed from Robert's pen, fabulous dishes from Panchita's kitchen, mathematical calculations from Carmen's fertile brain, and my investigations from the library, our spirits changed. Robert's aches and pains diminished, and he's thinking of buying a sailboat. Panchita stopped saying her beads, Carmen gained a few pounds, and I tattooed a shrimp on my navel. The first manifestations of concupiscence appeared when we outlined the list of subjects. By the time we tasted the first aphrodisiac mouthfuls, we already had one foot in an extended orgy. Robert is a bachelor, so I prefer not to ask how things have been going for him. Carmen Balcells's skin is like porcelain after taking her weekly baths in chicken broth. Panchita's husband and mine have a bounce in their step and leap out at us from behind doors with a wicked gleam in their eyes. If these dishes have been that successful with old codgers like us, what might they do for you?

Toward the end, when I thought we were finished and in the last round of revisions, I realized that among all the aphrodisiacs, from shellfish with herbs and spices to lace chemises, rose-colored lights, and aromatic bath salts, there was one, the most powerful of all, I hadn't included: stories. In our long lives as appreciators of pleasure, Robert, Panchita, Carmen, and I had ascertained that the greatest enhancement to eroticism, as effective as the most knowing caresses, is the story, told between freshly ironed sheets, that leads to love—as demonstrated by Scheherazade, the prodigious storyteller of Araby who for 1,001 nights captivated a cruel sultan with her golden tongue.

He had returned from the field of battle without warning—an unpardonable error that has produced a multitude of tragedies—and found one of his wives, his favorite, happily frolicking with her slaves. He had her decapitated and then, with clear masculine logic, decided to possess a virgin every night and deliver her to the executioner at dawn to have her beheaded. That would leave no opportunity for her to be unfaithful to him. Scheherazade was one of the last available damsels in that nightmarish kingdom. She was not so much beautiful as wise, and she had the gift of words and an overflowing imagination. The first night, after the sultan had taken her without giving it much thought, she arranged her veils and began to tell him a long and fascinating story that lasted several hours. With the first light of dawn, Scheherazade discreetly fell silent, leaving the monarch

in such suspense that he granted her one more day of life, even at the risk that she would deceive him in her thoughts, for considering her heavy guard, she could not deceive him any other way. And so, story after story, night after night, the girl saved her neck from the scimitar, relieved the sultan's pathological insecurity, and achieved immortality.

Once an exquisite dinner has been prepared and served, once the secret warmth of the wine and tickle of the spices are coursing through the bloodstream and the anticipation of caresses turns the skin to a rosy glow, it is the moment to pause for a few minutes, postponing the encounter so that the lovers may regale each other with a story or a poem, as in the most refined traditions of the East. A story may also reawaken passion after the first enfolding, when lucidity and breath return and the couple is resting, well satisfied. Storytelling is a good way to keep the man awake, who tends to drop as if anesthetized, and to divert the woman when she begins to feel bored. That story or those verses are unique and precious: no one has told them or will ever tell them in that tone, at that rhythm, with that particular voice or precise intent. It isn't at all the same as a video, please, I beg you. If both lack a natural talent for making up stories, they can call upon the enormous, titillating repertoire of world literature, from the most exquisite erotic books to the most vulgar pornography—as long as it's kept to a minimum. The skill lies in prolonging pleasure by reading an exciting but brief excerpt; the amorous impetus won with the meal should not be misspent in literary excess. We are talking about how something as trivial as sex can be turned into an unforgettable occasion.

In my book *The Stories of Eva Luna*, there is a prologue that evokes the power of storytelling, something I couldn't have written had I not lived it. Forgive the arrogance of quoting myself, but I believe it illustrates my point. The lovers, Eva Luna and Rolf Carlé, are resting after impassioned lovemaking. In Rolf's photographic memory, the scene resembles an ancient painting in which a man's lover is lying beside him, her legs drawn up, a silk shawl over one shoulder, her skin still moist from love. Rolf describes the painting this way:

The man's eyes are closed; one hand is on his chest and the other on her thigh, in intimate complicity. That vision is recurrent and immutable; nothing changes: always the same peaceful smile on the man's face, always the woman's languor, the same folds in the sheets,

the same dark corners of the room, always the lamplight strikes her breasts and cheekbones at the same angle, and always the silk shawl and the dark hair fall with the same delicacy.

Every time I think of you, that is how I see you, how I see us, frozen for all time on that canvas, immune to the fading of memory. I spend immeasurable moments imagining myself in that scene, until I feel I am entering the space of the photograph and am no longer the man who observes but the man lying beside the woman. Then the quiet symmetry of the picture is broken and I hear voices very close to my ear.

"Tell me a story," I say to you.

"What about?"

"Tell me a story you have never told anyone before. Make it up for me."

Mea Culpa of the Culpable

ROBERT SHEKTER

In a neighborhood bookstore, one of those places with beautiful wood floors and antique chairs that remind me of my grandparents' house, I met Robert Shekter. I go nearly every morning to that bookstore, drawn by contradictory emotions. On the one hand, I love plunging into that atmosphere filled with spirits and stories escaped from the pages of its books, but on the other, I find it exceedingly depressing to see the stunning number of new titles that appear every day. All that competition takes the wind out of my sails. To lift my spirit, nothing better than a fragrant croissant and a double cappuccino, mainlined; they temporarily alleviate the shock.

I was impressed by Robert Shekter the moment I saw him because his profile is identical to my grandfather's, God rest him. That aquiline nose, those steel-colored eyes, and slightly cruel lips intrigued me, and I learned to love the man secretly long before we exchanged our first words. I suppose that he couldn't help but notice my insistent glances, and like the fine Swiss gentleman he is, he resigned himself to take the initiative and say hello. That was the beginning of a friendship based on cups of coffee, croissants, and a discreet raillery that flows between us like a powerful current. Someone has said that conversation is sex for the soul.

One of those mornings of coffee and crunchy calories, I confessed to my friend one of my strange erotic dreams, in which I was one of Rubens's matrons, only older, bounding about naked, an obese fairy in an enchanted garden lush with asparagus as tall as trees, fleshy mushrooms, awesome eggplants, and an array of morbid fruit dripping a heavy golden honey. There were also animals in that prodigious oasis: duck à la orange, roast pheasant, *lapin au vin*, glazed pigs, and, here and there, squid in garlic sauce. As I was describing these fakir's hallucinations, Robert discreetly wiped the sweat from his brow and, perhaps to distract himself, he removed the splints he wears on his hands when the pain in his joints becomes unbearable, and with fingers stiff as eagle's claws, he picked up a

pencil and on a paper napkin, with marvelous ease, sketched a chubby nymph. That's my future if I don't go on a diet, I admitted, blushing. Then I saw a galloping satyr flow from his pencil, and there was no need to explain that despite the infirmity that had contorted his bones this was how he felt inside. And so were born on that napkin the characters that would enhance the protagonists of these pages: bold nymphs and mischievous satyrs.

"Why do I have these nightmares, Robert?" I asked. "I've spent half a century jousting with the demons of flesh and chocolate."

"I have bad news for you," he replied, "I'm seventy-two and I feel the same way. The temptation endures, but the execution flags."

From there the conversation drifted quite naturally toward the theme of aphrodisiacs, while we drank another cappuccino and joked about my transparent nightgowns, which with every day that passes are less and less effective in luring my husband from his computer, and about Robert's legs, which no longer oblige him in chasing women . . . or escaping from them. "When all's said and done, everything is sex." Robert sighed sadly.

Talking about aphrodisiacs, my friend called on his knowledge of medicine and began drawing up a list from memory, but I, somewhat more modern, went to the bookstore's shelves to look up texts on the subject. We discovered that there is less information than one would expect and attributed it to the fact that as we approach the millennium, people no longer pant and puff in love skirmishes, they prefer getting out of breath in a gym. That was a hasty conclusion, however; in fact, there is still the same interest in aphrodisiacs that distinguished the chefs of Lucrezia Borgia, whose fame as a poisoner, we might add in passing, has unjustly clouded her talents as a great hostess.

As soon as Robert and I began questioning friends and acquaintances, we were buried under an avalanche of advice. Everyone wanted to enlist to test the recipes. Later, when we got the project going, we had squadrons of volunteers who devoured Panchita's cooking with militant vigor. Afterward, they would call at ungodly hours to report their erotic feats.

Without Robert Shekter's friendship, it would have been hard to create this book. Without his humor and his wisdom, I would be a straitlaced grandma writing tragic stories.

PANCHITA LLONA

Little by little, I worked up a list of everything that according to my own experience and the knowledge accumulated through centuries in different cultures enhances the passionate life, or just life in general. As is only natural, food headed the list. The moment the word *food* came up, I thought of Panchita Llona, the best cook I know, and from Robert's magical hands emerged a companion for the nymphs and satyrs: a sorceress with all the paraphernalia attending the witchcraft of cuisine and love potions. I suppose that so there will be no misunderstandings I should clarify that Panchita is my mother. If I'm going to put my time and effort into something like this, I'd rather to do it with someone I trust. In the many years of my friendship with this splendid woman, I have never seen her serve the same dish twice; she always introduces some variation and garnishes her creations with such originality that in her hands a common cabbage is transformed into a work of art, like an ikebana, one of those Japanese floral arrangements with two chrysanthemums and a twisted branch. Triumph of aesthetics over paucity.

My mother has an elegant, coquettish, and ironic air that at first sight could be mistaken for frivolous inattention. Not at all: she is supremely lucid. When something interests her, she studies it with the concentration of an astronomer, but since she does so without any visible fuss, we are always tremendously surprised when she appears one day converted into an expert on something no one in the family suspected her of caring about. That's how it was, for example, with the Italian Renaissance, Impressionist painting, and twentieth-century literature. Cuisine is one of her strong points. All she has to do is taste a dish, however elaborate, to know immediately what ingredients it contains and in what proportions, how long it was cooked, and how she can improve it. That was how she developed her famous almond torte, starting with a recipe that was the secret another family had guarded like a saint's relic since colonial times in Chile. Nothing escapes her nose, her taste buds, and her instincts as a master cook, not the hidden mysteries of cod *à la vizcaína* coddled over a country cook fire in Bilbao, or the musk sweets served on tiny mother-of-pearl plates at a funeral in Damascus, or least of all the ingenuous recipes

of nouvelle cuisine—especially as practiced in California—which she sniffs at with an expression of deep scorn. To accompany my mother to a restaurant is a mortifying experience. When we go in, she looks over the tables, checking out what other people are eating, sometimes so closely that she alarms the diners. She reads the menu with excessive attention and torments the waiter with malicious questions that force him to go the kitchen and return with written answers. Then she urges us to all order something different, and when the food arrives she takes photos with the Polaroid camera she always carries in her purse. The rest is easy; she takes a bite from each plate and with that taste knows how to interpret it later at home. Her culinary art has been a determining factor in her fate. I'm witness to that.

My mother has lived a storybook romance. When she fell in love with my stepfather, our incomparable Tío Ramón, more than half a century ago, no one would have bet a penny on the chances for that tortuous relationship. Each was married to a different partner, between them they had seven children, and they lived in the most devout and conservative surroundings possible to imagine, a place where, as the last straw, divorce did not exist. Chile is the only country in the galaxy where still today, well in sight of the year 2000, couples are legally bonded for eternity. Nevertheless, my mother and Tío Ramón found a way to share their lives and to make of that clandestine attraction a legendary romance that their seven children, envious tongues, and the limited resources of a public servant could not destroy or corrupt. We believe that the solid pillar of that relationship was the happy balance between eroticism and good food, but in our family that is never mentioned; we prefer to say that this pair of great-grandparents are joined by deep spiritual affinity. In any case, I called my mother in Chile, invited her take part in this project, and just as I had expected, she was immediately hooked. It seemed, though, that at the mention of the word *aphrodisiac* I heard a meaningful pause from the southern part of the American continent, but my mother is too loyal to deny her daughter a small caprice.

"What will my friends in the prayer group say when they hear this!" she said with a sigh.

"They'll never know, Mother. By the time we finish this book, they'll all be in their graves."

CARMEN BALCELLS

I admit that I was terrified at the prospect of proposing the idea of a book about aphrodisiacs to Carmen Balcells, the world's most famous literary agent, whose mere presence causes editors to break out in a cold sweat and writers to grovel in fits of fawning. This woman has invested a great deal of effort in my so-called literary career. From the beginning, when in 1982 the mailman delivered a package containing the original manuscript of my first novel, *The House of the Spirits,* to her desk in Barcelona, she has hatched ambitious plans for me and with impressive patience has waited, and continues to wait, for me to mature gracefully, like a good wine. Proof of her unshakable faith is that with each of my visits to Barcelona she prepares the most awe-inspiring— and aphrodisiac—dish in her repertoire: an authentic Catalan soup. No one can describe with justice the spectacle of Carmen in her kitchen, wrapped in her apron, a kerchief around her head and a string of curses upon her lips, juggling wooden spoons, black iron pots, mountains of ingredients, bottles of spices, sprigs of herbs, and generous dashes of the best brandy. It is impossible to describe the aromas issuing from her stockpot, the savor of a broth to raise the dead, the texture of the chunks of blood sausage, chicken, and beef that melt in your mouth. At Carmen Balcells's round table, the china is the finest porcelain, the tablecloth starched linen richly embroidered in cloistered convents, the goblets cut crystal to hold the best Rioja wine, and the spoons of heavy antique silver, a bequest of remote ancestors. And after several hours of spirited labor in the kitchen, we go to the table, where with due ceremony Carmen extracts the treasures of her magnum opus from a potbellied tureen and fills our plates. And we eat until our souls rise up sighing and the most hidden virtues of our wretched humanity are renewed as that blessed soup seeps into our bones, sweeping away with one stroke the fatigue of all the disappointments gathered along the road of life and restoring to us the uncontrollable sensuality of our twenties. But I live in California, where everyone nibbles on kiwi and ricotta and jogs through the streets with crazed concentration, so I had forgotten the famed Catalan soup when I called Carmen in Barcelona to tell her, timidly, that instead of the grand

novel she has been awaiting for fifteen years, what would fall upon her desk was a bundle of divagations on sensuality and recipes from my mother's kitchen.

"*Deu meu!*" she exclaimed—I'm not sure whether in Latin or Catalan—with the same exalted tone she would have used had Cervantes gifted her with one of his manuscripts. And with that legendary generosity that separates her from the sharks of the literary community, Carmen offered me the recipe for her extraordinary stew as a gift for the readers of this book. You will find it, naturally, in the section on orgies.

ME

One January night in 1996 I dreamed that I jumped into a swimming pool filled with rice pudding (see recipe on page 315), where I swam with the grace of a porpoise. It's my favorite dessert—rice pudding, that is, not porpoise. I love it so much so that in 1991, in a restaurant in Madrid, I ordered four servings, and then a fifth for dessert. I ate them down without blinking, with the vague hope that that nostalgic dessert from my childhood would help me bear the anguish of seeing my daughter so ill. Neither my soul nor my daughter improved, but rice pudding remains associated in my memory with spiritual comfort. There was nothing, however, elevating about the dream: I dived in, and that delicious creaminess caressed my skin, slipped into all the crevices of my body, filled my mouth. I awoke feeling happy and threw myself on my husband before the poor man realized what was happening to him. The next week I dreamed I was arranging a naked Antonio Banderas on a Mexican tortilla; I slathered on guacamole and salsa, rolled him up, and wolfed him down. That time I woke up in terror. And a few days later, I dreamed . . . well, there's no point in going on with the list, it's enough to say that when I told my mother of these cruelties, she advised me to see a psychiatrist—or a cook. You're going to get fat, she added, and so I decided to confront the problem with the only solution I know for my obsessions: writing.

After the death of my daughter, Paula, I spent three years trying to exorcise my sadness with futile rituals. Those years were three centuries

filled with the sensation that the world had lost its color and that a universal grayness had spread inexorably over every surface. I cannot pinpoint the moment when I saw the first brush strokes of color, but when my dreams about food began, I knew that I was reaching the end of a long tunnel of mourning and finally coming out the other end, into the light, with a tremendous desire to eat and cuddle once again. And so, little by little, pound after pound and kiss after kiss, this project was born.

My role in this team effort required research. I'm not complaining. I have discovered in the vast array of books passed through my hands more than one little gem I had never known. I wrote these pages in a room in my house, because at first I didn't want the piles of explicitly illustrated books to lie around my office exposed to the eyes of my virtuous assistants and the occasional visitor. Neither did I want to display this material in my home, so I began by keeping it under lock and key, but as I became familiar with all the possible, and even a few impossible, positions for making love, as well as all the devices, philters, balms, lotions, spices, herbs, drugs, ostrich plumes, and candy penises offered in the marketplace, I left books scattered around everywhere, and my grandchildren, innocents who have not yet reached the age of reason, built playhouses with them, as if they were perverse bricks from another tower of Babel. After gazing at them for so long now, nothing impresses me, or my grandchildren either.

Aphrodisiacs

How to define an aphrodisiac? Let's say it is any substance or activity that piques amorous desire. Some have a scientific basis, but most are activated by the imagination. Cultures and individuals react to them in their own way. For thousands of years, humanity has experimented with countless possibilities in an incessant search for new stimuli, a search that led to pornography and the genesis of erotic art ancient as the dawn of millennary cave paintings. The difference between the two is a question of taste; what is erotic for one may be pornographic for another. For the Victorians, Evil was everywhere. They covered the legs of their tables to preclude bad thoughts, and a young lady was not allowed to hang a man's portrait on the walls of her room, for fear that the painting might look on as she was undressing. It didn't take much to excite those good folks.

Some aphrodisiacs function through analogy, like the vulva-shaped oyster or phallic asparagus; others by association, because they remind us of something erotic. They also work through suggestion, because we believe that when we eat the vital organ of another animal—and in some cases, that of another human, as happens among cannibals—we absorb their strength. In general, anything with a French name seems aphrodisiac. Serving mushrooms with garlic isn't at all the same as *champignons à la Provençale,* nor is ham and cheese comparable to a *croque-monsieur.* The same criteria apply on the battlefields of love. It is a good idea to assign suggestive names to the different postures, as in the enlightened erotic manuals of Asia. It isn't necessary to remember the authentic terms; you can invent them and no one will be the wiser: *delicate butterfly in somersault, swooning lotus flower in lake with ducks*, and others of that ilk. Of course, we cannot overlook therapeutic stimulants, plants, and hormones, but after testing a good number of them I believe that sensorial stimuli are more effective: daring games, massages, shows, erotic literature, and art.

Patriarchal societies, which means nearly all of them with the exception of a few Indian tribes lost in the chronicles of forgotten conquistadors,

are characterized by a real obsession with virility and its symbol: the penis. One must, after all, produce children—male, of course—to guarantee succession and maintain the power of the family. In every phallocracy, aphrodisiacs are very important, given the limitations of the capricious male appendage that is wont to fade from surfeit, if not from the owner's shortcomings. As soon as men conceived the curious idea that their superiority over women is based in that organ of their anatomy, they began to have problems. They attribute disproportionate powers to this prized possession; in truth, it is rather insignificant compared to an arm or a leg. And as for the size . . . frankly, the names of weapons and tools it often goes by are little justified for something that can comfortably be fitted into a sardine tin—although I doubt anyone wants to try that. You merely need to glance below a man's navel to calculate how much help he will need to keep his morale flying high; hence the interest in aphrodisiacs.

Eating and copulating depend less on the digestive and sexual systems than on the brain, as does nearly everything that happens to us, which is but dream, illusion, deception. Shakespeare has a wonderful line about this, but I'm sorry, I couldn't find it. Instead, I can quote Calderón de la Barca, who said in "Life Is a Dream":

> *What is life? An illusion,*
> *a shadow, a fiction*
> *For all of life is a dream*
> *And dreams? dreams are dreams.*

As for food and sex, nature demands a minimum, quite basic, for the preservation of the individual and the species; all else is ornamentation or subterfuges we invent to celebrate life. The imagination is a persistent demon; the world would be black and white without it. We would be living in a paradise of the military, fundamentalists, and bureaucrats, in which the energy we today invest in a good table and good lovemaking would be directed to other ends, such as more disciplined methods of killing one another.

If we ate only wild fruit and copulated with the innocence of rabbits, we would be saved quantities of literature on these themes; millions of trees would escape their fate of being turned into pulp, and the seven deadly sins would not include lust and gluttony, thus significantly increasing the numbers of souls in Paradise. But nature has endowed us—or cursed us—with an insatiable brain capable of imagining not only all manner of stupendous

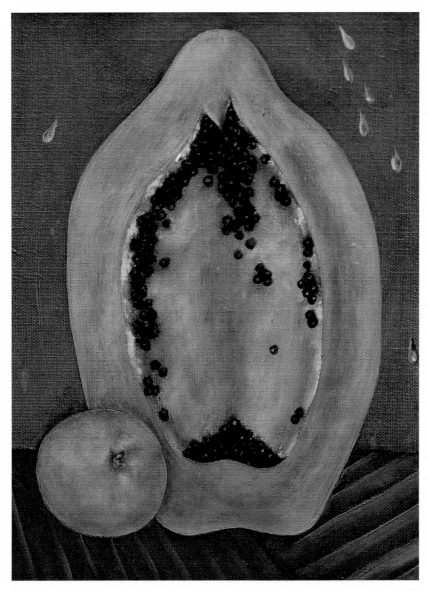

foods and variations on love, but, along with them, the corresponding guilt
and punishment. Ever since the first humans dropped a vulture or rat carcass
on glowing coals and then celebrated that agape with festive fornication, the
bond between food and sex has been constant in all cultures. We do not
know whether it works that way among animals, but observing the rac-
coons that come to steal my cat's food, I have noticed that on nights of the

full moon, they yowl on the rooftops imitating the love cries of the neighborhood felines. There's something in those disgusting cans of fish paste that stirs the hearts of cats and raccoons alike.

Aphrodisiacs are the bridge between gluttony and lust. In a perfect world, I suppose that any food that is natural, healthful, fresh, attractive to our eyes, mouthwatering, tempting—that is, that has the same virtues one looks for in a mate—would be aphrodisiac, but the truth is quite the opposite. In the untiring quest for ways to put starch in the frail male member and rectify the indifference of inattentive women, we go to such extremes as swallowing powders made from crushed cockroaches. The study of the stimulating virtues of food is so ancient that it is lost in the night of civilizations buried for centuries. Many recipes have disappeared down the cracks of history, but some have endured in oral tradition. More than two thousand years ago there was a Taoist monk in China whose wife wafted through this life refining her mind and her healing gift by practicing love with countless volunteers, while her husband took note of those marathons and perfected a diet to preserve her health, provoke crystalline dreams, and increase his wife's genital jubilation. She followed the diet religiously, with most excellent results. This monk was also the author of a poisonous elixir with a mercury base, which when ingested after a lifetime of meditation and herbs illuminated the mind and speeded the spirit in its final astral voyage, leaving the body inert but impervious to decomposition. His wife, his faithful disciple to the end, took the potion as well.

And now, while we're in China, I must not overlook a priestess, mentioned in the book *The Monkey Goes East*, who came to be the most powerful female Tao master. This woman maintained that reality is achieved only through sexual ecstasy. More than a thousand men a year, devout followers, dedicated their lives to ritualistic discipline in order to convert their sexual energy into spiritual energy and thus achieve illumination, but most of them lost control when they gazed upon their female master's beauty, fell along the wayside, and wasted away. She absorbed their male energy and kept as eternally beautiful and young as a girl of seventeen. The story tells that she lived five hundred years.

In other cultures, fasting and abstinence are recommended for attaining illumination. Fasting and abstinence, however, are also aphrodisiac, even though it is painful to go to such extremes. During the Middle Ages, in some regions of Europe there existed a tradition that

bride and groom should sleep three nights together before their wed-
ding, naked but without touching, separated by a sword. In several erotic
texts, to whet desire, total fasting and rigorous chastity is counseled for
a minimum of six days. How do saints, anchorites, gurus, fakirs, priests,
anorexics, and others who practice these eccentricities as virtues con-
quer the demons of the flesh?

Just as there are ways to heighten desire, there are those known to
quench it. Among the surest antiaphrodisiacs is bad breath (in this case,
there is no room for euphemisms). Not long ago, dental problems were
unavoidable; there was no damsel or gallant over fifteen, however noble
and illustrious, who did not have rotten teeth and inflamed gums. Many
substances thought to be aphrodisiacs are merely aromatic, astringent, or
antiseptic. Other antiaphrodisiacs worth mentioning are the common
cold, a naked man in his stocking feet, a woman with her hair in rollers,
television, and ordinary fatigue. Some substances are considered fatal to
the libido: valerian, for example, which in small doses has a long-standing
reputation as a stimulant—it used to be mixed with beer or wine to liven
up the clients in brothels—in large doses causes spasms, narcolepsy, aber-
rant thought, and a repugnance for lovemaking. Ice-water baths are also
counterproductive: if they are used to calm the mad, imagine how they
may congeal the ardor of desire. The list continues with vinegar, whose
medicinal virtues include reviving one from a faint, but which also pro-
vokes vomiting, sets the teeth on edge, and produces temporary impo-
tence, because it cools the blood. In the old days they used a lettuce tea
drunk at bedtime and alum under the bed to prevent the lustful dreams of
young men in the military service and in religious orders. By the way, my
Catholic friends add to this list the saintly devotion of praying the rosary in
bed, which puts the most faithful to sleep, as well as the most lovesick. On
this point, there is more than one opinion. The cucumber, which because
of its shape is considered erotic in many regions, was in others used in
monasteries to calm the virile ardor of the monks. I don't know whether
they ate it, applied it in compresses, or used it in ways I prefer not to
detail. When in doubt, my grandfather always said, refrain.

In these pages I intend to offer, to the extent of my knowledge, a
description of the most common aphrodisiacs. I hope you have them in
your kitchen and that they add to your life the touches of flavor and good
humor so badly needed in the whirlwind of modern life. We go racing

through our days as if to see who can be first to die. All that's left to be said is that if you are lucky, and these tonics give the desired result, you will live and die happy, perhaps of a sudden attack caused by a combination of gluttony and lust, the only capital sins that encompass the possibility of style—the others are pure evil and ruin.

The Spice Is in Variety

Now is the time to state, with absolute frankness and before the reader wastes any more time reading, that the only truly infallible aphrodisiac is love. Nothing can stay the burning passion of two people in love. When love exists, nothing else matters, not life's predicaments, not the fury of the years, not a physical winding down or scarcity of opportunity; lovers will find a way to love each other because, by definition, that is their fate. But love, like luck, comes unbidden, thrusts us into a state of confusion, and burns off like fog when we attempt to hold on to it. As to the reliability of love as a stimulus, therefore, it becomes the luxury of a fortunate few, unattainable for those who have not been the target of its arrow. So that leads us to the second most powerful aphrodisiac: variety.

Variety renews amorous ardor again and again; that explains polygamy and infidelity, both of which are exhausting. The wise King Solomon loved—in addition to Pharaoh's daughter—many women Jehovah disapproved of, not for their numbers but because they were foreigners: "And he had seven hundred wives, princesses, and three hundred concubines, and his wives turned away his heart." (1 Kings 11:3)

How could an aged Solomon handle that many women? Even with aphrodisiacs and divine aid at his beck and call, one thousand is an epic number. Once after I had six women at my house for tea, I had a headache for a week. And how could I cope with, well, not a thousand by a long shot, but even *two* men? Since I no longer have energy for more than one

lover at a time, I have to look for other ways to insinuate surprise into my love life. So one day I disguised myself in a platinum wig and sunglasses—burdened still with scruples that a decade in San Francisco has not managed to eliminate completely—and went down to a porno shop in the gay district, looking for educational material for these pages. I didn't pause too long before the S&M appurtenances, the sexually explicit dolls—including a sheep called the Inflatable Ewe—or the attractive vibrators with fluorescent lights, not even one that played a Viennese waltz when it was plugged in, like an old-fashioned music box. I headed straight for the shelves of books, where I proceeded to fill a couple of shopping bags. I got so wound up in making my choices that only my eagerness to get started reading them out of sight of witnesses could drag me out of there. Since my mother was waiting for me at home, I tried to hide my new acquisitions so that my shamelessness wouldn't take her breath away, but before long I caught her leafing through them, sitting in her rocking chair with a cup of chamomile tea. Our conclusion, after weeks of fascinating reading, is that if you aren't going to change your partner, you'd better at least introduce variety into your practices.

In cultures in which eroticism has the standing of art, there are lengthy illustrated manuals for people who marry and want to wander the paths of love with good spirits and success. Most of these tomes place a great deal of emphasis on the ins and outs of positions, including some that are anatomically improbable. Only we humans can grant ourselves this luxury, because we are the only mammals capable of making love face-to-face; that's what they say, although I can imagine that a porcupine would prefer that position, and dolphins, which spend a third of their lives in sensual play, surely have discovered that pleasure. All other creatures perform the act rapidly, and from the rear, thus enabling the female to make a fast escape should danger arise. No need to wear ourselves out making up fantasies, since every possibility has already been invented and tried; all that is required to incorporate exquisite variation into what might otherwise become routine are a curious mind and a little erotic literature on the night table.

If cookbooks make up part of your library, books on eroticism should, too. Among the most celebrated manuals are the *Kama-sutra* of India, the Chinese pillow books, and the *shungas* of Japan (which were written and illustrated primarily by monks in monasteries), but there are many others; nearly all peoples have pondered the spice of variety, among them Asians,

Arabs, Polynesians, and Africans—inhabitants of nearly any place in the world exempt from religious stigmas that castigate pleasure. In Europe, in the midsixteenth century, Giulio Romano painted on the walls of the Vatican a series of positions that Pietro Aretino immortalized in sonnets. Two centuries later those sixteen sketches were still used as an integral part of the sexual education of young aristocrats. Some positions in those exotic handbooks, especially the Indian ones, are too acrobatic for bour-geois taste: elbows and knees bending in reverse configurations, heads turning 180 degrees, and a swirl of arms and legs so intricate that without the aid of a chiropractor, I don't know how they could be untangled. I can no longer knit my legs behind my head, wiggle my ears, or touch my nose with the tip of my tongue, so I have no choice but to renounce a sizable part of such capers. Neither am I overly entranced with trapezes and other circus apparatus. I suffer from vertigo, and besides, all that twirling around can be fatal if you swallow your tongue or get strangled by a rope.

More than one of us have been frightened when faced with variants on the love act. A good friend of mine, a burly, bearded descendant of Quaker blacksmiths, a poet and beekeeper by profession, was once invited to din-ner—for the obvious purpose of seduction—by a woman who admired his verses and his bee honey. At the end of a gala meal served beside a warm fireplace in the pale glow of scented candles, as the hostess was uncorking the second bottle of wine and unbuttoning the third button of her blouse, my friend discreetly excused himself to go to the bathroom. On his way there, he glanced into the woman's bedroom to get an idea of the layout and plot his strategy—it's always a good idea to case the territory before you lift a woman in your arms and stagger blindly toward an unfamiliar bed. That night, when he peered in, he saw twinkling lights, mirrored walls, and a trapeze above the bed. Horrified, the poet fled through a win-dow and was never again seen in those parts.

In one of his letters, my friend commented that our obsession with variety has a lot to do with having lost the gift of savoring a simple tomato, with our inability to exist in the world of the senses. In our desire to com-pensate for those losses, there are some who go to such extremes as that inoffensive swing, to say nothing of real perversions. He told me about a friend of his named Tom, who always carried a small notebook in his pocket so he could make a mark for each woman he had "possessed." And what were their names? This easy rider had forgotten to write them down;

he did not "possess" them even in memory. In his exhausting career of one-night stands, Tom had learned less than other men who have loved only one woman and known her in every sense of the word. His obsession is like that of compulsive eaters who gulp their food without tasting it or those who drink to excess without ever discovering the mystery of the grape; like people who accumulate money and belongings with insatiable thirst and never experience plenitude.

Howard Hughes, a famous playboy and one of the richest men of all time, who at his death had more money than the gross national product of most countries, died of hunger in a Las Vegas motel, completely alone, reduced to skin and bone, looking like a wraith in a concentration camp, terrified of germs and bacteria, wearing shoe boxes for shoes because he had the finger- and toenails of a mandarin. He died of poverty. Poverty of the senses and spirit. A few radishes pulled from the earth and a few sips of water would have saved him. So much wealth and so little abundance! We are obsessed with an insatiable appetite for ever more vivid sensations, because in our haste to devour everything we see, we separate body from soul. A subtle caress, the pleasure of skin against skin or of sharing a peach, is not enough anymore; we demand a cosmic euphoria that nothing—not drugs, not cinematic violence, not the most brutal pornography—can provide. Searching for relief from boredom, we raise cruelty to the level of art . . . or a joke. (Enough of that! I've been a mother for so long that preaching just rolls out on its own.)

The Good Table

People who write about cuisine come naturally from a long tradition of culinary refinement; they have been born and have grown up in evocative locations such as the French provinces or an Italian villa, where their mothers and grandmothers cultivated an art as delicate as it is succulent.

The finest wines daily graced their tables, and while the father, napkin knotted around his neck, solemnly cut a huge country loaf, clasping it to his chest like someone slitting the throat of a rival, the mother with her gaze directed a parade of robust serving girls bearing steaming china soup tureens from the kitchen, trays of quintessential ragouts, boards of country cheeses, and platters with pyramids of fruits and sweets. These were copious feasts that daily united an extended family in the leisurely ceremony of the meal. On those tables, always laid with cloths of starched damask, glittered crystal goblets, cruets of purest olive oil and balsamic vinegar, and vases of flowers and silver candelabra, mute witnesses to several centuries of excellent cuisine. Maybe in those dining rooms only pleasant matters were discussed, such as the incomparable texture of the pâté with truffles, the taste of roast venison, the sensuality of a cherry soufflé, and the perfume of a new coffee sent from Brazil by an explorer friend. It is such an ambiance, surely, that produces celebrated cooks and gourmets, expert wine tasters, authors of cookbooks, and, finally, the aristocrats of food who set the standards for the palates of that tiny percentile of humanity who can eat every day. I fear I possess no such credentials.

I come from a family in which disdain for earthly pleasures was a virtue and asceticism in habits considered a boon to good health. The only acceptable values were those having to do with the mind and, in a few cases, the spirit. My grandfather, who throughout his life was fascinated with advances in science and technology, with Olympian disregard ignored hot water and central heating until the middle of the twentieth century. With him it was a matter of arrogance—he placed himself above comfort and other such bourgeois customs—but other members of our clan adopted the same attitude for reasons of saintliness, madness, avarice, or mere fogginess—which was the case with my grandmother. While other ladies of her age and social status were overseeing the details of the household and the behavior of their heirs, mine was occupied with learning to levitate. My early childhood spent with her must have been very happy, but what dominates my memory are the years after her death when the house lost its light and joy. I remember a large, dark house in which my grandfather reigned like a severe although always just Zeus, amid countless relatives, protégés, and servant girls who passed through those high-ceilinged rooms like characters in a

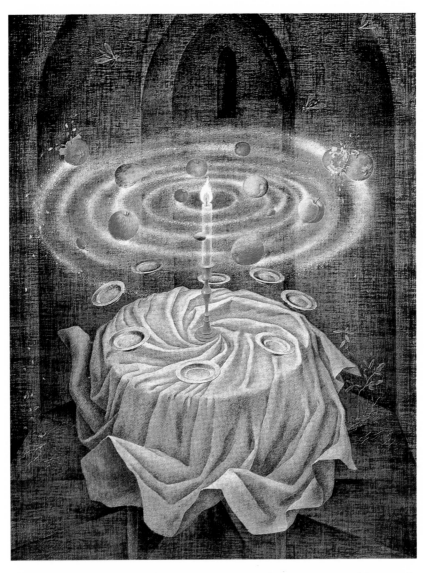

novel, all with their own dramas, passions, and eccentricities. My grand-mother's absence left a tremendous void in my life that to this very day, in the full autumn of my years, is a source of deep grief. She was a legendary woman about whom improbable stories are told, and who spent her life on an intermediate plane between reality and dream, more concerned with extrasensory phenomena and charitable works than with the vulgar realities of this world. Domestic chores and maternal duties interested

her very little; she delegated those responsibilities to the many nannies she always had around.

Just as my grandmother would put on the first dress that came to hand, indifferent to style or season, she would eat anything set before her. The question of food, like so many connected with the body and its functions, she considered in bad taste, and therefore it was not mentioned in her presence. Never hungry, she sat at the table out of habit, thinking of the prankish ghosts that visited her in her weekly séances or concentrating on receiving telepathic messages from her spiritist friends. Her too pale face emphasized large black eyes that lent her an absent air; for the same reasons, her ready laughter and sense of irony were a constant surprise. Perhaps because we didn't believe she was entirely human, we had never thought she was susceptible to death, but one day this wondrous grandmother drew a deep sigh of farewell and departed, without explanation, for the other world. With her parting, we all lost our way, first among us, her husband, unable to forgive her for abandoning him thirty years before the time he had planned.

After my grandmother's death, it fell to my mother, who was still very young, separated from her husband, and caring for three small children, to take charge of running that huge house. At her disposal were several elderly employees little inclined to obey her orders and a fearsome cook whose duties included the thankless jobs of drowning the newborn kittens of the cats that populated the rooftops, wringing the necks of the hens and ducks in the back patio, and fattening the other creatures only later to chop off their heads and toss their remains into her pots. That martinet ruled in the kitchen, a spacious, shadowy, badly ventilated room with wooden furniture permeated with the grease of a thousand meals. From hooks in the ceiling hung metal utensils so blackened by use that they had lost their original outlines. While my grandmother had been alive, the cook made her decisions in the back of the house where the servants, children, and animals lived. No one would have dared contradict her, much less make an unfavorable comment about her dubious concoctions. Every day she served formidable plates of Chilean foods that are delicious when prepared with love but that she turned into boarding-school pap: peas and lentils morning and night, country hashes and soups, heavy potato or corn pies, predictable beef goulash, and, for dessert, always that quince jelly jiggly as a toad's belly. Cooking that delightful, gelatinous treat was a summer

ceremony in which all the maids took part, gloved, faces protected by kerchiefs, taking turns stirring the copper kettle where the fruit was bubbling. If guests were invited for dinner, the cook would grudgingly open a jar of chestnuts in syrup and tromp off, key in hand, to the cellar to choose a wine corresponding to the status of the visitors.

My mother, who through one of those incomprehensible genetic accidents had in the midst of that Spartan tribe been born with a refined sensibility, tried to make some improvements in the style of our lives, but the cook, who had watched her grow up, was not disposed to take her suggestions. A silent war broke out between them.

My mother made every effort to modernize the family's customs, while the cook clung to her ancient manias with the tacit support of the men of the house, who had no intention of complicating their lives with any Frenchified ideas. Regarding food, my grandfather held to an unassailable position: he would not try anything new; he would not mix ingredients; the eggs of his Spanish omelet had to be served on one plate and the potatoes on another; he shook salt and pepper onto his food by the spoonful before tasting it because he believed it was good for the intestines; desserts were for sissies; and instead of wine, he drank large glasses of gin with his meal. When one of my uncles returned from India turned into a fakir, dressed in a breechcloth and chewing every mouthful of food sixty times, my grandfather found the perfect pretext for not eating at home. He left the house early in the day and did not return until late at night—except on Sundays, when he gathered the family together in Pantagruelian feasts.

For a while my mother continued to try to institute change, but in the end she stopped because of her relatives' jibes, the sloth of the servants, and the tyranny of the cook. Instead, she made up a set weekly menu, with slight variations according to the season, to be served year-round. There were no surprises, except for the Sunday and holiday empanadas and pastries. To that unholy regimen must be added the fact that I was educated in English schools, where abominable food was one element of an educational philosophy for strengthening student character. There was a heart-rending clarity in the moral principles of English schools of those days. Ah, the Thursday soups! A dark liquid in which floated unrecognizable gray globs, possibly yesterday's leftovers. Lifting each spoonful to one's lips under the compassionate but unyielding gaze of the headmistress required so much self-control that at the end of the meal I was suffused with a spiritual satisfaction comparable only to

erotic pleasure. I know, I know, this is fodder for a psychiatrist. Let's just say that now everything I eat tastes like the manna of the gods—except for beet root, which I can't bear. I am proud of my deep loathing of beet root. After all, there is an ethic even in loathing.

Over the following years, my childhood home sank into oblivion. The ferocious cook died, along with a goodly number of my extraordinary relatives, my grandfather was turning into an ancient, twisted oak, and my mother married a diplomat. In her long journey from embassy to embassy, she at last had the opportunity to develop her domestic genius, and I say genius because here we are talking about a supreme and spontaneous talent, apparently effortless, which she did not learn through any systematic training or inherit from any known ancestor. Her house and her kitchen are models impossible to emulate, and I don't even have a complex about it, although daughters of mothers like mine are supposed to. At her side I learned the value of a pinch of spices, a dash of liquor, a dab of salt, a soupçon of mustard, a handful of herbs, a cloud of powdered sugar, and other subjective measures of culinary art. Nevertheless, many years would pass before the kitchen ceased to be a spectacle coordinated by my mother and came to interest me personally. That happened when I realized that among the few things that men and women have in common is sex and food. Then I undertook the adventure of exploring both. It was a long journey through the senses that eventually led to the genesis of these pages.

Cooking in the Nude

I once heard a celebrated designer say, while draping a little semitransparent, seven-thousand-dollar chiffon over the bones of a bulimic model, that the most flattering thing a woman can wear is a radiant smile. Sometimes that is all that is needed, although, unfortunately, I discovered that rather late, after having spent years of my life standing frothing at the mouth before

my closet, and at an age when it is not flattering to go around stark naked.

Everything cooked for a lover is sensual, but it is even more so if both take part in the preparation and seize the opportunity to naughtily shed a garment or two as the onions are peeled or leaves stripped from the artichokes. To my sorrow, my husband is a good cook but not a tease. It would be so entertaining to watch him laboring amidst his pots and pans as articles of clothing go flying through the air. I've told him about the Adamites, an eleventh-century Christian sect whose members went around naked, with the idea that they could recapture the innocence of Adam before the original sin, but he is not a man to pick up on a hint, and until now I've never quite succeeded in getting get him out of the greasy blue jeans he wears when exercising his unquestionable authority in the kitchen. There are few virtues a man can possess more erotic than culinary skill. The first thing that attracted me to my husband was his incredible life story— which he was willing to tell me at our first meeting, and which was the inspiration for my fifth book, *The Infinite Plan*—but I actually fell in love with him several hours later as I was watching him prepare dinner for me. The day after we met, he invited me to dinner at his house. At the time, he was living with several monsters I later learned were his children and a collection of detestable pets including neurotic mice that spent their miserable existences in a cage biting one another's tails, a dog that had lost all control of its sphincter, and a tank of agonizing fish. That spectacle would have terrified any normal woman, but I had eyes only for the man moving about so easily among skillets and saucepans. That's an experience very few Latin American women have had; usually the machos of our continent consider any household activity a danger to their perpetually threatened virility. I admit it: while he was cooking, I was mentally taking off his clothes. When my Amphitryon lighted the coals of the grill and with one cruel stroke of his cleaver split a chicken in half, I felt a mixture of vegetarian terror and primitive fascination. Then when he cut fresh herbs from the garden and selected a variety of spices from a kitchen cupboard, I knew that I was in the presence of a potential candidate gifted with excellent raw material, who would, after a few years with me, be polished into a jewel. And when he took a kind of scimitar from the wall and with four samurai passes transformed an insignificant lettuce into a hearty salad, my knees buckled and my head swam with lewd images. That still happens a lot. It has kept our relationship at a constant simmer.

We women are impressed by men who know about food, but that is something that doesn't work in reverse. A man who cooks is sexy, a woman isn't; maybe it's too reminiscent of domestic archetypes. Contrast and surprise are erotic. A girl dressed like a gang member and straddling a motorcycle can be exciting; in contrast, a man in the same posture is merely a ridiculous macho. I never admit that I know how to cook; that's fatal. My friend Hannah, who composes that New Age music you hear in beauty spas and dentist's offices, and her last husband are a good example of my thesis. During a brief period as a single woman between her second divorce and her third husband, Hannah answered one of those personal ads in the classified section of the newspaper. Over the phone, the man who was looking for a partner sounded perfect: he earned his living training dogs for the blind and had gone as a volunteer to build schools in Guatemala, where a stray bullet had blown away one ear. My friend, inexperienced in personal ads and not a little desperate, invited him to dinner before she had ever seen him. (Don't even think of it! Blind dates are really dangerous. Most appropriate in such cases is a brief meeting in a neutral place from which either can escape with dignity, never a solitary meal that can turn into an endless martyrdom.) She was expecting a mature version of Che Guevara, but the person who showed up was a replica of Vincent van Gogh. She has nothing against Impressionist painting, even though she prefers astrological motifs for her walls, but that stranger with the carrot-colored hair and crazy eyes was a disappointment. She was sorry the minute she saw him. Oh, well, he was there, and she couldn't shut the door in his face over a matter of an ear, more or less.

My friend was in no position to be fussy about trifles—however, this pipsqueak was worse than anything she had imagined in her solitary nightmares. She had planned candlelight and a few slow sambas from Brazil, but she was afraid to provoke any unwanted moves on her guest's part, so she turned on all the lights and put on one of her musical compositions of wind blowing and coyotes howling, which usually produce a hypnotic lethargy. She skipped the preliminary glass of wine and other obligatory courtesies and led the man straight to the kitchen, planning instead to prepare some last-minute spaghetti, feed him in a hurry, and send him on his way before dessert. He followed her tamely, showing no sign of disenchantment, like someone all too accustomed to receiving rather rude treatment.

Once in the kitchen, however, something about him changed; he took a deep breath, puffed out his chest, stiffened his spine, as his rabbity eyes scouted the lay of the land, taking command of the terrain, conquering it. Allow me, he said, and without giving Hannah the opportunity to protest, he gently removed the apron from her hands, tied it around his own waist, and sat her down in a chair to watch. Let's see what we have here, he reflected, and started rescuing from the refrigerator the ingredients she had decided to keep for the next day, as well as some she hadn't thought of. This Van Gogh started wielding pots and skillets as if he had been born within those four walls. With unexpected grace and dexterity, his knives flashed as they danced over vegetables and shellfish he then lightly sautéed in olive oil; he hurled spaghetti into the boiling water and in a thrice had prepared a translucent cilantro-and-lemon sauce, all the while telling my friend about his adventures in Central America. Within a few moments, the pathetic little rabbit was transformed: his clown's mop vibrated with the virile strength of a lion's mane, and his castaway's bearing turned into an air of serene concentration—an irresistible combination for a woman like Hannah.

As aromas billowed from the skillet and water bubbled in the deep pot, my friend was aware of a growing anticipation; her blouse was clammy from the sweat trickling down her backbone, her thighs were steamy, and her mouth was watering—all as she was noticing for the first time, to her utter amazement, the elegant hands and broad shoulders of the man standing before her. His heroic anecdotes about Guatemala and about the dogs for the blind filled her eyes with tears; the lopped-off ear began to take on the cachet of a medal, and an irrepressible desire to caress the scar shook her from head to toes. When Van Gogh set before her a platter with steaming spaghetti *à la pescatore*, which was his name for the dish, she sighed in surrender. From its hiding place, she took the wine she had planned to keep for another, more deserving candidate, turned out the light, lit the candles, and put the slow samba from Brazil on the player. Wait just a minute, she purred, like a kitten, I want to slip into something more comfortable. And returned in her black leather suit and dominatrix's boots.

Gourmets capable of ordering from a French menu and discussing wines with the sommelier inspire respect in women, a respect that can easily be transmuted into a voracious, passionate hunger. We cannot resist men who know how to cook. I'm not talking about those clowns in histri-

onic caps who dub themselves experts and with great flourishes scorch a hot dog on the patio barbecue. No, I mean epicures who lovingly choose the freshest and most arousing ingredients, prepare them with art, and offer them as a gift to the senses and the soul, men who uncork a bottle with style, breathe in its aroma, and decant the wine into our goblet to taste, as they describe the juices, color, tenderness, aroma, and texture of the filet mignon in the tone we believe they will later use to refer to our own enchantments. It seems to us that all the sensibilities of a man like that must be equally refined, including his sense of humor. Who knows? Maybe he can even laugh at himself! While we watch him clean, spice, and cook the shrimp, we imagine that patience and dexterity applied to an erotic massage. If he delicately tastes a piece of fish to test whether it's done, we tremble, anticipating a similarly knowing nibble on the neck. We suppose that if he can remember how many minutes frog legs can tolerate in the skillet, how much greater reason he will have to remember how many tickles our G spot demands. Of course, that isn't always true; in real life he may be much more interested in the frogs' legs than our own.

Not long ago I got a call from Jason, one of my stepchildren. He was calling from New York to tell me he had met the woman of his life; this would be number seventeen, if I have the count right. He urgently needed instructions for his first date. His salary is as limited as his experience, so it would serve no purpose to suggest a good play, a small Moroccan restaurant, and, to top off the evening, a carriage ride through the park and a jazz session in Harlem. On the other hand, to recommend that he cook for her would be tantamount to a death sentence. Then I remembered my chocolate cake, and it seemed to me that an occasion like this justified a small deceit. It doesn't always pay to be honest; sometimes it's better to be creative. Making a chocolate cake is too complicated for my busy life, and that's why when I'm expecting important visitors, I buy one at a very good pastry shop, remove all the frippery, slide it onto one of our own plates, and then skip around the dining room table a couple of times, until it looks sufficiently languid to have been baked at home. Store-bought cakes, like salon hairstyles, have the undisguisable seal of the professional hand, but with a vigorous shake or two, both are reduced to a state of homemade casualness.

I told Jason to go out and pick up some exotic food, although nothing so exotic that it would be suspicious. Chinese cooking, for example, can't be camouflaged. No one in his right mind would think my stepson capable

of preparing wonton or lumpias, but some Arab dish, one of those that looks prechewed, could pass the test, especially if when he invites his date he tells her he'll cook her something with aphrodisiac ingredients. Once out of the disposable container, falafel or shish kebab lose their superiority and quietly adapt to their new surroundings. I told him about Hannah and her new husband and suggested that he set a beautiful table, put on some good music, and, when his date rang the bell, open the door with a pan in one hand and a wooden cooking spoon in the other—the first impression is usually crucial—then ask her to sit down, hand her a glass of chilled wine, and to distract her as he pretends to cook ask her questions about herself. I reminded him to be sure and take off his shoes first, like a California Buddhist, and then unbutton his shirt to show off his pecs. He should get some good out of all that weight lifting.

Unlike men, who think only of the objective, we women are inclined toward rituals and processes. I should have explained to Jason that the ceremony I have just described, although an illusionist's act, would surely be as exciting for the girl as the subsequent erotic acrobatics. Don't rush her, I begged him; savor with her the perfume of the candles, the delicacy of the flowers, each sip of wine and each mouthful of food. Talk very little yourself, and pretend to pay attention to everything she says. No woman is truly interested in what a man says, only what he murmurs. Dance with her—that way you can put your arms around her without resembling a gorilla in rut, and when you think that the moment has come to take her to a more comfortable place, wait. And then wait a good while longer. You can't hurry the perfecting of a good stew. Joke with her, I told Jason, knowing that laughter is an excellent aphrodisiac, something this boy with literary aspirations tends to forget in his immoderate enthusiasm for tragedy. And if there's a second date, remember that the shared preparation of food is a good preamble to love. It doesn't matter too much whether or not the recipes are actually aphrodisiac—from the scientific point of view, I mean—just that the nibbles and nuzzling in the kitchen are. Make a game of bed and a game of food.

Great authors, from Henry Miller in his tropics to Pablo Neruda in his infinite poetic metaphors, have turned food into sexual inspiration. Think of the aged dictator in Gabriel García Márquez's novel *The Autumn of the Patriarch*, I told him, how he attracted schoolgirls to the gardens of his palace to rub their erogenous zones with salad ingredients and then . . .

Hey, read the book, Jason, for God's sake! I had heard an exclamation of disgust over the line. Jason is too young for such subtleties. So I referred him to one of the forgotten texts lying around in some corner of my house, G. Legman's *Oragenitalism*, in which he suggests something similar with strawberries and bananas, as well as serving sweet wine in the same location, but evidently that author never thought about itching. This kind of thing should be tested by the person who proposes it. Gallants of long ago drank champagne from courtesan's high-top slippers, and we can always place the best mouthfuls in the valleys, mountains, and clefts of our lover's anatomy. (Be careful about the rug and sheets, Jason, it's hard to get the stains out.) All of this I tried to summarize in a long-distance phone call, but my stepson answered that nowadays girls wear combat boots, not slippers laced up to the ankle, and that the radiant smile my designer had suggested would look stupid on a young person.

I don't want to give the impression, however, that I'm one of those grandmothers who's capable of swathing herself in an odalisque's veils to chop onions, or of serving dinner in curly-toed Turkish babouches while rippling her navel like an exotic dancer, because that would be a dangerous lie. It could induce in other women a depression similar to the one that flattens me when I compare myself to those homemakers in magazines who use the leftover guacamole for facial masks and paint flowers on the toilet paper. If I ever did that—the belly dance, I mean—it was in my youth, maybe at the beginning of a passionate affair that I thought was transcendental at the time and today can scarcely remember, but I don't have the same desire I had to look ridiculous, and as my mother always says, if I waste my energies in costumes, who's going to watch the soufflé?

The Spell of Aromas

Woman is like a fruit which will only yield its fragrance when rubbed by the hands. Take for example the basil: unless it be warmed by the fingers, it emits no perfume. And do you know that unless amber is warmed and manipulated it retains its aroma within? The same with women: if you do not animate her with your frolics and kisses, with nibbling of her thighs and close embraces, you will not obtain what you desire: you will experience no pleasure when she shares your couch and she will feel no affection for you. —The Perfumed Garden, translated into English by Sir Richard Burton, 1886

Where does taste end and smell begin? They are inseparable. The temptation of coffee is not born of the taste, which leaves smoky dregs in memory, but in that intense and mysterious fragrance of remote forests. With our eyes closed and nostrils pinched shut, we can't distinguish between a raw potato and an apple, between lard and chocolate. The nose is capable of detecting more than ten thousand odors, and the brain of distinguishing among them, yet that same brain cannot distinguish between lust and love. The olfactory sense is, from the viewpoint of evolution, our oldest sense. It is precise, swift, and powerful, and it bores into our memory with persistent tenacity, hence the efficacy of perfumes. The secret is always to wear the same scent, until it becomes a personal, untransferable trademark, something that identifies us.

Cleopatra knew this and, like everything else she did, carried it to an extreme. In ports along the Nile, the breeze announced the impending arrival of her gilded barge hours in advance because it bore the fragrance of the roses of Damascus in which that spellbinding queen drenched her sails. During her celebrated visit to Rome, where she traveled with Caesarion, her son by Julius Caesar, the center of a formidable social and political scandal that she ignored with the natural arrogance of the pharaohs, essence of rose became the fashion, and every woman of style, except Calpurnia, the

humiliated wife of Julius Caesar, used it. Sometimes that perfume lingered in the streets like an Egyptian mockery, reminding the citizens of Rome that their invincible empire could be lost in the bedsheets of a foreign woman. At the banquets of powerful Romans, slaves counted among their tasks perfuming the rooms by blowing sweet attars through ingenious silver tubes and tossing a rain of flower petals from the ceiling. The aroma of roses, as costly as liquid myrrh but much more erotic, was sprinkled upon the guests—roses everywhere: from his followers, flattery for his Egyptian queen; from his enemies, ironic obeisance for his Egyptian whore. Several centuries later in medieval castles the floor was covered with flower petals and aromatic herbs to mask the stench of garbage and excrement. Those were times when nobles and lackeys relieved themselves behind the draperies: the toilet is a much later invention. There were French monarchs who lavished liters of floral essences on themselves to conceal the fact that they never bathed. Other European nobles, who like the French were not noted for personal hygiene but did not have the famous French perfumers at hand, simply stank like a stable.

For centuries humanity has stretched its ingenuity in searching for delicious fragrances, always with the dream of creating the scent capable of granting the user the power of absolute seduction. In his novel *Perfume*, Patrick Suskind treats the subject in a memorable manner. The protagonist is a man born without any body odor, a man loved by no one, not even his mother. Obsessed with discovering the balm that will make him irresistible, he learns the science of perfumers and succeeds in distilling the fragrance of the bodies of virgin girls to supplant what he is lacking. Maybe Suskind's story is an inspired metaphor about charisma. In any case, the art of fabricating perfumes is as complex and difficult as that of distilling wines. How did humanity first discover a way to trap the subtle spirit of an aroma? Maybe it was monks or witches who discovered amber among other tree resins when they were looking for magical plants for their potions and balms. Ambergris, the secretion from the intestines of certain whales, may have been a gift from the sirens to a sailor who plied the icy seas. And it must have been one of Genghis Khan's fearsome warriors, chasing a stag across the steppes of Asia, who accidentally cut from the animal's carcass a gland with ineffable fragrance, never suspecting it was musk, the musk that in the hands of an alchemist would become the principal component of exquisite elixirs. Like these three, there are other sub-

stances that are mixed with flowers and spices to form the base of almost all commercial fragrances.

A family of skunks lives in the basement of my home in California. For a couple of years we waged a heartless war against them, employing every manner of weapon short of poison and bullets—after all, we're decent folks. We placed cages in strategic places, but when the moment came to dispose of the catch, no one wanted to go anywhere near, and faced with the task of feeding the skunks to prevent them from dying of hunger or the natural distress of being captives, we ended up paying absurd sums to an employee of the Humane Society to resolve the problem. The man appeared encased in a kind of astronaut's gear, picked up the cages with a long hook, carried them into the garden, and from a distance opened the cage doors with a magnetized pole. The skunks staggered out, shook themselves, and raced straight back to our cellar.

My stepson Harleigh, who was at the time a teenager with a Satanic calling who dressed completely in black leather, covered his body with sepulchral tattoos, and wore his purple hair spiked like the horns of a prehistoric animal, had seen on TV the method the North American marines had used to subdue General Noriega. (Interesting to imagine the reverse, that the Panamanian army invaded the United States to take the president prisoner and lead him off in chains to be judged in their country.) Harleigh informed us that the marines had blasted a continuous rock-music concert before the walls of the Nunciatura where General Noriega had taken refuge, until the racket forced him to come out with his hands over his ears. Everyone, including the papal nuncio and the neighbors, was going crazy. Harleigh deduced that if Noriega had preferred serving time in a high-security prison to the roar of rock, maybe the skunks would be of the same mind. He installed his record player in the foundations of the house and for twenty-four hours tortured us all with his favorite beat. It had the desired effect. The animals marched out in Indian file, tails erect, offended. But we ourselves were also ready to go . . . anywhere. The system was short-lived, because the moment the noise stopped, our guests returned. One day, months later, we discovered that the smell no longer bothered us—in fact, to the contrary, we found it exciting and started gulping it down by the mouthful. Today the skunks and my family coexist on friendly terms.

The human body, especially during sexual excitation, emits a marine odor similar to the smell of crustaceans and fish. It is so important that we sniff and smell one another that—as Diana Ackerman reports in her extra-

ordinary book *A Natural History of the Senses*—in some parts of the world the word *kiss* means "smell." The scent of genitals and armpits is a signal, a coded message that travels directly to another person's brain, activating the sympathetic system, along with that series of amazing physical and emotional reactions that incite us to make love. Science has recently proved something that women, with far less study, have known for millennia: that amorous desire begins in the nose.

You approaching me
with the smell
of fresh cut
morning grass:
my nipples turn hard
—Haiku, Yuko Kawano

We have a sensor at the opening of our nasal passages that perceives not odors but pheromones, which are, they say, flags, romantic signals exuded by the skin. This may be the basis of that nonsense about the "alchemy" between lovers, that often inexplicable attraction that causes us to bond as a couple. Why is it that we like a certain human type or some individuals in particular? What do some of my women friends see in their husbands, I ask myself? It's all the fault of pheromones. In sane and cautious people, the first impulse to know each other better is determined by signals imperceptible at a conscious level but plenty loud to the hormones. Then we listen to our mother's warnings and everyone's advice; next, our mind sets up cultural, aesthetic, financial, and other filters; and then finally we choose the companion who will help us in the absurd task of propagating the species. When scientists finally were able to isolate pheromones, someone got the idea of creating a perfume capable of endowing the user with a commanding physical attraction, like that given off by hogs. The pheromones on a boar's breath can madden a sow in heat. At last the universal dream of an erotic potion that will make us irresistible is within reach of science: human pheromones synthesized in the laboratory are being touted as the one infallible aphrodisiac. One of my friends bought an extremely expensive little bottle containing that promise of instantaneous love, which turned out to be a liquid as transparent, odorless, and insipid as water. Following the instructions, she mixed a few drops with her cologne and went out for a stroll. Nothing happened; no passerby threw himself at her feet raving with love, she merely experienced a ravenous hunger

for pork. The study of pheromones is still in diapers, but scientists promise that the most delicious sensations will be available in the next century—that is, when it's too late for me.

In the Tantra there is a whole chapter devoted to different perfumes that, when applied to special parts of the body, exalt the senses and invite love. The prophet Mohammed, a sober and saintly man, nonetheless liked perfumes and recommended them to his wives. And aromatic essences are often mentioned in the Bible:

I have perfumed my bed with myrrh,
aloes, and cinnamon.
Come, let us take our fill of love until the morning;
let us solace ourselves with loves.
—Proverbs 7:17–18

In his *Songs of Bilitis*, the poet and novelist Pierre Louÿs (1870–1925) writes:

At night, they left us on a high white terrace, swooning among the roses. Warm sweat dripped from our armpits like heavy tears, bathing our chests. An exhausting, libidinous pleasure flushed our listless heads. Four captive doves bathed in four different perfumes fluttered silently above us. Drops of scent rained from their wings upon the naked women. I was streaming with the essence of the lily. Ah, weariness! I laid my cheek upon the belly of a young girl, cooling her body with my damp hair. My half-open mouth breathed in the intoxication of the saffron scent of her skin. Slowly, her thighs closed about my neck.

What Louÿs may not have known is that lilies (*Iris pseudocorus*) are poisonous, not a good thing to lick from a lover's skin.

If we did not have so many prejudices and inhibitions, the smell of a human in his or her natural state—and, why not, that of a skunk as well—would come in bottles, just as they are attempting to achieve with pheromones. I have to wonder who came up with the idea of vaginal deodorants? That's as crazy as pretending that shrimp smell of lavender and mushrooms of incense. Certainly it wasn't Napoleon Bonaparte, who in his letters begged Josephine not to bathe her intimate parts in the weeks prior to his return from the battlefield. Casanova says in his *Memoires* that

there is something in his beloved's room, voluptuous emanations so intimate and balmy that had he to choose between that scent and heaven, he would not hesitate to choose the former.

The sense of smell is more developed in women than in men. A mother, blindfolded, can pick out her child's clothing among that of twenty other babies in the nursery. Smell is also closely linked with eroticism in women, although the male is even more vulnerable to the infallible weapon emanating from the female sex, something that holds

true among nearly all mammals. A woman's unique and personal aroma is like an unerring arrow speeding through space toward a man's most primitive instinct. In French, that sortilege of odors each woman exudes is called her *cassolette*, a word borrowed by other languages. In the Song of Songs, King Solomon tells the Shulamite: "Thy plants are an orchard of pomegranates, with pleasant fruits; camphire, with spikenard, Spikenard and saffron; calamus and cinnamon, with all trees of frankincense; myrrh and aloes, with all the chief spices." (4:13–14) Now there's a *cassolette* for you!

A woman is more sensitive to the peculiar odor of the male body when she is ovulating and her level of estrogen is high. The odor of a man's sweat affects the menstrual cycles of his bed companion; from that I deduce that separate beds are not a good idea. Nothing is as delectable as the smell of a child, or as exciting as that of a young man! Well, sometimes the age isn't important. Soon after we were introduced, Willie asked me to dance. I was in my high heels, and my nose came about midway to his sternum. I had no difficulty identifying his scent as the reason for the drumbeats I sensed pounding in my temples. The music ended, and I could not tear myself away from his shirt, sniffing at it like a bird dog. And this innocent maintains that ours was a meeting of souls. . . . A man's scent is stronger and more direct than a woman's, maybe because it is usually not camouflaged by colognes but merely mitigated by soap and water. In some Arab tales, the audacious adventurers who, risking a slow death, climb the walls of the palace to seduce the odalisques of another man's harem are wont to smell of camel milk or dates. And the Shulamite replies to Solomon: "His cheeks are as a bed of spices, as sweet flowers; his lips like lilies, dropping sweet smelling myrrh." (5:13)

That reminds me of how my grandchildren smell.

Just as bodily aromas are exciting, so too are those of fresh, well-prepared foods. The perfumes of good cooking not only make us salivate, they also cause us to throb with a desire that is, if not erotic, closely related to it. Close your eyes and try to remember the exact bouquet of a skillet in which delicate onions, noble garlic cloves, stoic red peppers, and tender tomatoes are sizzling in olive oil. Now imagine how that fragrance changes when we add three threads of saffron followed by a fresh fish marinated in herbs, then, finally, a spurt of wine and juice of a lemon. The result is as exciting as the most sensual of exhalations and a thousand times more than any bottled perfume.

Sometimes, when I evoke the aroma of a mouthwatering dish, nostalgia and pleasure move me to tears. In my memory I see again the blazing sun of Seville and sitting on a rustic wall of white adobe a blue ceramic platter spilling over with ripe plums, some burst open, languorously offering themselves to the appetite of a yellowjacket that had nose-dived into that indecent flesh. Seville for me is the sweet, sweet fragrance of those plums and the jasmine that at dusk filled the air with desire.

From that time
earth, sun, snow,
sudden gusts
of rain in October,
along the roads,
everything,
light, rain,
left
in my memory
the smell
and transparency
of the plum;
Life ovaled
a goblet to contain
its clarity, its darkness,
its coolness.
O kiss
of the lips
on the fruit,
teeth
and lips
dripping
a fragrant amber,
the liquid
light of the plum!

—Pablo Neruda, from "Ode to the Plum"

"Death by Perfume"

At the end of the tenth century, a period in which Japan's most refined literature flourished, outstanding women's voices were heard in extraordinary stories, profound novels, immortal poetry, and erotica. This story was written in the Court of Heian by Lady Onogoro:

Once there was a faithless courtier who deceived his mistress with three different women in one night. One of the women, being the lady's maidservant, tearfully confessed to her, and the lady, who had quite enough of her lover's nonsense, conceived a plot to dispose of him.

On the courtier's next visit she affected a sweet and trusting demeanor, and begged him to accompany her to the perfume-mixing chamber, on the pretext of concocting a new scent which would be theirs alone. The courtier, who fancied himself a connoisseur of the perfumer's art, eagerly followed his mistress to the marble chamber where mixing vats steamed, and angelica leaves hung drying in long strings, and evening-primrose petals yielded their oils to the pressure of great iron mangles.

Never had the courtier smelled such a confluence of scents, and his nostrils thrilled to the harmony of peaflower and violet, of honeysuckle and lemon balm and wild hyacinth. Passing the grinding slab he pinched powder of nutmeg and cloves between his finger and thumb, and crushed the white crystal which comes from the bark of the camphor tree, quoting, as he did so, snippets of poems he thought relevant, for snippets, it must be said, were all he could remember.

Hiding her scorn at such self-satisfaction, the lady embraced her lover passionately and promised him an entirely novel sensation. Intrigued, the courtier was easily persuaded to remove his garments

and lie down on the robe which his mistress had spread on the floor.

The lady began with dabs of iris and cloves on her lover's temples and proceeded to the soft hollow at the base of the throat, which received the potent essence of marigold. Under each armpit she dabbed yarrow and gentian, and continued with her tender ministrations until she had distributed the scents across the lover's entire enraptured body.

But what the lady knew was that, just as an excess of yin transforms itself into the opposite yang principle, so, in certain dosages, the otherwise healing and stimulating flower essences can be induced to take on a negative aspect.

Once again she plied her vials above the courtier's body, and the mustard plunged her lover into that deep gloom which has no origin, and the mimulus filled him with the fear of illness and its consequences, and the larch convinced him of failure, and the holly pricked his heart with envious vexation, and the honeysuckle brought tears of homesickness to his eyes.

The heather, added in a certain secret proportion, made mountains out of molehills, and the gorse discouraged him, and the clematis bemused him, and the elm overwhelmed him with inadequacies, and the crab apple convinced him that he was unclean. The chestnut bud caused him to replay compulsively the memory of his many mistakes, and the willow made him begrudge the good fortune of his fellow men, and the aspen made him sweat and tremble with vague apprehensions, and the cherry plum convinced him that his mind would give way, and the wild rose resigned him to apathy, so that he did not care whether he lived or died but would have preferred, on balance, the latter.

Satisfied that she had thus brought him to a point of preparedness, the lady administered two more dabs of crab apple to his temples, to exacerbate the self-hatred. In a swoon of self-disgust her lover begged her to deal him a fatal dose, so that he might pay the

price for all his crimes against her. The lady, seeing the courtier powerless in her arms, took pity on his torment and delivered a drop of aconite to his waiting tongue. And so died the faithless lover, all naked and relieved, and not since the death of the Shining Prince himself was there ever a corpse so fragrant at its funeral.

—The Pillow Boy of the Lady Onogoro

At First Sight

Lola Montez (1821–1861), the celebrated courtesan at whose feet crowned kings and bankers threw themselves and their fortunes, created a spider dance she called the tarantula, which inflamed her spectators with mad desire. She passed herself off as an aristocratic Spanish dancer, although she knew nothing about dance and nothing about her was Spanish, but what she lacked in talent and Castilian blood, she made up for in self-assurance. With the fury of her castanets, the blur of her tapping heels, and the witchery of her lies, she created her own legend. (Why do I identify with this woman?) In private, Lola Montez used the raptures of the tarantula as a pretext for removing her veils; she never, however, committed the error of disrobing completely. She preferred to display her charms amidst clouds of lace that enhanced a glimmer of skin and disguised the imperfections of her body. In the erotic art of Japan, the subjects always appear in splendid raiment, regally robed for making love. In the symbolic language of those paintings, the voluptuous folds of the tunics indicate passion, as flowers and fruit represent the sexual organs and curled toes the orgasm.

In India, women never remove their jewels or wipe the kohl from their eyelids, because the tinkle of their bracelets and dusky call of their gaze entangle men in the ineffable attraction of mystery. My grandfather, who was born before there were electric lights in the streets of Santiago and public transportation consisted of horse-drawn trolleys—they called them blood cars—steered serenely through the fashion of the miniskirt but when it came to hippies, as an old man, wheeled nimbly to glance a female ankle peeking from beneath a long, swirling skirt. Temptation does not lie in nakedness, he maintained, but in the transparent or slinky. Hence the success of provocative lingerie, which will never go out of style. Beneath the brutal synthetic garb of some modern girls, you still find traces of silk. There are people who collect catalogues of intimate apparel, and there is a flourishing market for used undergarments to satisfy the

needs of certain fetishists. Recently, through an error on the part of the mailman, I received a pair of Madonna's panties in discreet brown-paper wrapping. I didn't know that Madonna wore such things.

The mother of one of my friends, an eighty-one-year-old widow, was married for the third time to a similarly octogenarian gallant. Shortly before the wedding, we accompanied this admirable lady to buy the most essential articles of her trousseau: lace pajamas, bras with swansdown in the nipples, underpants covered with signs of the Zodiac, and an amusing garter belt that had lights activated by a tiny battery. "At my age," the bride commented, "I need all the help I can get."

Among humans, attraction begins from a distance, through the eyes. The remaining senses, such as smell, come into play with closer contact. That's why we resort to makeup, hairstyling, jewels, tattoos, and even decorative scars. The theories of soul mates, intellectual affinity, and having been hypothetical lovers in previous incarnations come after the fact, with honorable exceptions such as the case of my poet friend, the one who went running from the erotic swing, who is capable of falling in love via the letter of a woman he's never set eyes on but whose poems touch his heart.

Usually, women are more given to adorning themselves, but men are no less vain. No woman would dare flaunt the imperial capes, panaches, and medallions sported by military men. In Niger, in the Wodaabe tribe, a male beauty pageant is held every year. Young men ornament themselves and dance before the women, who choose the most attractive one among them. Warriors make themselves cross-eyed and invent fearsome grimaces that reveal their last molar, because the white of the eyes and the teeth is the greatest attribute of beauty. On this side of the world, we have an equivalent, but here it's girls in bathing suits parading before a jury of men, flashing a lot of breast and thigh instead of teeth and eye. The winner carries off a crown of fake diamonds and the title of the most beautiful woman in the universe.

Food, too, appeals to the eye. The freshness of natural ingredients should be enough, but indefatigable human inventiveness cooks, blends, transforms, and decorates our fare with the same passion we devote to our personal appearance. The association between the shapes and colors of food and those of the body is inevitable. At the beginning of the century, a French poster that often hung in men's rooms showed girls sucking asparagus with such pleasure that only an innocent could have missed the direct

allusion. Panchita, who primps over her table as much as her own attire, maintains that the color of the meal is important: pea soup should never be served if the course that follows is also green—unless one is seeking a specific effect. For example, in Milan I was once invited to dine in the home of a famous designer. The dark mirrors lining her dining room reflected inky black chairs and tablecloth. Yellow flowers and napkins stood out with regal radiance against that lugubrious background. The buffet featured rice and various curries in tones of saffron; even the dessert, a delicious mango flambé, belonged to the same color family.

Under the pretext of destroying bacteria, vegetables in South America were for years cooked until they were reduced to sad shadows of themselves. Lately, however, under the influence of a foreign cooking that emphasizes taste, texture, and vitamins, they have begun to be served crisp. Some foods are so beautiful that they require no talent at all to be presented with pride, but others need a little help. A slice of liver or fistful of tripe must call upon art to disguise its appearance. The shells of oysters, those seductive tears of the sea, which lend themselves to slipping from mouth to mouth like a prolonged kiss, are hell to open. They can be purchased in bottles, but there they look like malignant tumors; in contrast, moist and turgid in their shells they suggest delicate vulvae—a prime example of food that appeals to the eye. Ever since I began to be interested in cooking, I have tried to imitate my mother's genius, but my dishes, even though tasty, always look as if they've been rescued from the jaws of the family pet. It has taken me years to learn to serve food with a certain grace.

I prefer aliments in their natural state, which is also the way I like men. I distrust unnecessary adornment, men with gold chains, slick mustaches, and polished fingernails, as much as I suspect chicken smothered in some impenetrable sauce or flower petals sailing through my soup, but from time to time it's entertaining to be innovative. Try long, firm asparagus served with two new potatoes at the base of the stem, or two peach halves with raspberry nipples in *crème Chantilly*. For lovers disposed to spend time on such details, I recommend stocking up on candles in the shape of apples, hearts, and cupids, long tablecloths of sumptuous satin, and evocative china (I have a set with drawings of the erotic frescoes of Pompeii). In the same pornography shop in San Francisco where I bought books by the pound, I found some hideous red goblets in the shape of a woman's stiletto-heeled shoe. I couldn't resist them. I use them to serve

cocktails that hint at erotic delights merely from the whimsy of the vessel. I also own a mold in the form of Venus, which I use to prepare aspic on nights of cupidity. Aspic, by the way, is an ingenious solution for serving leftovers. The secret is prudence with the gelatin; use just enough to hold the shape, but not so much that it takes on a life of its own.

Speaking of gelatin . . . All through her life, my grandmother's feet never touched the ground, but that angelic distractedness did not prevent her from arousing passions. I'm not referring to my grandfather's, who loved her desperately to the end of the hundred years of his life, but to a chance acquaintance, a Peruvian caballero. My grandmother, while still a girl, was traveling through Arequipa, a white city filled with the flowers of the Andean sierra. She was staying at a colonial inn with shadowy corri-

dors that invited romance. One night, while standing beside the fountain in the garden where she was counting the stars and listening to sweet, suggestive guitar music borne on the evening breeze, another traveler came up to her. This man had been observing her from a distance all day and finally had worked up enough courage to speak to her. After several gallant phrases, to which she had replied with her habitual candor, the would-be seducer invited her to share a famous dish of the region. When they were seated, the chef himself emerged from the kitchen carrying a platter adorned with chervil and jasmine, in the center of which lay two jellied guinea pigs. Those king-size mice, intact from the tips of their stiff whiskers to the toenails of their tiny paws, encased in their shroud of glassy, shivering gelatin, shook with the master cook's every step, as if ready to leap upon the waiting diners. For once in her life, my grandmother landed in the real world, falling to the floor in a swoon.

And since we're on the subject of gelatin, I can't resist the temptation to quote a few lines:

> O avidity
> for the elephantine leg,
> pillowy with fat!
> O majesty
> of the divine thigh
> of jelly-like liquidity!
> . . . Long live the adipose
> idolators of idleness,
> those of the class who leave the
> odious scutwork to the mule
> and eat everything that fattens the ass.
> —Enrique Serna, from "Hymn to Cellulite"

Forgive me, I'm afraid I strayed again. The presentation of the table, as much as the flavor of the food and abundance and quality of the liquors, determines the diners' states of mind. In *Babette's Feast*, that moving film based on a story by Isak Dinesen, the camera tracks back and forth between the kitchen, where the dishes are being lovingly prepared, and the dining room, where the severe faces of those Spartan inhabitants of a faraway, icy world are transformed as the wine and food permeates their

senses. In *The Discreet Charm of the Bourgeoisie*, Luis Buñuel creates an atmosphere of growing tension by showing tables set with splendid china and crystal and food the actors are never able to touch because of the constant interruptions.

Etiquette

Four fundamental principles, burned into my psyche from earliest childhood, were the underpinnings of my formation as a young lady: sit with your knees together, stand up straight, don't offer your opinion, and eat like a lady. All my mother's efforts, however, were not enough to turn me into a gentlewoman: she simply didn't have the right raw material. My family has never recovered from its disappointment. At sixteen, when I discovered that parting my knees was much more interesting than keeping them closed, I devoted myself to violating the severe precepts of my upbringing, and now, after a half century of life well lived, I realize that the only one of those rules that has been of value is to stand up straight. And I don't mean that in any metaphorical sense: for a woman just five feet tall, an erect posture and head held high is part of a survival strategy. If I slump, I'm crushed underfoot. As for "eat like a lady," I quickly realized that such a directive depends upon the latitude and the circumstances, and that for someone who enjoys making love eating, and vice versa, the matter of manners is merely relative.

Most of humanity, for practical reasons, eats with its fingers. In India, food is always eaten with the right hand, because the left is used for rinsing oneself in the bathroom; toilet paper is thought to be a disgusting European habit. The concept of table settings is relatively new and that of strict table manners newer still; both correspond to a culture that relates to the world through sight, and which has a strange lack of confidence in the other four senses, particularly touch. From the time we are small, we

are taught to respect physical distance from others and to ignore our own body. Even before we learn to talk and tie our shoes, we have internalized the prohibition of exploring any orifice of our own anatomy and, naturally, that of others. Later in life we spend fortunes in therapy discovering the healing power of touch. Here in California there has been a recent rash of workshops for teaching what any orangutan knows without instruction: touching oneself and touching others.

Handling food joins the sense of touch with the basic pleasure of satisfying the appetite. Eating with our hands allows us to perceive the essence of our food before we consume it. I like to make cookies, to feel the softness of the flour on my fingertips, to pleasure in the rough texture of the sugar and the slipperiness of the butter and egg, to mix the dough, roll it out, cut it. I enjoy the patient occupation of washing strawberries and mushrooms, squeezing a lemon, or sinking my knife into the firm consistency of an apple. The only food I can remember is the food I've eaten with my hands: ripe watermelon and tender corn in the Chilean summertime, cornmeal *arepas* in Venezuela, chicken and cinnamon in Morocco, wild mangos in Bali. When we think of an aphrodisiac meal, etiquette is immediately set aside: we imagine a Roman orgy, Fellini-style, in which the participants throw fruit and sweets at one another, wipe their hands in the hair of the slaves, fornicate with roast ducks, and tickle their uvula with feathers to void their stomach and start all over again. Or we think of that unforgettable scene in *Tom Jones*, that wonderful English comedy from the sixties, in which the hero and a whore, sitting face-to-face across a narrow table, share a Pantagruelian meal. The camera revels in hands ripping apart chickens and shellfish, in mouths sipping, chewing, sucking, laughing, in juices streaming down chins and necks, as if those lobster claws and silky pears were the caresses the camera chose not to view. Later, when we discover that the whore is actually Tom Jones's mother, the meal is turned into a waggish metaphor of incest.

Images of abandon and dissoluteness evoke sensuality, but sometimes, strangely, ritual and good manners can be exciting. Norms of conduct at the table are basically a series of prohibitions that for an impatient lover may not be erotic but, like the Vatican Index, because of its very strictness can produce the opposite effect. Several of my books have had the great good fortune to be included on the blacklist of a fundamentalist Catholic sect and to be banned by some Mormon schools and God knows what

other virtuous organizations, all of which has greatly increased the numbers of my readers. My grandfather, a man of strong religious convictions, was uneasy every time the women of his family went to confession, fearing the interrogation of meticulous priests who, with saintly devotion, went by the manual when asking a list of their sins. In that manual, which circulated around the school yard with the speed of a dirty book, a long repertoire of indecent behaviors was enumerated, sins whose perversity far exceeded anything a normal person might imagine, much less commit. There's nothing better for firing the lower regions and corrupting the soul with twisted desires than those famous lists of sins.

In the time of Queen Victoria, the subjects of imperial Britain turned social conventions into a philosophy of honor. Everything was allowed, as long as it didn't violate etiquette. Those maniacs of good manners committed countless barbarities in the dark, and as they cultivated the language of flowers there grew in their shadow world a parallel proliferation of whorehouses, Satanism, and clubs for flagellants where members mercilessly lashed each other's buttocks but restrained themselves from naming the part of the body addressed, which they called "where one sits down." Don't get me wrong, I don't mean to insinuate that table manners lead to such extremes. On this point, as so often happens, I begin on one subject and then my tongue flies off in unexpected directions. To get back to the subject: it occurs to me that just as lists of sins excite rebellion, the con-

straints imposed at table may have a stimulating effect. There is a component of eroticism in formality.

How but in custom and in ceremony
Are innocence and beauty born?
—William Butler Yeats, from "A Prayer for My Daughter"

Let us imagine a special occasion, perhaps a formal meal in the dining hall of a Renaissance palace converted into a restaurant or hotel, as so many are in the ancient cities of Europe. Chandeliers and candelabra shed a faint glow, soft rugs protect the ancient wooden floors, three-hundred-year-old tapestries cover the walls, and mythological frescoes decorate the ceilings. Elegantly robed diners are seated in richly carved chairs at round tables covered with cloths to the floor and decorated with sprays of orchids. Ruby- and amber-filled goblets, muted voices in genteel conversation, the clink of silver against porcelain. . . . Waiters dance among the tables, priests at a sumptuous mass, solicitous, ironic, ferrying trays of delicious foodstuffs.

A couple occupies one of the tables by the window. The heavy brocade drapes are tied back, and through the glass panes one sees a strip of shadowy garden palely illuminated by a timid moon. The woman, resplendent, is gowned in velvet the color of blood, her shoulders are bare, and her ears glowing with two magnificent baroque pearls. The man is in black, impeccable, his shirt front studded with gold. They sit very straight, maintaining the precise distance between chair and table; their gestures are controlled, even slightly rigid, as if they were moving in a cardboard choreography, but behind the studied manners one can sense the mutual attraction that like a turbulent river threatens to sweep everything away before it.

Beneath the tablecloth, knees brush by accident, and that nearly imperceptible contact strikes like a powerful current; a wrathful flame rises up their thighs and ignites the moist parting of their legs. Nothing changes in their posture, but desire is so intense that one can see it throbbing, a warm mist erasing the outlines of the world about them. Nothing exists but the two of them. The waiter approaches to decant more wine, but they do not see him. They tremble. She lifts her fork, opens her lips, and from across the table he divines the savor of her saliva and the warmth of her breath; he feels her tongue moving in his own mouth like a smothering, terrible mollusk. A moan escapes from his lips that he immediately

disguises by coughing discreetly and placing his napkin before his face. Her eyes are fastened on the last oyster on her companion's plate, a swollen, palpitating, indecent vulva moistened with milky, oceanic liquid, the synthesis of her own delirium. Nothing betrays their turmoil.

In silence, with decorum at every stage, they fulfill the precise rules of etiquette. But they do not hear the notes of the pianist enlivening the night from one corner of the palatial salon; they are deafened by the roaring hurricane of desire in their bosoms. Primitive forces have been unleashed: the drums and panting of war, a breath of the jungle, of humus, of rotting tuberose, infiltrating their bodies through the delicate aromas of food and women's perfumes: images of naked flesh, of cruel embraces, of engorged lances and carnivorous flowers. Without touching, the man and the woman perceive the other's scent and heat, the secret forms of their bodies in the act of surrender and pleasure, textures of skin and hair they have yet to know; they imagine new caresses, never before experienced, intimate and daring caresses they will invent for themselves alone. A fine film of sweat covers their brows. Their eyes do not meet; they observe each other's hands, beautifully cared for hands holding the silverware with grace, flitting back and forth between plate and lips like birds.

They lift their goblets in a toast heavy with suggestion; for an instant their glances meet, and it is as if they had kissed. They are aflame, terrified before the devastating fury of their own emotions; she is wet, he is erect; both are ticking off the minutes of that eternal dinner and yet, at the same time, wanting that torture to last until every fiber of their bodies and every hallucination of their souls reach the limits of what they can endure, reckoning the moment they will be able to embrace, disposed to do it now, there on the table, before the balletic waiters and the entire chorus of formally dressed ghosts, she facedown across the table, legs spread, her nymph's buttocks exposed to the light of the Viennese lamps, shouting obscenities, he attacking from behind among the folds of garnet velvet, howling, with plates flying, both of them stained with food, streaked with sauces, streaming wine, ripping off clothing, baroque pearls, gold studs, biting each other, devouring each other. That vision is so intense that both are teetering on the edge of the abyss, on the verge of erupting in cosmic orgasm. And then two waiters appear beside the table, bow ceremoniously, set their main course before them and with identical gestures lift the silver lids. *Bon appétit*, they murmur.

With the Tip of the Tongue

Despite the mountains of cookbooks published every year, there is very little written about the sense of taste, because it is almost as difficult to define a flavor as it is a smell. Both are spirits with their own lives, ghosts that appear without being invoked to fling open a window of memory and lead us through time to a forgotten event. On other occasions we call to them eagerly, seeking an erotic effect from the past, and they bring us instead our naked innocence. We are omnivorous, we can ingest anything, we like variety, and we spend our lives experimenting with different flavors, nearly all acquired, because in infancy the only tastes we tolerate are sweet and neutral. No baby appreciates mustard, although they are addicted to Coca-Cola, and I know many adults who have never learned to eat caviar. All the better, that leaves more for the rest of us. According to science, we can differentiate among only four tastes: sweet, salty, bitter, and acid; all the rest are blends of those four, with thousands of different emanations. I have to wonder. How do they classify the metallic taste of fear, the gritty bite of envy, or the sparkling flavor of our first kiss? But all in all, I shall respect scholarly opinion, in view of the fact that mine has no authority to back it up.

The pleasure of taste is located in the tongue and palate, although often it begins not there, but in memory. And an essential part of that enjoyment resides in the other senses: sight, smell, touch, and even hearing. In the Japanese tea ceremony, the taste of the tea is the least important element—actually, the tea is bitter—rather, it is the serene intimacy of the bare walls, the clean lines of the vessels, the elegance of the ritual, the concentrated harmony of the gestures of the person offering the tea, the quiet appreciation of the one who accepts it, the faint odor of wood and charcoal, the sound, in the silence of the room, of water dipped by a wooden spoon, that create a celebration for the soul and the senses.

Taste is associated with sexuality much more than puritans would wish. Skin, bodily creases, and secretions have strong, defined tastes, as

personal as odors. But we know little about them because we have lost the custom of licking and sniffing one another. I still remember the chewing gum, tobacco, and beer taste of my first kiss, exactly forty years ago, although I have completely forgotten the face of the American sailor who kissed me. The sense of taste is cultivated, much like our ear for jazz: free of prejudices, with a spirit of curiosity, and not taking anything too seriously. Once, in my younger days, when I was looking for bottled wisdom, I went to a lecture by a celebrated guru. He came from a Jewish family that lived in the heart of Manhattan, but his long stay in India and his years of study and meditation had made him not merely a spiritual guide, he had assumed the very accents of Calcutta and the look of a snake charmer. In the course of the conference, every neophyte was handed a large rosy grape by the master, with the instruction to eat it but in no fewer than twenty minutes—which took much longer than the sixty times my fakir uncle chewed every mouthful at my grandfather's table. During those interminable twenty minutes, I touched, looked at, smelled, turned over in my mouth with excruciating slowness, and finally, sweating, swallowed the famous grape. Ten years later, I can describe its shape, its texture, its temperature, its taste and smell. I learned to eat grapes with enormous respect, a technique I have tried to apply to other foods, although, if truth be known, without the vigilant eye of the guru I find it impossible to keep anything in my mouth for more than a few seconds. I'm referring to food, of course. I have more patience with other things.

But let's get back to our meal. According to Panchita, when we plan a menu we should consider all the different tastes so they will comple-

ment one another and be differentiated without competition. The order in which the dishes are served has an effect on how each is appreciated. It is not good to begin with the most succulent, because if it is served first, the remaining courses will seem insipid. A magnificent osso buco must always be a solo protagonist, because it vanquishes anything that dares raise its head to it. It should be preceded by a modest green salad, and, as a light finishing touch, an ice. A well thought out dinner forms a crescendo beginning with the pianissimo of the soup, passing through the delicate arpeggios of the appetizer, culminating with the fanfare of the main course, which is followed, finally, by the dulcet chords of the dessert. The process is comparable to that of making love with style, beginning with insinuations, savoring erotic juices, reaching the climax with the usual crash of cymbals, and finally sinking into a pleasureful and well-deserved repose. Haste in lovemaking leaves an angry itch in one's soul, and haste in eating alters the basic humors of the digestion. The taste buds, like every major organ and some not so major, also fall victim to fatigue. At banquets and in luxurious restaurants, one is usually served a small portion of a tart sorbet between assertive courses, to erase all traces of the first before savoring the second. Temperature is as important as texture and color; everything has its role in the sensual experience of a meal.

Herbs and Spices

In times before the modern methods of preserving foodstuffs, spices were more precious than gold. Still today, the hotter the country's climate, the more spices used in its national cuisine, because of the faster rate of spoilage. Curry was invented in India, not Norway. It was in pursuit of spices that pirates, adventurers, traders, and conquistadors traveled to the East.

And when the queen of Sheba heard of the fame of Solomon concerning the name of the Lord, she came to prove him with hard questions. And she came to Jerusalem with a very great train, with camels that bare spices, and very much gold, and precious stones. —1 Kings 10:1–2

Spices have been used not only for seasoning foods and creating perfumes, but also for love philters. Mixed with aromatic herbs, they improve their flavor—let's not forget that such formulae tended to include fingernail shavings, bile, cow dung, and other delicacies that can only be thought of as acquired tastes. If these magic potions did have some effect on arousing human passions, it was not so much for those horrendous ingredients as for the herbs and spices used in their confection. The latter were cultivated in the domestic gardens and orchards of monasteries and convents, more for medicinal than for culinary uses; many were remedies for impotence and sterility. All that wisdom has died out; today we add parsley to our salad and saffron to the rice without suspecting their secret properties. For aphrodisiac herbs and spices to take effect, frequent use is recommended; it is naive to expect that at the first whiff of cinnamon in our apple tart our libido leaps up.

In past ages it was supposed that any food originating on distant shores was laden with erotic properties, including the first potatoes imported from the New World and, with greater reason, aromatic spices from what was then called the Far East. But in today's world, in which the mystery of distance has been lost—we can drink Tibetan tea with yak butter in Texas—little surprises or excites us, and we demand constantly more unnatural aphrodisiacs: battery-driven devices, and shows, live or on video, closer to pornography than the art of erotica. Pornography is method without inspiration; eroticism is inspiration without method. (Eroticism is using a feather; pornography is using the whole hen.)

Plants are subtle aphrodisiacs, and like love, they act without ostentation, discreetly, and over time. How can we lack confidence in them if nearly all of our modern pharmacopoeia rests on them? And, as habitually happens with love, the most everyday and modest are also the most precious. It is not advisable to go in pursuit of exotic plants like *Cassytha filiformis, Bourveria ovata, Artemesia absinthium*, and others unless your obsession is botany, because if you spend your time creeping through the woods on all fours looking for them, you will miss many opportunities to make use

of them. Nature is dangerous; in its bosom hide predators, poisonous plants, irascible beasts, and bandits disguised as geographers who tend to lurk in thickets in wait for victims. One must not get carried away by bucolic curiosity but accept gratefully what can be grown in the garden or obtained in the market. Consult our list of domestic herbs and spices, and try never to run out of balsamic vinegar, the best mustard, the purest honey, and virgin olive oil (one of the few times that virginity is worth its salt), along with other fundamental ingredients to enhance your cooking and your love life.

Herbs and spices are the soul of your kitchen, not only because they turn an ordinary dish into a potential aphrodisiac, but also because they cover up culinary mistakes. "If it smells bad, smother it in curry" is the basic axiom of Indian cooking, and in Latin America we use hot chilis for the same purpose. Without going to quite such extremes, I admit that a few sprigs of fresh herbs or a pinch of spices has often saved my mediocre experiments in the kitchen, which is why I grow the former in pots on my balcony. Let me make myself clear. I am not one of those people who find spiritual peace in digging in the dirt. I don't even have a garden. I like nature in photographs. But in this case neither talent nor vocation is required, nothing more than a little noble dirt—the kind sold in bags— water, sunlight, and the rest is left to the life force. A month after planting the seeds there are herbs for all your aphrodisiac dinners, for giving to friends, and enough left over to take mint or coriander baths to clear your skin and your conscience.

When Panchita comes from Chile to visit me, we buy spices in a tiny shop in San Francisco presided over by a turbaned man who looks more like a holy man from the Ganges than a merchant. There is something secretive and impalpable in that Hindu's shop. After each visit, we leave with the sensation of never having been there at all but, rather, of having wandered lost in the labyrinths of our own imagination; only the package with our purchases is proof that the store is not pure illusion. Everything there is poetry: the mélange of potent aromas, the small altar oriented toward the northeast where there are always offerings of rice, incense, and flower petals, the wall tapestry with elephants and gods embroidered in gold thread, the humble, dust-covered Indian crafts no one has bought in all these years. The extravaganza of the powders, leaves, bark, and seeds, the bottles holding mysterious liquids, the box with the snakes, and the

silent family of the owner, all slim, dark, and with enormous, visionary eyes, slipping like silhouettes across the back of the room, all of this fully compensates for the effort of the trip into the city and the adventure of winding through narrow streets to find that tiny hole-in-the-wall. With reverent pleasure the man measures out spices with a wooden spoon, weighs them on an ancient bronze scale, and hands them to us in small plastic bags. They are usually more expensive than the ones in the supermarket but have not lost their evocative strength; they are more penetrating and thus, so I deduce, more aphrodisiac. In Katmandu I found a similar shop, although much narrower and more tortured, where with excessive enthusiasm I bought more spices than generations of my descendants could ever use. They were packaged in cones of newspaper, and I went back to the hotel balancing this treasure in my arms. Half of them spilled out in my suitcase, permanently perfuming my clothes, and the rest are still in a kitchen drawer in their original packets. I can't identify their contents and don't dare put them in food, but I keep them in case sometime in the future someone from the other side of the world comes to my house, a visitor who will be able to pronounce their names.

Forbidden Herbs

A list of herbs and spices blacklisted in the convent of the Barefoot Sisters of the Poor because of their aphrodisiac properties—with Panchita's commentary.

Anise (Pimpinella anisum) *A plant with white flowers and small, aromatic seeds used in making jams, syrups, essences, salad dressings, and liqueurs. Anise is the base for Pernod, a liqueur fashionable in nineteenth-century Europe, which, when drunk in excess, as absinthe, leads to madness and death. Have no fear, the seeds are not fatal. In many countries of the Mideast it is used to excite the lovemaking of newlyweds and to cure impotence.*

Basil (Ocimum basilicum *and* Ocimum minimum) *It smells of summer lunches in the south of Italy. Its aromatic leaves are indispensable in any respectable kitchen. It is most effective when fresh—added at the end—but can be used dry during the preparation of certain dishes. In ancient cultures—and still in the voodoo of Haiti—basil is associated with fecundity and passion.*

Bay leaf (Laurus nobilis) *Roman heroes were crowned with laurel leaves, a symbol of virility. The next time you dance for your lover, adorn yourself with a crown of these sacred leaves. Laughter is aphrodisiac, too. Bay leaf is used sparingly in cooking, barely a small leaf or half a large one, because it has a very strong, rather bitter flavor.*

Borage (Borago officinalis) *Used in preparing meat and fish, as well as fresh in salads. The Mapuche Indians of Chile use it as an abortifacient. They brew a strong tea and drink several cups a day, until it brings on cramps and spasms, which in addition to aborting the fetus provoke evil imaginings. Used with moderation and luck, however, it fuels lust.*

Capers (Capparis spinosa) *Tiny round strong-flavored fruit that nature created to be the perfect accompaniment to fish. (One of my children stuck a caper up his nose, and it took an operation to remove it, an antiaphrodisiac experience by definition.)*

Cardamom (Elettaria cardamomum) *Comes in seeds that are ground for cooking, or in powder, which quickly loses its aroma. In Arabic countries it is put in coffee to enrich the flavor and stimulate good feeling among friends. The seeds are chewed to refresh the mouth—let's not forget that one of the worst enemies of passion is bad breath. In some Tantric rituals it is used as a symbol of the yoni, or female genitals.*

Cayenne (Capsicum frutescens) *A hot power made from dried, ground red pepper, which is also the base of paprika, chili powder, Tabasco, and, in Japan, santaka. It is used, sparingly, to add color, flavor, and a touch of hot taste. If you get it in your eyes, it burns forever.*

Cinnamon (Cinnamomum zeylanicum *and* Cinnamomum cassia) *Extracted from the bark of the tree and used in sticks and powdered form, not only in sweets but also in meats and various curries in Asia and the Mideast. It is the classic condiment in Christmas recipes. Tea brewed from cinnamon bark is recommended as a medicine for the ills of menstruation and pregnancy.*

Clove (Eugenia aromatica) *So aromatic and spicy that it must be used with caution and removed from the food before serving, but in powdered form it is milder. Used as a condiment in desserts, meats—especially ham—and many exotic dishes of the East. In Asia and South America, when there is not enough money to pay for a dentist, a clove is placed on the affected tooth. It doesn't cure it, but it relieves the pain and dulls one's reason.*

Cumin (Cuminum cyminum) *Tiny seeds that give the characteristic flavor to Oriental food and to recipes of lentils and beans; the oil is used for balms and love philters.*

Curry powder *Not a spice but a mixture of several: coriander, cardamom, cayenne, pepper, ginger, cinnamon, mustard seeds, turmeric, and others. In Indian or Indonesian cuisine, for example, curry is prepared specifically for each dish—the proportions are often a family secret—and is always browned in oil or butter to obtain the maximum aroma and flavor. In the West we content ourselves with a yellow powder to which we give the generic name "curry," and which is offered to us in two choices: mild or strong. The strong is for the valiant.*

Dill (Anethum graveolens) *The leaves and seeds are used especially with fish. In Scandinavian houses, dill is ever present on the table. Seeds will lend their aroma to a bottle of oil or vinegar, while the leaves are ideal for tickling the feet.*

Fenugreek (Trigonella foenumgraecum) *With slightly hairy leaves and yellow seeds, it has an odor that is repugnant to the finicky. It is difficult to find, but we include it here because for centuries it has been thought in Europe to inflame low passions and provoke sensual dreams.*

Ginger (Zingiber officinale) *The fresh root, which will last two or three weeks in a dry place, is more flavorful, but ginger can also be obtained as powder or syrup. Its characteristic, rather hot taste enhances sweets, desserts, and innumerable exotic dishes. No Japanese kitchen is without it—the only*

way of getting down sushi, I suppose. Madame du Barry's chefs prepared a mixture of egg yolks and ginger that drove this courtesan's lovers, even Louis XV himself, to unbridled lust.

Lavender (Lavandula angustifolia) *The seeds lend their aroma to perfumes and soaps, but in the past they were also used in cooking as an aphrodisiac. They are rather bitter and hot and can ruin a salad but enhance a soup (they must be strained out before serving). If you do not want to take chances in your kitchen, place them in a sachet beneath the pillow where you will be making love.*

Lemon balm (Melissa officinalis) *Has a lemony taste and is good in mayonnaise, recipes that call for fresh cheese and cream, and in dressings and salads, including some fruit desserts. In Chile, lemon balm is drunk as a tea because it is thought to help one lose weight. If it were only that easy!*

Mint (Mentha veridis, Mentha rotundifolia, and other varieties) *Its fresh taste is popular in candies and drinks, but it is also used in many recipes. For the British, it is the inseparable companion to lamb. Shakespeare refers to it, along with lavender and rosemary, as a stimulant for middle-aged gentlemen. It grows like a weed and so is easy to cultivate in your garden. In some countries of the Mideast, guests are always welcomed with a cup of mint tea, strong, hot, and heavily sugared.*

Mustard (Brassica nigra and Sinapsis alba) *May be purchased as seeds, powder, and bottled. When I indicate mustard in my recipes, I always refer to the easily available jar, because I feel sure that on your erotic calendar you have more urgent matters to attend to than preparing your own mustard. A folklore remedy for impotence is to rub the male member with mustard, in my opinion a rather brutal method of persuasion.*

Nutmeg (Myristica fragrans) *A hard nut used to lend fragrance to pastries and desserts, but it also complements the flavor of some vegetables, such as spinach, and mild-flavored meats. It comes in powdered form but is more effective when grated from fresh nuts.*

Oregano (Origanum vulgare and Origanum onite) *Something your kitchen cannot be without. Its strong flavor and penetrating aroma are typical of Mediterranean cuisine. A handful thrown in the hot bath shared with your partner is an erotic experience.*

Parsley (Petroselinum crispum) *Witches used parsley as one of the ingredients of the magic potion for flying. Some texts say they prepared a balm for rubbing on their body—especially the erogenous zones—whose purpose was to produce hallucinations; others that they rubbed the phallic broom of their nocturnal*

flights with parsley. An uncle of mine, who had read about the virtues of parsley in an ancient tome, tried both methods but encountered an aerodynamic problem and, when he launched himself from the second-floor terrace on a broom, broke several ribs. There are more than thirty edible varieties: it is served with meats, fish, and salads, among other uses. Its freshens the breath after eating onion or garlic. Like dill, it is good for tickling and other sensual caresses, replacing the feathers that are now completely passé.

Pepper (Piper nigrum) *I go on record as saying that it brings joy to widows and alleviates the impotence of the timid. You will see that it is mentioned in nearly all the recipes in this book, excluding desserts. It is best to grind the corns in a mill as needed, not only to obtain more flavor, but for the ceremony as well, but ground pepper available in any market will do equally well. Did you know that sneezing is an erotic pleasure? My grandfather always carried a small gold box for his snuff and three batiste handkerchiefs embroidered by nuns to sneeze into. Put pepper on the pillow the next time you lure your man into bed, and if that doesn't work, you can always make love on the rug.*

Saffron (Crocus sativus) *A reddish-orange spice, in threads or powder, that turns everything yellow—including the cook if she isn't careful—and for that reason is used to dye cloth in Asia. In Tibet the color saffron is holy. In general, this is a very expensive spice, but to avoid its bitter taste it is used in small quantities anyway, merely two or three threads. It is the indispensable condiment in paella and other Spanish dishes and always delicious with certain shellfish. In the East, it is thought to be a stimulant.*

Sage (Salvia officinalis) *This is a favorite herb for assertive meats such as pork or game birds. It is much better fresh than dried. The soldiers of ancient Greece were welcomed by their wives with sage tea, to stimulate fertility and perpetuate the Greek race, which was always in danger of extinction because of their manic habit of following their heroes into war. Sage has a very strong aroma and must be used with moderation.*

Tarragon (Artemisia dracunculus) *Much better fresh than dried. It can be preserved in a bottle of vinegar; that way it perfumes the vinegar and you have leaves on hand when you need them.*

Thyme (Thymus vulgaris and other varieties) *It gracefully accompanies red meats and is practically indispensable in pâté and several red-wine sauces.*

Turmeric (Curcuma longa) *Native to India, it has a rather bitter taste, a subtle fragrance, and deep yellow color. It must be used with a delicate hand, because it can obscure all other flavors.*

Vanilla (Vanilla fragrans, Vanilla planifolia, *and other varieties*) *Indispensable condiment for sweets, cakes, ice creams, puddings, coffee, and chocolate, among others. It comes in beans and in extract or essence. If you have a choice, avoid synthetic vanilla; it has a rough, sometimes toxic flavor. Madame Pompadour's habit of perfuming her clothes with vanilla is again in style; there are complete lines of products for the bath, lotions, creams, and perfumes with that scent, but I don't enjoy smelling like dessert. It draws flies.*

The Orgy

You will recall my earlier reference to my stepfather, the incomparable Tío Ramón. One of the curious tribal traditions of Chile is that children call their parents' friends, in fact, everyone ten years their elder, Aunt and Uncle—as long, that is, as they belong to the same social class. When my mother introduced her suitor to us, we children naturally called him Uncle—*Tío*—Ramón, a name he carries to this day. Tío Ramón was a diplomat for sixty years. In the difficult first years of his career, when the social scandal resulting from his love affair with my mother had not yet blown over, he was posted to Lebanon. There he went to live, bringing with him his new wife and her three children, while still supporting his first wife and four children in Chile, all this on a public servant's modest salary. Need I say that there was no money to spare in our household, and abundant problems, but Tío Ramón and my mother were determined to live out their romance to the end.

In Beirut we lived in an apartment that had tiled floors, where any sound was magnified in the echoing corridors and half-furnished rooms—a situation not very conducive to lovemaking. From time to time, inspired surely by the four red leather-bound, gilded volumes of *The Thousand and One Nights* that he kept hidden under lock and key in his armoire, or per-

haps by the sensual aromas rising from the market and carried on winds from the desert, Tío Ramón took great pains to plan loving tête-à-têtes with my mother—low-budget, perhaps, but intimate and glorious. We children would watch as he dragged into their bedroom a beautifully polychromed screen from the living room, along with assorted rugs and Turkish cushions; then he would plug in speakers, cover the lamps with silk scarves, and prepare mysterious cocktails garnished with maraschino cherries and accompanied by toast points with caviar, the one luxury they could afford. Once the door closed behind them, we heard boleros and Peruvian waltzes whose purpose was not merely to enliven that discreet, private orgy but also to drown out the words and sighs of love. That was when my imagination roared into gear. I, too, had read *The Thousand and One Nights.* Tío Ramón, in his infinite innocence, never suspected that I had a copy of his armoire key and was reading those forbidden books every time he went out, which was frequently. What was happening behind that closed door? I was assaulted by lascivious visions: Arabian gardens, fountains spilling fruit and flowers, baths of perfumed waters, slaves, eunuchs, odalisques, bold thieves and cuckolded sultans, sex, adventure, intrigue, and poetry, all mixed together.

Years passed, many years, but I never forgot that closed door. Secretly I have always wanted some lover to drag furniture through the house to create an exotic corner where we could make love, but none has carried out my wish, despite countless carefully dropped hints. One of my most recurrent erotic fantasies is the orgy. In a book on the Roman Empire, also kept locked in Tío Ramón's armoire, I learned that the practice is as ancient as humankind. Under different pretexts, from religious holidays to victories at war, private sprees and public bacchanals have served as an escape valve for everyday tensions and heavy hearts. Once the world did not suffer problems of overpopulation; on the contrary, it was desirable to produce quantities of children. Fertility was celebrated by all ancient civilizations in ceremonial orgies. For a few hours or days, rules and laws were set aside and people poured into the streets in a happy jumble of women and men, nobles and plebes, saints and sinners. From those revels we derive our faded modern carnivals, which with very few exceptions are sorry imitations of the bacchanals of antiquity, when abandon gripped the soul and there was license to drink and fornicate to excess.

Before the triumph of Christianity in Europe, there was no such thing

as the concept of compassion or of love for one's neighbor; neither had it occurred to anyone that physical suffering was good for the soul. The idea of denying oneself pleasure for the sake of cultivating a superior state of consciousness had already been formulated but had not received much popular acceptance. The Spartan philosophy based on severity and discipline found followers only among warriors. Epicurus better represented the tendency of his time: earth, and all it contains, was created by the gods for the use and enjoyment of mankind. In the Greek and Roman cultures, pleasure was an end in itself, in no way a vice one had to expiate. The upper classes lived a life of leisure, totally free of any sense of guilt—labor was not considered a virtue but a calamity—indifferent to the fate of the less fortunate and surrounded by slaves whom they could torment at will.

During Roman feasts, which tended to last for days, fortunes were squandered in an unending competition to surpass the extravagances of other hosts: one after another came a parade of exquisite and novel dishes, washed down by the best wines; slaves covered the floors with renewed layers of fresh flower petals, sprinkled perfumes upon the guests, cleaned up their vomit, and offered them baths—sometimes in tubs of sparkling wines—massages, and clean tunics; musicians, magicians, jesters, and dancers entertained the participants; dwarfs and monsters pirouetted before them, exotic animals were exhibited in cages before ending up in the kitchen kettles; gladiators fought to the death among the tables, and beautiful, drugged slave girls submitted to every imaginable debasement. Finally, exhausted and often ill, the guests returned home to purge themselves, never suspecting that in the kitchens, the patios, the streets, everywhere, the slaves were spreading in whispers word of a strange faith that would end the world as they knew it.

That new religion was based on love of one's fellow beings, especially the poor and the meek, on simplicity of customs and negation of all pleasure-giving aspects of existence; the senses and appetites were the tools of the Devil that condemned souls to hell and must therefore be subdued with iron determination. I can imagine the jeering amazement of wealthy Romans when they heard the first teachings of the new fanatics; they must have considered them nothing more than delirium and have attempted to prevent the spread of contagion through the impressive lesson of feeding them to starving lions in the Coliseum. They never suspected the repercussions and kept laughing as Christianity flamed among the poor like an

uncontainable wildfire, a conflagration that in the end would be their doom. Several centuries of obscurantism had to pass before the ashes settled, the dense smoke dissipated, and Europe regained a respect for the senses and a taste for extravagance.

During the Middle Ages, art, luxury, and beauty had been cause for suspicion: delight became a source of guilt, and the body was transformed into the enemy of the soul it housed. Suffering in this life was the surest way to gain eternal rejoicing in the next. The great saints of Christianity found virtue mainly in torturing themselves in inconceivable ways, like the stylites who squandered their lives perched atop a column, never changing position, often with their hands clenched so that their nails pierced their flesh and grew out the backs, eating scraps, never talking to anyone, never bathing, covered with pustules and worms. Believers, open-mouthed, bowed before this spectacle that supposedly pleased God. There were exceptions, of course; there always are among the wealthy and the wise. Nobles and prelates of the church, for example, who had never renounced good food and beautiful women, and travelers who had discovered the marvels of the East during the Crusades and returned with a taste for the exotic spices, perfumes, sciences, and art forgotten since the times of the Roman Empire. Those refinements, however, were limited to a few sybarites in the ruling classes; the great mass of humanity lived in misery, ignorance, and fear. The hedonism of the Greeks and Romans, who deemed pleasure the supreme goal of life, was replaced by the somber postulate that the world is a place for the expiation of sins, a vale of tears in which souls strive to live exemplary lives and suffer martyrdom in order to win a place in a hypothetical Paradise. The ancient festivals related to the grape harvest, fertility, changing seasons, and the gods deteriorated into simple gluttony in times of good harvests, and orgies into the brutal violence of victorious troops' sacking and plundering.

For a thousand years, Christianity systematically destroyed the old gods, wiping out all trace of them in barbarous ways, burying them in the dark ashes of memory, transforming them into devils, and burning at the stake, as heretics and witches, those who had the bad fortune to remember them. When the church could not entirely suppress pagan celebrations, it assimilated them into its own liturgy. This is how, for example, the loaves shaped like phalluses and female genitals once used in orgiastic feasts were reshaped into rolls marked with a cross and called Corpus Christi buns.

But there were times that the deposed deity would not be subjected: during Carnival in Trani, Italy, a statue of Priapus was paraded through the streets and his enormous wood phallus venerated as *Il Santo Membro*. The more repression the human being must bear, the greater the number of rebellious ideas that emerge from a tortured imagination. There was one Slavic Christian sect, the Khlysti, who celebrated orgiastic ceremonies in which men and women copulated in representation of the divine union of Jesus and Mary amid widespread drunkenness, singing, dancing, and flagellation. These rites took place following months of abstinence, chastity, and fasting during which married couples slept in the same bed without

touching. Some Khlysti rites survived until the end of the eighteenth century: it is said that Rasputin had heard of them and adopted some of their eccentricities.

There have always been orgies, thank God, even in the times of the Inquisition and the Puritans, when everyone went about dressed in black and walls were adorned with lugubrious crosses, but they have been most brilliant and entertaining in the historical epochs when pleasure was cultivated as an art. Marie Jeanne Isabel Bécu du Barry, the celebrated courtesan who lived and loved in France at the beginning of the eighteenth century, turned her excesses into fashion and her orgies into social events. When she was fifteen, she married the Comte du Barry, who could not match his wife's energy and died of exhaustion four years later. It was a glorious era when conversation flourished in salons, refinement in dress, and luxury in decor; for the first time, after many centuries of obscurantism, the women of the aristocracy had access to education. Madame du Barry, beautiful, rich, and of explosive character, threw herself into a headlong dash through lovers of every stripe, Homeric revels, and financial scandals that were the gossip of nobles and plebeians alike. Nothing intimidated her. Her father, who came to be regent of France, and who, it was said, had incestuous relations with his daughter, applauded everything the young widow devised to amuse herself. At her soirées wine flowed like water, and guests, naked as babies, copulated with animals when they tired of one another. This Comtesse du Barry, a rebellious and fearless spirit who would go down in history as a degenerate, died at the age of twenty-four.

But let's get back to my erotic fantasy. In practical terms, what would my own orgy be like? Whom would I invite, and where would I hold it? What would I offer in the stead of monsters, beasts, and gladiators? I know I couldn't invite anyone I know and then later look them in the face—not for nothing am I bowed down by centuries of Christian moderation. Nor could it be held in my house. Too many family members and friends have keys. As for slaves and freaks, not a chance; that would be frowned on in California. As entertainment, I would have to resort to videos and risqué games like the strip poker of the sixties, when you had to forfeit an article of clothing each time you lost.

By the way, Robert Shekter told me that the inspiration for some of his illustrations came from an orgy he attended in Sweden some years

back. One impenetrable winter night, cold as the North Pole, he was invited to a summer house two hours from Stockholm, where he found a group of people around a bar drinking alcohol, smoking marijuana, and talking about Nietzsche's influence on Ingmar Bergman. There was very little to eat, except smoked raw fish, sliced meats, and a basket of quail eggs, but he's a vegetarian. After a while, the gathering heated up and people began taking off their clothes, running their hands over each other, and falling into corners together, all with the greatest courtesy, seriousness, and respect for taking turns. After each coupling, they would sit in the sauna for ten minutes and then run outside—as expiation, we must suppose—and roll in the snow. Robert was hungry and cold and beginning to get bored, so he went out to see if he could find somewhere to eat. When he returned, everyone was dressed and standing at the bar drinking, smoking marijuana, and talking about Schopenhauer's influence on Ingmar Bergman.

What would I serve at my orgy? If I had unlimited resources, I would offer the guests platters with raw and cooked shellfish, meat, game birds, and cold fish, salads, sweets, and fruits—especially grapes, which always appear in films about the Roman Empire. And mushrooms, of course, which are as aphrodisiac as oysters. The celebrated Roman poisoner Lucasta knew the popularity of those fungi. On Agrippina's orders, she killed the emperor Claudius with poisoned mushrooms and then used the same recipe to dispatch others after him. It was relatively easy to eliminate enemies with mushrooms during an orgy. Nero, a man short on patience, demanded that Lucasta provide a more powerful and quick-acting poison to unburden himself of his mother, but Agrippina had learned to be suspicious of anything cooked in her kitchen. Nero then shipped her off on a boat that—curious coincidence—sank on the coast of Anzio, but that mother was a hard bone to chew and knew how to swim. In the end, her son had to send a soldier to run her through with a sword, a somewhat more traditional method. Sorry. The subject of orgies always throws me off the track, and I can't concentrate.

When you plan your orgy, you must count on its lasting all night, so a buffet isn't such a good idea; after a few hours everything goes limp. But without slaves, neither is there any good way to present an uninterrupted parade of exotic dishes fresh from the kitchen, unless the mistress of the house devotes herself to cooking instead of having fun, and that's not the

point of the whole enterprise. In my case, maybe I should settle for an orgy of modest proportions, like the ones Tío Ramón prepared for my mother in those long-ago days in Lebanon. A bacchanal worthy of the name requires one truly staggering recipe that is both aphrodisiac and flexible enough to serve an indeterminate number of participants, since people always drop in on these things unannounced, and still have some to replenish everyone's strength at midnight. The only thing I can think of that meets those requirements is the aphrodisiac stew of Aunt Burgel, a jolly German matron who enlivened many pages of my third novel, *Eva Luna*. The origin of that stew goes back to a memorable trip I made more than twenty years ago to Easter Island.

AUNT BURGEL'S APHRODISIAC STEW
or Simple Curanto en Olla

Curanto originated in Polynesia. I ate it for the first time on Easter Island, where at the news that a *curanto* is in progress all the island inhabitants, including the few remaining lepers, head for the beach with their musical instruments and flower garlands. The event gets under way at midmorning when a bonfire is lighted to heat some large stones. The youngest men dig a pit a meter wide and a couple of meters long, piling the dirt to one side; meanwhile, the women are preparing the ingredients, children are washing banana leaves, and everyone is joking and shouting. All the fixings are heaped on large wooden tables: an entire lamb, cut into pieces and seasoned, sausages and pork chops, mounds of chickens marinated in lemon and herbs, a variety of fish, groggy lobsters, shellfish, potatoes, and corn. When it is reckoned that the stones are hot enough—about midafternoon—they throw them into the bottom of the pit, immediately set some clay pots atop them to collect the juices and broths, and then start layering all the ingredients for this prodigious *curanto*. Last of all, they cover the whole thing with clean, damp cloths, and on top of that place several layers of banana leaves that make a mound like a blanket. They shovel the dirt dug from the hole over the leaves and then sit down to wait for that patient heat to slowly work its miracle. No question of the wait being tedious, because there is plenty to drink: *pisco* and pineapple juice, or warm Coca-Cola with rum. Strings and percussions are playing, people are singing and telling stories and flirting, regardless of age, while a handful of German or Japanese tourists take photographs of the smoke rising from the pit and

discreetly snap the lepers. I don't have any idea how they work it out, but the *curanto* is ready to eat just at the moment the sun sets.

Easter Island, which the natives called the Navel of the World, is six hours by jet from the nearest inhabited point of land: Tahiti or the coast of Chile. It was born of telluric vomit from the most remote undersea volcanoes, an island lost in the middle of an infinite ocean, not on the maps, far from the sea lanes. Three volcanoes provided its matter and its magic. There is a magnetic point on the island where watches and measuring instruments cease to function, compasses whirl madly, and you can see the complete circle of the planet on the horizon: 360 degrees of sea and sky and solitude. On moonlit nights, you see dolphins playing in the silvery waves; on nights when there is no moon, dark as blackest velvet, you can count stars yet to be born. At sunset, the *moais*, giants of volcanic stone sculpted by ancient sorcerers, turn fiery red. At that moment, the young men shovel the dirt off the *curanto* and the girls carefully lift off the banana leaves. The white cloths are revealed without a particle of dirt, and as they are removed, a huge cloud with a marvelous bouquet floats down the beach. Around the pit there is an instant of silence, until the steam evaporates and you see the opened shells of the mollusks and the red crustaceans, then a celebratory cry announces: *Curanto!*

The older women, fat, solemn, powerful, lift out the booty and arrange it on the plates. The first servings are for the lepers, who stand some distance away. And then, layer by layer, the treasures emerge from the pit, beginning with the fruit of the sea, followed by meats and vegetables and, last of all, the broth in the clay pots, which is served boiling hot in paper cups. One sip is equal to the jolt from half a bottle of straight vodka. Anyone who has tasted that broth, the concentrated essence of all the flavors of earth and sea, will never again be satisfied with other aphrodisiacs. One cannot possibly describe the taste, only speak of its effect: it explodes like dynamite in the blood.

I wrote *Eva Luna* in an apartment in the heart of Caracas, where it was impossible to do a true *curanto*. Trying to imagine a recipe that would have the same power as the Easter Island aphrodisiac, it occurred to me to try to copy it in a kettle, not an original inspiration, since others more expert had already tried it, successfully. This meal is stimulating not merely for the quality of the ingredients, but especially for the bacchanalian atmosphere implicit in its preparation. The euphoria begins long before tasting

it. As I was unable to find a clay cassoulet large enough, I bought the largest aluminum vessel I could find, not so big around as tall, and fitted with a tight lid, and set myself the task of experimenting again and again, adding and taking away, until I came out with something similar to what I had eaten on Easter Island.

Curanto in a pot requires the same laborious preparation of ingredients as the one cooked in the ground pit, but it cooks rapidly, which means you have to pay special attention to the seasoning, since you can't count on the slow work of the heated stones. That gentle alchemy brings out the spirit of the ingredients, distilling them into the broth. The earth, banana leaves, smoke, and the slow cooking give the island dish an inimitable flavor. It wasn't the same in my kitchen in Caracas until I cast aside my tentativeness and with herbs and spices achieved a blast similar to that of the dynamite *curanto* on the Easter Island beach. And so was born Aunt Burgel's aphrodisiac recipe, which I don't dare offer here, because Panchita has one that's much better.

A bacchanal is a rather delicate undertaking, so choose your guests carefully. Not everyone is up for abandon. Forget your solemn friends, the silly ones, anyone overly religious or overly married, the hypochondriacs, and the melancholics. From among those left, select a group with robust constitutions and open minds. In order to avoid misunderstandings, notify them in writing of the time, place, and conditions of the fiesta, adding the traditional RSVP at the bottom, so you will know how bounteous your *curanto* must be; nothing more embarrassing than having to interrupt an orgy to send out for pizza. If your finances are in the shape mine are, I suggest you accept contributions: a kilo of squid, a salmon, sausages, lobsters, a hen, and of course, wine in abundance. As your friends arrive, bring them to the kitchen to help with the preparations, and the party will begin there. Using the excuse of not ruining your clothes as you clean the shrimp, peel onions, and chop chickens, you can begin to shed your clothes early in the evening: lively music and wine are de rigueur; other aphrodisiacs are optional.

PANCHITA'S *CURANTO EN OLLA*

Take a large kettle or pot of clay, iron, or heavy aluminum, and line the bottom with a layer of spinach leaves, onions lightly sautéed and studded with several cloves, a bunch of herbs—don't forget rosemary and bay leaf—a few carrots chosen with an eagle eye, turnips, peppers, and garlic

cloves. Then in a large frying pan, with method and enthusiasm, lightly brown smoked pork chops, pieces of skinless, tender chicken, and the best-quality sausage; once browned, place in orderly layers in the kettle, beginning with the pork chops and ending with the fowl. The night before you will have left garbanzos to soak; as soon as you skim off the skins, place the garbanzos in a mesh bag so they don't scatter through the stew. This addition contributes both flavor and entertainment: if the garbanzos stay hard, your bacchants can shoot them like spitballs, and if they turn soft, they are delicious and aphrodisiac. Add salt, pepper, and a few drops of Tabasco or hot chili, and pour in half a bottle of dry white wine. Cover the pot with a clean cloth and top it off with several volumes of the *Encyclopaedia Britannica,* or maybe a brick, so the steam can't escape. Leave everything at a rolling boil for fifteen minutes, while the guests you've invited to your orgy enjoy their wine and fresh oysters. (The advantage of oysters, in addition to their powers of arousal, is that opening them requires teamwork. You don't want to put them in the *curanto* because they are much tastier raw.)

After a quarter of an hour, take off the lid and add medium-size pota-toes, cleaned but not peeled; fish cut into portions, with head and tail retained for flavor—tuna, conger, swordfish, and other succulent, firm-fleshed fish—and last of all, shellfish, starting with those that take longest to cook, such as crab and shrimp, and ending with mussels, all well washed, of course, unless you want sand in your stew. Use fresh shellfish just as they come, crustaceans and mollusks still in their shells, but omit lobster, because alive they draw a lot of attention and you can't put a dead lobster in the pot. The squid will give body to the broth, as does the juice of a large lemon, a few sprigs of cilantro, a few more turns of the pepper grinder, and more wine—this time, the whole bottle. Weigh down the lid the way you did before, using the encyclopedias or the brick, and cook for a half hour longer, this time on a low flame.

When you take off the lid, a fragrant column of steam will billow out, rising toward the skies like a holy offering, and as you eat your way through the treasures, beginning with the lightest and ending with the pork, you come to the Olympian nectar collected at the bottom of the pot, the essence and spirit of all the ingredients, well seasoned and hot, that you drink with prudence in little clay jugs, knowing in advance that it intoxicates the soul and unleashes lust for all eternity.

SOUP FOR ORGIES

This soup has a robust country flavor that raises a sweat on your eyelids and awakens your basest instincts, even a desire to recite poetry. It's a very concentrated broth of meat and vegetables to which the whole Spanish landscape has been added. This dish, which can make friends of enemies and revive the passion of the most world-weary, is Carmen's favorite. It's what she always serves at her orgies. No way around it, it takes a lot of work, but it's more than worth it. The privileged guests who have tested its effect pass through the world commenting on its virtues, thereby spreading Carmen's fame far beyond the horizon.

Ingredients

FOR 10 BACCHANTS
6 quarts water
½ hen
1 veal bone
5 ounces bacon, well marbled
½ pound pork ear and jowl
1 pig's foot
1 ham hock
1 turnip
1 carrot
1 celery stalk
2 leeks
Salt
1 fryer
1 pound veal ribs
1 pound veal hock
1¼ pound potatoes
1 cabbage
½ pound pork sausage
½ pound garbanzos, soaked in
 water overnight

MEATBALLS
1 pound lean pork, ground,
 or ¾ pound pork and
 ¼ pound veal
1 egg
1 clove garlic
2 tablespoons bread crumbs
 soaked in milk
1 sprig parsley, chopped
1 tablespoon flour

Preparation

A huge pot is absolutely necessary for this recipe, a minimum 10-quart capacity. Set to boil water, hen, veal bone, bacon, pork ear and jowl, pig's foot, ham hock, and vegetables for the stock: turnip, carrot, celery, and leeks. Salt, too, of course. Cook for 1 hour.

This is more than enough time for cooking the garbanzos and preparing the meatballs, which hold no mystery. Mix ground meat with egg, garlic, milk-soaked bread crumbs, and parsley, and stir. Shape into balls, and dredge in flour.

Remove skins from the garbanzos, and put in a large pot with plenty of cold water; cook slowly until soft. Drain, then cook 10 minutes more in a small amount of pot liquor, to give them flavor. Keep warm.

When the stock has cooked for at least an hour, add the fryer, veal ribs and hock, and meatballs, and continue to cook for at least 1½ hours, until they are very tender and the entire house smells like Paradise. Strain off the

stock, and divide into two pots, one large, one medium. In the larger one boil the potatoes and the cabbage, and put well-strained stock into the other.

Pour a couple of inches of the stock into a large, heatproof vessel (it can be Pyrex), and keep warm over a very low flame. Carefully arrange the cut-up hen (after removing skin and ugly bones), the meat cut into equal-size pieces, laid out in families: pork, veal, fowl, jowl, with meatballs in the center, separating the meat from the fowl. The garbanzos can be served at the side of the platter or in a separate bowl. This is the platter that will be taken to the table, and so it must be arranged with a certain aesthetic intent or it will look like the result of a road kill.

At the last moment, just before gathering around the table, add pork sausage, which needs minimal cooking, to the broth containing the potatoes and cabbage. After a few minutes remove it from the stock and place it on the platter with the meat. Arrange the cabbage and potatoes on a separate platter.

It goes without saying that there are no fixed rules for an aphrodisiac casserole like this. You can give wing to your imagination, adding sausage, smoked meats, different vegetables, and, if you want to add an exotic South American touch, cassava and corn on the cob. Carmen spares no

expense or effort when it comes to an orgy. In her zeal for excellence, she often divides her divine stock into several tureens and in one, for example, serves the stock with corn and finely cut-up chicken, and in another stock with rice, in another vegetables, and so on.

Once everyone has recovered from the effects of the orgy, and before the guests say good-bye, she leads them to the kitchen, where they help wash up the mountain of pots and pans used in the feast.

About Tastes

Food, like eroticism, starts with the eyes, but there are people who will put just about anything in their mouth. In Samoa, live octopus is a delicacy. Natives of those islands hold the beast to their face, let the tentacles wrap around their head in an involuntary embrace, then bite the beak and, mouth-to-mouth in a long kiss of death, suck out its insides. Poor creature.

The first time I saw edible snails, I thought they were a joke. It was a winter day on the great square in Brussels, more than thirty years ago, one of those gray days that seem to stretch on for weeks. A man stood on a corner selling little paper sacks of French fries and snails. I had to watch with my own eyes as a mustached burgher dug those slimy worms from their shells with a toothpick and popped them in his mouth before I learned the true breadth of human nature.

In Sichuan, in the interior of China, I had to choose my breakfast from a pond writhing with sea snakes. The cook hooked out mine with a forked pole and five minutes later presented it in my soup. That was less traumatic than the huge land snake with green scales another chef had cooked and served on a plate surrounded by hot peppers and potatoes, its head raised as if to strike. It had a very strong taste, like slightly spoiled fish. Earlier I had seen the cook shaking a live mouse by the tail above a wooden box that held the reptiles; the minute one slipped free from the tumult, he seized it

behind the head and broke its neck. I don't know how after cooking it he was able to get the head erect and wearing that ferocious expression. I tasted it to be courteous, and ate the peppers.

In some parts of Mexico, fried ants are the children's favorite treat— sweet and hot—and in Chile the spider that lives in the sea urchin is thought to be aphrodisiac, as long as you eat it while it's alive. You place it on the tip of your tongue, and when the innocent arachnid tiptoes toward the back of your mouth, you slowly crush it against your palate until it is smashed flat. These barbarities, which would break a vegetarian's heart, are erotic for others. There are those who appreciate the remnants of cadaver of octopus, snail, snake, or spider in the kisses of their companion.

The skink is a North African lizard that from times as remote as Greek and Roman antiquity has been said to have fantastic aphrodisiac powers. The snout, feet, and especially the genitals are soaked in wine and cooked in a bed of herbs. The Persians mixed the flesh of the skink with ground pearls and amber. An exquisite aphrodisiac was also prepared from the *hippomanes*, a small slice of flesh taken from the forehead of a newborn colt and mixed with the blood of the beloved. If the blood was from the menses, the effect could be fulminating. It is suspected that Caesonia gave Caligula a similar brew to win his love, causing the frenzied and arrogant madness that led him to commit so many crimes, but this explanation is typical of historians, who always find a way to blame the woman.

In any case, the boundary between erotic philters and poisons is so subtle that sometimes it vanishes completely, sending more than one love object to the grave. Currently in the United States, as in many other countries, it is illegal to prescribe or administer philters, just as it is forbidden to practice the magic called "black." On the one hand, science disqualifies magic as pure superstition, and on the other, condemns it as dangerous.

Sometimes it is better not to ask what you're eating. In the end, it doesn't much matter. My son's favorite treat was fried potatoes smeared with condensed milk, and one of my brothers caught flies on the windowpanes and, to win bets from a semisadistic uncle who seeded the years of our childhood with unforgettable tales, ate them alive. In the most refined European gastronomy, kidneys in sherry, brains in butter, tongue with nuts, tripe with tomato, and even pigs' feet are considered true delicacies by the most discerning palates, yet none of these is presentable on a North American table. Before the arrival of the white men with their tin cans and

their manias, the Eskimos supplemented their diet with raw seal viscera and bear excrement, rich sources of proteins, vitamins, and minerals. The brains of monkeys, some other animal species, and us humans contain a substance of extreme aphrodisiac strength, thence the practice of eating brains and probably the origin of cannibalism.

Oscar Kiss-Maerth (1914–1990) was a Hungarian monk who developed and personally tested a strange theory about evolution based on anthropophagy. I don't know how he obtained the raw material for his experiments, but it must have been a thoroughly repugnant process, because in his last years he became a vegetarian. Certain medieval alchemists pulverized the brains of birds, particularly doves, and used the powder, dissolved in wine, as a remedy for impotence. In China and other regions of Asia, the brains of live monkeys are morsels much desired. They present the monkey in a narrow cage beneath a table with a hole in the surface that secures the already trepanned head of the primate. I won't go into further detail here because this is not a book about nightmares, but eroticism and cuisine. If you are one of those people who steadfastly believes in the magical virtues of something that hair-raising, I suggest you eat alone and not broadcast it.

Alligators and Piranhas

Deep in the Amazon, in the heart of South America, where the jungle can be so thick that if you wander two meters away from the trail you are lost in Venusian vegetation, monkey is greatly appreciated as food. I saw one skewered from mouth to anus roasting over a fire, burned to a crisp but still looking like a child. Depending on the season, the texture is tough or tender, but the flavor is always strong and sweetish. The jungle is an enormous, hot, exhausting, mysterious labyrinth in which one can wander in circles forever. With its birdcalls, screeching animals, and stealthy footfalls, the jungle is never silent; it smells of moss, of dankness, and sometimes you catch a mouthful of a clinging odor like rotted fruit. To inexpert eyes, everything is green, but for the native, it is a diverse and endlessly rich world: there are vines that gather liters and liters of pure water to drink, bark that reduces fevers, leaves used to treat diabetes, resins to close wounds, a milky sap that cures a cough, rubber for affixing arrow points—in short, it is the largest biogenetic preserve on the planet. The Indians use a poison extracted from plants that they throw into the water to stun the fish. They collect them when they float to the surface, then eat them without danger because the poison quickly degrades.

After the waters of the Río Negro and the Salomoes flow together, the river is called the Amazon. It is as broad as the sea in Normandy, a dark mirror when it is calm, terrifying when storms erupt. In a glass, water from the Rio Negro is a kind of amber color and has the delicate flavor of strong tea. At dawn, when the rising sun stains the horizon red, rosy dolphins come out to play, one of the few Amazonian fish that are not eaten, because the flesh is bitter and the skin unusable. The Indians harpoon them, nonetheless, and rip out their eyes and genitals to make into amulets for virility and fertility.

In that same warm river where the previous afternoon I had seen a couple of Russian tourists catch dozens of piranhas, I had swum naked. Although these fish have such a bad reputation, they normally do not

attack people and, along with alligators, are useful for cleaning the water; they fulfill the same function as birds of prey: they eat carrion. They are delicious and, to some Brazilian palates, even aphrodisiac, but those tourists from Moscow had no intention of cooking them; they were fishing for the sport, catching them and throwing them back in the river. Some piranhas had taken the bait many times, leaving their mouths raw and bleeding. Like some of us humans, who keep tripping over the same stone in our path, the piranhas never learn.

In these same waters there are more than thirty kinds of stingrays, all very dangerous, and the river is also home to the legendary anaconda, largest of all water snakes, a prehistoric creature that can reach fifteen meters in length. It lies lethargically in the mud, waiting for its lunch to swim by in the form of a distracted fish. I was assured that they don't eat people, but in Malaysia I saw the photograph of a boa split open with a man's body inside. I have no reason to believe that the Amazonian anaconda would be any more considerate than its Asian cousin.

Alligators, another aphrodisiac dish of the region, are hunted at night. I went out in a canoe with an adolescent guide, a young Indian who openly laughed at my ignorance. The boat was equipped with a powerful battery-operated spotlight, which when turned on dazzled bats and huge, brightly colored butterflies—also the piranhas, which in their terror would leap right into the boat. To throw them back in the river, we picked them up very gingerly by the tail, because one bite from their terrible jaws can take off a finger. The Indian would beam his light in among the tree roots and, when he spotted a pair of red eyes, unhesitatingly jump into the water. You would hear a great thrashing sound, and a half minute later he would reemerge with a *jacaré*, an Amazon crocodile, he had caught bare-handed and was holding by the neck, if it was small, and with a cord around its jaws, if it was larger.

In one village, composed of a single extended family of Sateré Maué Indians, I tasted *jacaré* for the first time. It was beneath a shared palm roof hung with a few hammocks where several young Indians and a centenarian elder were resting, lost in the smoke of their tobacco. A half dozen children were running around naked, and when they saw me they scampered off to take refuge among the women, although a pair of mud-covered, skin-and-bone dogs came running up to sniff at me. One of the Indians, the only one who spoke a few words of Portuguese, showed me his humble

belongings—arrows, a knife, some empty tin cans used as cook pots—and then led me to a small clearing in the vegetation where they had planted manioc, that miraculous root from which the Amazon peoples derive flour, tapioca, bread, and even a liquor for their celebrations. Out of curiosity, I walked over to the fire burning in a corner of the roofed area and found a crocodile a meter and a half long, quartered like a chicken, sadly roasting, its claws, teeth, eyes, and hide intact. Two piranhas were strung on a hook, along with something that resembled a muskrat; later, after a closer look, I realized it was a porcupine. I tried everything, of course: the *jacaré* tasted like dried and reconstituted codfish, the piranhas like pure smoke, and the porcupine like petrified pig—but I shouldn't judge indigenous cooking by that one limited experience.

Aphrodisiac Cruelties

Sheep vulvae and cow udders are infallible stimulants according to the testimony of Messalina and other women of dubious virtue, but for reasons of feminist solidarity, we omit those recipes. The testicles of certain animals, generally those who have the reputation of being potent, are equally prized in several cultures. Nothing is more appreciated in North Africa than the balls of the lion, which supposedly transmit strength, courage, and sexual power. The same was believed true of the ass in Greece, where men not only ate those glands but wore them around their necks as an amulet for virility. Testicles are not always easily found in the market, and once in your hands, what to do with them, anyway? In the country, when bulls are castrated, those intimate parts are threaded onto a spit and roasted over coals, usually in the presence of the ex-bulls, now steers. In an eighteenth-century erotic cookbook I found a rather more sophisticated recipe. You boil the testicles in salted water, let them cool, peel off the skin, dice them so fine they can't be recognized for what they are, mix them with onion,

fried minced calf liver, and bacon, season generously with rosemary, clove, cinnamon, salt, and pepper, cover with a thick wine sauce, and use as filling for a meat pie. Cook in the oven for a half hour. It's *awful*.

In the Argentine and Chilean regions of Patagonia, in the south of the south of the American continent, lies an unending stretch of flat, wind-lashed land where a straggly vegetation struggles to grow. It is one of the largest reserves of meat in the world. Animals graze freely on that enormous *pampa,* never suspecting that their one purpose in life is to supply the meat, milk, and, in the case of the sheep, wool industries. My grandfather earned his living raising sheep in Patagonia and shipping their wool to England, from which it often returned converted into sweaters and blankets. At shearing time many hands were needed, and men crossed the border by the hundreds to work. Dogs drove the terrified sheep from the pasture to the corrals, where they were vaccinated, then herded through to the hands of the shearers. The most expert of the men could shear a fleece in the blink of an eye, pinning the animal down with one arm while wielding the huge scissors in the other hand. Electric shears had not reached those parts in my grandfather's day. That was also the time they marked and counted the flock, selecting the breeding stock and separating the

young bucks, some for the slaughterhouse and others, after they were castrated, to be fattened and continue to produce wool and meat.

The workers began their day with a hunk of bread, *chicharrones* (fried skin, fat, and intestines), and *mate,* the green, bitter tea so esteemed in that region. They would not have another bite to eat until dusk, when the day's work was done. At sunset they lighted fires to roast slaughtered animals, guitars were resurrected, and the men shared enough liquor to soothe their souls and warm their bones but not enough to get drunk, since they had to begin at dawn with a clear head. The testicles of the castrated animals, roasted on the spit, were considered delicious. In *Patagonia Express,* Luis Sepúlveda describes a blood-curdling scene in which the men, making a show of their machismo, castrated the sheep by biting off their balls, but I never saw that happen. Shearing was a man's work; women had no place in that barbaric *pampas* ritual.

I am reminded of "The Butcher," a story by the French writer Alina Reyes, about a man who every week bought goat testicles from the butcher to maintain his extraordinary sexual powers. Without a word, the butcher would hand them over in a carefully wrapped package, himself convinced of their effect but not daring to test them, because, as Reyes writes: "That part of the male anatomy, so vilified in jokes and commentaries, nevertheless demands respect. It is no exaggeration to say that you can't go very far without stepping into sacred territory."

It's true, we treat the male organs with solemn deference. In the United States, the case of John Wayne Bobbitt made history. His wife, fed up with violence and abuse, waited one night until her husband was sleeping, then cut off his penis with a single slash of her butcher knife. Surprised at her own virulence, she jumped into her car and raced down the highway, but a few miles down the road realized she was carrying that piece of flesh in her lap. So she threw it out the window. Anyone would have done the same. Later, police with flashlights scrupulously searched the highway until they found the amputated appendage—they would never have taken such pains had it been female flesh—and rushed it to the hospital, where doctors sewed it back in place. The details, with color photos and vivid television images, were flashed across the country, for months dominating the imagination of countless women and occasioning a surge of insomnia among the male population. John Wayne Bobbitt, like his namesake, ended up in the film industry, a star. He specializes in pornographic movies, and now any-

one curious enough can observe, on the big screen and in Technicolor, that pathetic, scarred pickle. They say that some women fight for the chance to test personally whether that Dr. Frankenstein handiwork functions.

And by the way, do you remember the Japanese film *In the Realm of the Senses*? It's the story of a woman and a man whose sexual passion leads them to the extreme of closing out the world to do nothing but make love, excluding everything else from their lives. Searching for more and more intense sensations, they discover a game in which she strangles him with a silken muffler to prolong his erection. Every time, she draws the scarf tighter; every time the pleasure is longer and more brutal . . . until finally she kills him. Desolate when she realizes that she has lost him, she cuts off his genitals. The film is based on a true story of a woman who wandered around in open fields for five days with her lover's genitals in her hands, until she was stopped by the police. In a spectacular trial, which captured a nation's sympathy, she was sentenced to only five years in jail. When she emerged, free, she returned to her former profession as a prostitute, with startling success. Although she charged ten times the rate of her colleagues, men traveled from remote provinces and stood in line for hours to play the game of the silken muffler.

About Eroticism

In the forties, Anaïs Nin and Henry Miller survived for a while by writing erotic stories for a man who paid them by the page. This client, known to them only as the Collector, remained anonymous, piquing the indignant curiosity of the two great authors who lent their talents and their pens to satisfy his caprices. This collector of pornography did not appreciate style and repeatedly asked them to "cut the poetry" and concentrate on the sex, because that was all he was interested in. Nin wrote him a letter in which she masterfully defined the essence of eroticism:

Dear Collector:

We hate you. Sex loses all its power and magic when it becomes explicit, mechanical, overdone, when it becomes a mechanistic obsession.

It becomes a bore. You have taught us more than anyone I know how wrong it is not to mix it with emotion, hunger, desire, lust, whims, caprices, personal ties, deeper relationships that change its color, flavor, rhythms, intensities.

You do not know what you are missing by your microscopic examination of sexual activity to the exclusion of aspects which are the fuel that ignites it. Intellectual, imaginative, romantic, emotional. This is what gives sex its surprising textures, its subtle transformation, its aphrodisiac elements. You are shrinking your world of sensations. You are withering it, starving it, draining its blood.

If you nourished your sexual life with all the excitements and adventures which love injects into sensuality, you would be the most potent man in the world. The source of sexual power is curiosity, passion. You are watching its little flame die of asphyxiation. Sex does not thrive on monotony. Without feeling, inventions, mood, there are no surprises in bed. Sex must be mixed with tears, laughter, words, promises, scenes, jealousy, envy, all of the spices of fear, foreign travel, new faces, novels, stories, dreams, fantasies, music, dancing, opium, wine.

How much do you lose by this periscope at the tip of your sex, when you could enjoy a harem of distinct and never-repeated wonders? No two hairs alike, but you will not let us waste words on a description of hair; no two odors, but if we expand on this you cry: Cut the poetry! No two skins with the same texture, and never the same light, temperature, shadows, never the same gestures; for a lover, when he is aroused by true love, can run the gamut of centuries of love lore. What a range, what changes of age, what variations of maturity and innocence, Perversity and art.

We have sat around for hours and wondered how you look. If you have closed your senses upon silk, light, color, odor, character, temperament, you must by now be completely shriveled up. There are so many minor senses, all running like tributaries into the mainstream of sex, nourishing it. Only the united beat of sex and heart together can create ecstasy.

Large Birds and Small Birds

Nearly all game birds are considered aphrodisiac, but not roosters, chickens, and domestic turkeys, melancholy creatures that know nothing about love. These birds spend their short lives in atrocious cages with no visual perspective but the tail feathers of their nearest fellow, fed on fish meal, soused with hormones, and tricked by artificial lights that force them to grow fast and lay eggs as if obsessed. The instant they reach the ideal weight, they are killed. They know nothing of the adventure of pulling a worm from the soil or chasing another bird of the opposite sex. They are so miserable that misery is about all they can pass on. However, if you can manage to find free-range chickens and turkeys, the ones that go around happily pecking in natural sunlight, you can also include them in your erotic cuisine.

Some of the birds we list here tend to come from hatcheries, but their dark meat and strong flavor have a breath of the exotic and the wild capable of stimulating the human imagination, especially when prepared with abundant spices, herbs, and liquors. Nondomesticated birds have the reputation of being more aphrodisiac than their domestic relatives. That's true of the dove-and-pigeon family, but what Christian is going to eat a dove that symbolizes the Holy Spirit, unless, that is, he is dying of hunger, like a friend of mine, an exile in Canada, who crept out nights to the park to catch sleeping

pigeons and then cook them on a forbidden hot plate in the fleabag where he lived. His rented room was heated by a radiator regulated by coins fed into a slot. My friend found a much more economical way to make it work: he bought chocolates shaped like coins, carefully removed the contents, and saved the metallic paper. He ate the chocolate, filled the wrapping with water and placed it on the window ledge, where the polar cold froze it within a few minutes, removed the paper, which he would again use as a mold, and placed his ice-minted coin in the meter. Every month the inspector would come and labor in vain to repair the meter.

Pity the dove, a silly bird with neither imagination nor malice. One flew off from Noah's ark after forty days of the universal deluge and returned with an olive branch in its beak, which indicated the passengers could disembark because now there was dry land. The wretched innocent could never suspect that it would end its days sizzling in olive oil. Doves did not always represent fertile ground for Jews, or Christian peace; once they were associated with Aphrodite, Astarte, and Juno, goddesses of sexuality. In the mythology of India, they represent copulation and life. Panchita and I had decided not to include any recipes for dove in this book, in order not to wound the sensibility of any religious persons or lovers of metropolitan fauna, but we were unable to resist the temptation.

CARRIER PIGEONS OF LOVE

At a casual glance, these birds all look alike, but there are ring doves disguised as partridges, pouter pigeons that cause a stir at dawn, tourist pigeons around plazas and cathedrals, guerrilla doves that bomb your balcony with their droppings, and, of course, carrier pigeons. All these varieties can be attracted with bread crumbs, and you can snag one in a careless moment and stick it in the oven, following this old recipe:

Catch two doves and wring their necks without compassion. Before they get stiff and your conscience begins to plague you, submerse them in boiling water for 3 minutes; take them out, and, while still warm, pluck them. Rotate them above a gas flame to burn off any down that escaped you. Cut off feet and head and slit open the chest to gut them. Rub them with butter, lemon, salt, and lots of pepper, and leave them to sleep the just sleep of the dead for 24 hours. Pierce a clove of garlic with a spice clove and insert both into a small onion and wrap all three in a strip of bacon. (Repeat the operation, because you will need two stuffings.) Slip these

embellished onions inside the birds and close the opening with a tooth-pick. Pour over a cup of good cognac and light it. When the flame burns out, cook the doves for ½ hour in a medium oven, basting them with melted butter and liquor to taste. Serve with sweet potatoes and glazed carrots, accompanied by a good white wine.

My suggestion would be to buy your birds already dead and plucked. Many years ago there was a chicken coop at the back of the patio in my grandfather's house, a disgusting idea I don't recommend. After the departure of the aged cook whose chore it was to feed and kill them, the chickens died only of old age, because no one wanted to assume the cruel responsibility of cooking one of those creatures with whom all of us in the family had a personal relationship. So, after a while, when there was no one to clean out the coop and the odor had attracted the attention of the police, a close friend of the family offered to carry out the massacre.

This friend was a giant of a man with the neck of a gladiator and a laborer's huge hands, who had lived for years as a follower of a strange religious sect and was said to have been brain- *and* heart-washed, depriving him forever of human emotions. The man strode into the chicken coop with the aplomb of a bullfighter and cast a sneering look at the doddering hens, arranged in the invariable semicircle in which they lived their monotonous existence. I don't know what he saw in their eyes, but he backed out of the coop, this time gliding like an ice-skater, and asked for newspaper and glue. He spent an hour constructing paper cones to cover the heads of the chickens, so they would not have to witness the systematic murder of their companions as they awaited their turns. Once every one of the hens was duly hooded, he chose one at random and tucked her under his arm. Someone had explained the procedure to him: give a half twist to the neck, and jerk the head. That is what he did, after much vacillation and two cigarettes, but he was betrayed by his own strength, and to his horror, he ripped the skin right off his victim's head. With a guttural cry he dropped the unfortunate bird, which then trotted around flapping its wings and rattling its last death rattle.

To save witnessing further suffering, he picked it up by the legs and whacked it against the ground, again and again, while all the other hens milled around blindly in their paper hoods. Our slaughterer staggered out of the chicken coop holding a bloody blob in his hands, took two drunken steps, and fell flat on his face. He did not eat chicken again for ten years.

The remaining hens, freed from a like fate, died a peaceful death at their appointed time, some so ancient they had lost all their feathers and tottered naked about the patio. This experience demonstrated to me that it requires a special character to grow your own food.

In my grandfather's house, turkeys and a goat were bought in September and fattened to give up the ghost at Christmas, a task the cook executed without a shred of conscience. Even today that woman appears in my dreams with her knives dripping blood. For many years I couldn't eat a bite of Christmas dinner; that roast kid and those stuffed turkeys had frolicked through months of our childhood, they were part of the family. Devouring them was as bad as serving up Barrabás, our family dog, on a great tray, surrounded with vegetables and potatoes. (In fact, in many parts of Asia, dogs are raised to be eaten; I've been told that puppies are delicious. There is no reason why they shouldn't be.)

Panchita has fewer scruples than I do when it comes to domestic animals and is expert in the preparation of all kinds of birds. On more than one occasion I have seen on her table a perfect turkey, golden and aromatic, lying in repose among baked apples on a silver platter, from which, at the crucial moment, she removes four strategically placed toothpicks as, to the astonishment of the guests, the entire skin falls away and the meat is revealed cut into perfect slices. And she has an infallible recipe for rooster.

That bird, tough as rubber, can be boiled for hours without surrender, so my mother prepares her celebrated coq au vin using the tenderest hen in the market. Quail and partridges also pass across her table from time to time, insignificant birds whose meat I have never managed to taste because I give up too soon, tired of spitting out the pitiful little bones. Goose and duck I don't recommend; they float in their own grease, and cooking them at home can be a real mess, but Panchita insisted on including one of her recipes because the birds are aphrodisiac. If that were the only standard, we should include one for spotted owl and bald eagle. Pheasant, on the other hand, we omitted by mutual accord because with its feathers it is impressive but without them it resembles a scrawny chicken, no doubt the reason why at banquets during the Renaissance it was presented with tufts of feathers covering the pope's nose and the head. In modern life we have no time for such refinements. If we're going to spend the afternoon putting feathers back on the bird that we pulled out in order to bake it, we won't have the vitality to enjoy its aphrodisiac effect.

Whispers

That men are still closer to the monkey than women, I haven't a doubt. Men's sexual impulse is triggered by the eyes, an inheritance from those simian ancestors whom the female summons when she is in heat by means of a noticeable change in her intimate parts, which turn red and take on the

morbid appearance of a ripe pomegranate. For some reason, this works like waving a red flag at the males, should they not be paying attention.

Among humans, visual stimulus is equally irresistible, which explains the success of magazines filled with half-naked women. Attempts have been made to exploit the same publishing market among female readers, but images of well-endowed youths unfurling their charms on full-color pages have been a fiasco; they are more often bought by homosexuals than by women. We women have a better developed sense of the ridiculous, and besides, our sensuality is tied to our imagination and our auditory nerves. It may be that the only way we will listen is if someone whispers in our ear. The G spot is in the ears, and anyone who goofs around looking for it any farther down is wasting his time and ours. Professional lovers, and I am referring not just to lotharios like Casanova, Valentino, and Julio Iglesias, but to the quantities of men who collect amorous conquests to prove their virility with quantity—since quality is a question of luck—know that with women the best aphrodisiac is words.

Latins have raised sweet talk to the category of an art, thanks to the incomparable richness of our languages and the inexhaustible repertory of songs, poems, flattery, and set phrases that Germanic and Anglo-Saxon peoples would never dare use. Thence the fame of the Latin lover, able to ignite such heat with his lips that feminine resistance melts like wax. It is known, however, that these Romeos tend to lose themselves in the enthusiasm of their own rhetoric and, at the moment of truth, rarely know how to use those golden tongues for more daring caresses. Cyrano de Bergerac, the celebrated ugly man attached to a nose, used the magic of his verses to make a lady fall into the arms of another man. His friend would stand beneath the light from her window while from the shadows Cyrano recited seductive words intended to win her heart. Love, however, weaves ironic webs, and the poet became as enamored of her as she with his fortunate friend, whom Cyrano's talent had clad in borrowed finery. Bad judgment on the part of our hero. Had he murmured his impassioned verses into the damsel's ear, she would have prized his outsize nose as an erotic symbol.

The ritual of lovemaking is not unlike the prizes at children's birthday parties: everything comes down to building expectations. The conclusion is simple, orgasm in one case and a couple of candies or plastic toys in the other, but getting to that point—what a roundabout route you have to take!

Give me a thousand kisses, then a hundred, then another thousand, then a hundred more, then a thousand, followed by a hundred; finally, when we have added up many thousands, we will muddle the score so that we lose count and no envious person can cast the evil eye on us when they learn we have had so many kisses.
—Love letter from Catullus to Lesbia

O the vice of words . . . Once out of our mouths, we cannot take them back. And similar care should be taken with the written word, the source of countless tragedies that could have been avoided with a minimum of prudence. I know the case of one unfaithful wife who wrote two love letters while on a trip, one for her husband and the other for her lover. In her haste at the last minute, she mixed up the envelopes and each man received the other's letter. In her absence, the necessary measures were taken, and when she returned she had lost her family and her husband, the one true love of her life—the other man had been at best a diversion on Thursday noons. The scandal was so great that without ever having intended it she ended up marrying her lover to put an end to all the gossip. She spent the last thirty years of her life regretting it.

At *le moment suprême of* the rendezvous, words that at any other time sound vulgar have the same effect as skillful caresses. Everything is in the whispering. Language describes, suggests, excites; words act like a spell. In erotic literature, whose goal is to inflame the blood and arouse desires, there is room for euphemism but not timidity. Our consumer society offers stimulating words through the services of telephone sex. A neighbor of mine, who weighs about 250 pounds and who has two grandchildren, makes her living that way. Her job consists of deciphering her clients' fantasies and, from the other end of the line, satisfying them with the daring of her sentences. She specializes in passing herself off as a twelve-year-old schoolgirl, virgin, bold, and curious, with whom the client can discuss his most unconfessable whims.

Language is also aphrodisiac in regard to food; commenting on the dishes, their flavors and perfumes, is a sensual exercise for which we have a vast vocabulary filled with wit, metaphors, references, humor, word games, and subtleties. Why do we use it so little? The best pages of Henry Miller are not about sex, as has been claimed, but about food. I suggested a variation on her calling to my neighbor: a telephone gluttony line for

impenitent gourmands, dieters, bulimics, or anorexics. You call, and instead of listening to the indecent panting of a twelve-year-old girl named Serena or Desirée, you get a detailed description of a mouthwatering lamb stew.

The French, obsessed with the good life, never talk about money or politics at table, though they may do so in bed; they would rather pontificate on the food and the wines or simply enjoy the meal in silence. In France you eat and make love frugally, savoring both with religious gratitude. The United States, in contrast, has coined the practically untranslatable words *snack* and *quickie*, the former to define that tendency to wolf down food you can eat with your hands, standing up, at any hour, and the second for hurry-up sex. That country still suffers from a certain adolescent haste, but we can't generalize. I have been told that the world's greatest lovers are divorced New York Jews. After all, an obsession with your mother should be good for *something* . . .

It just isn't the same thing to peel a shrimp and unceremoniously gulp it down as it is to remove its shell with sybaritic pleasure while commenting on the color, the form, the delicate aroma of the shrimp, and the crunch when you bite into it.

A kiss should be sonorous. Its sound, light and prolonged, takes its rise between the tongue and the moist edge of the palate. It is produced by a movement of the tongue in the mouth and a displacement of the saliva provoked by suction.

A kiss given on the outside of the lips and accompanied with a sound like that made when calling a cat, gives no pleasure whatever. Such a kiss is meant for children, or the hands. The kiss I have described above, and, which belongs to copulation, provokes a delicious voluptuousness. It is for you to learn the difference.
—The Perfumed Garden, translated into English by Sir Richard Burton, 1886

This description can be applied almost literally to the pleasure of sipping an aphrodisiac soup, let's say a seafood chowder saturated with the aromas and flavors of the sea. At a table of strict etiquette, no one would serve this kind of soup, because it cannot be attacked with elegance and without noise, as good manners demand in Europe—if not other parts of the world, where a timely belch is considered a welcome expression of

contentment—but it is perfect for lovers in their intimacy. That sacred soup deserves the same enthusiastic sounds as Sheik Nafsawi's kisses.

Music can also contribute to making the meal a sensual experience, which is why the spectacle of people who sit at the table with the roar of a football game or bad news blaring from the television is so abominable. At banquets in other days, there were always string quartets on a balcony brightening the meal with their melodies. Is there really such a thing as erotic music? This is a very subjective matter, which has been argued for centuries, but certain instruments and suggestive rhythms can invite love. The repertoire is vast, from certain Spanish compositions, with their unmistakable Arab and Gypsy touches, their crescendos and great finales paralleling the progression of the sensual encounter between two lovers and the final explosion of the orgasm, to Oriental music with its profusion of moans and murmurs—not to forget jazz, which is caress and lament; Caribbean rhythms; romantic songs; and, for the initiate, even some arias.

Once while listening to Plácido Domingo at the Metropolitan Opera House, a respectable matron sitting beside me kept emitting dovelike cooings and squirming so distractingly that another lover of bel canto asked her to be quiet. The lady recovered her composure for a few seconds, but when the celebrated tenor loosed a prolonged *do* from the depths of his chest, she went rigid in her chair, her eyes turned back in her head, and she began biting her hands and uttering little wails like a woman possessed, to the annoyance of everyone present, including some members of the orchestra. The one person who remained unfazed was Plácido Domingo, who held his note until the lady in question was fully satisfied. Musical taste is very personal, and we do not all associate the same pieces with the same images or memories. I have often wondered what extraordinary delights were reborn in the memory of that lady at the opera—an intrepid singing teacher, maybe?

Frank Harris (1856–1930), in *My Life and Loves*, details with a notary's meticulous precision all the erotic encounters of his life, more than two thousand, he claims, although in this area exaggeration can reach hallucinatory proportions. Among his experiences, he tells of a time in his adolescence when he took advantage of his organ teacher's inattention to explore with a daring hand beneath the skirts of a fellow student and to discover, dumbfounded, that above the top of her stocking was a soft, warm region: "Curiosity was stronger even than desire in me, and I felt her sex all over, and at once the idea came into my head that it was like a fig."

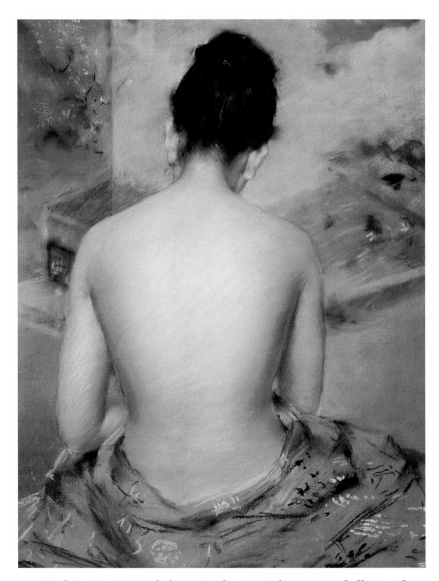

Nothing too original there: in the erotic literature of all eras, fruit and flowers are the metaphors most frequently used to describe those enchanted zones.

When it comes to food, sounds, too, can be aphrodisiac. I myself have a tin ear; I can't even hum "Happy Birthday," but I can unhesitatingly evoke the hissing sound of an onion browning in oil, the syncopated rhythm of a knife mincing vegetables, the burble of the boiling pot into which unfortu-

nate shellfish will fall in an instant, the *crrrack* of nuts being shelled, the patient song of the mortar grinding seeds; the liquid notes of wine being decanted into goblets, the chink of silver, crystal, and china on the table, the melodious murmur of after-dinner conversation, the satisfied sighs and the nearly imperceptible guttering of candles lighting the dining room. These sounds for me have an effect nearly as powerful as Plácido Domingo's voice for the good lady at the opera.

A Night in Egypt

My friend Tabra, who was the inspiration for the character of Tamar in my novel *The Infinite Plan*, is in real life a tireless, valiant traveler. Sometimes she disappears for weeks and, just when I begin to fear that she has been swallowed up by the Amazon jungle or fallen off a peak in the Himalayas, I receive in the mail a well-worn photograph from a village in Irian Jaya. Tabra, dressed like a Gypsy, layered in bracelets and necklaces, appears surrounded by naked women and daubed and painted men hoisting lances, a penis-covering gourd their only scrap of clothing. When she returns she brings huge duffle bags filled with treasures: cloth from the Andes, masks from Africa, arrows from Borneo, carved human skulls from Tibet. Above all else, she returns with inspiration for her work. The designs of her jewelry are a true celebration of the strength, beauty, and courage of women in remote corners of the earth: the Rajasthan desert in India, the New Guinea jungle, peasant villages in South America, all of these women united by a common aspiration to beautify and bedeck themselves.

This is a letter she sent me from one of her travels in 1990.

I am in some part of lower Egypt, I would have to have a map to know exactly where . . . I came here from Cairo because someone told me it was interesting, although I forget why. I don't know what

I expected to find in this place, maybe a little adventure. You know that I don't travel with any scientific logic, I prefer to be guided by intuition. I forget dates, names, and places, I am barely left with a vague general impression, the forms and colors that later appear in my designs.

At the airport I was approached by a young man who offered to act as my guide. Dark, handsome, with a brilliant smile and enormous black eyes, the kind of man who attracts me at first sight. In Egypt a woman can't go about alone without a guide, she won't have a moment's peace; I accepted because he inspired my confidence. I explained my business, and asked him to take me where I could see crafts, precious stones, beads for my pieces. Mahmoud decided to drive me to the one hotel in the town to leave my suitcases and then to a small Nubian village on the edge of the desert. That is what we did, and soon I found myself in a beat-up automobile, surrounded by four of my guide's male relatives who had joined the expedition. I'm sure you wouldn't have approved, Isabel . . . It passed through my mind that it wasn't a terribly good idea, but it was too late to turn back, and those men seemed so pleasant and so happy to practice their English with me that I buried my fears.

It was an exhausting trip. After a couple of hours, we could see a small white village gleaming against the endless sands. Mahmoud announced that we had arrived at the home of his grandfather, and drove the car into a walled area that according to what he told me continued for more than a kilometer. Inside the blue and white painted walls of dried mud were numerous buildings; it was clear that a large family group lived there. A small flood of people poured out to welcome us and to look me over with curiosity: cousins, uncles, sisters, nephews, many, many children. What confusion!

"Welcome to our home. You are the first foreign woman to step inside these walls," Mahmoud said.

I thought that with a little luck, here might be the adventure I

longed for. The women, dressed in black and at first a little shy, brought me dates and other fruits on large trays and invited me to their houses. One young girl took me to a trunk to show me the bridal dowry she had spent years making, embroidered all over with a design of intertwined leaves and flowers. Another one wanted me to see her sewing machine, and a third woman the large white refrigerator installed in the center of the main room, obviously her most precious possession. Outside, the sun was blazing down mercilessly, but inside the mud walls the air was cool; a sweet and melancholy music was coming from somewhere and I could hear the Muslim prayers from a nearby mosque. The women could not get enough of studying my bracelets and stroking my arms, amazed at my white skin and the color of my hair. It was pointless to try to explain to them that it is dyed; they spoke no English, and I no Arabic. I in turn studied their tattoos and silver adornments, while the men stood at a distance, staring at me, whispering and laughing without trying to hide it. All eyes were on me as I opened my purse, took out a mirror, and put on lipstick. They took me to a room with stiffbacked furniture lined up against the wall and hand-tinted photographs of weddings and ancestors; the women served tea and lemonade to the men and to me, but did not sit down with us. My guide told me that he had powerful friends in Egypt; anything I needed he would be able to get me, my happiness was all that mattered, he wanted me to enjoy his country and have many adventures, wasn't that what I was looking for? He laughed, and the other men laughed, too. I felt that their eyes were burning into me; the heat and weariness from the trip made me feel that I needed a bath; I wanted to go back to my room in the hotel but, if possible, without offending my hosts. I stood up with the intention of saying good-bye. I could see that the men were exchanging signals, but I couldn't interpret them, and I realized that one by one the women had discreetly retired, leaving me alone. I went to the door. It was twilight, and beginning to grow cool. I calculated that within a half hour

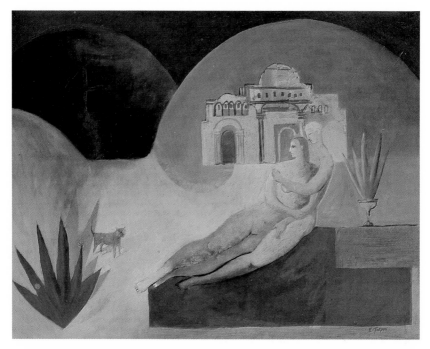

it would be dark, and the road back to the town was a long one. I walked outside with a determined step, brushing aside the men who stood in my way. Then Mahmoud and the others followed me to the automobile and, after some discussion, two got in front and I was put in the back, squeezed in-between the other two. I felt their breath on my cheeks, their legs against mine, their hands touching my shoulders, my elbows, my blouse. I crossed my arms across my breasts.

"It's time to go back to my hotel," I insisted.

"Yes, of course," Mahmoud replied, his smile never fading, "but first we want to show you the dunes."

Suddenly it was night. The profile of the moonlit desert was extraordinary. The road was dark and we were driving without headlights; the driver turned them on when he suspected another vehicle was coming from the opposite direction, blinding the occupants. And he refused to keep to his side of the road, we kept zigzagging from one side to the other, but the few cars we met were doing the same. I had the

impression that we were driving for a long time and going in circles, passing the same group of palm trees and same dunes several times, but by then I wasn't sure about anything, it's easy to lose your sense of direction in the desert.

"I'm very tired, Mahmoud, I want to get back to my hotel," I said with all the firmness I could muster.

"But you haven't had anything to eat! What will you think of our hospitality? First we must offer you a dinner in my home, as is customary."

"No, thank you very much."

"I insist. My mother has spent the afternoon preparing a meal for you."

That was when I realized that we were back in front of the same blue and white painted mud wall, entering through the same gate, now illuminated by two oil lamps. The rest of the compound was totally dark: the electricity in the village had been cut off, they explained. In the distance flickered the tremulous light of other lamps or small fires. We stopped before one of the houses, got out, and at last could stretch our legs; I was wet with sweat in spite of the cool night air. The four men began talking at the same time, arguing and gesticulating as if they were angry, but I couldn't understand a word of what they said. Finally, three of them disappeared and Mahmoud took me by the arm, apologizing for the lack of light, and led me into the shadowy house. We went through room after room, passing down seemingly interminable corridors; doors closed behind me, I heard footsteps and murmurs, but I saw no one. At times I tripped over a threshold or piece of furniture, but my host grasped me firmly, although with a certain finesse. We came to a room dimly lighted by two small, nearly burned-out candles; I saw a table and two chairs, one beside the other. A subtle aroma of incense floated on the air, mixed with the fragrance of food and spices.

"Where is the rest of your family?" I asked.

"They have already eaten, we are alone," Mahmoud replied, pulling back a chair for me. I sat down, choked with anxiety.

On the table were several platters whose contents were impossible to make out in the weak candlelight. Mahmoud picked up a plate and served me.

"What is it?"

"Meat."

"What kind of meat?"

"Boiled."

"What kind of boiled meat?"

He touched his stomach and ribs with an offhand gesture. I am a person who needs to see what she eats, especially when it's meat; I like to look everything over very carefully before I put it in my mouth, but it was very dark. Mahmoud took portions from the other platters and named them as he placed them on my plate: fish from the Nile, goat cheese, black olives, ripe figs, eggs, fried eggplant, a garbanzo paste, yogurt. I washed my hands in a basin of lemon water, and Mahmoud dried them for me with a cloth; his movements were as unhurried as caresses. I pulled back too brusquely, I may have offended him. I tasted a bite and I liked it; the meat was lamb, well seasoned, so tender it melted before you could chew it. This man, sitting so close to me that his face nearly touched mine, watched me eat, commenting on how beautiful I was. Once more he assured me that he was my friend in his country, that I should think of him as my Egyptian sweetheart. I said nothing, but sweat was running down my back, and my knees were trembling. The food, nevertheless, was exquisite, and the tea—warm, and very sweet, with a trace of mint or jasmine—was refreshing. Mahmoud picked up an olive and put it in my mouth; it was a little bitter, but delicious. Then he spread cheese and garbanzo paste on a piece of pita bread; he ate a little himself and then handed it to me, smiling with delight when I took it. The smell of the freshly baked bread, still warm, mixed with the fragrance of the food, the wax can-

dles, and the incense, was so intense that I closed my eyes. I felt drained, with all my senses elevated. In a low voice, nearly a whisper, he recited a litany comparing me with the moon and stars of the desert; my skin, he said, was like marble, he had never seen such smooth, white skin.

"I have to go back to the city . . . "

"Do you have a sweetheart in America? Maybe a husband?"

"Yes, I have a very jealous sweetheart."

"And why would he not be? I would never let a man set eyes on you; I would live only to love you and to give you pleasure. Why does this so-called man let you travel alone?"

"It's very late, Mahmoud. Please take me back to my hotel."

"Try these vegetables, they are from my mother's garden, cooked by her own hand . . . "

It was an eggplant dish, I could smell the aroma of nutmeg and cinnamon, an exotic mixture. I served myself another spoonful and more lamb; with each serving, I measured the extent of my foolhardiness. No one knew where I was, no one had seen me leave for the desert with those men, I could disappear without a trace. Mahmoud poured me more tea. The sound of the liquid as it flowed into the glass was as clear as the notes of a stringed instrument in the enormous silence of the dark house. One of the candles died in a pool of melted wax.

"Has this been a good day? A memorable day? Have you had a good time?" my host wanted to know, still whispering into my ear.

"Yes, thank you, but now I must go."

I tried to stand, but he held me back, nearly embracing me. Once again he enveloped me in his melodious voice, describing my beauty, comparing me with the houris in the paradise of Allah, and with movie stars, and assuring me that he would never tire of looking at me, that he could spend his entire life in ecstasy before a woman like me. He was putting me on, I suppose, but I wanted to believe him; his words were

so soothing, no one had ever said those things to me. And he kept talking and talking, always in that same tone. Did I not want him to have a good time, too? Want him to have a memorable day, too? His hand touched my throat, and I was swept by a long shiver. Mahmoud insisted that dinner was not over, we must have sweets. With great delicacy, he slipped a small pistachio and honey pastry into my mouth, still stroking my throat, playing with my necklaces and earrings, murmuring flattering words in his broken English. Taste this delicious Turkish delight, he begged. It was soft, sweet, and perfumed of roses. Wouldn't you like something to smoke? Maybe a little hashish? The flame of the last candle hesitated an instant and then burned entirely out. Through the window I saw the moon lighting the Egyptian night. I chose another sweet, and bit into it, voluptuously. . . ."

Sins of the Flesh

There are many vegetarians in this world who, despite their pallor and anguished souls, survive and reproduce perfectly well. On the other hand, there are those who believe with all their heart that a piece of meat, to the degree possible dripping blood, is the only reliable nourishment. Peoples whose diets contain very little meat are those who have the highest demographic explosion and those who have most diligently cultivated the art of the erotic, which is why I have serious doubts about the true aphrodisiac powers of the flesh of mammals. But I must speak of it, in view of the fact that so many serious texts prove my doubts unjustified. In any case, meat dishes are heavy, and with a full stomach and in the grip of the digestive process, few can boast of amatory prowess. If you do include meat in your menu, serve small portions.

Game animals *(deer, boar, hares, and others) In Nairobi there is a famous restaurant where every kind of game is served, including some nearing extinction. Favorites on the menu are fillets of buffalo, elephant, and ostrich. Unless you can count on a hunter in your family, someone who wakes up with a shotgun over his shoulder, skip this part, it isn't for you. If you do have a hunter, try to get him to stop, it's a fiendish sport. But if it can't be avoided, and a beast riddled with shot lands on your kitchen table, begin by hanging it by the feet for a couple of days in a cool, dry place, because the meat is most savory and tender when it is just at the point of turning bad, right before the neighborhood birds start pecking at it and the first worms appear (that is, faisandé, as the French say with more delicacy). I have also heard that you should use rubber gloves when you skin game, because the carcasses of wild animals can carry diseases, and besides that, you have to cook them to death to avoid trichinosis. With all these drawbacks, I wonder whether it's worth sampling one of these beasts unless it's been refrigerated. Better to get your game in the market, cleaned and ready for the pot. Have you ever watched anyone skin a hare? It's a depressing spectacle.*

Beef *The most delicate and easily digested cut is a fillet. Italians maintain that raw meat is erotic and often serve it cut in very fine, nearly transparent, slices called* carpaccio. *Raw meat has been eaten since ancient times, except that its erotic properties were not recognized then. The Tartar hordes who invaded Europe in the era of the Roman Empire had a unique way of preparing it: they put chunks of meat between horse and saddle and galloped all day long, until their dinner had been reduced to a bruised and black pulp salty with sweat. That gave rise to what today we call steak tartare (ground raw meat skillfully seasoned and topped with a raw egg), which lends itself to being presented in naughty forms on the plate, as well as to other sensual games.*

Goat *The ram symbolizes male sexual energy, but its flesh is tough and strong-smelling. This animal has the curious habit of rolling in its urine to attract the female (a typically male idea!). In view of all these things, we humans prefer eating the more tender kids in the full bloom of their charm and innocence, but I will not dwell on this subject because Robert Shekter is looking over my shoulder. (Robert loves these creatures so much that he has a farm in the Alps where he gives refuge to old and mistreated nanny goats. At his death I'm planning to have a great barbecue and invite all my editors.)*

Rabbit *A silly brother to the hare, a fluffy and timid animal who when alive evokes immediate sympathy but cooked can be mistaken for the family cat. It has a very strong odor, which is why it must be washed inside and out with vinegar water, then rinsed, dried, and perfumed with lemon before cooking.*

Pig and sheep *Forget them, they're not aphrodisiac.*

Testicles *(Are we women fascinated by orchids because they get their name from the Greek word for these body parts,* orkhis?) *From time immemorial, the organs of certain animals have had a reputation for having erotic properties. Women don't eat them. Men do, but it gives them the shivers when they relate what's on the plate with their own anatomy. Freud has a name for this complex, but I've forgotten it. In Asia they prefer monkey testicles, in America, the bull's, in other parts of the world, those of sheep and rams. In the United States, animal testes are called Rocky Mountain oysters. Chopped and cooked, they don't look like what they are, but even so, don't give it away until your guests are through gorging on them.*

Liver and kidney *Beef or sheep kidneys are a common item on menus in French and Spanish restaurants and save English cuisine from total disaster served up in the form of their famous steak-and-kidney pie, one of the few indige-*

nous recipes of Great Britain that can be eaten with pleasure and not out of sheer necessity. In older days, it was believed that the center of energy and life was the liver, not the heart as we now suppose, which is why power as a sexual stimulant was attributed to this organ. Not everyone likes liver. Liver extract in pill form is sold in health-food stores for anyone who desires the benefits without having to go through the disgusting process of chewing the meat. In Philip Roth's famous novel Portnoy's Complaint, *the young protagonist masturbates with the raw liver his mother had planned on using for dinner. There's no cause to go to such extremes; there are other ways to season it.*

Unclassifiables

Turtle *An ocean creature, but I find it difficult to include it among shellfish and fish. I have a tortoise in my house. It is a plodder without a shred of grace, with an attitude that is too Zen for my taste. I have no particular sympathy for it, but neither does it deserve to end up in the soup pot. And although that thought did once cross my mind, it would be difficult to carry out because my turtle guest lives hidden in unimaginable places and appears only from time to time, like a leisurely ghost. The mere idea of seizing it at a careless moment to chop off its head and rip its body from the shell turns my stomach. Fortunately, turtle is sold in cans, already cut into small cubes. The greenish flesh is ugly—it looks half rotten—but is considered more tasty and refined than the paler, whitish version. In Taiwan there are restaurants where they keep turtles in tanks and snakes in boxes. The customer selects one of each, then the cook decapitates them in the diner's presence and pours the blood into a strong, sugared liquor. While the customer drinks this cocktail, the cook prepares the turtle in a soup and roasts the snake, dishes so aphrodisiac that private rooms are available in the same restaurant—with women included on the menu—for burning off the calories.*

Venus, the goddess of love, has been represented riding on a turtle's back; its uplifted head symbolizes a phallus. Aphrodite Porne, patron of prostitutes in ancient Greece, was accompanied by a goose, whose long neck was an allegory—a rather optimistic one—for the male member. And Leda embraced her lascivious swan . . . In any case, it seems to me that

mythology has stretched things a little far. In the East, the flesh of the turtle is greatly appreciated for its stimulating virtues, and in antiquity it was an obligatory dish in the court of China: it was believed that, like birds' nest soups, it could inflame the decadent appetites of the emperor. Incidentally, these nests are obtained in caves, particularly those of Malaysia, where a certain kind of swallows lay their eggs. The birds build the nests from sea algae pasted together with a salivalike secretion. To collect them when they are fresh, the natives climb the slippery rocks in the darkness, steadying themselves with bamboo poles. They risk not only breaking their necks in a fall but also coming across poisonous insects and infuriated swallows. The enterprise is very lucrative because of the numbers of males in the world who are uncertain of their virility. The nests are cleaned, pressed, and packed before being sent to the markets of Asia, where clients pay true fortunes for a few grams of this questionable aphrodisiac.

Snail I can't imagine why they are so valued; alive they are repugnant, and cooked they reek of garlic and soil. They owe their reputation for being erotic to the belief that they resemble the clitoris, emerging from and disappearing amongst feminine creases and folds, but I find that metaphor offensive. I don't have anything resembling a snail on my body, nor, as far as I know, do most of my women friends.

Frog Only the legs are eaten, which taste like bland chicken, a good reason for smothering them with seasonings. When I was in school, it was my fate, as it is for so many unfortunate children, to dissect these batrachians in science class to prove I don't know what theory about electric currents. It seems that after they're dead, the legs jump on, but we were not able to verify that fact. I spent the night sitting up in bed staring into the darkness and thinking about the horrible experience that lay in store for me on the morning. I went to school early, crept into the laboratory, stole all the frogs, and let them loose in the garden. If you have a delicate heart, buy your frogs' legs peeled and ready to be cooked (at least four per person, that is, two executed froggies per guest), because if you are going to decapitate them, cut off their feet, dismember the legs, and rip off the skin, it is highly likely that you will suffer nausea and a bad conscience for a week. In which case the aphrodisiac value of the dish will be nil.

The Gigolo

Kept men belong to a tradition as ancient as that of concubines and hetairas but one less aired. This practice, considerably more common than we suppose on this side of the world, came to be a staple of Asian culture, where for centuries aristocratic ladies have employed young men, barely disguised under the classification of servants, to satisfy their intimate caprices. Since the invention of the automobile, the most common employment for the gigolo has been that of chauffeur. In recent decades, these playthings, like geishas, are being drowned in the whirlpool of capitalism, and in their place have emerged so-called independent professionals. In Italy, as recently as the nineteenth century, the official lover, tolerated by the husband as long as discretion was honored, had a name: *cicisbeo.* And why not? Marriages in those days were economic and social arrangements, not short-lived romances. Love played no part in the deal. Madeleine de Scudéry wrote in the midseventeenth century, "You marry to loathe. This is why a true lover should never speak of marriage, because to be a lover is to wish to be loved and to wish to be a husband is to wish to be loathed."

If the husband had lovers—in France, *maîtresses*—and many had a string of illegitimate children, it was only fair that the wife could seek love in other arms.

Today any woman capable of paying for this type of service can hire an expert lover for a few hours who will guarantee pleasure, hygiene, and absolute confidentiality. These young men, usually bisexual, are trained in erotic practices that most husbands cannot even imagine. Their lives turn about the instrument of their art: the body, which they must keep healthy and attractive. Free from the cares of work, of money patiently earned and therefore in short supply, as well as from the vanity of power or the torment of a guilty conscience, they devote their energy and their time to the sacred occupation of providing sensual pleasures. And I say sacred because sensuality can be traced back to the Taoist philosophy in which the cou-

pling of male and female symbolizes the union between the gods in the very act of creating the universe, although I doubt that the gigolos who wander around Japan or any other spot in the world tantalizing ladies have heard of the Tao or anything resembling it.

My good friend Miki Shima, the illustrious Japanese doctor to whom I turn when I have need to cure aches and pains or inquire about the exotic, sustains that these modern male prostitutes of his country usually memorize a major portion of the *shungas,* the ancient erotic manuals called "pillow books" because they were kept in the lacquered wooden boxes that elegant ladies used to support their necks at night without disturbing their hairdos. The illustrations of the *shungas* seem brutish to anyone not familiar with them: couples immobilized by clothing, wearing laboriously contrived hairdos and an expression of Buddhist placidity and equipped with enormous, threatening genitals, copulating in the most fascinating postures. Once the eye becomes accustomed, the *shungas* are very didactic. Although most women are content with two or three classic variations, deluxe Asian gigolos are capable of offering the complete repertoire for an adequate sum: galloping horse, jade flute, mandarin ducks, coupled doves, and other acrobatic postures with names too long to jot down during our conversation. Dr. Shima reminded me of the importance of diet for keeping in shape, imperative in that profession, and told me about a master of acupuncture from whom he himself had learned the most delicate techniques. The man had lived for more than a hundred years, with all his teeth and his hair still black, not neglecting a single day to pleasure himself with some ripe young girl, all of which he credited to ginseng, taken by the handful, and to a fabulous soup for which I was lucky enough to get the recipe, herewith included:

APHRODISIAC SOUP
OF ACUPUNCTURE MASTER

For two, you place in a beautiful clay flameproof casserole, with due ceremony, 4 pieces of red Korean ginseng, ¼ of a chicken, in pieces, 2 chives, minced, 4 slices fresh ginger, 2 tablespoons red or white miso. (These ingredients can been obtained in the Asian market of any more or less cosmopolitan city.) Cook over a slow fire until the chicken is tender, meanwhile reading an erotic text, and at the end add ½ cup sake and 6 raw prawns, shelled and deveined, which, in order to preserve their

potency, should not be allowed to boil any longer than 5 minutes.

Not only in Japan may ladies offer themselves the luxury of a professional lover by the hour. Women executives on business trips in Europe and the United States can also turn to them, but no one talks about this openly. The information is passed in whispers.

I met one of these gigolos in the airport hotel in Frankfurt where I was waiting for a plane connection to India that left in the furtive hours of the night. I suppose that the story would be juicier had it been a young Chinese man with a lustrous black ponytail and obliquely set eyes, someone expert in the erotic practices of the Tao, but I had no such luck. In my case it was a typical good-looking guy, blond, of indeterminate age, wearing jeans and backpack and carrying a tennis racket. His light-colored eyes and somewhat shy air instantly gained my trust; he looked like a young university student. He asked me in English where I had come from, and when he heard the word *California,* he smiled, enchanted. He immediately informed me that he had been born in Los Angeles and was working as a model to pay for his studies. We looked for a table and sat down to share some coffee and pass the time chatting. In less than ten minutes he had suggested that we might take a room where we could rest, since it would still be several hours before the plane left, and he offered to give me a massage with aromatherapy and "something more." I must have looked at him with the bland expression of an innocent granny, because he blinded me with another of his smiles, this time without a trace of shyness, and assured me that his fee of three hundred dollars was standard for these services. He showed me, without any fuss, a piece of paper I couldn't read because I didn't have my glasses at hand, but that I think was the results of a blood test.

I am not accustomed to the caresses of a mercenary, and besides, it seemed sinful to spend so much money for selfish purposes when there are so many people in the world who need charity, so I declined his offer as gently as I could and instead invited him to eat. I seized the moment to question him, at first circumspectly, out of fear of offending him, but later, when the pride he took in his office became evident, with more daring. While I was trying to make my soup last and he was devouring his lobster, he told me that his clients were not always women. "Gays let loose in airports because no one knows them. You can't imagine how many directors of corporations and solid family fathers solicit my services," he boasted. He preferred women, even though they demanded more dedication and time,

he said, because they gave good tips. He confessed, laughing, that often they don't understand the basic rules of this kind of transaction; they forget that they're the ones who are paying and put themselves out trying to make a good impression. Some go so far as to feign pleasure, to avoid disappointing him, a deceit he must immediately unmask because his reputation is at stake and he cannot allow a client to wrap him in maternal tenderness and end up unsatisfied.

Soon my dinner companion began to grow bored with me and began gazing around the dining room, looking for someone with a stronger inclination, and readier cash, than I, so I subtly slipped a twenty-dollar bill onto the table. He took it with such elegance that I blushed at not having given him more. I wanted to know how he managed when he had to deal with someone disagreeable, the kind of woman who evokes regret, not temptation, and he told me that whenever he posed as a model before the photographer's camera, he did his job without stopping to analyze his own emotions. This was no different, he clarified; he offered a service and the other person bought it: a simple, clean commercial transaction.

And if one day he couldn't perform . . . that is, couldn't do it? I asked him, worried. He glanced over at me, clearly surprised. For him it was like dancing: a skill, not an impulse. Since I already had the idea for this book in mind, I wanted to know whether he used stimulants to keep himself in

shape, and he said that as yet he didn't but his older colleagues lived on pills, and he knew one who injected a medication directly into his penis, thanks to which he could perform the feats of a man in love, although sometimes his discomfort was so great that he forgot his own name. My companion explained that his method for keeping in shape was simple: he jogged and lifted weights because without flexibility and muscles he had no future in that profession. He smoked marijuana but not tobacco because many American clients were disturbed by the smell; he didn't drink alcohol when he was working, he avoided tension and thought very little, to keep from wearing himself out. That is, he was the perfect companion for passing a few hours in an airport.

And what about food? I asked. Did he, for example, know about the aphrodisiac power of birds' nests? He hadn't a clue to what I was talking about. I mentioned my infallible wild-mushroom soup, which when administered with proper frequency is a heavenly aphrodisiac, but that young man had no vocation for the kitchen and I could see that he was beginning to find our conversation tedious. Before he got up, I asked him about the tennis racket. "It inspires confidence," he told me, "and if business is slow, I carry my golf clubs—they're irresistible." I paid the bill, but between the lobster and tips, I would have been better off paying his fee. At least I would have had something salacious to tell.

Bread, God's Grace

I don't recommend baking bread; it can become a dangerous passion. Some years ago I bought an amazing machine into which, employing the appropriate opening, I introduced flour, yeast, and water, and adjusted a clock; the next morning, at the exact hour, we were awakened by the fragrance of freshly baked bread. How that transmutation occurred is something that will live on in the realms of mystery. Soon, however, the conse-

quences became obvious on the waistlines of the adult members of the family and in the implacable refusal of the children to draw their nourishment from proteins or vegetables—all they wanted were rings, rolls, braids, and other breads. In view of which we decided to retire the machine from circulation. It sat abandoned in the garage for several months until my stepson Harleigh, he of the funereal tattoos, had the idea of changing a few pieces, adjusting a couple of screws, and using it to convert marijuana into chocolate cookies, which he sold at school at great profit. That was my one attempt at making bread.

Like poetry, baking is a rather melancholy vocation, whose primary requirement is free time for the soul. The poet and the baker are brothers in the essential task of nourishing the world.

If you insist on writing verses and making your own bread, skip this chapter, it's not for you. People who need to experience everything, even if only once, sooner or later fall into the temptation of bread making. In such cases, I suggest compensating for the skill naturally absent in a beginner by giving the shape of the bread an amusing twist. In that vein, I gave my mother a pan in the shape of *Il Santo Membro,* as they sometimes call the male organ in Italy, whether out of arrogance or irony, I don't know. After baking, however, the loaf was embarrassingly voluminous, and my mother hasn't dared serve it for fear of humiliating the octogenarian gentlemen who come to her home for five o'clock tea. In the erotic kitchen, bread is an indispensable accompaniment—wheat is considered aphrodisiac and is a symbol of fertility—but preparing it consumes hours that could better be employed in bed. My advice is to buy bread from a good bakery without any guilt whatsoever and forcefully renounce the patient art of working dough, because one can do only so much in this life.

In a story by Guy de Maupassant, the young servant of a bourgeois household goes every morning with her basket over her arm to buy bread. Through a window she sees a young baker kneading dough and carries with her the image of his broad shoulders, his powerful arms, the gleam of sweat on his skin, and those sensual hands, kneading and kneading the dough with a lover's patient determination, just as she would like hands to fondle her. And since this is a love story, her fantasy is fulfilled, with interest. The sight of one of those large country loaves inevitably brings back to me the memory of Maupassant's baker and his hands in the dough and on the firm flesh of the girl. There are hands and hands, some thick and

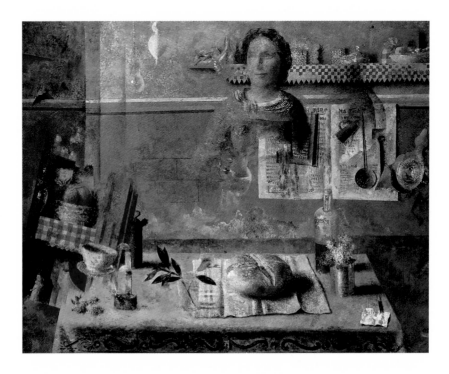

clumsy, others small and strong, there are light and timid hands, large and gentle hands, but for making bread and making love, what matters is the intent that guides the hands.

In Chile the most popular bread is called *marraqueta* and is shaped like vulvae. In France it is the baguette; though phallic in appearance, it is not phallic in temperament, since it is modest, trustworthy, and never failing. It can be bought in any civilized city, but nowhere is a baguette as crunchy outside and spongy inside as in Paris. If your menu calls for a different variety, pay no attention; your reputation can always be saved with a baguette, unless you need some pliable bread for an exotic dish, the kind you eat with your hands. The only drawback of the baguette is that since it contains no shortening, it grows stale within a matter of hours, which is why in France any respectable housewife buys bread twice a day. That kind of dedication, however, should not be demanded of anyone; you can resuscitate your baguette by sprinkling it with water and heating it in a conventional oven for a few minutes. If it is fossilized, soak it in milk and give it to the dog. But don't even think of putting it in the microwave; that will shatter its soul, and its violated essence will turn to rubber.

Tonight,
like many without a lover,
I'm going to bake bread
push my knuckles
into soft dough.
—Haiku, Patricia Donegan

I remember the kitchen of a convent in Brussels, where I witnessed, with reverence, the mysterious comingling of yeast, flour, and water. A nun, not wearing her habit, with the shoulders of a stevedore and delicate hands of a ballerina, arranged the dough in round and rectangular loaf pans, covered them with white cloths washed a thousand times and then washed again, and left them to rise beside a window, on a large medieval wood table. As she worked, at the far end of the kitchen the simple, daily miracle of flour and poetry ensued, the content of the pans took on life, and a slow and sensual process evolved beneath those white napkins that were discreet sheets covering the nakedness of the unbaked bread. The raw dough swelled with secret sighs, moved softly, pulsed like a woman's body in the surrender of love. The acid odor of the fermenting dough blended with the intense and vigorous breath of newly baked loaves. And I, sitting on a penitent's bench in a dark corner of that vast stone room, immersed in the warmth and fragrance of that mysterious process, wept, without knowing why.

Creatures of the Sea

In his *De Poenitentia Decretorum,* Bishop Burchard of Worms speaks of a curious erotic practice that sent sinners—it goes without saying—straight to the cauldrons of hell: the woman introduced a live fish (small, I suppose) into her private parts and, after it died, cooked it and fed it to the man of her desire.

Nearly all creatures that live in water, except whales, seals, and dolphins, splendid oceanic mammals that do not deserve to end up in a skillet, are aphrodisiac: eel, tuna, sea bass, turbot, salmon, sardine, herring, trout . . . and the list goes on. These treasures of the sea are rich in vitamins, minerals, and protein and low in fat; they have a delicious flavor and an aroma that evokes the most intimate regions of the human body.

Fugu is perhaps the most controversial fish. Panchita and I had serious doubts about whether or not to mention it in these pages, for this is not a delicacy easily prepared at home. What's more, you can't buy it anywhere except in Japan. It contains a powerful poison for which there is no antidote; even in minute quantities it immediately paralyzes the bravest heart and sucks the breath from the lungs, resulting in death. Cooks who specialize in this fish know how to clean it, leaving barely enough poison to induce only minimal symptoms and thereby produce erotic excitation without causing death. Be that as it may, in Japan some five hundred people die annually from eating *fugu*. I have never wanted to try it; I've had enough anguish in my life, I don't need more.

Another aphrodisiac from Japan is sashimi, which I shall describe with scientific rigor despite the nightmares that assault me when I think of this dish. (If you are a fanatic animal lover, don't read any farther in this paragraph). A waiter brings to the table a healthy, silvery exemplar just removed from the tank, still living and innocent of its karma, of the imminent agony of its damnation. Then the chef, who usually wears a white cloth tied around his forehead—along with a sinister expression—greets the diners with a brief bow, extracts several razor-sharp knives from his belt, makes them dance as he performs four passes from the martial arts, blades cutting the air with a viper's hiss, and then proceeds to slice the fish in fine layers, without killing it. Each piece is skillfully impaled upon a toothpick and savored with a dash of soy sauce. With each slice the unfortunate fish writhes as if it had received an electric charge.

To this cruelty we can contrast the beautiful story "The Cold Fish," by Lady Onogoro, which was written in Japan at the beginning of the eleventh century. Hanako, a beautiful if somewhat befuddled young girl, had a lover so scrupulous about cleanliness that he liked to make love wearing gloves. Before he touched her, the man personally oversaw her bath and demanded that she scrub herself with pumice stone from head to foot, shave off every last hair, and soap every fold and orifice of her

slim body: all of this without a single word of affection or appreciation for her charms.

Well, then, in Hanako's garden there was a pond in which an enormous carp made its home. Despite its forty years of living, the venerable fish had none of the peculiarities of Hanako's meticulous lover; to the contrary, it was strong as an athlete and considered to be an expert lover. It is scarcely strange, therefore, that she preferred the company of the fish. The girl liked to sit on the bank of the pond and call the carp by name; it would swim to the surface to play with her.

One night, after receiving the hygienic caresses of the gloved man, Hanako went out into the garden and threw herself down beside the pond to cry. Attracted by her sobs, the giant carp rose from the depths and, swimming up to the languid hand barely breaking the water, sucked each of her fingers, one after the other, with its strong lips. Hanako felt her skin prickling as an unknown sensuality raced through her entire body, shaking her to the pit of her being. She let one foot fall into the water, and the fish kissed each toe with the same dedication—and then the other hand and the other foot, and following them, she thrust her legs into the pond and the carp brushed the silvery scales of its belly against her skin. Hanako understood the invitation and sank into the mud at the bottom of the shallow pond, open and white as a lotus flower, while the bold fish circled around her, stroking her and kissing her and nudging her to spread her legs and surrender to its caresses. The fish bubbled streams of water across her most sensitive parts and thus, little by little, making ever deeper incursions, led Hanako along the most sublime paths of pleasure, a pleasure she had never known in the arms of any man, certainly not her begloved lover. Later, both girl and fish rested, floating happily in the ooze of the pond beneath the scrutiny of the stars. (Only a woman could imagine a story like this.)

Possibly the synthesis of all delectable dishes that can be prepared with fish is that marvel of a soup called bouillabaisse, which according to one version of the story was conceived by Venus to prod Vulcan to new and more ardent amorous feats, and according to another, more Christian version was brought to the three Marys of the Gospel by angels. The best place in the world to eat bouillabaisse is in one of the popular restaurants of the port of Marseilles, and fortunate are the sybarites to whom this possibility presents itself in a lifetime. I have never personally experienced that pleasure; the one time I passed through Marseilles, I was wearing a

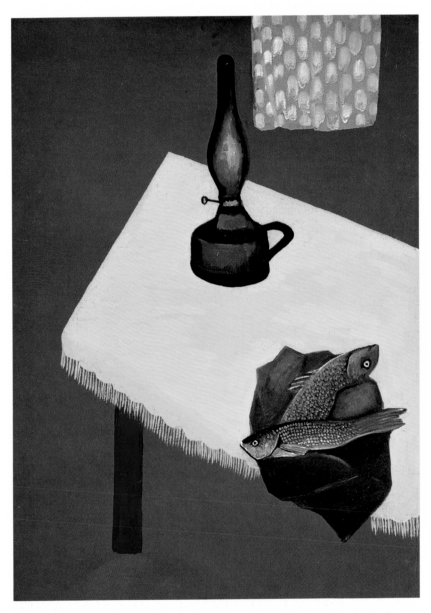

backpack and didn't have a centime in my pocket. Fortunately, I was unaware of the existence of such a culinary wonder and considered myself lucky to nibble on sausage and bread. My knowledge of bouillabaisse comes by reference, from stories pirates and sailors passed from mouth to mouth, stories that traveled the seven seas to reach my ears.

Not knowing the authentic soup, I content myself with the imitations, unnecessarily theatrical, that appear on menus of restaurants on many coasts—it goes without saying that there are as many versions of fish soups and chowders as there are ports on the shores of every continent. One of the first recipes registered by history dates from the second century, at the height of the Roman Empire. In the section on main courses we offer one of them, but Panchita, a more determined woman than I, felt that we must include an authentic bouillabaisse. She set out for Europe under the pretext of obtaining the secret of the most eminent chef she could find. She traveled from Chile to Paris and London, where for two weeks she plunged into a binge of extravagant purchases and then on her swift passage through Marseilles made the necessary inquiries in her quest for the coveted recipe. How she got it is something she will never reveal as long as her husband is alive. Enough to say that she prepares it from a variety of fish and, following mysterious processes of heat and loving care, comes up with a soup befitting the gods on Mount Olympus, a true aphrodisiac bomb. All this, plus the advantage that if you have the ingredients ready in advance, it can be prepared in fifteen minutes. This recipe makes too much for one couple, so I recommend it for an orgy of six participants—but no more than that because it must be served the moment it reaches the precise point of perfection. That doesn't afford time for a larger group of bacchants to gather, relax, and sit down to eat.

BOUILLABAISSE

This is a soup that must be made on the coast, because it requires six kinds of fish, all fresh from the sea, which will be washed and then chopped in large pieces without the least respect, discarding tails, heads, and other parts that look unappetizing to a sensitive eye. In an iron pot, preferably black and ugly, sauté 3 minced garlic cloves in ⅔ cup of good vegetable oil. Now, with one flourish, you add 3 large peeled and chopped tomatoes, a pinch of saffron, and 1 teaspoon sugar—the latter for pure superstition because you won't be able to taste it. And salt and pepper, of course. Add 8 cups of water and 1 cup of good dry white wine (don't think that just because it will be diluted in the broth you can use any old cheap label). Bring to a boil over a high flame. Immediately add another ⅔ cup of oil, then the fish, beginning with the varieties that have the firmest flesh—let them boil for about 10 minutes—followed by the more delicate ones,

which will need no more than 5 minutes. At last, serve this simple, aphrodisiac soup in large ceramic bowls. In Marseilles the broth is served separately, with croutons, but that's a bother; put it all together, and accompany it with a good country loaf or the ineffable baguette.

"ODE TO CONGER CHOWDER"

Chilean bouillabaisse is called *caldillo de congrio,* and though less pretentious and demanding, it is equally aphrodisiac and delicious. As my mother said, it really wasn't worth all that effort of traveling clear to Marseilles. You don't need five kinds of fish for this *caldillo,* only a good-size hunk of conger, the enormous eel that inhabits cold seas, and the good right hand of a humble cook or the sensual verses of a lover of the good life. This is the recipe of the Chilean poet Pablo Neruda:

In the storm-tossed
Chilean
sea
lives the rosy conger,
giant eel
of snowy flesh.
And in Chilean
stewpots
along the coast
was born the chowder,
thick and succulent,
a boon to man.
You bring the conger, skinned,
to the kitchen
(its mottled skin slips off
like a glove,
leaving the
grape of the sea
exposed to the world),
naked,

the tender eel
glistens,
prepared
to serve our appetites.
Now
you take
garlic,
first, caress
that precious
ivory,
smell
its irate fragrance,
then
blend the minced garlic
with onion
and tomato
until the onion
is the color of gold.
Meanwhile
steam
our regal
ocean prawns,
and when
they are tender,
when the savor is
set in a sauce
combining the liquors
of the ocean
and the clear water
released from the light of the onion,
then
you add the eel

that it may be immersed in glory,
that it may steep in the oils
of the pot,
shrink and be saturated.
Now all that remains is to
drop a dollop of cream
into the concoction,
a heavy rose,
then slowly
deliver
the treasure to the flame,
until in the chowder
are warmed
the essences of Chile,
and to the table
come, newly wed,
the savors
of land and sea,
that in this dish
you may know heaven.

More Creatures from the Sea

Andrea, one of my California friends, a pleasingly plump siren, beautiful and eternally good-humored, says that peeling squid is a sensual experience. I'm sure it must be, for people who like handling slippery cadavers. Andrea can turn any activity into an erotic adventure. She took a course to

learn to swim with dolphins—an innocent enough experience that has become fashionable in this New Age because people believe that the spiritual vibrations of these animals cure assorted ills. In one of her aquatic pirouettes, our siren was nearly raped. She felt a bull-like charge from the rear, an enormous kiss on her neck that shot her to the bottom of the tank, and then something like a firehose ripping her bathing suit to shreds. Two guards pulled her from the water half drowned, and while the roguish would-be beau made two Olympian revolutions, balancing on his tail, she, naked, was fished out kicking and churning in a net before the astonished eyes of the other participants in the class. This is what happens when you go swimming with strangers. My friend has never recovered from that epiphany: the memory of the dolphin's prodigious manhood, or should I say porpoisehood, which reduces that of any other mammal to the ridiculous, keeps her awake nights.

Marine mollusks and crustaceans are believed to have the highest aphrodisiac value, first among them, oysters. The word *aphrodisiac* comes from Aphrodite, the Greek goddess of love, born of the sea foam after Cronus castrated his father Uranus and threw the genitals into the deep— a rather unnatural means of fertilization, but in that case it worked well and the beautiful Aphrodite was procreated in the foam of the waves. In Botticelli's celebrated painting *The Birth of Venus,* the goddess emerges from the sea clothed only in her flowing hair and standing upon a scallop shell.

Shellfish are delicious and do not require complicated or protracted cooking methods. Many are served raw with pepper, lemon, and a little cilantro. Furthermore, as they rarely have expressive eyes or an audible voice, they seem to lack a soul and we therefore have less compunction about eating them. As for crabs and lobsters that go living into the pot of boiling water to die in the throes of horrible agonies, it's the cook who deserves punishment.

Shellfish, and especially crustaceans, have been accused of contributing to high cholesterol, but don't worry, that's yet another North American obsession the rest of the world has never heard of; mention that to gastronomes from Italy or France and see the faces they make. The greatest drawback to shellfish is that they often cause allergic reactions and also, if not absolutely fresh, can poison you—but, look, you have to die of something. Sometimes you have to struggle to get them out of the shells, as is the case with oysters, or put up with a revolting appearance, as with octopus.

The strangest saltwater fare I've ever eaten I encountered on a cruise through the waters of southern Chile: shoe clam, round-tail shrimp, purple prawns and hairy prawns, barnacles (the abalone of the poor), and some untranslatable varieties like *culengue, piure,* and others. We were sailing through small, abandoned islands and mythological coasts where the rain is eternal and there is an extraordinary variety of cold forest vegetation. The ship steamed for a few days across open seas and a few more through the passageways of a vast archipelago, headed for one of the most beautiful blue glaciers in the world, located in the bay of San Rafael. From time to time on the steep cliffs of the coastline we glimpsed villages bowed by solitude. The ship would put up at a rickety dock, sounding its whistles in greeting, and the villagers would come down to celebrate their only contact with a remote reality that they had heard lay beyond the horizon.

The first to approach the ship would be the local officials, dressed in their Sunday clothing: the mayor; the nurse, if they had one; the evangelical pastor or Catholic priest who tended souls; and the proud schoolteacher with her students all in little white pinafores but carrying their shoes in hand in order not to get them dirty. We tourists would explore a muddy street and immediately be surrounded by skinny dogs and children who were at first shy and then laughing, poor, dignified, with unforgettable faces, coarse hair, small hands nervous and scaly as harmless insects, their black eyes enormous and wise, their cheeks cracked by the blustery winds. Meanwhile, the men come aboard carrying on their heads huge baskets filled with shellfish and fish fresh from the waves.

Other times, the ship would interrupt its course in the midst of steel-colored waters and soon we would see emerging from the fog the ghostly silhouette of a rowboat bringing cargo to replenish the galley. Using a system of ropes and baskets, the crew would haul up the bounty of the sea and lower money, along with a few bottles of *pisco* or wine, which the fishermen received ceremoniously, with that immutable courtesy of Chile's poor. That day we tourists would huddle on the upper deck bundled in rough ponchos and shearling jackets bought for the trip and devour the raw creatures directly from their shells: sea urchins, razor clams, oysters. The captain, a square-built, astute man from the south with the name of a Greek pirate, would always pour a round of alcoholic drinks as he revealed to us the mysteries of strange provender we had never seen before, such as the *picoroco,* which looks for all the world like a dirty rock. Knowledgeable

folks identify it by a beak that is occasionally extended and which then they tug on, twisting off the head and extracting the flesh, which is white and long as a strip of intestine. We ate it raw, swimming in lemon, between sips of white wine. It requires courage.

Following, we offer a list of the most aphrodisiac seafood:

Abalone *In Chile we call it* loco, *maybe because to tenderize it you have to pound it unmercifully, the way mental patients once were treated. It lives in a thick shell, adhered to rocks, usually in cold waters. Harvesting it is not an agreeable task; you have to sink into icy water, equipped with an iron bar to pry the abalone from the rock. There is a science to cooking it, and the person who doesn't know it usually ends up gnawing on a piece of hard rubber, but when properly prepared it is delicious. It is widely used in Chinese and Japanese cuisines.*

Clams and mussels *These humble relatives of the oyster may be eaten raw with lemon, but they are better in soups and casseroles and also briefly baked in the shell with grated Parmesan, pepper, and a few drops of white wine. In shape they recall female genitals; in Italy, nonetheless, they are called* cozza, *one of several names for a very ugly woman.*

Scallops *The flesh, plump and white, normally is sold cleaned and ready to be cooked. If you do find them with shells, it's a good idea to have some on hand for your romantic dinners; filled, they work well for French dishes like the acclaimed coquilles St. Jacques.*

Squid and octopus *These creatures seem to be from another planet but are a delicacy for those who learn to eat them. In Spain they use octopus ink to make a black rice so erotic that it would be inadvisable to serve it to nuns or widows.*

Shrimp, prawns, crabs, lobsters, and other crustaceans *Tasty, decorative, and very aphrodisiac, these are also easy to prepare—simply boil or broil them—but sometimes you must have a heart of ice to kill them. To use the example of the lobster: you have to peg and bind its claws and submerse it head first in boiling water, turning a deaf ear to its faint moans, and cook it until the shell turns red. Keeping in mind that some lobsters are the size of a rat, this is not a task recommended for the faint of heart or for maidens. Before you offer a crustacean to a new lover, be sure to find out whether he has any allergies. Many years ago I served prawns to a man I was trying to seduce, but the dinner, alas, led to horror instead of lovemaking. Five minutes after putting the first bite in his mouth, he was turned into a monstrous vision of a hanged man, his tongue so obscenely swollen it hung down over his chest as he strained for breath and an icy sweat coursed down his temples.*

Sea urchins *The first person to open a sea urchin and place it in his mouth must have been very hungry. The mere look of it is daunting. It is eaten in Asia and South America, where it is thought to be more aphrodisiac than the oyster, but the rest of the world looks upon it with revulsion. It comes inside a dark ball covered with spines; the tongues—which aren't tongues but genitals—are fleshy and sensual, the color of peaches. They emit the intense odor of the ocean depths and something more, something indefinable but frankly erotic. The taste is pure iodine and salt to the noninitiate; for the cognoscenti it makes a mouthful, as we say, worthy of a cardinal. For me the sea urchin is related to a forbidden experience. I was eight years old and alone on the beach; a fisherman emerged from the waves and offered me a sea urchin. Later he led me to the forest . . . but that is another story.*

Oysters *The beautiful and frivolous Pauline Bonaparte was sent by her brother Napoleon to Santo Domingo, in lightly veiled exile, to silence the gossip about her scandalous behavior in Paris. On that island of heat, distance, and boredom, her senses were exacerbated and, seeking relief from cupidity and the desolation of rejection, she became addicted to black men.*

Hysterical, spoiled, and in bad health, La Bonaparte bathed in milk, slept a good part of the day, and occupied the rest of her time with her wardrobe and her beauty. But at night she liked to escape to revel with slaves in filthy hovels and to eat from their lips, between kisses and nibblings, the coarse food of the poor; meanwhile, in the dining room of his palace, General Leclerc, a cuckolded and complaisant husband, was enjoying the refined cuisine and best wines of France. Pauline returned to Europe with four African female slaves to serve her and a handsome, husky black man who carried her every morning naked to her bath and fed her breakfast: fresh oysters and champagne.

Oysters are the queens of aphrodisiac cuisine, protagonists of every erotic scene recorded in literature or on film. The best way to eat them is raw, after squeezing lemon over them to test whether they are alive, because otherwise they are very toxic. The miserable creatures writhe in the acid. The flesh must look firm and plump, creamy in color, and float in a transparent, inoffensive-smelling liquid. If you buy them in their shells, I warn you that opening them takes strength and skill. Buy them already opened or eat them at restaurants, where someone else has been responsible for the work of preparing them. Oysters are so highly prized that the duke of Lauzun, before being led to the gallows, ordered a serving of oysters with white wine, which he shared with the hangman: "You have some, too," the duke told him, "because to carry out your office, you need courage."

The Harem

Although it seems unimaginable, there once was a time before television. I grew up playing house with rag dolls and reading anything I could get my hands on, especially serials, which my grandfather abominated but nonetheless made their way into the house as contraband. It was in serial form that I read classic novels and countless romantic tales, most of them

set in past epochs and exotic climes. The only one that left its mark on my mind was the tragedy of a noble Englishman whose sweetheart was stolen from him by Turkish pirates on the Mediterranean Sea. The author must have found his inspiration in the story of Aimée de Rivery, a young French cousin of Josephine Bonaparte kidnapped by Levantine pirates on the high seas toward the end of the eighteenth century and sold as a slave into the harem of the sultan Abd al-Hamid I.

After many adventures, the hero of my romance discovered that his beloved had been bought for the seraglio of the sultan and determined to rescue her with the complicity of a Jewish merchant who had access to the inner courtyard of the palace, where he went to offer his rich cloth, although he was always closely watched and separated from the women by screens and curtains. My noble Englishman shaved off his beard and dressed as an odalisque—an entire chapter was devoted to the description of babouches embroidered in pearls, a belt of gold, silken harem pants, brocaded vest, all his veils and jewels—and, swinging his hips like a sultry charmer and modestly covering his face with a veil, he was able to deceive the Great Black Eunuch, the maximum authority in the harem.

Once inside the *gynaeceum*—another long chapter about the opulent rooms, the women, the baths and gardens—he found his sweetheart, just in the nick of time, and saved her from being led to the bed of the depraved sultan; they then escaped by leaping walls and eluding Janizaries, a feat that would have been impossible in real life but that launched me, with no turning back, into the vice of exaggeration and adventure.

What man has not had the fantasy of having a harem? And what woman with a lick of sense has not thought of it as her worst nightmare? I say this from the perspective of my mature years, because at eighteen, when I was working at a job copying forestry statistics, I used to dream of being the fourth wife of an Arab millionaire who would appreciate my buttocks and allow me to spend my life eating chocolates and reading novels. Feminism saved me from the traps of imagination. Great painters such as Ingres and Delacroix idealized on their canvases the exotic and secret beauty of those immured women, birds in their golden cages, whose only fate was to satisfy the whims of a master and give him male offspring. At the midpoint of the last century, when accessible routes were opened to North Africa and Asia, many travelers returned to Europe with fabulous stories that generated a true Orientalist obsession in literature, art, and

fashion. The eroticism of the harem so captured the imagination of more than one gentleman of bountiful means that many tried to buy Circassian slave girls and bring them to London or to Paris to undertake their own version of polygamy.

The *gynaeceum,* or harem (from the Arabic word for "forbidden or protected place"), where women lived physically and spiritually isolated lives under the watchful care of eunuchs, has existed throughout history in many places, especially in China, India, and Arabic countries, but the best example was the Great Seraglio of the sultan of Turkey, which had more than two thousand individuals inside its walls. When the closed doors of that sumptuous palace were finally opened in 1909 because of political changes in that country, the world learned that thousands and thousands of women had lived there over the course of four hundred years. Of them no trace remains. No one ever knew their origins or held a memory of their deaths; it is as if they had never existed.

Alev Lytle Croutier, in her passionate book *Harem: The World Behind the Veil,* explains that the harem is the result of several cultural and religious traditions. According to Jews and Christians, God created man in His own spiritual image; woman, on the other hand, is flesh and temptation, an animal dominated by sensuality, who can be uplifted only through her husband. In the patriarchal system, men have the sexual freedom women are denied. Islam imposed the most strict separation between the sexes and converted women into prisoners by using the argument that she cannot be trusted: she is a seductress and promiscuous by nature. In this way, the female is blamed for the lust that characterizes the male. The harem was created not to protect women, as the word implies, but to preserve man's morality. A Muslim may have four legitimate wives and an unlimited number of concubines.

The fabulous riches and power of the sultan of Turkey are reflected in the Great Seraglio. In the harem, the mother of the sultan reigned supreme, followed by wives, favorites, and finally the odalisques, or servants. Women of high rank had their own servants, eunuchs, and rooms decorated with the most exquisite *objets;* the other women lived together in shared quarters but always surrounded with great abundance. Luxury may not have compensated for captivity, but it made it more tolerable. Although some women were born inside the palace, most came from the slave market, many of them kidnapped or sold in childhood by their fathers.

The slave market was one of my favorite haunts. . . . One enters this building which is situated in a quarter the most dark, dirty and obscure of any at Cairo by a sort of lane. . . . In the center of this court the slaves are exposed for sale and in general to the number of thirty to forty, nearly all young, many quite infants. The scene is of a revolting nature; yet I did not see as I expected the dejection and sorrow as I was led to imagine watching the master remove the entire covering of a female—a thick woolen cloth—and expose her to the gaze of the bystander. —William James Muller, 1838

Once she was bought, the woman disappeared from the eyes of the world, her family forgotten, to become a part of the harem's intricate system of hierarchies, favoritism, and conspiracies. She did not emerge again except on rare occasions and then always covered from head to toe, including gloves for her hands. Her life passed in idleness and ignorance, lightened by childish games, puppets, riddles, stories, and strolls through the gardens, far from indiscreet gazes. If she was very beautiful, astute, and lucky, she learned the art of pleasing the sultan's mother, the Great Eunuch, and her master, giving him a son and rising in category. Then she passed the rest of her brief existence defending herself against attempted assassinations and trying to protect her son until he reached adulthood. The slightest misstep led to execution without trial: the Great Eunuch would personally oversee

the process of placing her in a sack and throwing her to the bottom of the sea. A similar practice—illegal but allowed by society—still exists in some countries, where a father or husband may kill a woman in punishment for dishonoring the family. Most of the women in the seraglio lived out their days as odalisques, in near oblivion, in tones of gray.

Much speculation has been devoted to these beauties hidden behind the veil—the fairest in the slave market were destined for the sultan, of course—but little has been said about how briefly their charms endured. They spent hours every day sitting cross-legged, eating sweets, and smoking opium and tobacco: before they were twenty, they were fat, their legs were misshapen, and their teeth rotten, details one doesn't find in erotic fantasies about the harem. It is not the purpose here to vilify these unfortunate women, however, but to talk about aphrodisiacs.

Outside of the celebrated Turkish bath (*haman*), a place where female sensuality could be unleashed, and of the intrigues that occupied a large part of the lives of those women, eating was the most important activity in the harem. And thus was born the culinary tradition that characterizes Turkey. Croutier writes that to feed that throng of women, children, and eunuchs, there were 20 kitchens and 150 cooks responsible for producing an uninterrupted stream of meat and vegetables, Turkish coffee, sweets and assorted pastries, all passed around on silver and bronze trays. Forbidden by Islam, alcohol was not drunk, but refreshing liquids were served continuously: lemonade, teas, perfumed sugar water, and *cevosa*, a bittersweet drink made from barley. Eggplant was considered the most effective aphrodisiac—it was served daily to the sultan—and still today in Turkey, good wives pride themselves on knowing at least fifty recipes for this vegetable. Sorbets were everyone's favorite; they were prepared from spices, flowers, and fruits, and ice carried by muleback from mountain peaks seventy kilometers away. Ever present were small plates of delicate sweets made from a paste of sugar, semolina, honey, rosewater, and nuts, the treats known around the world as Turkish delights.

As there was very little else to do, every meal was prolonged for hours, following a ceremonial etiquette the odalisques learned in childhood. One ate with one's fingers, with elegance and delicacy, and afterward servants passed among the women with embroidered towels and carafes of perfumed water for rinsing the hands. Finally the women would rest, reclining on divans and cushions smoking narghiles and cigarettes, to

which they were greatly addicted. The sultan's food was tasted by a eunuch, to prevent his being poisoned, and the more prudent favorites of the harem demanded the same treatment.

In India and China, too, there were luxurious gynaeceums where women lived as prisoners but in the midst of the most exorbitant opulence. The emperors of ancient China, and nobles who could afford the expense, had numerous wives, consorts, and concubines. There was one emperor of the Tang dynasty who had two thousand women in his harem and engendered nearly five hundred children. A labor worthy of Hercules. Every night, after dinner, he received the menu from the harem and selected one or several companions; no argument prevailed against it. Forget the possibility of listening to his nightingales or playing mahjong; the prosperity of the nation was measured in the number of children he conceived: patriotic duty called. To guarantee his enthusiasm and good disposition, he had at his disposal a team of physicians, acupuncturists, and experts in aphrodisiacs whose duty it was to stimulate him with any method known to that millennary tradition. Food was an essential component—not only ingredients, but combinations that increased virility. More than one chef was decapitated without preamble because his birds' nest soup did not have the desired effect upon the emperor. Once dinner was over, the physicians' herbs swallowed, the needles of the acupuncturist on duty duly inserted, and the pillow books leafed through, the fortunate—may we hope—wife or concubine for the night was shown into the presence of the emperor.

What followed was not a private engagement but a matter of supreme importance and security for the empire, attended by various witnesses. A notary recorded those amorous soirées and thus could calculate with exactitude the days of each infant's gestation. If the dates did not coincide with the usual nine months, the head of the mother accused of adultery went to join that of the chef on the chopping block. The emperor's every mouthful was noted down in the same detail, in order and in quantity. With so many women at his disposition, he could attend each—in the best of cases—only once a year.

The concubines lived at the margins of these main events, but as they were young and idle women they had no need of aphrodisiacs. What else was there to think about? They consoled one another with febrile resourcefulness and the prodigious inventiveness of the eunuchs, who

146

were capable of outrageous innovation and of giving them more pleasure than the emperor, with all his miraculous herbs and turtle soups, could offer. Castration did not abolish desire, and although the eunuchs could not produce children, as lovers they possessed extraordinary gifts. It was believed that once a woman had known a eunuch, no complete man could satisfy her. This tradition has not reached Western hearths, and eunuchs are very scarce on this side of the world. Nevertheless, Chinese wisdom regarding aphrodisiacs and erotic food is not lost to us.

Eggs

In all cultures, erotic and restorative powers are attributed to eggs; they are supposed to invigorate old men, cure indifference, and regenerate the dried-up wombs of infertile women. In *The Perfumed Garden,* a prodigious man named Mimún—and how proud he was of his feat!—practiced the game of love for sixty days without slaking his thirst, all thanks to eating nothing but egg yolks and bread. You don't have to be a genius to see the relationship between eggs and fertility, which is why they have always been favorites in erotic cuisine, from caviar, the minuscule fish eggs whose market value makes them even more aphrodisiac, to the enormous ostrich egg capable of feeding an entire family.

In Chile we have the tradition of eating eggs "à la oyster," that is, raw, as an incitement to virility and to mend the body and recover memory upon waking up from a drunken spree. After the birth of each of my children, my mother-in-law brought me every day a beer she beat with raw eggs and honey, an age-old home remedy given to nursing mothers. Obedient, I drank it down, ignoring any thought of calories or of the irrefutable fact that it was turning me yellow and making my knees too wobbly to hold me up. To restore vigor to men going through a sexual crisis, in some European cultures they are deluged with astounding quantities

of raw egg yolks beaten with cognac, exactly the formula we use in Chile to wash our hair. Eggs lend themselves to all sorts of naughtiness: hard-boiled, you can roll them in bed; scrambled, you can serve them in the palm of your hand, without a fork; as meringue they can be spread on your breasts for your greedy lover to lick off.

The noblest way to prepare eggs for an erotic skirmish is also the simplest and most classic: as an omelet, that is, the elegant French way of serving scrambled eggs with countless variations from garden herbs and spices to vegetables and chopped meat. For a good omelet, you need a thick iron skillet in which eggs will cook evenly and then slip out effortlessly. In exactly the same way that a barber cares for his scissors, a chef cares for his skillet and will not allow it to be used for any other purpose. You never wash it, you just wipe it out, and as the years of its noble life go by, it turns increasingly dark and wise.

In the same *Perfumed Garden* in which Mimún made like a rabbit, the pious Sheik Nefzawi, who had never heard the word *cholesterol*, dedicates several paragraphs to the aphrodisiac power of eggs.

He who will feed for several days on eggs cooked with myrrh, cinnamon and pepper, will find an increased vigor in his erection and his capacity for coition. His member shall be in such a turgid state that it will seem as if it could never return to a state of repose. (May Allah in his greatness preserve him to the Resurrection Day.) He who wishes to operate a whole night through and who, due to the suddenness of the desire, has not been able to make the preparations I have already mentioned, will have recourse to the following; he will fry a good number of eggs in fresh fat and butter and, when they are well cooked, he will mix them with honey. If he will eat as much as possible of this with a piece of bread, he will be able to soothe and comfort all through the night. (With the help of Allah. May he bestow his blessings on his Prophet and grant us salvation and mercy.)

Quail eggs—small, with dark spots and free of cholesterol—are sold as aphrodisiacs. Their size makes them ideal for hors d'oeuvres and for garnish. Personally, I prefer caviar, of course, and I can think of a thousand pornographic ways to serve it, but since it is so expensive, I have caviar only on spe-

cial occasions when I must resort to excesses of cleverness and sensuality to achieve my amorous objective. And of course I take it when it is offered to first-class passengers in airplanes, although it isn't easy to play games with caviar on a commercial flight: the stewardess is always watching. As a modest alternative, I also like a raw egg served on my lover's navel, with chopped onion, pepper, salt, lemon, and a drop of Tabasco, although I can't always use the last ingredient: my man is allergic to hot spices. Caviar is one of the most expensive aphrodisiacs in the world, almost as expensive as the famous birds' nests so prized in China. It is taken (logically) from the female sturgeon, not from a surgeon, as I thought in my youth. This denizen of icy seas, one of the most ancient creatures on the planet, is usually about four meters in length. The price of the caviar varies according to the quality, and that is measured by rarity, following the natural law that the more difficult something is to obtain, the more we want it. The largest eggs, called beluga, are the most expensive and come from the largest fish. The highest-grade beluga, practically unknown outside Russia, is totally consumed by political higher-ups and the Bolshoi Ballet. Ossetra are medium-size eggs, and sevruga, the smallest. In Russian processing plants they employ a taster, whose liver, over

time, acquires the boilerplate invulnerability of the battleship *Potemkin*. This expert tests the caviar to classify it and to determine how much salt is to be added; like wine tasters, he swishes it around in his mouth and immediately spits it out. There are some addicts, nevertheless, who devour fantastic quantities of this intense edible between great swigs of hot tea.

Supreme Stimulus for Lechery

One of the most notable monarchs of all times was Catherine the Great (1729–1796). This German princess—married young to the Grand Duke Peter, the ugly, gluttonous, cowardly, violent, and rather imbecilic heir to the throne of Russia, found the way, with the aid of five handsome army officers, the brothers Orloff, to be widowed at an early age. Then, as czarina of Russia, she reigned with an iron fist for half a century. She spoke four languages, supported the artists and intellectuals of Europe, exchanged a voluminous correspondence with several of them, but in her own kingdom she did not tolerate any of the modern ideas she applauded outside it. She had many official lovers—among them the celebrated Potemkin, a political genius and the true éminence gris behind the throne—and countless companions-for-a-night whose names are not recorded in history. Legend accuses her of being so insatiable in bed that she went so far as to have relations with her horse, and that she herself designed a harness from which to suspend the animal, although this may only have been malicious gossip. She had prodigious vitality and good health. To the end of her seventy-seven years she rose at five in the morning to work and still late at night had enough energy to indulge herself with the favorite of the day. Her breakfast consisted of vodka-laced tea and a caviar omelet.

A freshly prepared omelet can be a song for the spirit comparable only to the music of the fakir's flute that seduces the serpent to rise from its basket, erect and powerful. In the streets of India, from a prudent distance, I watched several of these cobra charmers and always thought: If they have all that power with a snake, what might they not arouse with their music? Perhaps that is why male tourists of a certain age offer special tips to have the charmers play for them. (I don't know why this reminds me of the lighthouse of San Francisco. Every time fog is predicted, a number of men wander over to the lighthouse, because when the lugubrious horn begins to sound to warn ships of danger, the vibration awakens the visitors' libidos). But let's get back to our perfect aphrodisiac omelet.

THE EMPRESS'S OMELET

For two people in love, you need 5 eggs, fresh from the nest of a virgin hen, salt and pepper, fresh country butter, chopped chives, 4 fine but succulent slices of Norwegian smoked salmon, ½ cup of beluga caviar, if possible from the Baltic Sea, 2 teaspoons sour cream, and, of course, toast. Ever so delicately, break the eggs into a fine porcelain bowl—porcelain for reasons of elegance, nothing more—and beat lightly, adding salt and pepper. Warm the butter in the omelet pan sacred to every good cook, and as soon as the butter begins to turn the tint of warm Caribbean skin, pour in the eggs. When the omelet is half cooked on the bottom, loosen it with infinite gentleness, whispering encouragingly, because if you are rough, it will lose its enchanting disposition; add the chives and salmon and fold it over, exactly as you would close a book. To free it entirely, experts move the skillet back and forth with the pulsing syncopation of a good dancer and then, with a sudden flip of the wrist, toss it up in the air and catch it, now reversed, so it will cook to a golden brown on both sides—although I admit that every time I've tried that move, the omelet has landed on my head. These gyrations are pure exhibitionism, because when you make an omelet, as when you make love, affection counts for more than technique. Serve your omelet on your most beautiful plates, already warmed in the oven. Spoon on the caviar, and beside this triumph place the sour cream and warm toast. After a night of passion, this is the breakfast indicated for making love, no holds barred, the rest of the day.

Forbidden Fruits

In erotic literature, oral sex sometimes is called "forbidden fruits," but it is not my purpose here to analyze the incongruencies of language and prudery. It's enough to recommend as stupendous aphrodisiacs both forbidden fruits and others considered to be respectable, which we will enumerate for purposes of pure overkill.

Almond *In mythology, the almond emerges from the vulva of the goddess Cybele, but I don't see that as cause for alarm. Almond, milk, honey . . . Do they not evoke* The Thousand and One Nights *and* The Song of Songs? *The almond is associated with passion and fertility and is the most sensual component of Arabic pastry making. In Italy it is used as a medicine and tonic for amours, which may be the origin of the custom of offering almonds before a meal with cocktails. Their aroma, penetrating, persistent, sometimes slightly bitter, is supposed to excite women and therefore is cherished in creams, soaps, and massage lotions.*

Apple *The symbol of temptation.*

> *And the Lord God took the man, and put him into the garden of Eden to dress it and to keep it. And the Lord God commanded the man, saying, Of every tree of the garden thou mayest freely eat; But of the tree of the knowledge of good and evil, thou shalt not eat of it; for in the day that thou eatest thereof thou shalt surely die.* ——Genesis 2:16–17

But the serpent convinced the woman, and she, in turn, her companion, and both ate "thereof," and so began the problems of the human couple. The Bible does not say, however, that the fruit was an apple. We must suppose that the fathers of the church—celibate and misogynist—chose the apple as the forbidden fruit because when cut in half its seeds appear arranged in the shape of a vulva, a part of her anatomy the wicked Eve used to tempt that virtuous Adam. Later in history, the Shulamite sings to Solomon: "Stay me with flagons, comfort me with apples; for I am sick of [from] love." (The Song of Solomon 2:5)

At any rate, the fame of the apple in the duel of love is universal. It is used in many magic potions, philters, and enchantments. The liquors of the apple, such as calvados and cider, are stimulating and thought to rejuvenate.

Avocado In some parts of the world, the avocado is considered a vegetable, but in fact it is a fruit the Aztecs called ahuacatl, which means "testicle." It is, nevertheless, a "feminine" fruit, with soft texture and delicate taste that more often evoke sensuality in women than in men. It was taken to Europe by Spanish conquistadors, who were responsible for spreading its fame as a stimulant—so effectively that in the confessional Catholic priests forbade it to their parishioners. It has so many calories that I prefer to use it to decorate plates, for facials, and for an occasional mischievous game.

Banana Associated with erotic energy in the Tantric tradition and the phallic symbol par excellence, although I don't know what man would like having his yellow, and with spots. I think that as an aphrodisiac it has nothing to offer but its shape, although that's better than nothing.

Cherry In more innocent times, in the United States, jocks in locker rooms would boast of making it with the blondest cheerleader by saying he'd "gotten her cherry," which was his way of saying he was the first to break her hymen. Today he would be considered a nerd. We have come a long way, baby.

Coconut In India it is thought to increase the quality and quantity of semen and to cure illnesses of the urinary tract. Stimulating properties are attributed to a drink confected of coconut milk, honey, and spices, but it may be the spices, more than the coconut, that are responsible for the effect.

Dates Rich in vitamins and calories; a handful is equivalent to an entire meal. The date provides energy and increases erotic potency in men and coquetry in women, more than enough reason to make it a staple of the diet of Africa and the Mideast, where it is always found in the saddlebags of camel caravans crossing the desert. With the fermented juice from the crown of the date palm, an aphrodisiac liquor called palm wine is brewed.

Figs In ancient Greece this fruit was one of the sacred foods associated with fertility and physical love. In China it was given to sweethearts, and in Europe it is considered aphrodisiac because of its shape and color; in some places female genitals are called figs, while in other parts of the world fig is a term for homosexuals.

Grape No self-respecting orgy can do without grapes, the fruit associated with pleasure, fertility, Dionysus, Priapus, Bacchus, and merry gods in all traditions, because wine is made from the grape, and without wine any attempt at an orgy turns into collective boredom.

Mango *Like so many tropical fruits, this one has an intense fragrance and flavor. Its orangeish pulp, rich in vitamins, is the base for many dishes in Asia and Polynesia, where it is considered a male food because of its resemblance to a testicle (given the size of mangos, a bit of an exaggeration).*

Peach and apricot *Perhaps the most sensual of all fruits, for their delectable perfume, soft and juicy texture, and flesh color, an eloquent representation of the female private parts. The peach is a native of China, where it has been cultivated for more than two thousand years. Shakespeare knew its magical reputation, and in* A Midsummer Night's Dream, *the fairies use it as an aphrodisiac.*

Pear *Favorite of erotic art for its feminine shape, it contains vitamins and iodine. A salad of pear spears, fresh watercress, and nuts is an interesting way to begin a lovers' meal, among other reasons, because it can be eaten with the fingers and has a delicious fragrance.*

Pistachio *A small fruit very popular in all of Asia and mentioned in the Bible and in Persian and Arab writings. With true perseverance, women of the harems consumed honey cakes with pistachios to maintain their fleshy bodies and dimples, which in those days were appetizing and today, sadly, are only fat and cellulite.*

Plum *Like the peach, used in Chinese art as a symbol for a woman's intimate parts.*

Even though I have forgotten her

I continue to eat

plum after plum. . . .

—Haiku, James Tipton

Pomegranate *Brought to Europe during Arab invasions. In some erotic texts of the East, the pomegranate is accorded aphrodisiac virtues and associated with ceremonies of fertility, thence the tradition of using the seeds at nuptial festivities as rice is used in the West. In Greece it is, like grapes and figs, a ceremonial fruit of Dionysian rites.*

Quince *Along with the apple and the pomegranate, the symbolic fruit of Aphrodite, the goddess of sexual ecstasy and youth.*

Strawberry and raspberry *Delicate fruit nipples that in the code of eroticism invite love. They are the ideal complement to champagne in courtship rituals, as noted by the beautiful and frivolous Pauline Bonaparte.*

I know what you are thinking, dear reader: Why this interminable list? Can't this woman just sum things up in a single "and so forth"? No, no I can't. You may skip the list if that's what you want to do, but scientific rigor obliges me to be exhaustive. If someday this book is published, I intend to claim the reputation of being the foremost authority on aphrodisiacs in the world. People will come from all corners of the globe to consult with me, and if widowed, I will not want for suitors.

Other Delicious Aphrodisiacs

Coffee (Coffea arabica, Coffea liberica, Coffea robusta, *and* other varieties) *Properly listed among herbs and spices; however, I believe that, like chocolate, coffee deserves a chapter of its own. Stimulating due to its caffeine, a powerful alkaloid, which is why Mormons—who also do not consume alcohol—do not drink it. On the other hand, in many Muslim countries, particularly Arab nations, where the Koran forbids alcohol and other stimulants, coffee is de rigueur. For those of us who suffer the vice, we cannot face life before the first morning fix. Any aphrodisiac factor is doubtful. In the United States, fanaticism has risen to such a level that awning-covered carts selling espresso are multiplying on every street corner, yet the libido of Americans is not especially notable. So sophisticated has the coffee trade become that a special idiom has developed around it, much like the ancient language of flowers. My favorite is Cap-large-decaf-soy-nonfat-wet-cin-choc, a name recited in a single breath and which means: a large decaffeinated cappuccino with no-fat soy milk, half milk, half foam, with cinnamon and chocolate. To an Italian, inventors of the cappuccino, this is, of course, heresy.*

Tea Known in India and China for several centuries before Christ, first as a medicine and then as a refreshing drink, tea did not arrive in Europe until the beginnings of the sixteenth century, brought by Portuguese merchants from India in 1530. By the eighteenth century it was a common drink

in England, where Thomas Twining began selling it by weight. Twinings of London, and the custom of drinking this brew at five o'clock in the afternoon, exist in that country to the present day. In 1773 North American colonists threw bundles of tea into the harbor as a protest against taxes and lack of political guarantees, thus beginning the United States War of Independence against England. From that time on, North Americans have drunk little tea (and they prefer it iced).

Tea is cultivated primarily in the warm, humid climates of Asia, and there are countless varieties, whose aphrodisiac value depends on the faith of the imbiber. Chai, tea brewed with spices, milk, and lots of sugar, is popular in India, while in Russia tea is drunk (in a glass, never a cup) with lemon and sugar and, in winter, a shot of brandy or vodka. The refined tea ceremony of Japan, chanoyu, is considered a choreographed art and a form of meditation in accord with the principles of Zen: harmony, respect, purity, and tranquillity. These four principles, in apparent contradiction to sensuality, can come to be the essence of sensuality itself, but for that to happen it is necessary to travel twice the complete path of the senses.

Chocolate Contains theobroma, "fruit of the gods." Whoever said that chocolate is not one of the fundamentals of the human diet? To me it seems more nutritional than beans and broccoli, to mention only two. Chocolate was the sacred drink of the Aztecs, related to a goddess of fertility, Xochiquetzal, and consumed only by nobility. The cruel conqueror of Mexico, Hernán Cortés, tasted it first in the court of the emperor Moctezuma and shortly thereafter introduced it into Spain, where its fame as an aphrodisiac was so great that women drank it in secret. It is as addictive and stimulating as coffee—because of the alkaloid theobromine—but it is also symbolic in rituals of romantic courtship. What woman has not seen her defenses crumble before a box of chocolates? The taste, so popular in Europe and America, is not equally appreciated in Asia and Africa. On a trip to the interior of India I could not find chocolate and suffered such tortures of privation that now I understand the trauma of drug addicts.

Honey The nectar of Aphrodite, golden treasure of the earth drawn from the soul of flowers and the labor of bees, honey served to sweeten life long before the discovery of sugar. Its taste and aroma depend upon the flowers from which the winged toilers have sipped. Honey's reputation as an aphrodisiac is extensive: bride and groom go on a "honeymoon," and in many cultures honey is part of the wedding ceremony and banquet. Its high vitamins B and C content, and the minerals in the pollen, stimulate the production of

sex hormones. It instantly revives exhausted lovers, because the body absorbs it in minimal time. Avicenna, the celebrated Arab physician, whose prescriptions were used for several centuries during the Middle Ages, recommends honey and ginger to cure impotence. Honey is used in the preparation of sensual sweets, mixed with nuts, coconut, camel or goat's milk, eggs, spices, and so on. It is thought that the saliva of the beautiful houris of Allah's Paradise, as well as female secretions during certain days of the menstrual cycle, taste of honey. Attila, who believed steadfastly in its stimulating power, drank so much mead on the day of his wedding that he died of cardiac arrest, to the jubilation of his enemies and possibly his bride. King Solomon sings to his beloved, "Thy lips, O my spouse, drop as the honeycomb; honey and milk are under thy tongue, and the smell of your garments is like the smell of Lebanon." (The Song of Solomon 4:11)

If it hasn't already occurred to you, here is a fact: warm honey on your body lends itself to many exotic games. Cleopatra liked to apply a mixture of honey and ground almonds to beautify her skin. Julius Caesar and Mark Antony grew fat at her side not only because they had deserted the rude life of the barracks for the languid pleasures of the Egyptian court, but because they grew so fond of licking dessert from the intimate goblet of that seductive queen.

Nouvelle Cuisine

The latest culinary mode is nouvelle cuisine, which has very little new about it, since it uses the same ingredients that have always been used, only in more ethnic combinations, as a chef in New York defined it to me. I suppose he was referring to Asian and Latin American influences, ignored until only recently in most of Europe and North America. This cuisine is also lighter, with less fat and fewer calories, and the portions are smaller— although they cost more because they require decoration. My mother

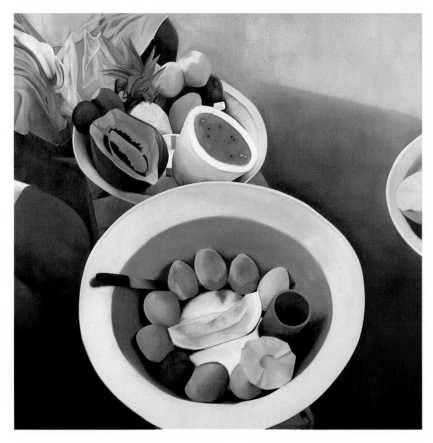

always says that if it looks too good, you can be sure that someone has put his fingers in it. If we served nouvelle cuisine at home, it would give the deplorable impression that there wasn't enough food to go around.

I don't trust these modern restaurants where the waiter—an athlete with pirate rings in his ears and tattoos on his hands—introduces himself by his given name and treats me as if I wanted to sell him a Bible. It's a sure thing that here I will be served nouvelle cuisine. If I don't have the option of escaping, I am faced with an exhaustive menu on which each dish is described in the pedantic language of an aspiring literary critic. Usually I choose the least expensive thing on the menu, with the hope that it will also be the simplest, but invariably I am served the creation of a psychotic. My humble fish comes disguised as a hat, and when I lift away the carrot fringe, celery feathers, petals of flowers, and onion veil, there's very little trout beneath. It seems a shame to wreck such a work of art, and when finally I decide to sink my fork

into it, the whole thing falls apart and a radish in the shape of a bee lands in my lap. I am left with the sensation of not having eaten enough and having paid too much. It isn't like a Basque inn or Mexican taco shop, where for a modest price you are stupefied for four or five days.

Nouvelle cuisine can be interesting, but when it comes to food—and men as well—I prefer more robust flavors and a simpler appearance, like an honest fish that is not ashamed of its nakedness. It's true, I do want it dead. I am horrified by food that moves, which is why I avoid gelatin and oysters, but this is a mania I must combat: many animals in the aphrodisiac recipe file are barely more than swooning when brought to the table. Once in a Scandinavian restaurant I was served a sea serpent—eel, I think they called the poor thing—that suffered a brief attack of epilepsy when I tried to cut it. I let out a screech, and the waiter, who at that instant was serving the wine, dropped the bottle. The ideal is for your food to be good and dead but to have avoided rigor mortis. And no eyes, please, even if they're closed. There's nothing so horrifying as the entreating gaze of a whole animal on a tray. Since they've gone to all the work of killing it, why not cut off its head in the bargain?

My objections to tomatoes turned into roses, potatoes disguised as nightingales, and other euphemisms of nouvelle cuisine do not mean that I have a taste for dishes that look like prison mush, the kind of gruel I had in the English school where I acquired my characteristic stoic stomach, or that I like the brutish offerings of peasant origins. Those roast pigs in Spain with an apple in their snout and a sprig of parsley up their ass deserve a requiem mass. It's sin enough to kill animals; there's no need to humiliate them on top of it.

Cheese

Cheese is milk teeming with bacteria, and everything else is wishful thinking. The first time I saw cheese being made was at a dairy in the interior of Venezuela, hot as the Sahara, in a germ-filled shed where six cows were distractedly waiting their turn to be milked, chewing their cud and flicking away flies with their tails. Part of the milk, destined for the well-named "hand cheese," was mixed with curds; the heat multiplied the bacteria, and as soon as the liquid curdled it was strained through a large sieve. The whey went straight to the hogs, who were right beside the milking shed, which explained the smell, a bouquet more far-reaching than cow dung. The rest of the milk went into the round tubs where Don Maurizio, a gigantic half-Indian, half-African, naked from the waist up, sweating and singing, plunged his arm in up to his armpit and conscientiously stirred. Don Maurizio, a great cheesemaker, had a battery-operated radio tuned to a station where *joropos*, salsas, and country songs gauged the time needed to turn the curds into cheese, and his timing was so exact that the result was always identical.

Since then, I have had the opportunity to visit industrial computerized cheese-processing plants where hygiene is as strict as that of the operating room and the barns smell of pine forests. The cows have been fed so many hormones that they moo in soprano and any one of them could produce enough milk to fill the celebrated bath of Cleopatra; the cheeses, nevertheless, do not seem as perfect, or nearly as tasty, as those made by Don Maurizio. He molded them into round loaf shapes, left them to set in the shade, and after a few hours they were ready to be sold and eaten. After picking out the flies, which tended to get stuck in the surface, we ate the cheese with *cachapas*, warm corn tortillas right off the coals. It is one of my most pleasant memories of that difficult period as an immigrant in a foreign land. And that hand cheese must have been aphrodisiac, because all I have to do is recall its delicate flavor and the sweat slipping down the brawny arms

of that king of cheese, Don Maurizio, to feel adulterous impulses.

There are cheeses for all tastes; it would be impossible to list all the flavors and consistencies, as they are nearly infinite. Each region has its favorites. In Switzerland you eat the best Gruyère and Emmenthal, in Italy Parmesan and Gorgonzola, and in Holland Gouda. In a premeditated act of gluttony during his childhood, my brother Pancho peeled a good-size Gouda cheese as if it were an apple and patiently devoured it down to the last crumb; we were sure he would die of incurable indigestion, but he has lived in good health for fifty years. I have few more colorful and sensual memories than those of the cheese and flower markets in tulip season in Amsterdam. In England, Cheddar is very popular, as is Stilton with its gray and green veins, served by the spoonful, beginning in the center of the cheese and accompanied by a glass of sherry.

In France, where every province produces an important variety of delicious cheese, no meal worthy of the name can end without a tray of several kinds, served before dessert along with the best robust and aromatic red house wine. Some, like Gruyère, take three or four months to ripen, and its quality depends on the regular distribution of its holes. The gourmet will choose the Brie of the day, testing it as if it were a fruit, and Camembert by the smell, which indicates its maturity. This latter cheese was invented by a French peasant woman of the eighteenth century, whose statue rules over the small village of Camembert. My grandfather, who adored that cheese, although his doctor had forbidden him to eat it, bought it on the sly and hid it in his clothes press. Sometimes the odor was so nauseating you couldn't walk into the room.

Dry, strong-flavored cheeses like Parmesan are thought to be the most stimulating, but some of the softer ones, like goat cheese and mozzarella, have an equal reputation in that regard. As for Parmesan and mozzarella, the essential ingredients of a good pizza, this is the moment to recommend them to those of you who long to flaunt posteriors as sensual as those of the damsels painted by Rubens and Botero. At the beginning of the seventies in Chile, I made a brief incursion into the theater world with a pair of musical comedies. One of them, *Los Siete Espejos,* or *The Seven Mirrors,* incorporated a ballet corps of several beautiful fat young women who acted as a Greek chorus, telling the story as they danced and giggled and jiggled. It was the era of Twiggy, that English model who looked like a survivor of a concentration camp and whose picture was splashed across the

covers of all the fashion magazines, she of the toothpick legs and orthopedic shoes and starving expression. By one of those aberrations of history, this twiglet became the decade's feminine ideal; there was no woman alive who didn't aspire to the androgynous wormdom of the famous Twiggy. The fat women in *The Seven Mirrors* were a direct challenge to that aesthetic, a hymn to abundance. I learned from any number of theatergoers that they came to the performance more than once just to applaud the obese chorus girls. These women, who had attained their voluminous proportions thanks to good teeth and a sedentary life, were now skipping dinner and for two hours flitting like dragonflies across the stage. As a result, they began dropping pounds at an alarming rate. The director of the company saved the play from disaster by putting up a sign in the foyer saying: PLEASE DON'T SEND FLOWERS TO OUR CHUBBY CHORINES. ORDER PIZZA.

When you consider that the sole ingredient of cheese is milk, then there can be nothing aphrodisiac about it, but when accompanied by bread, wine, and pleasant conversation, the effect is the same as if there were.

Si Non è Vero . . .

Truffles, a rare delicacy, are actually insignificant mushrooms that pigs and dogs are trained to sniff out and dig up. According to ancient wisdom, abusing them foments melancholy, but they are so rare and so prized, and therefore served in such miserly quantities, that no one is in danger of being poisoned by them; on the other hand, a mere breath of their intense perfume is enough to overcome a surfeit of love and to uplift an appendage that may simply have fainted. Truffles cannot be cultivated; they grow in accord with the mysterious vegetal laws that determine size, color, and fragrance. Every day there are fewer woodland terrains sympathetic to the existence of truffles, so the price has risen to the levels of that for caviar and gold. (And speaking of gold, did you know that in cities like Hong

Kong you can drink a small espresso coffee containing gold dust? In the Piazza San Marco in Venice, you can pay just as much for an espresso *without* the gold.) Madame du Barry, the Marquis de Sade, and Louis XIV consumed truffles with incontrovertible faith in the effect they wrought in moments of intimacy, and Rasputin prescribed them to the tsar to thicken his blood and strengthen the royal bloodline. A recipe from the time of the Borgias reads: "Take a truffle cleaned of dirt and excrement, soften it by brushing it with fragrant oil, wrap it in a fine ribbon of pig fat, and place it over the fire until, the fat melted away, the truffle exudes its essence."

Napoleon ate truffles before meeting Josephine in their amorous battles in the imperial bedchamber, in which, it is no exaggeration to say, he always wound up defeated. Scientists—however do they come up with these experiments, I wonder?—have discovered that the scent of the truffle activates a gland in the pig that produces the same pheromones present in humans when they are smitten by love. It is a sweaty, garlic-tinged odor that reminds me of the New York subway.

Some years ago, I invited to dinner—with intentions of seduction, naturally—an evasive beau whose reputation as a good cook forced me to outdo myself with the menu. I decided that a truffle omelet sprinkled with a dusting of red caviar at serving time (the gray was beyond my possibilities) constituted an obvious erotic overture, something akin to giving him red roses and the *Kama-sutra*. I searched high and low for truffles, and when finally I located some, my modest salary in a land not my own would not stretch far enough to buy them. The clerk in the delicatessen, an Italian as much an immigrant as I, counseled me to forget the truffles.

"Why don't you use mushrooms instead?" he asked as I disconsolately gazed at those little bits black as rabbit droppings, which to my eyes shone like diamonds.

"It isn't the same. Truffles are aphrodisiacs."

"They're what?"

"Sensual," I said, to avoid going into detail.

I must have blushed, because the man came out from behind the showcase and approached me with a strange smile. He imagined, I suppose, that I was a nymphomaniac hoping to rub my erogenous zones with his truffles.

"Romantic," I murmured, blushing redder and redder.

"Ah! For a man? Your sweetheart? Your husband?"

"Well, yes . . ."

At that instant his smile lost its sarcastic twist and turned complicitous: he stepped behind the counter and produced a small bottle, like a perfume vial.

"Olio d'oliva aromatizato al tartufo bianco," he announced in the tone of someone pulling an ace out of his sleeve. "Olive oil with the scent of white truffles," he clarified.

And immediately he slipped a few black olives into a plastic bag, with the direction to wash them carefully to remove the flavor, chop them into small pieces, and marinate them a couple of hours in the truffle-scented oil.

"As romantic as truffles, and much cheaper!" he assured me.

I did as he said. The omelet was perfect, and when my exquisite beau detected the unmistakable fragrance and asked with surprise whether those inky fragments were indeed truffles and, if so, where the hell I'd found them, I made a vague gesture that he interpreted as flirtatious. He devoured the omelet, constantly casting sideways glances dark with perplexity, an expression that at the time I found irresistible but in fact, seen with the detachment of age, was closer to being comic. I'm really glad I gave him olives. His reputation as a beau was as exaggerated as that of truffles.

And since we are talking about "truffled" olive oil, the moment has come for me to share my "emergency recipe." Since the age of nineteen, I have been married every day of my life except for three months of playing around between a divorce and a second marriage. That means that I have had approximately 16,425 occasions to drive some man mad. The creation

of this soup was a matter not of chance, but of necessity. It is a practically infallible aphrodisiac that I always fix after some terrible fight, a flag of truce that allows me to make peace without humiliating myself too greatly. My opponent has only to smell it to understand the message.

RECONCILIATION SOUP

Preparation

If you can't find fresh mushrooms and must use the dried ones, soak them in ½ cup of good red wine until they spring up happily; in the meantime, while they're soaking, I calmly drink the remainder of the wine. Then I mince the garlic clove for the pure pleasure of smelling my fingers, because I could just as easily use it whole, and then sauté it with all the mushrooms in the olive oil, stirring vigorously for a few minutes—I've never counted, but let's say 5. I add the stock, the port, and the truffled olive oil—not quite all of it, I leave a couple of drops to dab behind my ears; let's not forget, it's aphrodisiac. I season with salt and pepper, and cook over low heat with the lid on until the mushrooms are soft and the house smells like Heaven. The last step is to process it in the blender; this is the least poetic part of the preparation but unavoidable. The soup should end up with a slightly thick texture, like mud, and with a perfume that makes you salivate and awakens other secretions of body and soul. I put on my best dress, paint my fingernails red, and serve the soup, in warmed bowls, garnished with a dollop of sour cream.

Ingredients

½ cup chopped Portobello mushrooms (if dried, ¼ cup)
½ cup chopped porcini mushrooms (if dried, ¼ cup)
1 cup brown mushrooms
1 clove garlic
3 tablespoons olive oil
2 cups stock (beef, chicken, or vegetable)
¼ cup port
1 tablespoon truffled olive oil
Salt and pepper
2 tablespoons sour cream

The Spirit of Wine

Nectar of the gods, consolation of mortals, wine is a marvelous beverage that has the power to drive away worries and to give us, though it be for but an instant, a vision of Paradise. No one can argue the aphrodisiac power of wine: in moderate quantities it dilates the blood vessels, carrying more blood to the genitals and prolonging erection; it lessens inhibitions, relaxes, and fosters joy, three fundamental requirements for good performance, not only in bed but at the piano as well. In my distant youth, I believed that white wines were served during the day and red wines at night. Later someone tried to rescue me from ignorance by offering me his version: white wines are for women and red for men, a heresy capable of felling an oenologist with a fatal stroke. We are talking about an ancient and elaborate art to which countless volumes have been devoted through the centuries; it would be a blasphemy to try to sum them up in a couple of sentences. It has taken me several decades to learn some basic principles; from the beginning, I state my ignorance.

In expensive restaurants, I smell the cork, chew the first sip with an expression of profound concentration, and then return the bottle, complaining of a certain acidity. That always impresses the waiter and earns me a little respect. The truth is that I have a bad head for alcohol and with the second glass I start taking off my clothes and skipping down the street. The theoretical part of this chapter wasn't at all difficult; I sought the counsel of experts and consulted a half dozen books, but the practical part cost me more than one cold. My neighbors think I belong to a euphoric nudist sect.

I always wanted to have a wine cellar. I'm not referring to six bottles in the back of a closet—that I have—but to a cold, dark cellar embroidered with spiderwebs and closed off with a wooden, triple-locked door whose keys hang at my waist, a vault in which bottles of exquisite wines have lain for years. I imagine the ceremony of descending into the belly of the earth with a candle to seek the perfect complement to enhance my dinner with my lover . . . all right, it can just as well be with my husband. We had that tradition in my family. I don't

mean the lovers, I mean the cellar. There was one in my grandparents' home and another in my mother's. Once a year a special trip was undertaken to the famous vineyards of Macul and Concha y Toro to buy wine in fifteen-liter demijohns that were then divided into bottles my mother sealed with melted candle wax and marked with a mysterious code before laying them down in the cellar. There they rested, in darkness and silence; it was rare that one was opened before it was five years old.

That was the everyday wine of my childhood, but for grand occasions a reserve from one of the best Chilean vineyards was chosen. During one of her husband's many diplomatic missions, my mother lived in Turkey. In those days Ankara was not the cosmopolitan city it is today, and many products were difficult to obtain, among them quality wines, but my mother has always had mysterious contacts. A French diplomat revealed to her the best-kept secret of his embassy, something that would horrify a sommelier but that got my mother out of a scrape on more than one occasion: you pour out the neck of a bottle of mediocre red wine and replace it with port, turn the wine over a couple of times, let it rest, then serve it in a crystal carafe. For white wine, proceed in the same manner, using the driest sherry. That good friend added that you always serve the good wines first and bad ones later, when no one notices the difference, as indicated in the Gospel according to Saint John. The first miracle Jesus performs takes place in Cana of Galilee during a wedding he attended with his mother and his disciples. Halfway through the feast, Mary comes to him and says that they've run out of wine, so Jesus commands that six large stone vessels be filled with water, and when the servants draw out the liquid they contain, they discover it is wine. And to prove it, the master of the feast says: "Every man at the beginning sets out the good wine and when the guests have well drunk, then that which is inferior; but you have kept the good wine until now."

Exactly what connoisseurs recommend. At any rate, no one's meaning to set a trap here, only to give some clues with a clear conscience, so let's get down to the meat of the matter, I mean, down to the grape of things.

Recent research indicates that wine drunk with moderation and regularity reduces wear on the heart, thus allowing us to die of cancer. Folklore has always told us that wine dissolves the fat from a meal and washes out the veins, a truism proved by modern medicine: wine elevates the levels of HDL cholesterol and cleans the arteries. In France, where ten times more wine is drunk than in the United States, and where four times more animal

fat and red meat is consumed, blood cholesterol levels are considerably lower than they are here and the incidence of heart attacks one of the lowest in the world after Japan. Besides living better, the French grant themselves the pleasure of living longer. This "discovery"—called the French paradox—has produced a new generation of red-wine drinkers in the United States, but until now the results have not been observable. It may be that it's not only the wine that prolongs health but the way of drinking it; the French eat sitting down, with calm, enjoying each mouthful. Watching a bourgeois couple in a provincial bistro is a most instructive lesson: they dine ritually, in silence, concentrating on their food and drink, unaware of the rest of the universe. Their menu is varied, the portions small, and they do not eat at all hours of the day and night. One key word defines the French paradox: moderation.

Whole volumes are dedicated to a single class of wine, in case you wish to delve deeply into this subject, but here we will have room for only a modicum of general information. All wines are sensual, including what in Chile we call *litreado*, a most humble wine sold in refillable containers and by the cup, and which, being the sole consolation of the poor, has its

equivalent in most parts of the world. The varieties of wines are infinite, determined not only by the regions in which they are produced, the types of the grape, and the process of fermentation, but by the year and even the hour of the harvest. The wood used in making the barrel, the temperature, the humor and love of those who make it, the spirits that wander by night through the caves in which the wine sleeps, all affect the final product.

Wines brings out the flavor of the meal. Choosing the right one for each course is a science and an art; whole computer programs have been created to resolve that doubt in less than a second's time. Taste buds are easily dulled.

It is suggested that no cocktails be served before the meal other than vermouth, champagne, port, or sherry, because otherwise it will be impossible to savor what follows; the wine should be preceded and followed by other children of the grape. Once only European wines—especially French—were acceptable, but today you can unashamedly serve a bottle from California, Chile, South Africa, Australia, and other regions. Rigid rules in regard to which wine to serve with which dish have also been relaxed, and it is no longer obligatory to accompany lamb with a French Bordeaux; you can serve a Spanish Rioja or a Merlot from California. However, an elegant table is still set with as many glasses as wines to be offered, each meticulously chosen for the dish with which it will be served. The ideal is always to serve the white first and then two or three varieties of red, if your guests deserve such largesse. When choosing the reds, it's best that they be from the same type or region, Bordeaux with Bordeaux, for example. If you follow this rule, it is recommended that you pour the youngest wine first, followed by the older one or the better label. Despite the counsel of that diplomat in Turkey, a good French host always reserves the best red for the end of the meal, to be served with the cheeses, before dessert. But take caution when applying these rules during an erotic dinner, because too much indulgence and the impetuous lover will become comatose while still at the table.

We know that you're not an expert; if you were, you wouldn't be reading these pages, and therefore we dare to offer this information. The majority of wines can be classified in five categories: light whites, whites with body, rosés, light reds, and robust reds. The fruits of the sea are served with white wine—oysters always with Chablis—because owing to a chemical reaction that is not worth elaborating on here, when fish and seafood are mixed with red wine they leave a bitter taste. White wine also

enhances the flavor of fowl and of vegetable dishes, which, being delicate, usually cannot stand up to the impact of red wine—although there are exceptions, everything depends upon the sauce. A good example is coq au vin, which is prepared and served with a Burgundy. Red meat goes well with red wine; the trick lies in choosing the appropriate one: the more assertive the dish, the more robust the wine, always keeping in mind the sauce and method of preparation. The mystery lies in finding the balance between beverage and food: mild with mild, light with light, strong with strong, sweet with sweet. Here are a few examples *a grosso modo:*

A light white: *Fish and shellfish.*

A full-bodied white: *Delicate fowl, veal, strongly flavored fish like tuna or salmon, brains and other tender and mild-flavored organ meats.*

A light red: *Lamb, beef, pork, Italian pasta, organs such as kidney, liver, and tripe, wild fowl, and vegetables.*

A robust red: *Game such as deer, boar, hare, and even some birds like wild duck, certain stronger red meats, and assertive stews.*

A full-bodied red wine of highest quality: *Cheese.*

A cold rosé: *Rustic lunches, picnics, light summer suppers.*

Ruin to the taste of most wines: *Spicy dishes, such as curry.*

The typical cuisine of each country demands, logically, to be served with the beverage of the same area: sake, tea, beer, and so on. If you have questions, ask in a liquor shop when you buy your wine. Today there are wine boutiques where an expert can help you select the best bottles for your menu.

Isabel Allende

Liquors

All peoples, including those who for religious reasons are forbidden it, know the medicinal properties of alcohol. Before other antiseptics were known or anesthesia developed, alcohol was used to disinfect wounds and to stun the patient before some painful procedure. Alcohol's worst defect is that converted into a vice it destroys anyone who drinks it, and its greatest virtue is that in moderate quantities it produces the illusion of well-being and sparks a desire for celebration. Again and again we seek the temporary relief of alcohol to escape for a while the anxieties of life. We are not the only ones—there are even animals and birds that purposely become inebriated on fermented fruits. In the summertime bluebirds crash into the windows of my house, dizzy from the small red fruit of a nearby tree. The first alcoholic drink in history was mead, a sweet wine made from honey, drunk in Europe until the eighteenth century. It was the Arabs, with their refined culture, who developed the technique of distillation; they called the spirits of the vine *alkuhul*. Common souls consumed a crude, strong beer; wine, with a greater alcohol content and more delicate flavor, was the luxury of the privileged classes.

In ancient times Bacchus and Dionysus, the Greek and Roman gods of wine, ecstasy, and eroticism, figured prominently in their pantheons; they had their equivalent in nearly all pantheistic mythologies. Orgiastic festivals were celebrated in their honor, during which the masses poured into the street to drink and fornicate without restraint. In the Old Testament, the cities of Sodom and Gomorrah were destroyed as a punishment for their libertine customs: orgies, incest, adultery, and other diversions offensive to God. This is one of the many parts of the Bible I wasn't allowed to read in school. If we judge by the description, it seems that Jehovah, fed up with their clamor and outcry, launched upon their city the equivalent of an atomic attack, but there are other versions that place the responsibility in the lap of Abraham and his armies. Before manifesting his ire, Jehovah sent two angels as messengers to warn Lot, the one just man

172

to be found. The two angels were near to falling into the hands of an inflamed crowd of Sodomites, but Lot managed to protect them by taking them into "the shadow of his roof" and offering the attackers his virgin daughters as a distraction. Talk about an exemplary host! Before God loosed his wrath upon the city, His messengers commanded Lot to escape with his family, never looking back. Lot's wife, overcome by curiosity, or nostalgia, did turn to look and was turned into a pillar of salt. Finally, after many adventures, Lot and his two daughters found asylum in a cave. In view of the fact that there were no other men available to "come in unto us after the manner of all the earth," the girls got Lot drunk and, as they used to say before the invention of the Pill, "took advantage of him." A slightly dysfunctional family, but I suppose that in desperate cases, one doesn't dwell on details.

According to the Bible, Lot's two daughters "lay with" their father for two consecutive nights, without his having been aware of what happened. Both conceived, giving name and origin to the Moabite and Ammonite tribes. This is one of the few times when a man drunk out of his mind has been known to perform such a feat, because too much alcohol makes the male member swoon, producing temporary impotence, and submerges its owner into the dark shadows of melancholy. At such a moment, one always quotes Shakespeare, of course. In *Macbeth,* in answer to a question about the consequences of drink, a second responds: "Marry, sir, nose-painting, sleep and urine. Lechery, sir; it provokes and unprovokes; it provokes desire but it takes away the performance."

In a different section of this book, I'm not sure which, I mention that fresh snake blood and sugar stirred into liquor is a greatly esteemed stimulant in Taiwan and other Asian countries. In China they toss a few baby cockroaches into warm sake and drink it down in a single swallow. According to an issue of the *San Francisco Chronicle* from the end of the last century, Malaysian Chinese immigrants imbibed rattlesnake blood. They opened a slit in the tail, and while one person held the snake by the head and squeezed downward to drain it, the other lay on the ground and sucked the blood between swigs of whiskey. A prodigious aphrodisiac cocktail for those with exotic tastes.

My friend Miki Shima told me that once in the Colorado mountains, at eight thousand feet and in freezing cold, sitting by a campfire in the light of the moon, he was served a menu of elk sausage and raw buffalo liver

marinated in beer, all liberally washed down with a drink called Black Dog, which is a mixture of whiskey, tobacco juice, and gunpowder. With the first swallow of this concoction the cold disappeared; with the second, he recovered the memory of his oldest yearnings; and with the third, just when his brain was about to explode, came fantastic visions of all the beautiful women he had wanted during his lifetime. One of the most terrible battles of the nineteenth-century War of the Pacific, which pitted Chile against Peru and Bolivia, was that of Morro de Arica, an impregnable escarpment that Chilean soldiers conquered by climbing up the cliff face with curved knives clamped between their teeth after, as the legend goes, being drugged with a mixture of whiskey and gunpowder not unlike Black Dog. In some South American prisons, the men get drunk on *pajaro verde,* green bird, a drink made from alcohol and paint thinner, which eventually leads to madness and death.

Like almost everything else in this world, liquors, too, go out of style. In his memoirs, the Spanish film director Luis Buñuel gives his recipe for the perfect martini: allowing a ray of light to pass through the bottle of vermouth and for an instant touch the gin. After the martini, so popular in the sixties and seventies, we went through a decade of white wine, which in the nineties has culminated in the popularity of kirsch. Whatever the vogue, the vessel is nearly as important as the contents. In a paper cup, the finest champagne tastes just like that green punch you drank at high school dances, whereas a mediocre wine in a fine goblet rises in category. It's like women, whose clothes reveal their economic and sometimes, not always, their social class. In certain Tantric ceremonies, *arga,* chalices shaped like vulvae, are employed, but that degree of refinement is not necessary for serving your cocktails. Good crystal will do.

Absinthe, or wormwood *A green liqueur extracted from the plant of the same name (Artemisia absinthium) to which various herbs are added; it has had the reputation for being a powerful aphrodisiac since the time of the Greeks, but it is so toxic that in 1915 it was outlawed in France and then later in other countries. It causes muscular and gastric spasms and if consumed on a regular basis leads to paralysis and death. Absinthe is served with a little water and sugar to cut the bitter taste. In the nineteenth century it was the favorite drink of intellectuals and artists in the Place Pigalle, because it was believed that it convoked the muses. In England, on*

the other hand, it was used in the flagellation clubs, at the time a very popular sport.

Amaretto *Made from the almond, it has a sweet, strong flavor. It is used as a digestive and in cocktails and desserts. Its erotic reputation comes from the almond, the mythological fruit born of the womb of a goddess, as we have earlier pointed out.*

Anise *Popular in France and Spain, this is a transparent liquid that turns milky when mixed with water. The well-known brand Marie Brizard was created in the city of Bordeaux in 1755 by a woman of that name, known for her good heart. They say that she saved a man's life during an epidemic and that in payment he whispered the secret for making the liqueur into her ear. The woman became rich and devoted a large part of her fortune to charitable works. Marie Brizard is still sold in that city. Similar to absinthe in flavor but less toxic, anise is the base of several aphrodisiac liqueurs such as Pernod, Ricard, Pastis, and arak, the national liquor of the Greeks and Turks.*

Benedictine *This name derives from that of its originators, the Benedictine monks of France, themselves chaste, who surely did not suspect that they were contributing another aphrodisiac to the long list of temptations humanity must suffer.*

Calvados *Native to Normandy, this is an apple liqueur, intense and velvety like all good brandy, to which are attributed the same invigorating qualities as the fruit. In the past it was also used as a tonic for staying youthful.*

Champagne *The inarguable queen of wines, indispensable at celebrations. A sparkling white wine from the Champagne region of France, it can be successfully produced elsewhere, but only the authentic wine can be called by that name. In 1806 Barbara Nicole Ponsardin, widow of a banker whose family name was Clicquot, dedicated the fortune she inherited from her deceased husband to developing the champagne produced in his vineyards and celebrated throughout the world under the name Veuve Clicquot. Champagne is always drunk in good company and at moments of celebration, which may be why it acts as an aphrodisiac even when that is not the intent. Sparkling and light, it goes down without a thought, and it is more intoxicating than wine because, thanks to the bubbles, the alcohol enters the bloodstream so rapidly. Champagne is considered a "feminine" wine and is thought to have more erotic effect on women than on men. In the feasts of ancient imperial Rome, baths were filled with bubbling wine, in which naked men and women frothed and frolicked. Champagne made solely with the Chardonnay grape is the driest and most prized.*

Cognac, brandy, and Armagnac *Henry IV of France made this drink stylish as an aphrodisiac; the idea spread rapidly, and soon, as a precaution, gentlemen began having a glass before going to bed, just in case the wife didn't have a headache that night. Thus originated the custom of ending a good dinner with a cigar and glass of cognac or brandy, a ritual in which the women did not share. Brandy beaten with sugar and egg yolks is a formidable tonic for the depression suffered by pregnant woman and blues brought on by rainy days.*

Grand Marnier *A French cognac with the flavor of orange; very similar to Curaçao, a sweet drink made of bitter orange rinds on the Caribbean island of the same name. The Dutch who colonized the island credited the sensuality of its beautiful mulatto women to this liqueur, and exported it to the rest of the world at great profit.*

Kirsch *Made from a cherry base, kirsch is very much in vogue for lending a bouquet to champagne or white wine, the drink of the elegant. The aphrodisiac power of this mixture lies primarily in the festive reputation of the champagne, and surely in the rosy color it gives the cocktail, a treat to the eye.*

Parfaît Amour *A rare lavender-scented liqueur once served in a few refined brothels in France because it was believed that it instantly stimulated the libido. It has gone out of style but still can be found, in case you want to impress your partner some special night.*

Sherry and port *Strong, sweet wines, very popular in Portugal and Spain, served at any time of the day other than with a meal. In the past, the favorites of women because of their delicate texture, but today's women drink vodka and ride motorcycles.*

Vodka *Like many strong liquors—whiskey, gin, pisco, and others—vodka is not particularly aphrodisiac, except in the moderate quantities that relax inhibitions, but we include it on this list because it is the indispensable complement to caviar. Is there anyone who hasn't made love after a preamble of caviar and icy vodka?*

Love Philters

The list of aphrodisiacs is much longer than I imagined when I began these pages, and I'm beginning to be bored by the subject. (With all this thinking about gluttony and lust, I'm afraid I'll become anorexic and frigid.) I have learned, for example, that licorice, which I sucked like sugar candy in my childhood, is loaded with estrogen, and sarsaparilla, which I enjoyed as a soft drink, is heavy on testosterone. Mexican Indians have always used sarsaparilla to restore the carnal ardor of the depressed and despondent. After scoffing at folklore for centuries, today scientists are extracting the male hormone from that native American plant—to what end, I can't imagine, since we already have more than enough testosterone in this world. Stimulants of great renown come in the form of powder, liquid, or capsule, from the popular extract of green oats and famed ginseng, whose unsurpassed efficacy in strengthening the immune system, calming the nerves, and stimulating the hormones is well known in China, to Spanish fly (*Cantharis vesicatoria*), a cockroach species ground to a powder that initially produces an arrogant erection but also mercilessly irritates the urinary tract and can lead to irreversible agony. According to *El Libro de los Venenos, The Book of Poisons,* by Antonio Gamoneda: "Great injury befalls those who take the Spanish Fly, because they will feel a burning corrosion in almost all their body, stretching from the mouth to the bladder, and it will represent in their taste a certain fishy flavor or the astringency of cedar. They will suffer from swoons, surfeit, and lightheadedness, and will fall to the floor and gnaw table legs."

It is told that the Marquis de Sade landed in jail for having given candy laced with Spanish fly to certain ladies of light morals he had invited to one of his orgies. One of them nearly died, and the others, yes, "fell to the floor and gnawed table legs."

Love philters have been known in all cultures since ancient times. My acupuncturist friend, the wise and good Dr. Miki Shima, tells that in the mysterious little shops of San Francisco's or New York's Chinatown you can buy

the famous rhinoceros-horn powder so prized in Asia as an infallible aphrodisiac. That reputation has cost the lives of thousands of those pachyderms, exterminated without a second thought merely for the horn. We are told that this powder is so toxic to the human brain that a pinch is enough to turn one's memory to magma and lead the soul down astral paths, so if you take it and experience no secondary effects, surely you were sold a substitute. Some users ingest it, and others, more reckless, prick their skin and rub in a minute amount, not enough to cause death, but enough that desire spills through their blood and fires the lust of even octogenarians.

This dermal method reminds me of the celebrated case, recorded in the annals of modern medicine, of a man whose joints were so rigid that he was stiff as a statue but who after being attacked by bees and suffering forty-seven bites on his chest was by week's end leaping about and bending up and down with no trace of his former impairment. I have also heard that deformities of the bone can be remedied with bat excrement and wasps' nests, which, I should add in passing, also have aphrodisiac virtues. Rhinoceros-horn powders also facilitate the technique called *kabbazah* (taken from the Arabic word for "clasp"), which some expert women use to lead their lover to Allah's Paradise by squeezing and suctioning contractions of the muscles of their intimate parts. Malicious tongues attributed this rare talent to Diane de Poitiers (1499–1566), with whom King Henry II of France fell madly in love, even though she was twenty years older than he. This wise woman, accepted by all as his official lover, held the place of sovereign until the death of the king, and it is believed that she kept her muscles toned and trained well into advanced age. *Kabbazah* demands nothing of the male, whose role is totally passive. If he is by nature lacking in staying power, pulverized rhinoceros horn will lend it to him.

Love potions are not only hangovers from antiquity, they are a prosperous modern business. I remember that in Venezuela, my friends, some of them professionals who worked with the most sophisticated computers, would slip off to Santería shops to buy good-luck amulets, protection against the evil eye, and elixirs for a variety of sentimental purposes. There are philters to cure excessive jealousy, to detect infidelity, to regain the favor of the indifferent, to soften the resistance of chaste women, to alienate the lover of whom we've tired, and to punish those our heart longs for but who keep us at arm's length. Right in the center of the city, amid the steel-and-glass skyscrapers of great corporations, it is possible to commission a *trabajo,* a

magical fetish, to attract love. With an article of clothing, hair, fingernail clip-pings, or handwriting of the person you want to win, the *brujo* or *bruja* makes a doll, which will then be subjected to various enchantments.

Here we need to concentrate on common plants, however, not exam-ples of sorcery. There are aphrodisiac plants like yohimbine (*Pausinytalia yohimbe*), which is obtained from the bark of a tree in Cameroon and sold in shops specializing in herbs and pornographic appurtenances with the warning that it is poisonous and that an overdose can provoke strong tremors, anguishing hallucinations, and unbearable digestive disorders. Marijuana and hashish, also aphrodisiac, are considered innocuous in many parts of the world but forbidden in others because they mitigate moral judgment, induce laziness, break down inhibitions, and empty the heart of its concerns, symptoms authorities do not look upon with kind eyes. Marijuana was known as a stimulant by all of ancient Europe, from the Greeks to the Vikings, and in a good part of the East, especially China and Arabia, as well as among the Indians of North and South America. Today it is still one of the most widely used drugs, even—perhaps especially—in countries where it is illegal.

Cocaine, another forbidden substance, is an alkaloid derived from the leaves of the coca bush; it, too, excites the imagination and the senses. It is addictive, and when accompanied by loneliness and poverty it has tragic consequences for life. Coca leaves, on the other hand, patiently chewed, help the Indians of the high plains of Bolivia and Peru bear the rigors of their fates and the hunger of five centuries.

In Tantric rites in India they used a mixture of hashish, honey, and amber-gris. This cult, whose followers have been persecuted for more than two thousand years, predates Hinduism and is related to yoga in that both place an emphasis on breathing and asanas, but Tantra also explores the possibilities of eroticism as a path to illumination. The idea is to transform the libido into spiritual energy. From the point of view of a grandmother who still has not renounced the sins of lust and fantasy, one of the more interesting aspects of the practice is the variety of Tantric exercises intended to prolong the tension before the man reaches climax, thus guaranteeing the woman's pleasure and a unified orgasm. Sad that there is such a sparse number of Tantric initiates on these shores . . . Oh, well, nothing to be gained in regrets, better to do as Aesop's fox did when he couldn't reach the grapes, and say that since they were green he wasn't interested in them anyway.

My experience with this mode of sensuality is limited to an incident involving a pair of gloves. Once, many years ago, I needed to buy gloves because it was such a cold autumn in Venice. I went into a shop about as wide as a closet where in a glass showcase there was a display of the most beautifully made gloves. The clerk—or maybe he was the owner—was a prim little man who affected a magician's mustache and a dark three-piece suit. He took my hands in his as if he were holding a wounded dove and with such amorous care that I felt a shiver run down my spine and all my body hair stand on end. A wave of sweetish cologne wafted into my nostrils as he bent over my hands. I thought he was going to kiss them and had an instant's panic, but instead he limited himself to inspecting them closely, for a long time, as if he were studying a diamond. Then he turned my hands over so that the backs rested in his palms, which were dry and very warm, like fresh baked loaves of bread. With unbearable lightness and deliberation, his index finger followed the lines of my destiny, brushed the tips of my fingers, traced circles of fire around my wrists. Blood was pounding in my temples, and he obviously knew that, because he could feel it pulsing in the veins at my wrists. He raised his eyes and looked at me without smiling. We both knew; I think we stopped breathing for an eternal moment, until I couldn't stand it any longer and turned my face away, embarrassed. He murmured something in Italian that to my ears sounded like a declaration of love, but it may have been the price of the gloves. Finally, reluctantly, he released my hands to go to a drawer and pull out a pair of sepia-colored chamois gloves as soft as a squirrel's belly. And then, with infinite concentration, he began to fit them on my hand, finger by finger, looking into my eyes, pausing at each joint, panting, his lips moist. I was twenty-three years old, and that man must have been at least sixty, but our ages were erased and we both entered the eternal limbo of illusory lovers.

That happened thirty years ago, yet I still remember with absolute precision the feelings I lived in those moments. I have never forgotten either the exact hue of the gloves, the floral scent of his cologne, or the perverse softness of his hands caressing mine—least of all, my terrible excitement. Ever since that time I have regarded my hands with affection because I see them through the eyes of that Italian glove salesman. That, I believe, is Tantra.

There are countless plants whose effects are based more in magic than in science, such as the tenebrous root of the mandrake. That is one of the

most common ingredients in the love philters of the Middle Ages and Renaissance. It had to be picked at the foot of the gallows, where it had been sown by the sperm of men hanged or tortured on the wheel. It was said that when touched by the knife's blade, the mandrake cried out, and that anyone who heard that wail would lose his senses for the rest of his days. In his comedy *La Mandragola,* Machiavelli used the myths about this diabolical plant to develop his thesis: "The origin of movement and of change in earthly things begins in the appetites and the passions."

The plot is classic: an old man married to a young woman wants heirs, and a young Don Juan makes use of that desire to cuckold the husband and seduce the wife. The youth convinces the old man that the mandrake, rooted up at night by a black dog, will assure his wife's fertility, for it was known to have worked in the case of an unidentified queen of France. He warns him, however, about the powerful poison of the mandrake: he who first has sexual congress with the woman who takes it will die within a week. So the husband agreed that his wife should lie first with the young man, disguised as a vagabond, so that *he* will be the one to absorb the plant's poison and thus spare the old man's life. *The end justifies the means,* concludes this great Florentine of the Renaissance. Everyone ends up happy: the old man is unaware he has been tricked, the woman discovers pleasure, and the lying young gallant achieves his goal.

Most erotic stimulants in popular use are sold without a medical pre- scription and are legal, despite the fact that some, such as Spanish fly, pose grave dangers. I suppose that in desperate cases a few tablespoons of gin- seng in your soup, or the contents of a couple of capsules of Chinese herbs on your salad, can do no harm. Very few people die from the effects of nat- ural medicines.

> *Fillet of a fenny snake,*
> *In the caldron boil and bake;*
> *Eye of newt, and toe of frog,*
> *Wool of bat, and tongue of dog,*
> *Adder's fork, and blind-worm's sting,*
> *Lizard's leg, and howlet's wing;*
> *For a charm of powerful trouble,*
> *Like a hell-broth boil and bubble.*

. .

Scale of dragon, tooth of wolf,
Witches' mummy, maw and gulf
Of the ravined salt-sea shark,
Root of hemlock digged i' th' dark,
Liver of blaspheming Jew,
Gall of goat, and slips of yew
Slivered in the moon's eclipse,
Nose of Turk, and Tartar's lips,
Finger of birth-strangled babe,
Ditch-delivered by a drab,
Make the gruel thick and slab.
Add thereto a tiger's chaudron,
For th' ingredience of our caldron.
—William Shakespeare, *Macbeth*

The Language of Flowers

In the past, flowers, among their many enchantments, had the task of transmitting subtle amorous messages, but in all the haste of the twentieth century this art has become a dead language. I don't see any advantage to reviving it. It's like Sanskrit: there's no one to speak it with. But just in case the reader of these pages is given to moments of madness, I'm going to devote a few paragraphs to the language of flowers. My experience is that in the Western world it doesn't pay to invest too much effort in details as delicate as these, because most of the time they are totally ignored. Drastic methods yield better results.

The symbolism of flowers reached its apogee in the midnineteenth century during the reign of Queen Victoria in England, although it wasn't

there the language originated but in Turkey, where it was used to send coded love notes within the harem. Lady Mary Wortley Montagu, who as the wife of a British ambassador lived in that country from 1716 to 1718, introduced the language of flowers into England. It evolved through several decades until it became a romantic epidemic so sophisticated that by using different combinations in a bouquet it was possible to maintain a long correspondence without a single written word.

Ladies placed great care in the selection of the paper for their notes, because even printed flowers could convey messages. A handkerchief embroidered with pansies was an indication that the lady would never forget her sweetheart, with roses, a promise of love. If the needle masterfully re-created the quince flower, the recipient could consider himself fortunate, because quince indicated lifelong fidelity. Things reached the point that the placement of the ribbon on a bouquet determined whether the sentiments expressed referred to the giver or the receiver, and the hand with which flowers were presented or accepted affected their meaning, as did the place on her body the woman chose to wear the offering: the nearer the heart, the more accessible she was to love. Thence the tradition of giving a corsage before a dance; the lady selects the place she wants to

pin them, whether at hip, waist, hair, or bosom. Any way you look at it, it's an abominable custom; no dress ever looked good with all that rubbish attached to it.

If flowers were handed or accepted with the blossoms pointing down-ward and the stems up, their meaning was completely reversed. So if a swain came to call carrying a bouquet of tulips with a bow on the left, which was tantamount to a declaration of love, and the lady handed them back with the heads upside down, that meant there was no shred of hope for the suitor; his rejection was final. The interpretation was not that dra-matic in every case; it depended on the variety of the flowers. Anemones, for example, represented forgetfulness, but a bouquet presented with the flowers pointing down did not translate as nostalgia, and a hyacinth, which from the time of Greek mythology spoke of sorrow, or a calendula, which also embodies suffering, did not turn into an expression of joy.

No one has time for such complexities nowadays, and we have to imagine that if you've progressed to the stage of cooking aphrodisiac dishes for your date, it won't matter with what hand he gives you the red rose or where you decide to pin the camellia. A few basics are more than enough: the color red proclaims passion; white, purity; pink, tender-ness; yellow, forgetfulness; purple, modesty (although now feminists claim that color). To a Victorian it would have been maladroit to give yel-low flowers to someone you wanted to win, but today flowers are so expensive that we appreciate the gesture without dwelling on such details. I still remember with pleasure the last time someone brought me a flower: a thirsty, newspaper-wrapped sunflower in the hands of my five-year-old grandson.

Wild daisies, from which we plucked the leaves when I was young to find out whether the redhead on the corner loved us, symbolize inno-cence. Once it was believed that a libation brewed from these humble flowers and drunk with regularity could assuage the pain of madness and reintegrate dispersed spirits. The narcissus is, logically, the flower of vanity and egotism. Its name derives from the Greek legend of Narcissus, a shep-herd in love with his own reflection in a pool, who died trying to kiss that image. Besides conceited, not too bright. The poppy—opium flower—expresses surcease from sorrow, temporal pleasure, and relief from short-ness of breath, but for the English, because of its color, it also symbolizes the blood of soldiers fallen in war. Geraniums, which rarely are included in

a bouquet because of their sharp odor, are by their color a representation of sadness, disillusion, consolation, and other rather useless sentiments.

The heliotrope, whose name in Greek means "with the head turned toward the sun," indicates sincerity and devotion in love; it is given as a promise or allegation of fidelity should one have been detected in a compromising situation. Lilies predict a message. This is an interesting flower; in some cultures of the Mideast and Mediterranean it is associated, because of its shape, with the female genitals, as is true of the orchid as well, but the lily is also the flower of purity, the Virgin Mary's flower, and, not least, the emblem of France, the fleur-de-lis. The flower of the lavender signifies distrust. The perfumes of violets and jasmines have such high aphrodisiac qualities—especially at night—that they can turn the most virtuous of maidens into an insatiable nymphomaniac, yet in the language of flowers violets symbolize modesty and jasmine represents elegance, discretion, and grace. The scent of the tuberose is also irresistible to women, although nauseating to most men. Lilacs connote humility, but ever since the Renaissance these flowers have been credited with the ability to excite men. I had them in my garden for years and never knew that because of them the postman harbored lustful intentions. To the Victorians, incapable of confessing thoughts of passion in the presence of a lady, lilacs also stood for the first move toward professing their love; they were a way of testing the water before making a more explicit declaration, which might consist of a bouquet of white roses—purity—followed immediately by another of red roses—love. Never together, because that would mean separation and death, as in the fate of Tristan and Isolde or Romeo and Juliet. Finally, after formalizing the betrothal, if the suitor was very bold he might offer his fiancée branches of the flowering almond to express his sublime passion without beating about the bush—almond or any other.

According to the classic language of flowers, the forget-me-not meant true love and remembrance. An Austrian legend tells the story of two lovers who were walking along the Danube when the girl, who always had her way, saw a small blue flower floating in the water and nothing would do but that her young man get it for her. He leaped into the river at her bidding but was caught in the current and pulled under. With his last burst of strength, he reached the flower and tossed it to his sweetheart, calling, "Forget me not." For me, nevertheless, this small blue blossom will always be the symbol of exile. When it became my fate to leave my country following the mil-

itary coup of 1973, I was able to take very few things with me. My grandfather, my mother-in-law—whom I loved with rare devotion—my friends, my family, and the incomparable landscape of my homeland were all left behind in Chile. As for Lot's wife when she was fleeing Sodom, the rule was not to look back, but who can leave the house where her children were born without one last look? I didn't as yet know that I was cutting off my roots with a brutal slash, that little by little I would dry up like a mutilated tree, and that only the unrelenting exercise of memory would keep me, again like Lot's wife, from turning into a pillar of salt. In the bottom of my suitcase I carried a little bag containing dirt from my garden, intending to plant forget-me-nots in that unknown country where I was to begin a new destiny. Forget me not, pleads the one who is leaving. Which explains why I chose that delicate flower to symbolize my exile—for its name alone. But the flower did not thrive in the exuberant climate of the Caribbean, and gradually, at the same pace that my nostalgia grew, it died.

From the Earth with Love

In ancient Greece the statue of the god Priapus, son of Aphrodite, stood erect—literally—in every garden as custodian of fertility and agriculture and as protector against thieves. The representation of the deity was often reduced, more accurately, expanded, into the shape of an energetic phallus, called *olisbokolice*. Today very few people can give themselves the luxury of growing their own vegetables, and neither is there humor or space for a scandalous god in the garden, even though in the embers of our collective memory the success of the harvests is still intimately linked with human eroticism and fertility. The cult has been lost in history, but even today in some Mediterranean villages the men wear phallic amulets around their neck to guard against the evil eye.

The taste, the nutrients, and the aphrodisiac power of vegetables and

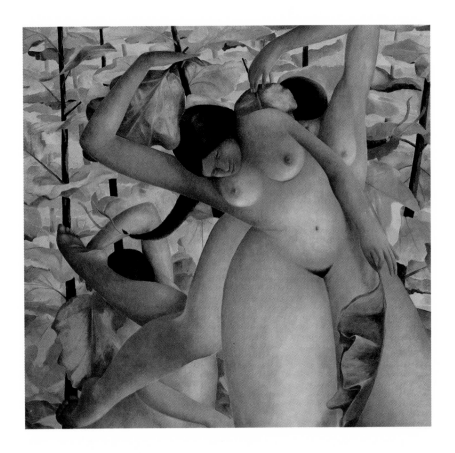

grains are directly related to their freshness. (I can't say that sexual attrac-
tion in humans depends on *their* freshness, because that would be politi-
cally incorrect. As this century nears its end, it is expected that we will be
sensual whatever our age—How exhausting! my mother would say.)
Returning to our vegetables, the ideal is to rip them from the earth and
run directly with them to the pan, but for most of us, urban creatures that
we are, that is no longer possible. The modern tendency is to buy in quan-
tity and keep perishable products crammed into the refrigerator, a justifi-
able method when trying to feed a family, but it seems probable that if you
are interested in erotic cuisine, it's because your children have flown the
nest, you still are not caring for grandparents, and you enjoy enough peace
of mind to take pleasure in the ingredients of your cooking. No Italian
mamma would use a shriveled zucchini or wrinkled tomato. Imagine what
her neighbors would say! We suggest you imitate those indefatigable

matrons when it comes to your aphrodisiac recipes. Buy fresh vegetables in the market, and choose them with care to be sure they are at their peak. If you can't find what you're looking for, don't fall into the temptation of substituting something from a can; better to change the menu.

In the game of food and erotic play, the most desirable shapes, for obvious reasons, are phallic and rounded: carrots and peaches; fleshy, moist textures, like tomatoes and avocados; the sensual colors of skin and the most personal orifices, pomegranates and strawberries; and lingering scents like mangos or garlic. Many edible plants used and abused in erotic literature owe their reputation as aphrodisiacs to their appearance. I've read a dozen stories about schoolgirls and young nuns sinning with cucumbers. I'm surprised they haven't been forbidden by religious decree, a precautionary measure the sultans of Arabia imposed on their harems. Men don't like to be compared. Other vegetables recall female forms, round and smooth like breasts and hips. No one who has lived to adulthood and has held a fresh tomato in the palm of his hand and bitten into it, feeling its flesh in his mouth as juice streams down his chin, can escape the temptation to compare it with other oral pleasures.

Robert Shekter is one of those immovable vegetarians, but at least he isn't motivated by puritanical rigor. Robert treats veggies with the passionate devotion others feel for oysters. I have seen him bite a humble carrot with all the appetite of a legendary glutton, and I know that in times of necessity, when Annette, the woman of his erotic dreams, comes to visit, he prepares with his own hands an authentic French ratatouille, one of the most stimulating vegetable recipes in the universal culinary repertoire.

SHEKTER'S VEGETARIAN APHRODISIAC

Robert takes eggplants (4 for each of the other components), onions, peppers, tomatoes, garlic, coriander, parsley, sweet basil, bay leaf, cayenne pepper, salt and pepper, slices the vegetables with all the finesse his arthritic fingers allow, fries the eggplant in olive oil for 5 minutes as he hums "O Sole Mio," adds the other ingredients, covers the casserole with a lid, and cooks it for 1 hour over a very low heat. While it's cooking, he showers, puts on his best shirt, and welcomes Annette with a rose between his teeth. Then he lifts the lid, stirs well, and lets his infallible ratatouille sit for 10 minutes before charming her with it. It is also delicious served cold the following morning, for restoring spent energies.

Subjective List of Aphrodisiac Vegetables

I apologize for errors and omissions in this list. After consulting a number of volumes, I concluded that there is no accord in regard to the stimulating power of vegetables and grains. Bad news for vegetarians.

Artichoke *Of a person who goes from love affair to love affair it is said that he (or she) has a "heart like an artichoke," scattering leaves right and left. This vegetable is eaten with the fingers, slowly; there is something ritualistic about the process of stripping the artichoke, removing its leaves one by one to dip them in a dressing of oil, lemon, salt, and pepper and share them with your lover.*

Asparagus *Those with thick stems, pale color, and a tip somewhere between rose and purple are the most aphrodisiac. They look like anemic phalluses. Green asparagus is the most popular but the least erotic-looking. In Sheikh Nefzawi's* The Perfumed Garden *we find several recipes for reviving the enthusiasm of the exhausted lover: "He who boils asparagus and then fries them in fat, adding egg yolks and powdered condiments, and eats this dish daily, will see his desire and his powers considerably fortified."*

The best thing about this vegetable is its simplicity: from the pot straight to the lovers' mouths. It must be firm. No one likes his spear wilted. To achieve that it is a good idea to cook your asparagus with the tips up; that way the stems, which are tougher, are cooked longer and the tips remain crisp. You eat them, naturally, with your fingers, slathered with salted melted butter. Could anyone miss the metaphor?

Bean *To Teutons and Romans the bean was a stimulant and its flower symbolized sexual pleasure. Bean soup had such a high reputation for being erotic that in the seventeenth century beans were banned from the Convent of Saint Jerome in order to prevent inopportune excitation, but since nuns have discarded the habit, that reputation has been lost.*

Carrot *This root, vulgarly called "widow's consolation," began to be cultivated in Europe during the sixteenth century and was brought to America by the first English colonists. Because of its vitamin A content and its shape, it is ascribed the power to feed sexual appetites, but to tell the truth I don't know anyone who gets excited over a carrot (strictly in terms of consumption, of course).*

Celery *Madame Pompadour invented a celery soup to inflame Louis XV when the fires of passion had cooled to dismal ashes, but in fact its good name as an aphrodisiac dates from the time of the Greeks and Romans.*

Corn *Sacred plant of the Indians of America, it symbolizes fertility and abundance. The poorer the indigenous peoples, the more extraordinary their culinary creativeness in ways to use these kernels.*

Cucumber *The only thing erotic about it would seem to be its shape. Its virtues are questionable; while in some regions it is considered a stimulant, in others it is regarded as having the opposite effect.*

Eggplant *Thought to be a native of India that arrived in Europe with the incursion of the Arabs into Spain. Classed as a stimulant, especially when combined with other erotic ingredients such as garlic, onion, pepper, and various spices. In Turkey there is a classic recipe called* imam bayildi, *whose origins go back to an imam, who swooned with pleasure when his concubine served him this dish. We like to think that he recovered from his faint with renewed vigor. In Bali, on the other hand, men don't eat it because they believe it kills desire, proof enough that eroticism depends more on illusion and faith than on physiology.*

Endive, escarole, lettuce *In some European texts all varieties of lettuce are listed as stimulants. In other regions, however, an infusion brewed from lettuce leaves is calming and* antiaphrodisiac.

Garbanzo *In* The Perfumed Garden *the young Abu El Heidja fulfills the Herculean task of deflowering eighty virgins in a single night, all thanks to the boost received from a succulent dinner of garbanzos, meat, onions, and camel milk. I have to doubt this story; there never were that many available virgins. Except for the camel milk, these are some of the same ingredients contained in Carmen Balcells's famous Catalan soup.*

Garlic *Essential for the kitchen. It is thought to be sacred, erotic, medicinal, and restorative and was for that reason given to athletes during the Olympic Games in Greece. So many curative properties are credited to it—even in cases of cancer—that it is sold in capsules for those who can't abide the taste. Garlic has been used as an aphrodisiac from time immemorial, and the one condition in using it is that, as with onion, both lovers eat it, because you can smell it even on the skin. I don't mind it; to the contrary,*

nothing excites me as much as garlic in the hands of a man who cooks. (And by the way, today it is known that the chemical substance that causes garlic's odor is also present in a woman's sexual secretions.)

Leek In ancient Rome and Greece leeks were imputed to have aphrodisiac value, possibly for their resemblance to the phallus. The emperor Nero ate leek soup every day to improve his voice, but there is no solid evidence that it had the least effect.

Mushroom Because of its look, color, and scent, it is reminiscent of the head of an atrophied penis—oh, very atrophied indeed. The simpler its preparation, the more intense the flavor. All you need do is sauté it in a little olive oil with garlic, pepper, salt, and a few tablespoons of wine, and then serve it on toast as a preamble to an impromptu assignation. There's not always time for a Pharaonic production. (See our recipe for Reconciliation Soup, page 166.)

Onion Fundamental in all kitchens, from the most erotic to the most chaste. A native of Asia. Chaldeans, Egyptians, Romans, Greeks, and Arabs all considered it aphrodisiac before Europeans ever knew of its existence. Sheik Nefzawi assures us in The Perfumed Garden, written in the sixteenth century, that after Abu el Heiloukh ate onions, his member remained erect for thirty uninterrupted days.

Pepper and/or chili Universally considered aphrodisiac, especially the hot red pepper rich in the alkaloid capsiacina. The flavor and name varies from one region to another, but under any name the pepper is a fiery component of all those exotic dishes that leave your mouth aflame and your imagination and appetite for love roundly stimulated.

Rice A symbol of fertility. When with greatest innocence we throw rice at the bride and groom as they leave the church, few people know that the gesture represents the ejaculation of semen. Just as well. In regard to the aphrodisiac properties of rice, Robert, Panchita, and I have held discussions as Byzantine as those debating how many angels can dance on the head of a pin. Some of us argue that it is impossible to excite anyone with a bowl of rice, but my mother maintains that the best proof of the efficacy of this grain is the overpopulation of China.

Spinach Native to Persia, rich in vitamins and minerals, it strengthens the body and the longing to make love.

Tomato Native to America, the tomato should be catalogued among the fruits. The Spanish took it back to Europe under the names "Peruvian apple" and "love apple." The red, juicy, sensual flesh created a scandal; so much credence was

given to its powers that fortunes were paid for a single tomato. Virtuous
women refused to eat it, but not their counterparts, who could then blame
their peccadilloes on the irresistible tomato.

Truffle Called "testicle of the earth," this fungus has an intense scent and flavor
and for that reason is used in small quantities. Of proven reputation as an
aphrodisiac, it is indispensable in traditional French cuisine, especially in
foie gras and in the preparation of certain meats and fowl.

Turnip It can be said that along with onion and garlic, the turnip is the aphrodisiac
of the poor. This humble vegetable is an excellent source of sustenance.

Watercress Small leaves—innocuous in appearance and somewhat sharp in
taste—the Romans called "shameless" for their supposed stimulating val-
ues. They grow near stagnant water, which is why it is recommended that
they be washed thoroughly before being included in your salad.

Wheat The oldest and most loyal form of human nourishment; like rice, it represents
fertility. The shape of the wheat head is considered phallic, which proves that
human imagination knows no limits. Long, long ago, loaves of bread were
baked in the shape of genitals for Dionysian ceremonies. Not a bad idea at all.

Colomba in Nature

And now that we're on the subject of bucolic plants, there comes to mind the
true story of a friend of mine whose name I will not mention, because if I did,
she'd kill me. Let's say that she's called Colomba. She was at the time of the
incident a rosy-cheeked girl with voluminous pink, freckled flesh and long hair
of that reddish tint that Titian made fashionable during the Renaissance and
today you buy in a bottle. Her delicate, nymphlike feet could barely sustain the
stout columns of her legs, her tumultuous buttocks, the perfect melons of her
breasts, her neck with its sensual double chins, and her round Valkyrie arms.
As often happens in such cases, my plump friend was a vegetarian. (Because
they spurn meat, these people fill up on carbohydrates.)

Colomba had an art professor at the university who couldn't keep his eyes off her, maddened by her milky skin, her Venetian hair, her billowing flesh, the dimples that peered from beneath her sleeves and others that he imagined in the torment of sleepless nights lying in the matrimonial bed he shared with his tall, dried-up wife, one of those distinguished women whose clothes always drape gracefully over their bones. (I hate them.) The poor man enlisted all his knowledge in the cause of his obsession and spoke so often to Colomba of Rubens's *Rape of the Sabine Women*, Rodin's *The Kiss*, Picasso's *Lovers*, and Renoir's *After the Bath*, read so many chapters of *Lady Chatterley's Lover* aloud to her, and placed so many boxes of candy in her lap, that finally she, a woman, after all, accepted his invitation for a pastoral picnic. Could there be anything more innocent? Ah! But the professor wasn't a person to let an opportunity like that slip by him.

He laid his plans with all the cunning of a Machiavelli. He deduced that Colomba would never agree to go to a hotel on their first meeting, and there might never be a second: he would have to play his cards in one masterful stroke. All he had at his command was a Deux Chevaux, one of those painted tin cans that France made fashionable among the middle class in the sixties, a vehicle that was a cross between a biscuit tin and a wheelchair, in which only a contortionist dwarf could make love. To seduce a person of Colomba's size in a car that size was out of the question. So a picnic offered a solution that was romantic and practical at the same time.

The professor's strategy was to attack his student's defenses at the weakest point: her gluttony. Using a thousand pretexts and circumlocutions, he collected a list of his beloved's favorite foods and, not allowing her vegetarianism to stand in the way, he filled a beautiful basket with aphrodisiac delicacies: two bottles of the best rosé wine, well chilled; hard-boiled eggs, French bread, a mushroom quiche, celery and avocado salad, cooked artichokes, tender roast corn, aromatic fruits of the season, and an assortment of sweets. As reinforcement, should he have to resort to extreme measures, he carried a small tin of beluga caviar that had cost him two weeks' salary, a bottle of chestnuts in heavy syrup, and two joints. A meticulous man—being a Virgo—he also brought a pillow, a blanket, and insect repellent.

On a corner of the Plaza de los Libertadores, Colomba awaited, dressed in filmy white and crowned by an Italian straw hat with a wide silk ribbon. From afar, she looked like a vessel under full sail—actually she looked the same when one got close. When he saw her, the professor felt

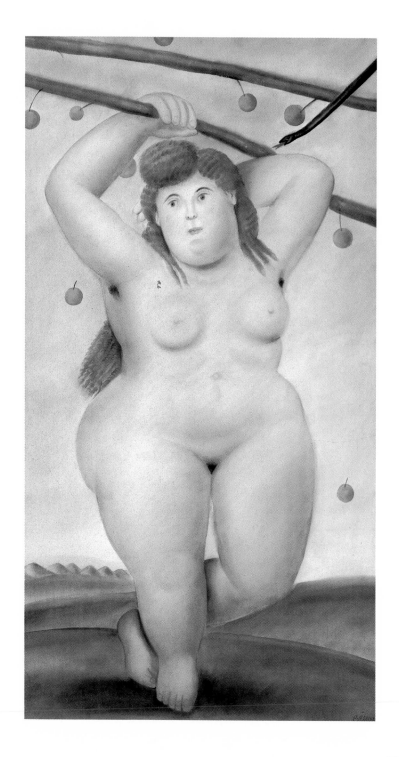

the weight of years, the memory of his distinguished wife, his fear of dire consequences all melt away; nothing in this world existed but that delicious flesh swathed in virginal voile that trembled with every movement, triggering a savage surge of lust that came from where he could not imagine. He was an academic, a man of letters, a student of art, a husband, and, not least by any means, a theoretician! Of raw lust he knew nothing, until then.

Colomba squeezed herself into the fragile, perilously tilting Deux Chevaux, which for a moment seemed in danger of being forever embedded in the asphalt, but after a brief bucking and swaying, the noble conveyance started off in the direction of the city outskirts. Along the way they spoke of art and food—more the latter than the former. And so, made giddy by their conversation and the splendid morning, they finally reached the spot the professor had earlier selected, a beautiful, lush green pasture beside a small stream bordered with weeping willows. It was a solitary nook, with no one to witness their love games but the birds in the branches of the willows and a placid cow munching on flowers at some distance away. The professor leaped from the automobile, and Colomba, with more difficulty, also alighted. While he diligently busied himself spreading out the blanket in the shade, fluffing the pillow, and displaying the treasures of his basket, his student removed her shoes and was taking timid little hops along the bank of the stream. She was a vision of delight.

The professor did not long delay in installing Colomba upon the blanket, half reclining against the pillow, or in arranging before her the mouthwatering contents of the basket. He poured the cool wine to refresh her and peeled a boiled egg, which he then handed her to eat as he twiddled the toes of her plump feet, reciting: "This little piggy bought a little eggy; this little piggy peeled the little eggy; this little piggy said, 'But won't you sup?'; this little piggy said, 'Oh, please beg me!'; and this BIG FAT piggy ate-it-all-up!"

Colomba giggled and shrieked, and the professor, emboldened, proceeded to feed her, one by one, all the leaves of an artichoke, and then after she had eaten both, he purveyed the mushroom quiche, then the strawberries, followed by figs and grapes, all the while teasing her with little touches here and there, and reciting, sweating with impatience, the most impassioned verses of Pablo Neruda's love poems. Colomba's head was whirling from the sun, the wine, the poetry, and one of the joints that the professor had lighted as soon as they finished the last of the caviar under the indifferent gaze of the cow, which by then had moved closer.

That was when the first ants appeared, which the professor had been eagerly awaiting; this was the excuse he needed. He assured Colomba that where there are ants there soon will be bees and mosquitoes but that she had nothing to fear because that was precisely why he had brought the repellent. He did not, naturally, want to stain her exquisite dress with insecticide. Did she by any chance remember the famous Impressionist painting *Le Déjeuner sur l'Herbe?* That picnic where the women were naked and the men clothed? No, Colomba didn't know what he was talking about, so he had to describe it in detail, taking advantage of the telling to undo, one by one, the buttons of that fine voile dress.

Well, to sum things up, let's say that in reasonably short order Colomba was divested of her sails and the sunlight was caressing the liquid hillocks of her voluptuous body. With her fingers she was scooping out sugary chestnuts, unconcerned about the trail of syrup dripping from her chin to her breasts, a trail the professor stared at, undone and panting, until he could not resist an instant longer and leaped upon that mountain of luminous, throbbing flesh, eager to lick the syrup and anything else within reach, tearing off his clothes as if possessed, until he too was naked. Colomba writhed in his grasp, choking with laughter— she had never seen such a skinny and hairy man with such a bold cucumber poking from below his belly button—but she did not part her legs; to the contrary, she defended herself with coquettish nudges that coming from her were more like bumps from an elephant. At last she managed to free herself from the professor's clumsy embrace and run about, teasing and laughing, like those mythological creatures in sylvan glades that are always rioting with fauns. And a faun the professor resembled, trying to overtake her.

In the meanwhile, the cow, which wasn't a cow at all but a bull, decided that he'd had enough hugger-mugger in his meadow and set out at a trot after the two lovers, who when they saw themselves charged by that enormous brute ran like souls pursued by the devil to take cover in the nearby woods.

It was several hours before the bull moved far enough away that the definitely-not-merry picnickers, naked and trembling, could start back. The effects of the marijuana, the wine, the tickling, and the food had evaporated long before. Colomba, hysterical, was shouting insults and threats as the professor, terrified, covering his shriveled pickle with both hands, tried vainly to calm her with lines from the poems of Rubén Darío. They reached

the place where they had set up their picnic to find that someone had stolen all their clothes, and the professor's car as well. Beside the weeping willow, still silvery with chirping little birds, lay the Italian straw hat.

"Eating the World"

I was born with my mouth open . . .
entering this juicy world
of peaches and lemons and ripe sun
and the pink and secret flesh of women,
this world where dinner is in the breath
of the subtle desert,
in the spices of the distant sea
which late at night drift over sleep

I was born somewhere between the brain and the pomegranate,
with a tongue tasting the delicious textures
of hair and hands and eyes;
I was born out of the heart stew,
out of the infinite bed, to walk upon
this infinite earth.

I want to feed you the flowers of ice
on this winter window,
the aroma of many soups,
the scent of sacred candles
that follows me around this cedar house,
I want to feed you the lavender
that lifts up out of certain poems,
and the cinnamon of apples baking,
and the simple joy we see
in the sky when we fall in love.

I want to feed you the pungent soil
where I harvested garlic,
I want to feed you the memories
rising out of the aspen logs
when I split them, and the pinyon smoke
that gathers around the house on a still night,
and the mums left by the kitchen door.
—Excerpted from the poem by James Tipton, 1995

Finally . . .

Appetite and sex are the great motivators of history; they preserve and propagate the species, they provoke wars and songs, they influence religions, law, and art. All of creation is one long uninterrupted cycle of digestion and fertility; everything in life is reduced to a process of organisms devouring one another, reproducing themselves, dying, fertilizing the earth, and being reborn transformed. Blood, semen, sweat, ashes, tears, and the incurable poetic imagination of humanity in search of meaning . . .

After a couple of complete trips around the world of aphrodisiacs, I have discovered that the only thing that truly excites me is love. I fear, however, that in these pages I have given the impression that I'm not a romantic and therefore lack the authority to speak about the delirium of love. Not so. Unfortunately, I'm the kind of person who believes in love at first sight and then carries it a step further and marries. Oscar Wilde said that "love is a mutual misunderstanding." In the fiftieth year of my life, I look back upon my past and, in all fairness, find that I have to agree with Wilde; even so, I have not become a total cynic and still can lose my head over a man (I'm heterosexual but not fanatic) given the right circumstances, such as words whispered into my ear and a good hand at massage.

I have never been judicious about falling in love; love has always struck like a bolt of lighting, leaving me slightly scorched, but experience and good luck have helped me keep the flame of passion burning longer than the six months that flush at first sight normally lasts. Usually I stay with the man of the hour for a respectable period of time. This bent toward long-lasting relationships is not masochism or lack of imagination on my part, but restraint. It's not easy to change mates: you have to invent new strategies for meeting at uncommon hours, buy sexy lingerie to veil your cellulite, be responsible for fueling his erotic fantasies, and other such foolishness. It's a bore, and in most cases not worth the time and effort. Old lovers are comfortable, like your favorite house slippers. At my respectable age, I've discovered the pleasure of being married to house slippers. When your husband and your lover are the same person, you may lose some entertainment value, but you have more time to go to the movies. I like going to the movies . . . and marriage isn't too bad, either.

I fell in love with my present companion for romantic reasons. I'd been chaste for a long time, two or three weeks, as I recall. I married, however, for purely practical reasons: I needed a visa to be able to stay in the United States. It all turned out well. It's easy to share my life with this man who cooks like a professional chef and speaks fluent Spanish (it would be awful to be forced to fight and make love in a foreign language; I would feel ridiculous panting in English). Vehement passion seems to be my natural state, but very soon the poor devil trapped in the relationship may turn pale and begin to lose weight. That is one of the reasons why I became interested in the subject of aphrodisiacs; I had the hope that with the proper diet my husband would survive me with full vigor and good health. Every day for a year now—the length of time I've spent writing these pages—I have prepared one of the aphrodisiac recipes that follow and tried nearly every erotic practice I have mentioned—except the swing and one or two of the *Kama-sutra* positions that aren't suitable at my age. It has been a happy year, because if eroticism is to flourish, stimulating edibles aren't enough; also essential is an atmosphere where spirits rejoice and there is no place for negative words or melancholy humors.

Greed and lust, which have been the source of so much madness, share a common origin: the survival instinct. The bond between food and sensual pleasure is the first thing we learn at birth. The sensation of the baby clamped to the maternal teat, immersed in its mother's warmth and smell, is purely

erotic and leaves an ineradicable mark on the remainder of that individual's life. From nursing to death, food and sex go hand in hand. In our mature years, when digesting and making love become tasks, the mind pushes away, grumbling, from the table and the bed, although there are some few who are able to reach the last day of a long and fruitful existence with their youthful appetite for earthly pleasure intact. Formidable ancients like Abraham, Mao, Picasso, Degas, and Chagall, along with millions of silent grandmothers who because they were women have not been recorded by history, make me wildly envious. Is there a relationship between creativity and eroticism? I hope there is. The deep joy I feel after eating well and making love loving is invariably reflected in my work, as if my body, gratified, destines the best of its energy to lend wings to my writing.

I don't know how it is with men, but with women no aphrodisiac takes effect without the indispensable ingredient of the affection, which, when carried to perfection, becomes love. I hope I am never without it. And that when I can no longer make love—not because of any indifference of my own, but perhaps from the difficulty of finding someone willing to frolic with a great-grandmother—I hope at least to continue enjoying food and memories.

Panchita's
Aphrodisiac Recipes

(With My Commentaries)

My mother is a woman with classic style and a tendency toward moderation. As she created these recipes she had the prudence to test them one by one; for months she agonized over each spoonful of butter and sprig of parsley in her compelling desire to achieve perfection. Then it was up to me to enter them in the computer, and in the process I admit that I made a few changes. Where Panchita wrote three drops of liquor, I put a hearty splash, because in my experience cyanide is the only thing that produces an effect with three drops. Perhaps the problem is generational: in my mother's time, gentlemen reacted to subtle stimuli, but in mine you have to hit them over the head to get their attention. I thought it important to clarify this point because Panchita never had a chance to read the final text. Therefore, any errors that appear are not hers but entirely mine. If one of the recipes doesn't work for you, my patient reader, I would rather my mother didn't know. At her age, she can't take it. Write me, and I will send the humble apologies indicated.

Isabel Allende

Sauces

THE SAUCY WAY TO FOREPLAY

Hands express our intentions:
they caress, comfort, punish, work.
A good hand for making
a sauce is like
a good hand for giving a massage:
a valuable and rare attribute.
Sensual sauces,
the ones the lover treasures in secret
along with the most intimate
and daring caresses,
require imagination.

Every cook knows that you cover errors and doubts beneath a sauce. (If what you're serving is truly repulsive, like octopus, serve it in half light.) A good sauce is fundamental to many recipes, and in your aphrodisiac cuisine it offers an opportunity to use herbs, spices, liquors, and other provocative ingredients. Our list is a long one, but don't be afraid; sooner or later you'll find them useful.

My Japanese doctor friend, Miki Shima, often gives me samples of his Asian herbs. When he learned about this book, he was immediately interested and one day came bearing a sack and offered it with one of his courtly bows. It contained bottles with unpronounceable labels, potent aphrodisiacs from Africa, China, India, and other places that evoke mystery, to be added to Panchita's recipes. Before including them in this book, I decided to test them on someone in whom I have confidence. My husband, however, who had agreed to serve as guinea pig for the culinary recipes, did not demonstrate the same enthusiasm for Dr. Shima's remedies. Without mentioning it, at breakfast I managed to slip him a spoonful of *Green Magma* (an extract of green barley and wild rice) and three capsules of Ba Wei Di Huang Wan (cooked rehmannia, dogwood, dioscorea, hoelen, water plantain, processed aconite, cinnamon, and moutan—what the devil all that is, I've no idea), but the next day I couldn't repeat the dose because my husband seemed very agitated; he went around with an unnatural smile, experiencing an inappropriate desire to dance and frolic. He couldn't see the stop lights clearly and twice he levitated a few inches off the ground. I called my acupuncturist sage to ask discreetly if these were symptoms of a sudden madness, but he assured me they weren't. The herbs are entirely safe, he said. In view of Willie's reaction, I haven't included them here, although sometimes I open the capsules and lightly sprinkle the contents over Panchita's sauces and dressings to increase their erotic powers. If I don't overdo it and the sauce is tasty, you can scarcely tell they're there.

It isn't easy to make a sauce for only two people because half of it will be left in the pan or the sieve. That's why the recipes in this chapter are a little more generous than necessary, but anything left over won't be wasted; it can always be used in some sensual game or other. I can think of several, but I imagine you can, too, so I won't waste time in details. Many sauces can be kept in the refrigerator in a covered plastic receptacle, but I prefer them fresh because I love making them. Making a sauce with good ingredients is like making love with an expert. Almost all the senses come

into play: the sauce must be attractive to the eye, like the face of the person you love; tasty as a kiss; smooth as the most intimate parts of the body; and it must have a unique aroma, untransferable, like skin.

Once Panchita suggested a marinade *aux fines herbes* for the Christmas turkey. In the blender she mixed white wine, onion juice, garlic, and a small bunch of herbs. I thought I perceived a certain timidity in her recipe, and when she wasn't looking, I added another handful of herbs and sprinkled in a few powdered seasonings as well. Then I was struck by an unfortunate inspiration: to inject the sauce into all parts of the holiday fowl with a syringe. I did this over the objections of my mother who prefers to marinate her bird in a more traditional way. The result was disastrous: once roasted, the turkey took on a suspicious greenish hue, and no one wanted to try even a taste. The irreverent use of so many spices and herbs also produced a queer odor. I learned that day that the aroma of a sauce should be subtle and well defined; too many ingredients muddy the waters and drown its appeal.

On a different occasion, trying to repeat from memory one of my mother-in-law's recipes for a dessert sauce, I was a little too enthusiastic with the mint extract. The sauce smelled like toothpaste and the flavor completely overpowered the taste of the *Bavarois*. Taste is, after all, the most important thing; the purpose of the sauce is to enhance the delights of other foods, or, as someone has said, to lift the morale of timid dishes, but if the principal ingredient is arrogant, the sauce must limit itself to a modest role and not compete with what it is supposed to augment. Which is what curry and other spicy sauces do; they leave your mouth in flames and you wondering what you're eating. The same rule applies to sweet sauces for desserts and fruits. It's wise to use small quantities and, when possible, not pour the sauce over the dessert but spoon it onto the plate first. Sauces are like fabrics: each has a precise texture. Some are as smooth and fluid as silk (béchamel, velouté), and others resemble linen (pesto) or are thick to the touch like a good English tweed (bolognese, chutney). In modern cuisine, sauces are light, sometimes so light they resemble simple transparent broths; it's no longer a matter of burying the meal beneath an opaque blanket that prevents our recognizing what's beneath it. Obsession with cholesterol has created an irrational panic in regard to butter and cream that threatens to ruin fine cuisine, but in the case of sauces, this paranoia has been beneficial. Instead of fat, new liquors, spices, and herbs are being used that once were sybaritic luxuries but today

can be bought anywhere. There are extracts on the market—from canned stocks and thick, creamy soups to a cube of concentrate—that can be used as a base for an original sauce or to enrich the taste of others.

I use them when no one is looking, even in place of salt, but for Panchita, that's cheating. If you are not, however, the kind of person who distills your own liquors, extracts your own essences, and cooks your own stocks, use what's available in the shop without torturing yourself with guilt—there are worse sins.

There are millions of sauces, and you can improve them, change them, and invent your own as soon as you lose your fear of cooking and of your ingredients. So what if you make a mistake? No one is filming your errors.

I invent them in the inspiration of the moment, and I can never repeat them—which is why you won't find mine here. Panchita, who is much more rigorous, has selected her basic sauces and dressings, which are nearly infallible and of multiple uses. With sauces, as with love, you must be guided by intuition and not manuals. Don't be afraid to add or substitute an ingredient or two, but keep the same proportions of oil, flour, liquids, and/or eggs. I'm hoping you aren't obsessive about precision and that you don't depend on kitchen scales but, like most normal people, measure more or less by eye; therefore, the ingredients usually are given in spoonfuls and cups, not grams and ounces. When Panchita says "a pinch," she means the amount you can hold between thumb and index finger or on the tip of a knife. You will find sweet sauces in the section on desserts.

Cold Sauces and Dressings

These recipes will provide generous helpings for two people, and with a little restraint they will do for four. You can't imagine how much the work is simplified with a food processor.

HOMEMADE MAYONNAISE

A basic cold salad dressing. Mayonnaise is sold in all the supermarkets, even nonfat (what can *that* be made of?), but it is much tastier and safer made at home. In the old days it was a trial to prepare; in every family there was someone with "a good hand," and no one else would attempt it. It was thought that if a woman was menstruating, the mayonnaise would curdle, and then you would have to dither over it, trying to restore it with cooked potato. In my grandmother's day, the egg yolks were beaten by hand with a fork the oil added drop by drop, a task that could take a half hour of aerobic exercise; definitely not recommended before an erotic encounter because it puts you in a bad humor. Panchita's method takes only two or three minutes, and the result is equally delicious but much lighter. The first time I made it, I added the oil too rapidly and it curdled; besides that, I splattered it all over the kitchen, ceiling-high. Remember—*slowly*. Now the lids of processors have an opening to facilitate this kind of operation.

Ingredients

1 large egg
½ teaspoon lemon juice
1 teaspoon mustard (optional)
¾ cup oil
½ teaspoon sugar
Salt and pepper to taste

Preparation
Place the egg, lemon juice, and mustard in a food processor or blender and beat on low for 10 seconds. Remove the lid and add 2 tablespoons of the oil and the sugar. Beat another 10 seconds and stir the mixture with a spatula. Then gradually beat in the remaining oil. In 1 minute the mayonnaise will be thick and ready to serve.

Variations
This mayonnaise can be varied by adding 3 tablespoons of canned pimiento or 3 tablespoons of ketchup and 1 tablespoon of whiskey. You may also add 3 tablespoons of minced parsley, or cilantro and tarragon (salsa verde). If you prefer a firmer consistency, add 1 teaspoon of unflavored gelatin dissolved in a very small amount of hot water. Allow to cool before stirring it into the mayonnaise.

TARTAR SAUCE

Ingredients

½ envelope unflavored gelatin
2 tablespoons white wine
1 hard-boiled egg
2 tablespoons pickled pearl
 onions
1 medium pickle
1 tablespoon chopped parsley
1 tablespoon tarragon
¾ cup mayonnaise
1 teaspoon mustard
Salt and cayenne pepper to taste

For cold meats, eggs, and salads.

Preparation

Soak the gelatin in the wine. Mince the hard-boiled egg, pearl onions, and pickle. Add the parsley, tarragon, mayonnaise, and mustard. Check the seasoning and add salt and pepper to taste. Heat the gelatin to dissolve it. Let it cool, add it to the other ingredients, and stir well. The sauce will remain firm and can be used as you wish.

FRENCH DRESSING

To enhance your salads. Can be prepared in your food processor or blender, or vigorously shaken in a bottle with a tight lid.

Preparation

Place all the ingredients in a sealed bottle and shake thoroughly or combine in a blender. Store in the refrigerator until time to serve.

Ingredients

¼ cup olive oil
3 tablespoons tarragon vinegar
1 tablespoon sugar
3 tablespoons lemon and
 orange juice, mixed
½ teaspoon Worcestershire sauce
½ teaspoon mustard
1 pinch ground ginger
Salt to taste

PEBRE

Ingredients

4 chili peppers (jalapeño, for
 example)
¼ cup lemon juice
¼ cup vegetable oil
1 level tablespoon salt
2 tablespoons chopped chives
2 tablespoons chopped cilantro
2 tablespoons chopped parsley
3 tablespoons vinegar

This is a very popular sauce in Chile and other Latin American countries as a complement to meats, fish, and vegetables. You don't want to try it if you're frightened by things spicy.

Preparation

Split open the jalapeño peppers, remove the seeds and veins, and mince by hand. Let marinate for 30 minutes in the lemon juice and salt, then drain. Add all the remaining spices and herbs and the vinegar. Store in a sealed bottle in the refrigerator until time to serve.

GUACAMOLE

This Mexican salsa made from avocados is ever present on the tables of that country. When you have fish left from the previous day, improvise an aphrodisiac dish by adding this sauce, to be served cold. Guacamole can't be kept because it turns dark, so I prepare it shortly before serving. It is also delicious as an hors d'oeuvre with toast triangles, fried potatoes, or tortilla chips.

Ingredients

2 large ripe avocados
1 small white onion, minced
1 jalapeño pepper, minced
2 medium tomatoes, peeled, chopped, seeded, and drained
2 tablespoons olive oil
1 teaspoon Worcestershire sauce
Salt to taste
1 beaten egg yolk
1 tablespoon lemon juice

Preparation

Do not peel the avocados until the last minute. Combine the onion, jalapeño pepper, tomatoes, oil, and Worcestershire sauce. Let the flavors blend for 1 hour. Add salt to taste. Peel the avocados and mash lightly with a fork. Dissolve the egg in the lemon juice. Add the avocados and egg just before serving to prevent the avocado from turning dark. Store in a cool place.

LIGHT DRESSING

For artichokes and asparagus, two green vegetables aphrodisiac not only in their internal properties but in their erotic external appearance—not overlooking the pleasure of eating them with your fingers. Unfortunately, this wonderful smelling and delicious tasting sauce doesn't keep well, so if you have some left from dinner, use it in novel preliminaries to lovemaking; surely no directions are needed for that.

Ingredients

4 ounces cream cheese
2 tablespoons grapefruit juice
1 tablespoon apple vinegar
1 tablespoon minced parsley
1 tablespoon minced mint
1 tablespoon chopped dill
Salt and powdered mustard to taste
1 egg white, stiffly beaten

Preparation

With a whip, beat the cream cheese with the grapefruit juice and vinegar. Add the parsley, mint, and dill. Season with salt and mustard. Add the stiffly beaten egg white just before serving.

TURKISH SAUCE

Ingredients

3 thick slices white bread, crusts removed
1 cup yogurt
1 cup walnuts, ground after brown skins are removed
⅓ cup olive oil
2 cloves garlic, crushed
½ cup chopped parsley
1 tablespoon minced fresh oregano
1 tablespoon chopped sweet basil
Salt and pepper to taste

For cold fowl.

Preparation

Crumble the bread into the yogurt. Place all the ingredients in a blender or food processor and combine well. The sauce should be thick, but if you want it thinner, use more olive oil.

MEDITERRANEAN SAUCE

Preparation

Combine all the ingredients except the jelly, salt, and pepper, and let sit for 2 hours to blend the flavors. Add the red currant jelly and season very lightly with salt and pepper. Stir well and cool before serving.

Ingredients

½ cup mayonnaise
½ cup chopped tomato, drained and seeded
3 tablespoons minced black olives
2 cloves garlic, crushed
1 teaspoon anisette
1 tablespoon tarragon vinegar
1 tablespoon grated onion
1 heaping tablespoon red currant jelly
Salt and pepper to taste

SALSA PICANTE

Ingredients

1 medium onion, minced
1 clove garlic, crushed
½ teaspoon paprika
Cumin to taste
Oregano to taste
½ tablespoon butter
2 slices white bread
1 cup milk
4 drops Tabasco
Salt to taste
⅓ cup vegetable oil
1 cup small shrimp, cooked and peeled
1 tablespoon rum or other non-sweet liquor

Using this sauce, the simplest dishes, such as potato or pasta salad, hard-boiled eggs, and cold fish, can be served with an erotic flourish.

Preparation

Sauté the onion, garlic, paprika, cumin, and oregano in the butter. Soak the bread in the milk for 5 minutes, then add to the onion-garlic mixture. Season with Tabasco and salt. Cook a few minutes, until the mixture thickens. Pass through a sieve or blend in a food processor. Cook over low heat, slowly adding the oil and shrimp. Add the liquor to accentuate the flavor.

HUANCAINA SAUCE

Typical of Bolivia and the Peruvian sierra, this sauce can be used warm or cold over boiled or baked potatoes and garnished with fresh lettuce leaves. It is also good with corn on the cob, hard-boiled eggs, and some white-fleshed fowl.

Ingredients

½ cup ricotta cheese
½ cup goat cheese
1 cup olive oil
3 tablespoons grated onion
2 tablespoons heavy cream
1 teaspoon Tabasco
⅓ cup lemon juice
1 garlic clove, thoroughly crushed
1 teaspoon grated orange zest
1 teaspoon peanut butter
Salt and white pepper to taste

Preparation

Place all the ingredients in a food processor and blend until thoroughly combined.

WALNUT SAUCE

For fowl, fish, and as a seasoning for cold pasta salads.

Ingredients

4 slices white bread, crusts
removed
1 cup Chicken Stock (page 241)
or ½ cube concentrate
1 cup crushed walnuts (nuts are
finer if blanched)
4 tablespoons heavy cream
Salt, pepper, and nutmeg to
taste (add salt with caution if
using concentrated stock)

Preparation

Soak the bread in the stock for 10 minutes and then squeeze dry. Combine with all the other ingredients and blend thoroughly. If the sauce is too thick, add a splash of olive oil.

RAVIGOTE

Excellent for cold meats. Don't be timid—you can use nearly any fresh herb you can find. This is one of the few times that excess is applauded.

Ingredients

1 teaspoon chopped mint
1 teaspoon chopped parsley
1 teaspoon chopped dill
1 teaspoon chopped cilantro
1 teaspoon chopped tarragon
1 teaspoon chopped chervil
1 teaspoon chopped celery
1 teaspoon chopped sweet basil
1 teaspoon chopped watercress
1 tablespoon capers
1 tablespoon lemon juice
1 egg yolk
½ cup olive oil
¼ teaspoon mustard
¼ teaspoon anisette
Salt and pepper to taste

Preparation

Blend all the herbs and capers with the lemon juice and egg yolk in a food processor. Slowly add the olive oil until a green mayonnaise is formed. Add the mustard and season with anisette, salt, and pepper to taste.

SWEET-AND-SOUR SAUCE

This is smoother and more discreet that the typical sweet-and-sour of Chinese cuisine. Serve as an accompaniment to pork and fowl.

Ingredients

2 tablespoons mustard
4 ounces plain yogurt (½ cup)
1 pinch salt
1 tablespoon orange
 marmalade
1 tablespoon cherry jam
1 jigger vodka

Preparation

Mix the mustard into the yogurt. Combine with the salt, marmalade, jam, and liquor. Stir well.

ORANGE WHIRL

This is a lightning-fast way to rescue the day. Hard-boiled eggs, asparagus, artichokes, and other vegetables look ready to grace a party when dressed with this sauce.

Ingredients

1 cup heavy cream
1 teaspoon sugar
1 egg yolk
1 tablespoon onion juice
Juice and grated rind of
 ½ orange
½ teaspoon ginger
Salt and green pepper

Preparation

Beat the cream with the sugar until it thickens. Add the remaining ingredients and stir gently so as not to make the mixture watery. This is excellent on a cooked onion and potato salad.

COSTA BRAVA

For green salads and cold fish.

Ingredients

1 tablespoon olive oil
2 tablespoons heavy cream
½ cup ricotta cheese
¼ cup minced green olives
¼ cup seeded and minced
 cucumber
1 tablespoon grated onion
1 tablespoon chopped mint
1 tablespoon lemon juice
1 pinch grated lemon rind
1 pinch garlic powder
Salt and pepper to taste

Preparation

Combine all the ingredients 30 minutes before serving.

THREE-MINUTE MARINADE

In love and in cooking one should never hurry, but often you don't have time to perform the entire *Kama-sutra*. This quick marinade goes perfectly with pork roast, ham, pork chops, or pork loin before cooking. The combination of ingredients for this sauce sounds loony—like the anchovies with condensed milk my son loved when he was a child—but I promise you, it's delicious.

Ingredients

½ teaspoon powdered mustard
½ cup plain yogurt
1 tablespoon grapefruit or
 lemon juice
1 tablespoon apricot preserves
1 jigger vodka

Preparation

Dissolve the mustard in the yogurt. Combine with the lemon juice, preserves, and liquor. Stir well. Nothing easier!

SALSA VERDE

For cold pasta salad, fish, cold meats, and cold cuts.

Ingredients

3 hard-boiled egg yolks
4 tablespoons olive oil
½ cup plain yogurt
1 cup cooked spinach
2 tablespoons balsamic vinegar
1 clove garlic, crushed
1 cup chopped mixed fresh
 herbs, such as tarragon, dill,
 borage, and chives
1 pinch nutmeg (preferably
 freshly ground, but if
 unavailable, powdered will do)
Powdered mustard, salt, and
 pepper to taste

Preparation

Mash the hard-boiled egg yolks with a fork or, even better, in a food processor. Add the oil, yogurt, and spinach. Add the vinegar, garlic, and herbs. Season with the nutmeg, mustard, salt, and pepper. If the sauce is too thick, it can be thinned with a little of the water in which the spinach was cooked.

EROTIC DRESSING

We've already said that eggs are aphrodisiac, remember? Here we have a sauce that abuses them. In some instances this dressing can be used in place of mayonnaise.

Ingredients

2 hard-boiled eggs
½ cup mayonnaise
2 tablespoons olive oil
1 tablespoon balsamic vinegar
1 teaspoon minced fresh
 tarragon
1 teaspoon lemon juice
1 tablespoon minced chives
1 pinch paprika or 1 teaspoon
 mustard
Salt to taste

Preparation

Mash the eggs with a fork. Mix well with the mayonnaise and all the other ingredients, and forget about cholesterol!

Sauces Served Hot

There are sauces served hot and sauces served cold, although the former may be used when lukewarm and the latter at room temperature. Again like love, extremes are dangerous. This flexibility frees up precious time because it allows you to prepare your sauce a little in advance, waiting discreetly in its uncovered pan. (If you cover it when it's still hot, the steam that builds up will make it watery.) The general rule in preparing sauces is to cook them over very low heat, stirring constantly with a wooden spoon and with the same affectionate tenacity that characterizes lovers' caresses. If you are careless and let lumps form, strain the sauce or pop it through the blender. If it begins to separate or curdle, you can rescue it with a few tablespoons of whipped cream. And if it's curdled beyond redemption, throw it in the garbage and start over. If cream or cheese is called for, add them at the end, and to be sure they don't come to a boil, it's essential that you cook the sauce in a double boiler. Fresh herbs can be tied in a garni so they can be removed more easily. The recipes are calculated to serve four or five.

BÉCHAMEL SAUCE

Also called white sauce, this formidable French invention is the base for numerous warm sauces. Resign yourself: you have to learn how to make it. All kinds of things may be added to the basic sauce: spices (pepper, ginger, nutmeg, cayenne, and curry, among others); fresh chopped herbs (thyme, parsley, rosemary, tarragon, lemon balm), which you add at the end so they don't lose their bouquet; a spoonful of sweet liquor (sherry, port, Marsala wine) or other flavors such as lemon zest, meat concentrates, chives, pimientos, walnuts, tomatoes, mushrooms, and crushed garlic.

Ingredients

1 rounded tablespoon butter
1 level tablespoon flour
1 cup milk
Salt and pepper to taste

Preparation

Melt the butter in a saucepan and add the flour. Stir until a smooth roux is formed. Add the milk gradually, stirring constantly to avoid lumps. Add the salt and pepper, and remove from the heat.

SHERRY SAUCE

To accompany fowl or lamb.

Ingredients
½ cup chopped dried figs
½ cup chopped dried
 mushrooms
1 cup sherry
1 tablespoon butter
1 tablespoon cornstarch
1 cup chicken stock
1 tablespoon whiskey
Salt and green pepper
3 tablespoons cream

Preparation
Soak the figs and mushrooms in the sherry for 2 hours, then sauté in the butter. Dissolve the cornstarch in the chicken stock, then add to the figs and mushrooms. Simmer over low heat for 15 minutes. Season with the whiskey, salt, and pepper. Just before serving, gently stir in the cream.

ROQUEFORT SAUCE

Roquefort, the blue-veined cheese that smells like a soldier's old boot, is a magnificent ingredient for enhancing certain dishes. It is especially appropriate for noodles and gnocchi, and, cold or hot, will also spice up certain fish and sautéed or steamed green vegetables. For obvious reasons you won't want to use anything containing Roquefort cheese in your erotic games.

Ingredients
3 tablespoons cream
3 tablespoons Roquefort cheese
1 tablespoon butter
3 tablespoons minced celery
Salt and pepper to taste
1 egg yolk
2 tablespoons white wine

Preparation
Beat the cream with the Roquefort. Add the butter, celery, salt, and pepper, and mix. Warm the mixture in a double boiler, but don't let it boil. Beat the egg yolk with the white wine and add to the sauce, stirring carefully until the sauce thickens.

AROMATIC SAUCE

For meat of all kinds—well, except human—and for simple Italian noodles (with fresh oregano or sweet basil instead of cilantro and bay leaf).

Ingredients

1 cup chopped fresh mushrooms
1 clove garlic, crushed
1 tablespoon olive oil
1 cup chopped, peeled, and seeded fresh tomato
½ cup Beef Stock (page 240)
2 tablespoons minced cilantro
1 bay leaf
Salt and pepper to taste (add salt with caution if using concentrated stock)
3 tablespoons sour cream

This sauce won't do at all for massages; if applied externally, many people break out in a rash.

Preparation

Sauté the mushrooms and garlic in the olive oil. Add the tomato, stock, cilantro, bay leaf, salt, and pepper. Cook for 15 minutes on low heat. Add the sour cream at the end and serve warm.

AMARANTA PESTO

A generic name that includes many variations, pesto was invented in Italy for pastas, especially warm pastas, but North Americans, who are so fond of eating cold pasta in salads, use it as a dressing. Pesto also goes well with seafood or can be added to a boring soup to give it more personality.

Ingredients

2 tablespoons golden raisins
½ cup stock
1 clove garlic, crushed
1 tablespoon vegetable oil
½ cup blanched and ground almonds
3 tablespoons chopped fresh oregano
½ teaspoon cumin
½ teaspoon paprika
Salt to taste
3 tablespoons grated Parmesan cheese

(Pesto will keep for several days in the refrigerator.) What we offer here is a more or less basic recipe, but you can add herbs and condiments or replace them with others of your choice. Pesto, too, is like making love: all you need are the basic instructions, and the rest is pure improvisation.

Preparation

Soak the raisins in the stock in advance. Sauté the garlic in the oil. Add the raisins, almonds, oregano, cumin, paprika, and salt. Just as you remove the mixture from the heat, add the Parmesan.

CORALINA SAUCE

For all hot fish. This sauce has an intense rosy color, an intimate aroma, and a slightly spicy taste; in short, it's openly sensual.

Ingredients

1 tablespoon cornstarch
1 cup Fish Stock (page 241)
4 prawns (scampi or large
 shrimp), cooked and chopped
2 tablespoons vodka
1 tablespoon soy sauce
1 tablespoon chopped chervil
1 canned pimiento
Coriander, paprika, and salt to
 taste
Powdered garlic to taste
 (optional)

Preparation

Dissolve the cornstarch in the stock and heat slowly, stirring until the stock thickens. Add the prawns, vodka, soy sauce, and chervil. Pass the pimiento through a sieve and add to the other ingredients. Season with coriander, paprika, salt, and powdered garlic. Cook a few minutes for the flavors to blend.

MYKONOS SAUCE

Also called Greek *nogada*, this is an aphrodisiac sauce that goes well with meats and some fish. In South America a similar recipe is served with tongue.

Preparation

Soak the bread in the milk. Sauté the garlic in the oil. Stir in the bread and milk, walnuts, sweet basil, and chives. Season with salt and pepper. Cook for 5 minutes, until the mixture thickens. Serve warm, adding the pistachios at the last minute. (If the sauce is very thick, thin it with olive oil.)

Ingredients

3 slices white bread, crumbled
1 cup milk
1 clove garlic, crushed
2 tablespoons olive oil
1 cup ground walnuts
½ cup mixed sweet basil and
 chopped fresh chives
Salt and pepper to taste
1 handful whole hulled
 pistachios

MARINARA SAUCE

This is also good when made with clams or other shellfish. In an emergency you can use canned shellfish, although they are always better fresh. This sauce goes well with fish, pasta, an omelet *aux fines herbes*, savory puddings, and vegetable soufflés. All the ingredients except the cornstarch and salt are aphrodisiac! Give your lover fair warning before serving.

Ingredients

½ cup minced onion
1 clove garlic, crushed
3 tablespoons vegetable oil
2 tablespoons tomato paste
1 pimiento, ground
1 cup Vegetable Stock
 (page 242)
1 tablespoon cornstarch
1 cup cooked mussels
Juice and grated zest of
 ½ lemon
Chopped rosemary to taste
Chopped parsley to taste
Salt and pepper to taste

Preparation

Sauté the onion and garlic in the oil. Add the tomato paste and pimiento. Thicken the stock with cornstarch and add to the onion and garlic mixture. Add the mussels, lemon juice and zest, rosemary, parsley, salt, and pepper. Cook at a slow boil until the flavors are blended.

WINE SAUCE *(White or Red)*

The white wine sauce goes with fowl, fish, and delicately flavored vegetables. The red goes with red meats and assertive vegetables.

Ingredients

2 tablespoons butter
1 tablespoon flour
1 cup warm stock (chicken or
 fish if you use white wine;
 beef if you use red wine)
¼ cup white or red wine
2 tablespoons sherry
Garlic powder, salt, and pepper
 to taste
2 generous tablespoons
 whipped cream (optional)

Preparation

Melt the butter over low heat. Stir in the flour and cook to caramel color. Gradually add the warm stock, stirring constantly. Add the wine and sherry. The sauce will be thin. Continue to stir until it thickens slightly. Check the garlic powder, salt, and pepper for taste. If you want the sauce thicker, add the cream but do not bring to a boil.

SALOME SAUCE

For fowl, lamb, and veal. It can also serve to disguise testicles. I refer, of course, to animal testes, usually served roasted or fried in butter.

Preparation

Soak the prunes in the wine for 2 hours. Blend the drained prunes, apple, and stock in a food processor. Season with salt and pepper. Warm in a small saucepan and add the cream when ready to serve.

Ingredients

½ cup pitted prunes
½ cup red wine
½ cup sliced and peeled green apple (Granny Smith)
1 cup Chicken Stock (page 241)
Salt and pepper to taste
3 tablespoons heavy cream

MANGO CHUTNEY

To bring a breath of the Far East to your table, this chutney is ideal. Serve it with vegetables and to accompany red meats, lentils, or garbanzos.

Ingredients

1 green mango
1 green pepper
2 tablespoons oil
1 tablespoon powdered coriander (dried cilantro seeds)
1 tablespoon powdered cumin
1 tablespoon turmeric
½ teaspoon cayenne powder
1 tablespoon curry powder
2 tablespoons honey
½ cup water (approximately)
Salt to taste (very little will be needed)

Preparation

Peel and cut the mango into small cubes. Cut the pepper into small cubes. In a frying pan, lightly sauté the mango and pepper in the oil with the coriander, cumin, turmeric, cayenne powder, and curry powder for no more than 5 minutes. Combine in a blender with the honey and water, and process thoroughly. If the sauce seems dry, add more water. Salt to taste. The chutney may be served immediately or kept in a bottle in the refrigerator for no more than a week.

QUICK CURRY

In India, curry is an integral part of the preparation of many dishes. It originated with the need to preserve food for several hours in a hot, humid climate. Curry isn't actually a sauce added at the end but part of the overall preparation of a meal. It is helpful, however, to have an easy recipe that will embellish any meat, fish, or vegetable when you want to improvise an aphrodisiac menu at the last minute or cover up something you've burned.

Ingredients

1 clove garlic, crushed
1 teaspoon curry powder
1 tablespoon oil
1 tablespoon sherry or white wine
1 teaspoon lemon juice
Salt and pepper to taste
1 pinch cumin
1 cup cream or Béchamel Sauce (page 219) prepared with skim milk for a sauce with fewer calories

Preparation

Sauté the garlic and curry powder in the oil for 2 minutes. Add the sherry and lemon juice. Remove from the heat and season with the salt, pepper, and cumin. Return to the heat and slowly pour in the cream, keeping the mixture warm but not allowing the sauce to reach a boil. If you use béchamel that has been in the refrigerator for several days, beat it with a hand or electric beater before using.

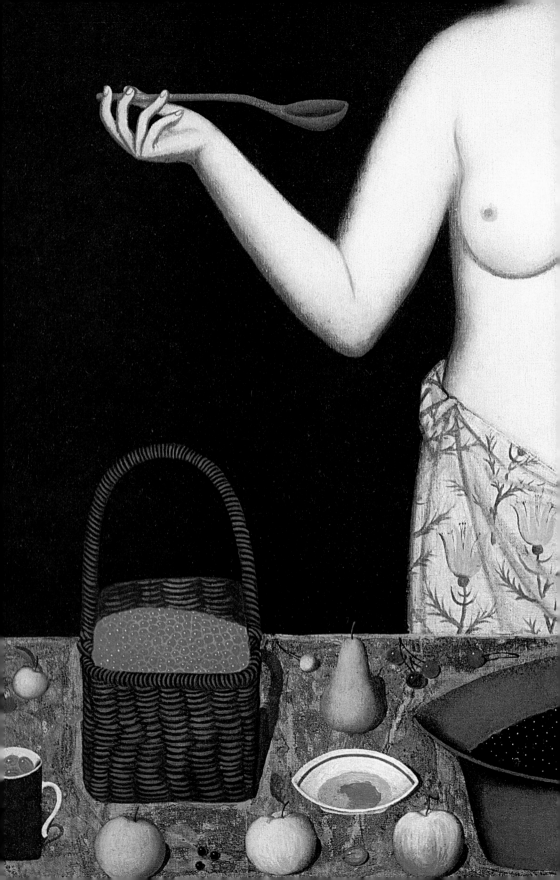

Hors d'Oeuvres

FIRST TICKLES AND NIBBLES

*Titbits are to the table
what kisses are
to lovers: a delicate demonstration
of what is to come later,
when you slip into something more
comfortable. They are served
to accompany a cocktail
or glass of white wine before moving
to the table. Or, in some cases,
when the urgency to make love
is so strong that
there is no time to lose,
they can take the place of a meal.*

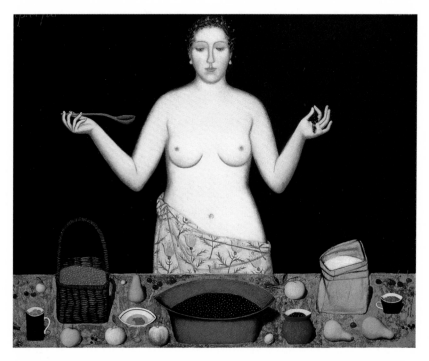

I know a several-times-divorced playboy whose sole culinary talent is hors d'oeuvres, which he prepares with the dedication of a monk and always has fresh in a refrigerator in his bedroom. He serves them as he undertakes his seduction and to recover his strength between performances. The selections Panchita and I have made for this section have recognized aphrodisiac properties. The servings are sufficient for two euphoric and greedy lovers or for four people of more laid-back temperament.

SEAFOOD IN COCKTAIL SAUCE

Mussels are visually very good—recalling the female sexual organs—appetizing, and easy to make. In Chile they are thought of as the oyster of the poor.

Ingredients

2 generous pounds mussels in the shell
½ cup water
½ cup white wine
1 slice lemon
3 tablespoons mayonnaise
1 tablespoon minced chives
2 tablespoons mixed finely minced cilantro, parsley, oregano, and celery
Lemon quarters for garnish

Preparation

Diligently scrub and rinse the mussels in cold water, then drain. Cook for 10 minutes in the water and wine with the lemon slice. Remove from the heat, drain, and let cool. (Keep the broth; it is very aphrodisiac. You can give it to your lover about midnight when he begins to droop.) Detach the mussels from the shell (reserve the shells); you want them easy to eat without staining the sofa. Make a salsa verde by mixing the mayonnaise with all the herbs. Season each mussel with a little salsa and serve in the shells on a platter garnished with lemon quarters.

ADAM'S NUTS

How we got to *Adam's* nuts from yesterday's turkey or chicken, I really can't say. Any fowl will do because this is a superb way to recycle your leftovers. What we offer is merely one suggestion. Use your imagination with other aphrodisiac fruits in season.

Preparation

If you use canned fruit, drain it on paper towels. Soak the fruit in the rum and then roll in the ground nuts. Thread 1 cube of fowl and 1 cube of fruit on individual toothpicks.

Ingredients

1 cup cubed fresh or canned peaches or apricots
½ small glass Jamaica rum
3 tablespoons ground nuts
2 cups cubed cooked turkey or other fowl

WIDOWER'S FIGS

These tidbits lead to sin, and you always want more. The bursting figs suggest a certain urgency, and everyone appreciates the sensuality of the sweet and spicy combination.

Ingredients

- 1 scant cup (8 ounces) semi-hard white cheese, such as goat cheese
- 1 tablespoon Salsa Picante (page 214)
- 1 large apple or grapefruit
- 4 large ripe figs

Preparation

Cut the cheese into ½-inch cubes and coat in the salsa picante. Spear on cocktail picks and insert into the apple or grapefruit. Place in the center of a round plate and surround with peeled and quartered figs.

CHEESE LOGS

These treats can be prepared a couple of days in advance and kept in the refrigerator. The logs are delicious made with fine strips of ham or smoked turkey. The recipe we are giving you calls for cheese and pimiento, but you can invent other variations, such as deviled eggs or artichokes with mayonnaise combined with Turkish Sauce (page 213), Huancaina Sauce (page 214), or Walnut Sauce (page 215). Since this recipe requires considerable forethought and some effort, the directions are for ample servings. That way you can have them on more than one occasion, preferably with different lovers so the repetition won't be noticed.

Ingredients

- ½ package (4 ounces) cream cheese
- 2 tablespoons butter
- 2 tablespoons cream
- ½ cup ground pimiento
- 1 tablespoon lemon juice
- 1 tablespoon vodka or *pisco*
- Salt and pepper to taste
- 4 thin slices ham or turkey

Preparation

Prepare the filling by combining the cream cheese, butter, cream, pimiento, lemon juice, liquor, salt, and pepper. Spread on the ham or turkey and roll into a log. If you feel ambitious, use different fillings. Cover the logs with aluminum foil and store in the refrigerator. To serve, slice as if they were sausages into ½-inch pieces.

SHRIMP *PICA PICA*

Appetizing, erotic, and easy to prepare.

Ingredients

10 medium shrimp, peeled and
 cleaned
½ cup white wine
½ bay leaf
Piece of lemon zest
Salt
Sauce (Homemade Mayonnaise,
 page 210; Guacamole, page
 212; or Mediterranean Sauce,
 page 213)

Preparation

Cook the shrimp with the wine, bay leaf, lemon zest, and salt for 4 minutes over low heat. Remove, drain, and let cool. Serve the shrimp on cocktail picks with a sauce of your choice.

FRIVOLOUS PRUNES

Remember what we said about the aphrodisiac merits of plums?

Ingredients

6 pitted prunes
½ cup sherry or dry white wine
1 tablespoon chopped nuts
1 pinch freshly grated nutmeg
3 strips bacon, cut in half

Preparation

Soak the prunes in the sherry for at least 8 hours, then drain on paper towels. Fill with portions of nuts that have been seasoned with nutmeg. Wrap a strip of bacon around each filled prune and bake in a hot oven for 8 to 10 minutes. Serve on cocktail toothpicks.

SALMON TEMPTATION

Ideal with ice-cold vodka, this can be stored for several days in the refrigerator.

Ingredients

½ cup shredded smoked salmon
 fillet
2½ ounces cream cheese (or
 approximately ⅓ block)
1 tablespoon mayonnaise
1 tablespoon butter
1 teaspoon whiskey
1 teaspoon lemon juice
Salt and pepper to taste
Red caviar for garnish
 (optional)
Fried potatoes or crackers

Preparation

In a food processor blend the salmon, cream cheese, mayonnaise, butter, whiskey, lemon juice, salt, and pepper to a smooth paste. Set aside for several hours so that the flavors may blend. Place in a small ceramic pot and, if your budget allows, garnish with a topping of red caviar. Serve surrounded with fried potatoes or crackers.

CELERY ROQUEFORT

The coolness of the celery balances the strong flavor of the cheese, and for anyone who likes Roquefort, this is a real treat. (I prefer it with a milder goat cheese, which is considered aphrodisiac in the Alps.)

Ingredients

2 stalks celery
¼ cup Roquefort cheese
1 tablespoon butter
1 tablespoon chopped celery
1 tablespoon cognac
Salt and pepper (only a little)
2 tablespoons finely minced
 chives for garnish

Preparation

Remove the strings from the celery stalks and cut into 2½-inch lengths. Chill in cold water for 2 hours. Drain and dry on paper towels. Blend the cheese, butter, chopped celery, cognac, salt, and pepper in a food processor until smooth. Fill the celery pieces and garnish with the chives. Chill before serving.

FESTIVE MUSHROOMS

If you can find olive oil scented with truffles, this is your opportunity to use it. A half teaspoon will lend these mushrooms the perfect touch, but even if you don't have the oil, they're still delicious.

Ingredients

8 medium mushrooms
Juice of ½ lemon
½ tablespoon butter, melted
2 tablespoons liver pâté
1 teaspoon cream
Salt and pepper to taste
1 teaspoon truffled olive oil
 (optional)

Preparation

Wash the mushrooms in running water to remove any sand. Cut off the stems. Soak the mushrooms and stems for 10 minutes in lemon juice and water. Remove, dry, and coat with the butter. Cook for 3 minutes over high heat, then cool on paper towels. Chop the tender part of the stems and mix them with the pâté and cream. Season with salt, pepper, and oil. Use a pastry bag to fill the mushrooms with this mixture. Serve either warm or chilled.

Soups
HEATING UP

Soups follow the same criteria
as those for sauces:
they are preambles to lovemaking, foreplay,
and must be prepared
while keeping all the senses in mind—
sight, smell, taste, texture, and,
in some cases, sound.
In the West it is bad form to lean over your plate
and slurp your soup,
but in the East it would be a slight to the host
to hold your spoon with
your fingertips and eat your soup without
enthusiasm or passion.

Good manners—whatever may be appropriate in the geographic location you find yourself—have their purpose; they allow us to live without offending one another. The nearly irresistible temptation to commit murder over a question of manners came close to ruining my life when I was barely twenty years old. On one of my first jobs, my boss never flushed the toilet. . . . But let's get back to food and soup. Don't hold back: just as freedom to whisper dirty words is an essential component of the lovers' embrace, so, too, is noisily sipping your soup when alone with your lover. You can't fully celebrate a stupendous soup and not make a fuss: sucking, dipping your bread, sighing, moaning, even licking the bowl if the soup is deserving. Can you make love following the rules of etiquette? You can do no less with soup. Real soup is to the body what peace is to the soul.

In soup making, as with sauces, you can give free rein to inspiration and instinct. You don't have to be bound by instructions, the recipes are merely a point of departure, a window on inspiration. For the person who possesses the rare talent—bordering on genius—of making a superb soup, no two are ever exactly alike. Each creation is unique, although also an approximation. A recipe is like a musical score: each artist interprets it according to his or her own spirit and skills. When the lid is lifted from the soup pot and the giant wooden spoon is sunk into its steaming contents, there must be but one constant: the delicious surprise of tasting something always new.

The process of making a good soup follows the same steps as those for making love; in both, you must immerse yourself in the sensual pleasure of mixing, smelling, tasting, licking, adding, withholding, doubting, adding a little something more. . . . These recipes of Panchita's have gone everywhere with me from the time I first married—something like a thousand years ago—but I don't hold them holy and hope you won't either. The philosophy of the kitchen is the same as that of gambling: if you're not having fun, forget it. You're not trying to reach perfection but to laugh along the way.

If you want to have the greatest success with your soups, it's a good idea to follow one of Panchita's culinary routines. Don't be afraid when you read what's to come, it's less traumatic than it seems. From time to time—once a week, let's say—she cooks up the stocks that will serve as the base for her soups; after they have been strained and chilled, she stores them in bottles or jars. If she plans to use them during the week, she puts them in the refrigerator, but if she wants to keep them longer than that, she freezes them. When she feels inclined to serve one of her sensual concoctions, she takes out the jar,

thaws the contents, and whips up a new soup. She also uses the stocks as a base for sauces, aspics, and as the liquid for baking fish or shellfish.

These highly concentrated stocks (*fonds* or *fumés,* as they're called in France, or *caldos* in Latin America) are absolutely essential in a good kitchen. Formerly they were made in special pots, and every kitchen had a contrivance for grinding bones, meat, vegetables, and shellfish that was very similar to the implements exhibited in the Museum of the Inquisition. Now making a stock is a breeze if you have a pressure cooker, but even that isn't indispensable. They do, of course, sell concentrates in cans, powders, and cubes, which will get you through in an emergency, but concentrates are short on aphrodisiac powers and, besides, are nothing but pure sodium and artificial flavor. My macrobiotic friends tell me they cause cancer. I must admit, however, that I keep a secret hoard of these culinary aberrations hidden in the back of my pantry to use when my mother isn't watching. When you make your own stock, you can use ingredients you would normally throw in the garbage, such as shells, chicken bones, pigs' hooves, leftover vegetables and meats, organ meats, fish heads and tails, and much more. As I watch my mother make her stock, I delve into the depths of her personality. At bottom, she is much like the witch Robert Shekter created in his drawings, merrily levitating in her striped yellow stockings somewhere between this world, with its casseroles and sins, and Heaven, toward which the aroma of all good work rises. That's how I would like to remember her always: bent over her steaming cauldron with a mischievous glint in her eye, tossing ingredients into the boiling water and cloaked in the aphrodisiac vapors of her brews.

We begin with Panchita's four fundamental stocks: beef, chicken, fish, and vegetable. They should be stored in separate bottles and labeled (including the date).

Four Basic Stocks

Quantities given here are larger because the stock is for storing in the refrigerator. It's scarcely worth the effort to make only the amount you will use for one amorous encounter, however gargantuan the lovers' hungers may be. Do you remember the masterful scene in García Márquez's *One Hundred Years of Solitude* when two epic gluttons, Aureliano Segundo and a delicate female singing teacher unjustly nicknamed The Elephant, lock horns in a tourney to prove which of the two is capable of eating more? For three days they devour cows, chickens, turkeys, whole stalks of bananas, cases of eggs, and liters of coffee, until Aureliano crumbles, on the verge of death, while the singing teacher continues to eat elegantly, never losing the rhythm of her digestion. But what were we talking about? Ah, yes, the stocks. In the large old mansion in which I spent my early childhood, there were "witches' kitchens" contrived by my grandfather to save fuel. Inside a large chest packed with wool and sawdust, two boiling-hot pots brimming with stocks and stews were set side by side, and then the lid of the chest was closed. In that darkness and warmth the food cooked for hours and by evening was ready to be served.

If a pressure cooker is used, reduce the amount of liquid and cooking time by half. If you use an ordinary pot with a lid, be sure the lid is tight and cook at a low heat. In my grandmother's time, the pot was set on the back of the charcoal or wood stove, and the ingredients would blend in a slow alchemy, gradually being transformed into a fundamental elixir. The slower the cooking, the richer the savor, but no one has time anymore to spend a day watching a pot, especially when it can be done in an hour or less using a pressure cooker.

If you prefer a clear stock, don't use raw bones. At the beginning you will have to skim off the scum that forms on the surface. Go easy on the salt. Remember that as the stock boils, the liquid will be reduced, and the stock may get too salty. It's better to add more at the end if necessary. If you think the stock is cooking down too fast, add water or white wine. After cooking, let it cool and then strain it through a cloth. If you plan to freeze the stock, first put it in the refrigerator for a few hours until fat congeals on the top; spoon that off before you divide it

into jars. If you want to refrigerate it without freezing it first, don't remove the fat because it acts as a seal until you use it (no more than three or four days).

This explanation sounds intimidating. When I wrote it, it frightened even me, but doing it is much simpler than it sounds. Panchita does it automatically, like knitting without looking at her needles.

BEEF STOCK

This is the slowest and most complicated of the stocks, and also the one you will use least often. We recommend that you use lean meat because fat will make it cloudy. You can use leftover meat, bones, organs, and other parts, but if starting from scratch, buy the following:

Ingredients

2 pounds ribs, chopped in pieces
1 split ox tail
2 beef marrow bones (cut in pieces by the butcher; if you try to do it yourself with a hatchet, you could lose a finger)
2 large onions, quartered
8 cloves garlic
4 stalks celery
1 large carrot, cut in 2-inch pieces
Bay leaf, thyme, rosemary, coriander, salt, and whole peppercorns to taste

Preparation in a Stockpot

Put the meat and bones in a large stockpot. Add 8 cups of cold water and let it sit for a couple of hours while you make love or use the time to prepare other dishes. Boil for 30 minutes. Skim off the scum with a slotted spoon. Add the remaining ingredients and boil for 3 hours on low heat. Use your time for pursuits more interesting than watching the pot, but check the level of the liquid from time to time, adding a little water if necessary. Strain through a cloth, let cool, and, if you're going to freeze the stock, skim off the fat.

Preparation in a Pressure Cooker

Put the meat and bones in a pressure cooker with 4 cups of water. When the valve whistles, turn the heat to the lowest setting. Cook for 1 hour. Add the vegetables and seasonings, and cook for 30 minutes. Strain through a cloth, let cool, and skim off the fat.

CHICKEN STOCK *(And All Other Fowl)*

You can use throwaways of cooked or raw fowl—that is, feet, necks, wings, carcass, liver, and heart. You can also use the cooked carcass of turkey, chicken, and other birds. If not available, buy the following:

Ingredients

1 roasting hen (including feet, neck, and organs), cut in pieces
2 large carrots, chopped
1 onion, chopped
2 stalks celery
1 green pepper, cut in large slices
1 leek, sliced
2 cloves garlic
4 cloves
Bay leaf, thyme, parsley, cumin, salt, and pepper to taste

Preparation in a Stockpot

Place the fowl in a stockpot. Cover with 8 cups of water and boil for 30 minutes. Skim off the scum. Add the remaining ingredients and boil over low heat for another 30 minutes. Strain through a cloth, let cool, and skim off the fat.

Preparation in a Pressure Cooker

Place all the ingredients in a pressure cooker with 4 cups of water. After the valve whistles, simmer on low heat for 30 minutes. Strain through a cloth, cool, and skim off the fat.

FISH STOCK

Ingredients

2 fish heads and tails
3 cups water
1 onion, quartered
1 carrot, cut in large pieces
1 stalk celery
2 cloves garlic
1 cup dry white wine
Juice and peel of 1 large lemon
Bay leaf, parsley, cilantro, pepper, and salt to taste

This is the most aphrodisiac of all the stocks. You can use uncooked fish heads and tails, or shells of shrimp, lobster, and other crustaceans, raw or cooked. If you don't have them, buy the following:

Preparation in a Stockpot

Boil the fish in the water for 15 minutes. Skim off the scum. Add the remaining ingredients and boil for 45 minutes, covered. Strain through a cloth and cool.

Preparation in a Pressure Cooker

Place all the ingredients in a pressure cooker. After the valve whistles, simmer on low heat for 30 minutes. Strain through a cloth and cool.

VEGETABLE STOCK

After you strain the stock, don't use the vegetables that are left for erotic games but for a delicious sauce. Blend in a processor and add one cup of sliced mushrooms that have been sautéed in butter and one teaspoon of lemon juice.

But back to the stock. You can use all the vegetables you didn't eat during the week even if they're not terribly fresh, but you must still wash them carefully. Or buy the following:

Ingredients

1 leek, cut in large slices
1 onion, quartered
1 turnip, sliced in rounds
2 medium zucchinis, sliced
4 cloves garlic
2 large carrots, diced
4 stalks celery
1 cup mushrooms
2 large tomatoes, quartered
1 red or green pepper, seeded
 and cut in large sections
Bay leaf, thyme, rosemary, and
 sweet basil to taste
1 pinch each of pepper, cumin,
 and paprika

Preparation in a Stockpot

Cook on low heat for 1 hour with the lid tightly closed. Strain through a cloth and let cool.

Preparation in a Pressure Cooker

Place all the ingredients in a pressure cooker. After the valve whistles, simmer on low heat for 30 minutes. Strain through a cloth and let cool.

Consommé

A consommé is as clear and transparent as a kiss on the forehead, and ideal for preceding a strong main dish. To assure a clear broth, drop in the white of an egg and its crushed shell while the consommé is still boiling. Impurities will cling to them and are then easy to remove with a slotted spoon. After the broth has cooled, strain it through a cloth placed inside a colander. To add body to a clear consommé, add 1 tablespoon of unflavored gelatin dissolved in stock.

CONSOMMÉ BACCHUS

So named because it is recommended for restoring well-being after a night on the town and for fortifying lovers at midnight.

Preparation

This consommé should be served very hot, so it is best to set 2 soup bowls in the warming oven as you prepare it. Melt the butter and sauté the onion and garlic for 2 minutes over medium heat. Add the stock, check the seasoning, and add salt and pepper to taste. Bring to a boil, add the sherry, and remove from the heat. Break an egg into each bowl. Pour the consommé over them and serve immediately.

Ingredients

1 tablespoon butter
1 tablespoon grated onion
1 small clove garlic, crushed
2 cups Beef Stock (page 240)
Salt and black pepper to taste
2 tablespoons sherry
2 eggs

RISE AND WALK SOUP

Ingredients

4 cups Beef Stock (page 240), carefully strained
½ teaspoon curry powder
Tabasco to taste
1 liqueur glass sherry
1 pinch cumin
Salt and pepper to taste
4 tablespoons cooked rice
1 tablespoon raisins, previously soaked in some of the Beef Stock

Also called Lazarus's Lifeblood, this is the consommé we use in Chile to cure colds. To even better purpose, it animates languishing lovers.

Preparation

Season the stock with the curry, which has been dissolved in a small amount of hot water. Add the Tabasco, sherry, and cumin, check the seasoning, and add salt and pepper to taste. Serve hot accompanied by the rice and raisins.

NEW LIFE

Let's say that your quarrel wasn't the worst you ever had, that it doesn't quite call for my infallible Reconciliation Soup (page 166), and that a more modest offering will serve to improve spirits. That's the time for this recipe. It also works well as a light preamble for assertive main courses and can be prepared in less than ten minutes!

Ingredients

2 cups Vegetable Stock (page 242) or canned or concentrate in cubes
1 teaspoon minced fresh tarragon
1 cup thinly sliced mushrooms (about 5 large ones)
2 tablespoons olive oil
¼ cup Marsala wine
1 egg yolk
2 tablespoons cream
Salt and pepper to taste

Preparation

Heat the stock with the tarragon. In a skillet, sauté the mushrooms in the oil for 2 minutes. Add the wine, cover the skillet, and simmer over low heat for 5 minutes. Pour into the hot stock. Remove from the heat and let cool for 1 minute while you beat the egg yolk with the cream. Add to the consommé. Check the seasoning, add salt and pepper to taste, and serve immediately.

CONSOMMÉ EL DORADO

Not the same as onion soup. This is a delicate preamble to more daring caresses.

Ingredients

2 medium onions, minced
1 clove garlic
1 clove
Salt and black pepper to taste
1 splash vegetable oil
4 cups hot Beef Stock (page 240)
4 tablespoons port
Several drops Worcestershire sauce
2 tablespoons grated Gruyère cheese

Preparation

Sauté the onions, garlic, clove, salt, and pepper in the oil until the onion is golden. Add the stock, port, and Worcestershire sauce. Simmer for 10 minutes. Remove the garlic and clove, and blend the remaining ingredients in a food processor. Just before serving, add the Gruyère.

CONSOMMÉ NEAPOLITAN

Ingredients

4 cups Chicken Stock (page 241)
½ cup angel hair pasta
1 teaspoon unflavored gelatin
2 beaten egg yolks, mixed slowly with stock
2 tablespoons fresh minced parsley
4 tablespoons grated Parmesan

Preparation

Heat the stock until it boils. Add the angel hair like rain and lower the heat. Cook for 5 minutes. Add the gelatin dissolved in ½ cup of the stock and passed through a sieve and, finally, the beaten yolks, but do not allow the consommé to boil. Cook for 3 minutes on the lowest heat. Just before serving, add the parsley and Parmesan to each bowl.

SHERRY CONSOMMÉ

Very mild, this is a discreet soup to go with strong main courses, such as game birds, rabbit, or red meat. Always serve in Chinese rice bowls with porcelain spoons. If my partner needs an extra boost, I break a raw egg into the soup before serving it to him.

Preparation

Soak the raisins in the sherry for 30 minutes. Simmer the stock with the curry for 3 minutes and add all the remaining ingredients.

Ingredients

1 tablespoon raisins
⅓ cup sherry
3 cups Beef Stock (page 240)
½ teaspoon curry powder
4 tablespoons cooked rice
Tabasco to taste

SPIRIT LIFTER

This soup may be consolation for the pain of burials and divorces, which explains the name. Liver is aphrodisiac, but it also has a strong flavor that not everyone can accept. Chicken liver is mildest.

Ingredients

4 cups Chicken Stock (page 241)
1 cup grated potato
½ cup chopped chicken livers sautéed in butter
3 tablespoons Marsala or sherry wine
1 tablespoon Worcestershire sauce
1 pinch powdered tarragon
Salt to taste

Preparation

Cook the stock and grated potato for 5 minutes. Add the chicken livers, wine, Worcestershire sauce, and tarragon. Check the seasoning and add salt to taste. Cook 5 minutes more.

ROYAL CONSOMMÉ

Ingredients

4 cups Chicken Stock (page 241)
2 egg yolks
2 tablespoons toasted sliced almonds
1 tablespoon butter
2 teaspoons cognac or brandy (optional)
2 tablespoons cream (optional)

Quick and easy. Ideal for lovers in a hurry.

Preparation

Beat the egg yolks with ½ cup of stock. Heat the remaining stock, then remove from the heat. Add the yolks, stir well, and cook on low heat for 3 minutes; do not allow the eggs to curdle. Add the remaining ingredients except the cream. Pour the soup into bowls and place a tablespoon of cream in each one without stirring.

Hot Soups

If you have homemade soups in your refrigerator, it's very easy to improvise an aphrodisiac dinner: The main course will be a marvelous soup accompanied by a salad, good bread, cheese, wine, and, as dessert, a chocolate bonbon or a sorbet, two backup items it is wise to keep in your kitchen for emergencies. Afterward, with a light meal on your stomach and in a good mood, you can happily make love for the rest of the night. This is a lesson I learned when I prepared a complete aphrodisiac menu, and by the time I had cooked all afternoon, served the dinner, and cleaned up the kitchen, I was so exhausted that if Gregory Peck had appeared in the full splendor of his youth, I would have been satisfied with a chaste back rub. On that occasion I had fixed a wild mushroom soup (the one I call, for obvious reasons, Reconciliation Soup, the recipe for which you will find on page 166) that left my companion in the state of supreme euphoria normally produced by the best Chinese herbs from my Japanese acupuncturist friend. The mushroom soup was followed by salmon with capers in a white wine sauce, accompanied by stuffed artichokes and asparagus tips, Caesar salad, and chocolate mousse. I fell fast asleep by the dishwasher, clutching a sponge, while the man of the moment, who was not, unfortunately, Gregory Peck, awaited in the bedroom, working a crossword puzzle. I no longer make this error. Now I devote myself to the soup the day before—sitting a day makes it even tastier—and have energy enough to make both salad and love.

CREAM OF ARTICHOKE

Ingredients

2 artichokes
1 lemon slice
2 cups Chicken Stock (page 241)
8 ounces plain yogurt
Salt and pepper to taste
2 teaspoons butter

Simple and savory, the only nuisance is scraping the leaves, but you will want to get the hang of that because artichokes stuffed with the pulp from the leaves are very erotic.

Preparation

Cook the artichokes in water with lemon until they are soft and the leaves detach easily, 30 to 40 minutes. When cool, remove the pulp from the leaves with a spoon. Scrape the choke from the heart and place the pulp and heart in a food processor with the stock and yogurt. Add salt and pepper to taste. Heat and serve with a curl of butter in each bowl.

CLAM CHOWDER

May be made with mussels or other shellfish, or with a combination of fresh or frozen seafood. The effect is remarkable. No one will believe you prepared it in less than ten minutes.

Ingredients

1 clove garlic, crushed
1 teaspoon butter
2 cups Fish Stock (page 241)
2 slices white bread, crusts removed
1 cup shellfish, either fresh or frozen, cooked without shells
½ cup white wine
2 tablespoons mixed chopped parsley and cilantro
Salt and paprika to taste

Preparation

Sauté the garlic in the butter. Add the fish stock. Soak the bread in the stock, warm, and stir strongly until the bread disintegrates. Add the shellfish, wine, parsley, and cilantro. Heat for 5 minutes. Check the seasoning, add salt and paprika to taste, and serve while hot.

ALICANTE CREAM

Ingredients

1 medium leek (white portion only)
½ small onion
1 tablespoon olive oil
1 tablespoon flour
2 cups Fish Stock (page 241)
½ cup peeled and cooked shrimp
6 cooked oysters
Paprika, rosemary, pepper, and other herbs to taste
2 tablespoons cream

Super aphrodisiac!

Preparation

Cut the leek and onion into thin slices and sauté in the oil until golden. Add the flour and cook until it, too, is golden. Slowly pour in the stock while stirring to prevent lumps from forming. Cook until you have a soup of clear consistency, about 10 minutes. Add the shrimp, oysters, and seasonings. Simmer another 5 minutes. Add the cream before serving, but do not boil.

ONION SOUP

This is the simple version of the celebrated French soup. It goes into the oven in heatproof pottery bowls, with bread and cheese. It can be a main course on its own.

Preparation

Sauté the onions in the oil until golden; be careful not to burn them because that will make them bitter. Add all the other ingredients except cheese and bread. Cook for 10 minutes. Place the toast in bowls, pour in the boiling soup, sprinkle with cheese, and return to the oven for 10 minutes.

Ingredients

2 medium onions, julienned
1 splash vegetable oil
3 cups Beef Stock (page 240)
1 pinch ground cloves
1 pinch sugar
A few drops Worcestershire sauce
2 slices toasted white bread
4 tablespoons grated Gruyère
 or Parmesan cheese

IT'S-A-FEAST! SOUP

Garbanzos are considered aphrodisiac in nearly all cultures. In my childhood in Chile they were a very modest dish that never appeared on an elegant table or restaurant menu. Well prepared, they're delicious; the hassle is skinning them. So if you plan to take the trouble, double the recipe and keep half of it frozen. This soup can also be made with beans or lentils, which even though not aphrodisiac are very tasty.

Ingredients

1 cup garbanzos
2 tablespoons minced onion
1 clove garlic, crushed
1 small carrot, grated
1 tablespoon olive oil
2 cups Chicken Stock
 (page 241), or Beef Stock
 (page 240)
½ cup milk
¼ cup white wine
Salt, pepper, and cumin to taste
2 tablespoons minced ham

Preparation

Soak the garbanzos overnight in water and then cook until softened, about 1 hour. (In an emergency, you can used canned garbanzos.) Sauté the onion, garlic, and carrot in the oil for 2 minutes. Add the skinned garbanzos. (No getting around it, you have to remove the skins. But if you soak them a while, they will slip off easily.) Add all the other ingredients except the ham and cook for 5 minutes. Put the mixture in a food processor and blend until creamy. Serve hot. Garnish with the ham. (If you have no problem with calories, replace the ham with bits of sausage or crisp bacon.)

QUICK CRAB BISQUE

Ingredients

1 slice white bread, crusts
 removed
⅓ cup milk
1 tomato, peeled, seeded, and
 chopped
1 pimiento, chopped
1 tablespoon oil
Salt, pepper, and garlic powder
 to taste
1 pinch thyme
½ cup cooked crabmeat or
 other crustacean
2 cups Fish Stock (page 241)
2 tablespoons cream

This may also be made with lobster or other crustaceans, fresh or frozen.

Preparation

Soak the bread in the milk until absorbed. Sauté the chopped tomato and pimiento in the oil. Season with salt, pepper, garlic powder, and thyme. Add the bread and crabmeat. Cook for 2 minutes so that the flavors blend. Pour in the stock and simmer, covered, for 5 minutes. Place in a food processor and blend. Add the cream and serve hot.

FISH SOUP

Ingredients

4 cups Fish Stock (page 241)
½ cup white wine
2 medium tomatoes, peeled and
 seeded
1 medium carrot, peeled and
 cut in thick slices
1 large potato, peeled and cut
 in thick slices
¼ cup minced onion
1 clove garlic, crushed
½ cup minced celery
1 tablespoon soy sauce
1 bay leaf
Salt and pepper to taste
2 medium fillets (½ pound) fish,
 preferably corbina, conger
 eel, or sea bass
2 squid, cleaned and cut in
 strips
½ pound shellfish (such as
 clams or mussels), removed
 from shell

May be served as a main course accompanied by salad. This healthy and delicious recipe makes four servings, because we are assuming that after their first embraces, the lovers will need another aphrodisiac hit.

Preparation

Cook the stock and all the ingredients except the fish, squid, and shellfish for 15 minutes. Add them and cook 10 minutes more.

CARROT SOUP

This old Arab recipe is still a favorite of men who hope to shine at the time of making love. For an exotic touch, you can substitute ½ cup orange juice for ½ cup of the stock.

Ingredients

2 large carrots
2 cups Vegetable Stock (page 242)
1 clove
1 stick cinnamon
1 knob fresh ginger or
 ½ teaspoon powdered ginger
1 pinch cardamom
1 pinch nutmeg
Salt and pepper to taste
1 teaspoon honey
4 tablespoons cream

Preparation

Peel the carrots and cut them in thin slices. Cook in a covered saucepan with the other ingredients—except the honey and cream—until soft, 10 to 15 minutes. Put in a food processor and blend. Process. Return to the saucepan to warm but don't allow the mixture to boil. Add the honey and cream, stir, and serve immediately.

Cold Soups

Nearly all of these soups may be prepared in advance. They are even more delicious after spending a night in the refrigerator, especially the gazpacho. The recipes are for two, but if you have an orgy or want to have something left to restore you the day after your first date, double the recipe.

MARGARITA ISLAND

Ingredients

1 large ripe avocado, peeled, seeded, and chopped
1 small glass grapefruit juice
Juice of ½ lemon
1 cup Chicken Stock (page 241), with fat skimmed off
1 teaspoon soy sauce
Salt and pepper to taste
A few drops Tabasco
2 large shrimp, cooked and cleaned

Very sensual, but this soup won't keep because it darkens in a matter of hours, turning the unappetizing color of greenish mud.

Preparation

Mix all the ingredients except the shrimp in a blender and serve cold, garnished with a shrimp in each bowl.

GAZPACHO

There are many recipes for this cold tomato soup typical of Spain, but this one is very simple to prepare.

Ingredients

4 large ripe tomatoes, peeled and seeded
1 small can tomato juice
1 pickle
1 tablespoon grated onion
1 tablespoon ketchup
2 rounded tablespoons mayonnaise
1 tablespoon vinegar
Salt, paprika, and garlic powder to taste
2 tablespoons minced cilantro
1 hard-boiled egg, diced

Preparation

Place all the ingredients in a food processor, except the cilantro and egg, and blend. Cool in the refrigerator until it is time to serve. Garnish with the cilantro and egg.

APPLE HOLIDAY

Ingredients

1 large green apple, peeled and sliced
1 tablespoon butter
1 cup Vegetable Stock (page 242)
½ teaspoon curry powder
1 pinch ground cinnamon
8 ounces natural yogurt or 2 tablespoons cream
1 pinch sugar
Salt to taste

Never fear, this doesn't taste like dessert. In fact, you can barely taste the apple.

Preparation

Sauté the apple in the butter. Add the stock, curry powder, and cinnamon. Cook for 5 minutes, then let cool. Add the yogurt and sugar. Place the mixture in a food processor and blend. Check the seasoning and add salt to taste. Serve well chilled.

VICHYSSOISE

Very popular in France, this cold potato soup has traveled around the world. It's a country soup, substantial and simple, often served hot in winter. You must give it your personal touch with some herb or spice of your liking. Change it freely; it always turns out well.

Ingredients

1 medium leek (white only), minced
1 large potato, peeled and cubed
2 tablespoons grated onion
1 rounded tablespoon butter
2 cups Beef Stock (page 240), Chicken Stock (page 241), or Vegetable Stock (page 242)
Salt and pepper to taste
1 pinch tarragon
1 pinch garlic powder
⅓ cup sour cream
4 leaves fresh mint

Preparation

Sauté the leek, potato, and onion in the butter for 2 or 3 minutes. Add the stock and cook over medium heat until the potato is soft, 10 or 15 minutes. Let cool, then place in a food processor and blend until creamy and smooth. Season with salt, pepper, tarragon, and garlic powder. Add the sour cream, stirring carefully. Serve chilled, garnished with the mint leaves.

CUCUMBER BREEZE

This is an original, cool, low-calorie soup, something not often seen in aphrodisiac cuisine. I think a soup like this must have refreshed the impetuous lovers of *A Thousand and One Nights*.

Ingredients

1 large cucumber, peeled and diced
2 chives, chopped
1 cup Vegetable Stock (page 242)
1 teaspoon honey
Salt and green pepper to taste
8 ounces low-fat yogurt
1 sprig fresh dill
2 sprigs fresh cilantro

Preparation

Thoroughly blend all the ingredients except the cilantro in a food processor. Serve very cold, garnished with the cilantro.

Appetizers

AMOROUS GAMES,
LEAF BY LEAF, KISS BY KISS

*Whatever happened
to the simple green salad of yore?
It seems to have disappeared,
blasted into the background by the fanfare
of nouvelle cuisine. It has been
dethroned by esoteric combinations
like mango, octopus, and
Chinese noodles dressed with
Teriyaki sauce and Roquefort cheese.*

Until only recently, the noble salad was a forthright composition of fresh lettuce leaves and a simon-pure dressing of oil and vinegar, salt, and in some cases pepper. And I mean pepper with no ceremony; none of this choreography with a foot-and-a-half-long implement that the waiter, with great flourishes, grates above the heads of the diners. That salad is the perfect accompaniment to all the substantial main courses in this book and some hearty soups; there is no need to complicate things with more sophisticated offerings. Nonetheless, in the following pages we suggest some appetizers that would serve as lunch for lovers who meet secretly at noon, for those who like a light supper before making love, or those virtuosos who want to exhibit their culinary skill with a more elaborate menu. If this is the case and you opt for variety, use very small portions. Stuffed, half-asleep lovers are no good for acrobatic feats.

HAVANA-STYLE PRAWNS

Preparation

Cut the whole grapefruit in half. Scoop out the fruit and discard (or use later); set aside the grapefruit halves. Combine the grapefruit segments, prawns, apple, nuts, and herbs. Fill the grapefruit halves with this salad and refrigerate. Just before serving, mix all the ingredients for the sauce except the pepper. Stir well and pour over the salad. As a final touch, add the pepper.

Ingredients

1 whole grapefruit
Segments of 1 grapefruit, membranes removed
1 cup cooked medium prawns
1 apple, cubed
1 tablespoon chopped nuts
2 tablespoons mixed minced cilantro, chervil, and mint

FOR THE DRESSING
2 tablespoons plain yogurt
2 tablespoons lemon juice
1 tablespoon honey
¼ teaspoon mustard
1 tablespoon vegetable oil
Freshly ground black pepper to taste

CRAB AND AVOCADO MOUSSE

Nearly all mousses—or molds—are made using the same basic recipe. All that changes is the ingredient or ingredients that give it flavor—here, shrimp and avocado. A mousse is a discreet way of easing into the preambles of eating or making love; it can be prepared in advance and is light on the stomach. Besides the elegance of the two-color scheme, this one can be made ahead, allowing you to welcome your lover without any last-minute uproar in the kitchen.

Ingredients

1 cup Béchamel Sauce (page 219)
½ cup mayonnaise
3 teaspoons unflavored gelatin
3 tablespoons boiling water
3 tablespoons sherry
1 cup cooked and shredded crabmeat
1 teaspoon lemon juice
¼ teaspoon Salsa Picante (page 214)
Salt and pepper to taste
1 medium ripe avocado, peeled, seeded, and chopped
1 cup cream
Lettuce and lemon slices for serving

Preparation

Mix the béchamel sauce with the mayonnaise. Dissolve the gelatin in boiling water and sherry. Strain, pour into the sauce, and stir well. Divide into 2 portions. Season the crabmeat with lemon juice, salsa picante, salt, and pepper, and add to 1 portion. Place the avocado in a food processor and blend with the cream, salt, and pepper. Add to the other portion.

Lightly oil the sides and bottom of a mold. Spoon in the crab mousse and spread evenly in the mold with a spoon. Carefully pour the avocado mousse on top of the crab so that no air remains between them but they are not mixed together. Refrigerate for 2 hours, until set. Turn out of the mold and serve on lettuce with slices of lemon.

ARTICHOKE WHISPER

Ingredients

2 artichokes
Salt and pepper to taste
1½ teaspoons unflavored
 gelatin
½ cup cream, or ½ cup
 evaporated—not
 condensed—milk

This is one of the few recipes for a mousse made without white sauce. It's very light and original.

Preparation

Boil the artichokes for at least 30 minutes, until the leaves are easily detached. Rinse well and let cool. Remove the pulp from the leaves with a spoon, scrape the choke from the heart, and mash both. Season with salt and pepper.

Dissolve the gelatin in a little boiling water.

Beat the cream until stiff. If you use evaporated milk, it will have to be well chilled, nearly frozen, before beating.

Put all the ingredients in a food processor and blend for a few seconds, until creamy. Place in 2 individual oiled molds and refrigerate for 2 hours. Turn out of the mold and serve on a sauce of your choice (perhaps Homemade Mayonnaise, page 210; Tartar Sauce, page 211; French Dressing, page 211; Light Dressing, page 212; Three-Minute Marinade, page 217).

SHRIMP COCKTAIL

Ingredients

- 1 avocado, peeled, seeded, crushed, and seasoned with 1 teaspoon lemon juice, salt, and pepper
- 1 cup cooked shrimp
- 1 medium apple, peeled and grated
- ½ cup tomato sauce
- 1 tablespoon oil
- 1 teaspoon Worcestershire sauce
- 1 teaspoon mustard
- Lemon slices or mint leaves for garnish

For this salad to look its best you need sherbet goblets or, even better, the kind of crystal bowl that rests on a bed of crushed ice. Remember that aphrodisiacs also appeal to the eye.

Preparation

Place the crushed avocado in sherbet goblets or crystal bowls. Add the shrimp. Combine the apple, tomato sauce, oil, Worcestershire sauce, and mustard. Cover the shrimp with this sauce. Garnish with a lemon slice or mint leaf.

SEVICHE

This Peruvian specialty, made of raw fish or shellfish marinated in lemon juice, has become famous and now travels the world under various names. All these ingredients are aphrodisiac; it's light on the stomach but provides lots of energy. It is served cold and must sit at least six hours after preparation for the lemon to "cook" the fish. This recipe will make four to six small servings, but if you want a real aphrodisiac jolt, it will leave two very contented.

Ingredients

- 1 pound corbina or any firm white fish
- ½ pound prawns or shrimp, peeled and cleaned
- 2 medium onions, minced
- 1 hot green pepper, seeded and cut in very thin slices
- 1 cup lemon juice
- ¼ cup unsweetened orange juice (optional)
- Salt, pepper, and Tabasco to taste (optional)
- Lettuce for serving
- 1 large sweet potato, cut in 6 slices

Preparation

Cut the fish into cubes, discarding the skin and veins. Wash the prawns or shrimp in salted water and dry. If they are fairly large, cut in pieces. Layer the fish, seafood, onions, and hot pepper in a glass or pottery bowl. Add the lemon and orange juices and a little salt and pepper. Cover and refrigerate for at least 6 hours, turning the mixture every hour so that all the fish will be bathed in the juices. Serve on lettuce with slices of cooked sweet potato. The spicy, tart taste of the seviche goes very well with the sweet potato.

ODALISQUES' SALAD

This dish is colorful, fresh, and novel.

Ingredients

- 1 large white onion, thinly sliced
- 1 cup boiling water
- 2 tablespoons tarragon vinegar
- Salt, white pepper, and Tabasco to taste
- 2 oranges, peeled and cut in thin slices
- 4 tablespoons fresh orange juice
- ½ tablespoon honey
- ½ teaspoon Grand Marnier
- 2 tablespoons olive oil
- 4 black olives for garnish
- 4 fresh mint leaves

Preparation

Soak the onion slices in the water with the vinegar, salt, and Tabasco for 10 minutes, then boil for 3 minutes. Remove from the heat and drain the onion on paper towels. Place slices of onion and orange on a serving plate. Cool in the refrigerator. Combine the orange juice, honey, Grand Marnier, and oil. Pour over the salad and garnish with the olives and mint leaves.

SIERRA POTATOES

Ingredients

- 2 cups cooked potatoes
- ½ cup vegetable oil
- ½ cup lemon juice
- 2 tablespoons cream
- 2 tablespoons grated onion
- ½ teaspoon mustard
- 2 hot green peppers, minced
- 1 clove garlic, crushed
- Salt and pepper to taste
- 2 hard-boiled eggs, peeled and quartered
- Black olives
- 3 ripe tomatoes, sliced
- Olive oil to dress salad
- 1 tablespoon chopped thyme
- 1 tablespoon chopped sage

This appetizer is inspired by a dish from the high plateaus of Bolivia. It is as substantial as a full meal. For two discreet lovers you can make half the recipe, followed with soup and dessert.

Preparation

Mash the potatoes before they cool. Place the vegetable oil, lemon juice, cream, onion, mustard, green peppers, garlic, salt, and pepper in a blender or food processor and blend. Pour over the potatoes and combine thoroughly. Place the mixture in an oiled mold, pat down, and chill.

Before serving, turn the potato mixture onto a serving plate. Decorate the top with the hard-boiled eggs and olives. Surround with the sliced tomatoes seasoned with salt, olive oil, thyme, and sage.

GREEK ISLANDS SALAD

Remember what we said about eggplant? In the Mediterranean it is thought to be aphrodisiac and was obligatory in the harems of Turkey, but in some places in Asia, men don't eat it. Run your own test with this recipe.

Ingredients

2 medium eggplants
1 tablespoon lemon juice
Sea salt and black pepper to taste
2 tablespoons minced parsley
1 cup sliced fresh mushrooms
1 clove garlic, crushed
½ pimiento, cut in thin strips
2 tablespoons olive oil
1 tablespoon grappa
4 tablespoons tomato sauce
4 tablespoons plain yogurt (optional)

Preparation

Cut the eggplants in four lengthwise segments. Sprinkle with lemon juice, salt, pepper, and parsley. Set aside for 1 hour at room temperature, then broil for 15 minutes. Sauté the mushrooms, crushed garlic, and pimiento in the oil. Add the tomato sauce and grappa, and cook 5 minutes more. Remove from the heat and pour the sauce over the eggplants. Serve cold with yogurt if desired.

BARILOCHE

Ingredients

4 endives, torn lengthwise
Segments of 1 grapefruit, membranes removed
1 cooked chicken breast

FOR THE DRESSING
2 tablespoons olive oil
¼ cup cream cheese
½ cup plain yogurt
1 teaspoon honey
1 tablespoon vodka
2 tablespoons tarragon vinegar
¼ teaspoon mustard
Salt and pepper to taste
½ pimiento

Preparation

Place the endives and grapefruit slices on a plate, forming a star. Cube the chicken breast and arrange it in the center. Place all the sauce ingredients except the pimiento in a food processor and blend. Pour on the salad and garnish with strips of pimiento.

PEARS ROQUEFORT

This salad should be prepared only moments before serving because pears will turn dark.

Ingredients

1 pear per person
1 tablespoon honey
Juice of ½ lemon
Salt and white pepper
Roquefort Sauce (page 220),
 cold
½ cup ground nuts

Preparation

Cut the pears in half lengthwise. Remove the seeds and fibers, hollowing out the center. Dress the pears with the honey, lemon juice, and a very small amount of salt and pepper. Place the pears facedown on a round plate, forming a star. Pour the cold Roquefort sauce over them and garnish with a sprinkling of ground nuts.

SPINACH CALIFORNIA

Ingredients

1 pound raw spinach, stems
 removed
½ cup ricotta cheese
½ cup pineapple chunks
½ cup broken walnuts
3 strips bacon
3 tablespoons olive oil
1 tablespoon tarragon vinegar
½ teaspoon mustard
Salt and white pepper to taste

Very fresh and original.

Preparation

Wash and dry the spinach. Tear it into smaller pieces. Mix with the ricotta and pineapple chunks. Broil the walnuts and bacon until crisp. Crumble the bacon and add to the salad with the nuts. Combine the oil, vinegar, mustard, salt, and pepper. Pour over the salad just as you serve it.

CREOLE

Ingredients

1 cup cooked saffron rice
1 cup grated carrot
1 teaspoon melted butter
1 tablespoon raisins, soaked in
 rum
1 tablespoon grated coconut
2 tablespoons mayonnaise
¼ teaspoon ground cinnamon
Several drops Tabasco
Orange Whirl (page 216)
1 orange, peeled and divided
 into segments
1 banana, sliced

Exotic and decorative, this salad is ideal for those warm summer evenings that invite love.

Preparation

Combine the rice, carrot, butter, raisins, coconut, mayonnaise, cinnamon, and Tabasco. Oil a mold and press the mixture into it. Refrigerate for 1 hour and turn out onto a plate. Top with the orange whirl sauce and encircle with alternating orange sections and banana slices.

SPRING SHOWER

This salad allows you to use your imagination and the leftovers in your refrigerator. The ingredients can be varied. It is equally delicious with fowl, cold meat, shrimp, and vegetables.

Ingredients

¼ pound shredded smoked
 salmon
1 head lettuce, finely chopped
1 medium carrot, quartered and
 chopped
1 tomato, peeled, seeded, and
 chopped
½ cup new peas
1 hard-boiled egg, quartered
French Dressing (page 211)

Preparation

Combine all the ingredients except the French dressing in a salad bowl. Add the French dressing shortly before serving.

CHILEAN SALAD

Very simply prepared with two aphrodisiac vegetables: tomato and onion.

Ingredients

2 medium onions
Vinegar
3 tomatoes
Red or green chili pepper to
 taste (*ají verde* in Chile)
Salt, pepper, and oil, to taste
2 sprigs fresh parsley

Preparation

Mince the onions and steep them in hot water and vinegar for 30 minutes. Pour off the liquid and dry the onions on paper towels. Peel the tomatoes and cut them into lengthwise spears. Mince the chili pepper and mix with the onions and tomatoes. Dress with salt, pepper, and oil. Sprinkle with parsley.

CELERY SALAD

Ingredients

½ cup golden raisins
1 cup tea
4 stalks celery, strings removed
1 green apple
1 teaspoon lemon juice
1 small avocado
½ cup sliced almonds, toasted
½ cup mayonnaise
Salt (optional)

Preparation

Soak the raisins in the tea. Drain and dry. Chop the celery and chill in cold water for 30 minutes. Drain. Peel and dice the apple. Sprinkle with the lemon juice to keep from turning dark. Peel the avocado and cut it into small pieces. Stir all the ingredients together. Check for seasoning and add salt if desired.

Main Courses

KAMA-SUTRA . . . WELL, MORE OR LESS!

This is the moment
when we get into some serious cooking.
Don't be afraid.
No one's perfect—even the best cooks
make mistakes. What matters
is never to admit it.
I have vast experience in culinary catastrophes,
and I can offer practical suggestions
that Panchita would never approve of.
Her watchword is impeccable
and honest execution; mine is creative bungling.
Try to steer a course
between these two extremes, at the
level of your talent.

In amorous relations there are several preambles, beginning with the first blast of the pheromones passing from the nose to the brain, transmitting the urgent call of the species, and culminating with the skirmishes of teenagers in the backseat of a car, where just when they abandon all caution, prepared to plunge into the abyss of unleashed lust, a policeman appears with a flashlight to douse the flames. Later in life, the same ceremonies of pairing are played out in a manner not unlike the ritual courtship dance of the flamingo. These warm-ups no longer take place in the backseat of a car but behind the office copy machine. As a general rule, the man moves as fast as circumstances allow, but if he possesses a lick of intelligence and good breeding, he will prolong the preambles in his bid to win his companion (the female of the species is rather ticklish on this point). This is the advice the author of the *Perfumed Garden* gives the Grand Vizier of Tunis:

Know, O Vizier (God's mercy be with you!), that if you wish to experience an agreeable copulation, one that gives equal satisfaction and pleasure to both parties, it is necessary to frolic with the woman and excite her with nibblings, kissings, and caressing. Turn her over in the bed, sometimes on her back, sometimes on her belly, until you see by her eyes that the moment of pleasure has arrived. . . .

The equivalent in cuisine of this foreplay in bed is hors d'oeuvres, soups, and appetizers. In Italy it would also be pasta, and in Spain their succulent *tapas*, including a kind of potato and sausage omelet that they consider a prelude, not a performance. Nevertheless, once executed, the steps in the dance of the flamingo that lead lovers to the point of no return is the moment the true talents of either lover or chef will be demonstrated. Erotic manuals devote 90 percent of their practical advice to foreplay and draw a lace curtain over what follows—not for reasons of discretion but because once that final threshold has been crossed, the floodgates of passion are irreversibly opened and there is no handbook that will be of help. Frankly, I know few people able to make love as they consult the instruction manual beside their pillow.

This is how Pablo Neruda describes sensual climax in a sonnet:

. . . and the genital fires transformed into pleasure
race along the narrow highways of the blood,
bursting open like a carnation of the night,
in the darkness, fading and not fading to a ray of light.

In the kitchen, the equivalent of Neruda's "genital fires transformed into pleasure" is the main course. As the orgasm is the culmination of lovemaking, the supreme moment of the hymn to the species, so the main course is the ne plus ultra of a luncheon or dinner. What comes before and after are delightful complements, a necessary part of the liturgy of the table, but only in the main dish does one test the mettle of the cook. I refer to one dish, for even though a banquet tends to feature more than one Homeric offering, these are erotic recipes, and we have already indicated that with a full stomach, no Casanova in the world is worth his salt.

Unless otherwise indicated, these recipes serve two lovers with a hearty appetite, and sometimes there's enough to stoke the fires at dawn.

Fruits of the Sea

CONGER EEL *DE LA CALETA*

Conger is a sea eel with very fine white flesh. It can be baked in the oven very simply with butter, a lot of lemon, and a little salt. In Chile the conger is eaten in soup (Conger Chowder, page 134), dredged in flour and fried, or steamed and served with a variety of sauces, either cold or hot. If you buy the whole eel, ask the fishmonger to skin it and cut off the head and tail, which can be used to make a *fumet* (see comments on stocks in the section on soups), an indispensable base for a good sauce.

Ingredients

1 pound cleaned conger
1 onion, thinly sliced
½ tablespoon red pepper
½ cup vegetable oil
½ cup white wine
Juice of 1 lemon
Salt and pepper to taste
1 tablespoon butter
¼ cup grated cheese
1 tablespoon minced parsley

Preparation

Wash the eel, divide it into pieces, and pat dry. In a heavy baking pan or casserole, sauté the onion and red pepper in the oil for 5 minutes. Add the eel, wine, lemon juice, salt, and pepper. Bake in a hot oven for 10 minutes. Remove from the oven, dot with butter, and sprinkle with the cheese and parsley. Baste in the pan juices, return to the oven, and cook 5 minutes more. Let sit for a few minutes before serving to allow the flavors to blend. Serve with boiled potatoes and parsley.

SEAFOOD NEWBURG

This dish can be prepared with eel, corbina, trout, sea bass, or any fine-fleshed fish. With this recipe you can also use leftover cooked fish.

Preparation

Salt the fish lightly and steam gently for 10 to 15 minutes. Heat the butter, cream, yogurt, and egg yolks in a double boiler. Cook over low heat, stirring constantly; do not allow the mixture to reach a boil. When it thickens, slowly add the whiskey, stock, salt, paprika, and lemon zest. Cover the fish with the sauce and cook over low heat for 5 minutes more.

Ingredients

2 white fish fillets
1 tablespoon butter
½ cup cream
½ cup plain yogurt
2 egg yolks, lightly beaten
1 tablespoon whiskey
4 tablespoons Fish Stock (page 241)
Salt and paprika to taste
½ teaspoon grated lemon zest

CORBINA À LA CRÈME

Can be made with salmon, conger eel, or other firm-fleshed fish.

Ingredients

1 pound corbina (middle section)
Salt and white pepper to taste
Juice of 1 lemon
¼ cup vodka
2 sprigs fresh rosemary
2 tablespoons butter
½ cup cream
1 pinch nutmeg
½ cup shredded almonds, blanched and toasted

Preparation

Wash the fish and pat dry. Season with salt, pepper, and lemon juice. Place in a buttered baking dish. Sprinkle with the vodka and fresh rosemary, and dot with butter. Cover with aluminum foil and cook in a medium oven for 20 to 25 minutes. Remove from the oven, add the cream, nutmeg, and toasted almonds, and return to the oven without foil for another 5 minutes before serving.

HAKE DIANA

If your budget won't stretch for a high-priced fish, that's no reason to deprive yourself of an aphrodisiac treat.

Ingredients

1 pound hake, flounder, or
 similar fish
Salt and pepper to taste
1 tablespoon butter
½ grapefruit
⅓ cup ricotta cheese
½ cup Homemade Mayonnaise
 (page 210)
Juice of 1 lemon
1 teaspoon capers
2 pickled pearl onions
½ teaspoon minced cilantro
Hard-boiled eggs and
 watercress for garnish

Preparation

Season the fish with salt and pepper, dot with butter, and place in a roasting pan. Remove the membrane from the grapefruit segments and place pieces on the fish. Squeeze any juice remaining in the grapefruit over the fish. Cook over medium heat for 15 to 25 minutes; the fish is done when the flesh separates easily from the spine. Remove from the heat, let cool, and place on a platter. Place the ricotta, mayonnaise, lemon juice, capers, pearl onions, and cilantro in a food processor and blend. Thin with juices from the fish to make a smooth sauce, check the seasoning, and pour over the fish. Garnish with hard-boiled eggs and watercress.

CURRIED SEA BASS

A delicious, substantial dish to fortify demanding lovers.

Preparation

Boil the onion, carrot, garni, pepper, and salt in the water for 15 minutes. Rub the fish with lemon and place in a cooking pot. Gently pour the boiling stock over it. Cook for 15 minutes on very low heat. Remove the fish, taking care not to break it apart, and keep warm. Reserve the liquid.

To make the sauce, melt the butter and add the curry, vinegar, apple, and sugar, stirring well. Add the flour and cook for 5 minutes over low heat. Still stirring, gradually add the liquid from the fish, coconut milk, and grated coconut, and cook over low heat 10 minutes more. Check the seasoning and add salt and pepper to taste. Keep warm but do not allow to boil. Add the cream with the egg yolk. Serve the fish and sauce with rice pilaf.

Ingredients

½ small onion, quartered
1 half carrot, sliced
1 garni of aromatic herbs
Salt and pepper to taste
1 cup water
2 sea bass fillets, skinned and washed
Juice of ½ lemon

FOR THE SAUCE
1 teaspoon butter
1 teaspoon curry powder
½ tablespoon vinegar
½ tart apple, peeled and grated
1 pinch brown sugar
1 teaspoon flour
Liquid from cooking fish
½ cup coconut milk
2 heaping tablespoons grated coconut
Salt and pepper to taste
2 tablespoons cream
1 egg yolk, lightly beaten

STUFFED TROUT

Is your lover an impenitent fisherman? Very likely his only trophy will be some rather pathetic trout. With this recipe they can be turned into a source of pleasure.

Preparation

Wash the fish well, pat dry, and season with lemon juice, salt, and pepper. Place the ham, pickle, celery, and chives in a food processor and make a paste. Add the egg yolk and ¼ cup of the cream. Stuff the trout with this filling and fasten the edges with wooden toothpicks. Place the fish in a buttered roasting pan and sprinkle with the wine. Cook in a medium oven for 15 minutes. Remove, pour on the remaining ¼ cup cream and decorate with the pineapple slice, and cook 5 minutes more in low heat. Serve warm, sprinkled with fresh parsley.

Ingredients

2 medium trout, cleaned, with heads and tails removed
Juice of 1 lemon
Salt and pepper to taste
½ cup chopped ham
1 small pickle
1 tablespoon minced celery
½ tablespoon minced chives
1 egg yolk
½ cup cream
2 tablespoons butter
¼ cup dry white wine
1 pineapple slice
1 tablespoon minced parsley

SALMON NEPTUNE

Easy, quick, light, and very stimulating, this is the ideal dish for impetuous lovers. Remember that the pasta must be cooked *al dente*; otherwise, it's like eating worms.

Ingredients

1 pound fresh salmon
Salt and pepper
2 tablespoons lemon juice
4 tablespoons olive oil
1 sprig fresh dill
½ pound angel hair pasta
1 large tomato, quartered
2 tablespoons minced cilantro
3 tablespoons minced fresh
 chives

Preparation

Season the fish with salt, pepper, 1 tablespoon of lemon juice, and a little olive oil, and place the dill on top. If you do not have a utensil for steam cooking, better buy one fast, but for now you can improvise by placing a large colander inside a large pot containing a few inches of water. Only the steam should reach the fish. Cook for approximately 15 minutes. The salmon should be nearly raw inside.

As the fish is cooking, start to boil 8 cups of water for the pasta. Add 1 tablespoon of oil and salt to the water. Remove the fish from the colander, set aside the dill, and cut the salmon into small pieces. Cook the angel hair pasta in the boiling water for only a few minutes, *al dente*. Remove from the heat and drain well. Mix with the salmon, tomato, cilantro, and chives. Season with 1 tablespoon of olive oil, 1 tablespoon of lemon juice, and salt and pepper to taste.

PARK AVENUE LOBSTER

This is a very easy way to prepare the queen of the seas, but since lobster is expensive, I suggest you read the recipe carefully.

Ingredients

1 lobster, cleaned
4 tablespoons olive oil
2 tablespoons minced onion
2 tomatoes, peeled, seeded, and chopped
1 pinch garlic powder
1 tablespoon chopped parsley
½ cup Fish Stock (page 241)
½ cup sherry
4 tablespoons cognac
Salt and cayenne pepper to taste
2 tablespoons butter

Preparation

Cut the lobster into medallions and sauté in the oil on both sides. Remove from the pan. In the same oil, sauté the onion until transparent. Add the tomatoes, garlic powder, and parsley. Stir until well coated and add the lobster, stock, sherry, and cognac. Season with salt and cayenne pepper. Cover the skillet and cook for 20 minutes over low heat. Remove the medallions from the skillet. Place the remaining contents of the skillet and the butter in a food processor and blend. Bathe the lobster medallions in this sauce and serve.

SQUID LUCULLUS

If you want squid in their own ink, order it in a restaurant. This recipe is easy and exquisite.

Ingredients

2 slices bread, crusts removed
½ cup milk
1 tablespoon chopped onion
1 clove garlic, crushed
2 tablespoons butter
1 pinch nutmeg
Salt and white pepper to taste
½ cup cooked spinach
1 egg yolk
½ cup chopped cooked shrimp
4 medium squid, cleaned
3 tablespoons oil
Sliced tomato for garnish

Preparation

Soak the bread in the milk. Sauté the onion and garlic in 1 tablespoon of butter with nutmeg, salt, and pepper. Add the bread soaked in milk, spinach, and egg yolk. Stir well. Add the shrimp and remaining butter. Cook for 5 minutes, stirring until smooth. Stuff the squid pockets ¾ full with this mixture. Close the opening with a wooden toothpick and fry one by one in the hot oil. Serve with sliced tomato for garnish.

SAFFRON SHRIMP

Remember that in the East saffron is thought to be a powerful stimulant. This recipe was given me by my friends Francesca and Marisa, who teach Italian cooking to American tourists in Milan.

Ingredients

8 large shrimp, peeled and cleaned
1 rounded tablespoon butter
½ cup Mascarpone cheese or very fresh cream cheese
½ teaspoon powdered saffron
Salt and pepper to taste
1 pinch paprika
1 pinch garlic powder
½ pound *farfala* pasta (bowtie or butterfly)
1 teaspoon olive oil

Preparation

Sauté the shrimp in the butter, then set aside. In the middle of the bowl in which you plan to serve the pasta, whip the cheese with a spoon and slowly add the saffron until you have a yellow cream. Add salt, pepper, paprika, and garlic powder, and stir well. Cook the pasta in 8 cups of hot water until *al dente*. Drain, add the oil, and stir. Immediately pour onto the cheese and stir until the pasta is thoroughly coated with the cheese. Arrange the shrimp on top and serve.

PSEUDO PAELLA

Real paella is prepared in a special pan (a *paellera*) over coals and takes hours of arduous work cleaning the seafood and chopping the other ingredients. It's a labor of love and patience, and not worth the effort for two people. This is an imitation that would make a legitimate Spaniard break out in hives—God forgive me—but that works in the same way as a preamble to lovemaking because all the ingredients are aphrodisiac.

Ingredients

1 tablespoon minced onion
3 tablespoons olive oil
1 pinch turmeric
1 pinch saffron
1 pinch paprika
2 cups assorted seafood (squid, shrimp, scallops, clams, and others), peeled and cleaned
1 small tomato, chopped
1 clove garlic, crushed
2 cups Fish Stock (page 241), or concentrate
1 cup white rice
6 mussels in the shell
Red pepper, cut in strips
Salt and pepper to taste

Preparation

In a skillet, sauté the onion in the oil until transparent but not yellow. Add the spices and sauté 1 minute more. Add the seafood—but not the mussels—tomato, and garlic. Cook for 5 minutes, turning occasionally. Add the stock. When it reaches a boil, sprinkle in the rice. Lower the heat, cover the skillet, and cook for 15 minutes. Arrange the mussels and red pepper on top, and cook for 5 to 10 minutes more. Test to see if the rice is done and check the seasoning. Add salt and pepper if necessary. Remove from the heat, uncover your pseudo paella, and let the steam evaporate for 2 minutes before serving.

Fowl

DUCK À LA PÊCHE

Ingredients

1 duck (about 3½ pounds), cut up
2 tablespoons lemon juice
1 tablespoon sugar
4 tablespoons vegetable oil
1 cup Chicken Stock (page 241)
1 can (8 ounces) peach halves in syrup, drained and syrup reserved
½ cup sherry or other sweet wine
1 clove garlic, crushed
1 bay leaf
Salt and pepper to taste

Usually duck is daunting to cook because it tends to be either as hard as rubber or swimming in its own grease. If you have the time, though, this is a surefire recipe. Half a duck really isn't worth the effort. This recipe will feed four to six people, but it could be served as the only dish to two lovers who have a hearty appetite and are prepared to savor it slowly and later recover strength while eating the leftovers.

Preparation

Wash the duck pieces, pat them dry, and rub them with the lemon juice. Sauté the duck with the sugar in very hot oil. Add the stock, peach syrup, sherry, garlic, bay leaf, salt, and pepper. Cover and cook for 1 hour, watching that the duck doesn't stick to the bottom of the pan. Remove the duck and put it in a baking dish.

Discard the bay leaf and skim the fat off the pan juices. The best way to do this is to cool the juices until the fat congeals. Cover the duck with sliced peach spears, pour the juices over both, cover the dish with aluminum foil, and place in a hot oven for 15 minutes before serving.

MEXICAN CHICKEN *MOLE*

Ingredients

4 chicken thighs
1 cup white wine
1 cup water
Salt and pepper to taste
1 small bay leaf
1 small banana
¼ red pepper
¼ green pepper
¼ cup peeled, chopped
 tomatoes
1 clove garlic
¼ large onion
1 pinch ginger
1 ounce unsweetened
 chocolate, melted
1 tablespoon blanched
 almonds, chopped
1 tablespoon salted peanuts,
 crushed
1 tablespoon raisins, soaked in
 stock

This dish works best when prepared the previous day, which makes it more savory and leaves you time enough to invent other erotic recourses for the day of your rendezvous. Can be served with rice and beans.

Preparation

Place the chicken, wine, water, salt, pepper, and bay leaf in a casserole and boil for 20 minutes. Drain, reserving the liquid, and discard the bay leaf. Skin the thighs and return to the casserole or a large skillet. Place the liquid and all the other ingredients except the almonds, peanuts, and raisins in a food processor and blend. Cover the chicken with this mixture and cook for 45 minutes over low heat. The next day add the almonds, raisins, and peanuts before warming to serve.

CHICKEN *ALEGRE*

Preparation

Sauté the bacon and chicken pieces in the oil until golden. Add the corn, garlic, and vinegar, and cook for 15 minutes over low heat. Remove from the heat and place the chicken in a baking dish. Stir the yogurt and cream into the pan juices. Season with salt and nutmeg. Pour over the chicken. Cover with the spinach leaves and top with tomato slices. Cook in the oven for 15 minutes. The dish will be a beautiful green highlighted with the red of the tomatoes.

Ingredients

2 slices hickory-smoked bacon,
 diced
2 cups chicken, cut in large
 pieces
2 tablespoons olive oil
1 cup fresh corn kernels
1 clove garlic, peeled and
 minced
1 tablespoon tarragon vinegar
1 cup plain yogurt
½ cup heavy cream
Salt and nutmeg to taste
1 pound fresh spinach, stems
 removed
2 large tomatoes, peeled and
 sliced

HAREM TURKEY

Since this book is for the amorous couple, we don't include directions for a whole turkey, which would feed an entire family, but half a turkey breast is delicious when cooked by this recipe.

Ingredients

½ turkey breast, cut into 4 pieces
¼ turnip
½ carrot
¼ onion
½ stalk celery
Salt and pepper
4 tablespoons olive oil
1 cup water
1 thick slice bread, crust removed
¼ cup minced parsley (leaves only)
1 garlic clove, peeled and crushed
1 cup ground walnuts
Black olives and tomato slices for garnish

Preparation

Sauté the turkey, turnip, carrot, onion, celery, salt, and pepper in 2 tablespoons of the olive oil. Add the water, cover, and cook for 45 minutes. Remove from the heat, drain, reserving the juices, and set aside the vegetables.

Remove all the bones from the turkey, leaving only the edible part. Soak the bread in 1 cup of the reserved turkey juices. Place in a food processor with the parsley, garlic, and walnuts and blend. This will make a thick paste; thin with what is needed of the remaining olive oil. Cover the turkey with this mixture and garnish with the black olives and tomato slices.

Isabel Allende

ROMANTIC CHICKEN

Easy, but should be prepared the day before. It can be served with saffron rice and raisins.

Ingredients

- 1 chicken breast
- 1 teaspoon vinegar
- Salt and white pepper
- 4 tablespoons butter
- ¼ onion, grated and drained
- ½ leek, chopped
- 1½ cups milk
- 1 teaspoon flour
- 1 pinch nutmeg
- 4 tablespoons sherry

Preparation

Cut the breast in 2 pieces, rub with the vinegar, and let stand for 15 minutes. Rinse in cold water and season with salt, pepper, and 1 tablespoon of butter, melted. Refrigerate the chicken overnight. The next day, sauté the onion and leek, and then the chicken, in the remaining 3 tablespoons of butter. Add the milk and cook over low heat for 30 minutes. Remove when tender. Add the flour to the pan juices and cook over low heat, stirring, to make a sauce. Season with nutmeg and sherry. Pour the sauce over the chicken breasts.

CHICKEN BREAST VALENTINO

Preparation

In a saucepan, mix the butter with the flour. When it is yellow, add the cream and stock, stirring to avoid forming lumps. Add the chicken breast and season with salt and pepper. Cook for 30 minutes, covered, over low heat, turning the pieces from time to time. After removing from the heat, add the egg yolk, red pepper, Kahlua, salsa picante, and Worcestershire sauce. Cook 10 minutes more on very low heat, stirring gently. Sprinkle the peanuts on top. This is even better reheated the next day.

Ingredients

- 1 tablespoon butter
- 1 tablespoon flour
- ½ cup cream
- ½ cup Chicken Stock (page 241)
- 1 whole breast of young hen, cut in quarters
- Salt and pepper to taste
- 1 egg yolk beaten with a little milk
- 1 tablespoon cooked, chopped red pepper
- 4 tablespoons Kahlua liqueur
- ½ teaspoon Salsa Picante (page 214)
- ½ teaspoon Worcestershire sauce
- ¼ cup chopped roasted peanuts

COQ AU VIN

Ingredients

1 medium chicken
½ cup diced bacon
1 medium onion, chopped
2 young carrots, sliced
2 cloves garlic, crushed
2 tablespoons olive oil
1 cup pearl onions
1 bay leaf
1 garni of aromatic herbs
2 tablespoons cognac
2 cups red wine (preferably Burgundy)
½ cup dried mushrooms, previously soaked in stock
1 cup concentrated chicken stock
1 tablespoon maple syrup
2 level tablespoons flour
1 tablespoon butter
2 cups sliced fresh mushrooms
Salt and pepper to taste
Croutons for serving

The classic recipe is made with a rooster, but experience has taught us that a roasting hen or plump young fryer is best. This dish is tastier when it sits for a while, even from the day before. It will serve four to six people, and it doesn't make sense to prepare less since it keeps well in the refrigerator or freezer.

Preparation

Cut the chicken into pieces, discarding the neck and wings. Sauté the bacon, onion, carrots, and garlic in the oil for 5 minutes. Add the pearl onions, bay leaf, and garni. Add the chicken pieces, smother in cognac, and set afire. When the flame burns down, add the wine, dried mushrooms, stock, and maple syrup. Cook over high heat until the liquid is reduced to 1½ cups. In a separate pan, make a roux of flour and butter. Gradually add to the chicken, along with the fresh mushrooms, salt, and pepper to taste. Cook 10 minutes more over low heat to blend the flavors. Before serving, remove the excess fat. Serve with croutons.

JELLIED PARTRIDGE

Ingredients

4 cleaned partridges
¼ cup cognac
Salt
6 small onions, quartered
½ cup olive oil
1 teaspoon sugar
1 piece orange zest
2 cloves
2 bay leaves
1 tablespoon vinegar
½ teaspoon pepper
½ cup concentrated chicken stock
1 large cup peeled grapes
1 bunch red grapes for garnish

This was my grandmother's recipe, and it never failed. It's a substantial, cold, aphrodisiac dish that can be made one or two days in advance and carried from the refrigerator to the table or bed.

Preparation

Bind the feet and wings of the birds so they don't come apart during cooking. Rub the wings with cognac and salt. Sauté the onions in the oil with the sugar until golden but do not burn. Add the orange zest, cloves, bay leaves, vinegar, pepper, stock, and the remaining cognac. Add the partridges, moisten with this mixture, and cook for 15 minutes. Add the peeled grapes and cook 15 minutes more. Turn off the heat and allow to cool. The partridges will be set in jelly. Before serving cold, remove the orange zest, bay leaves, and cloves. Arrange on a platter and garnish with the grape cluster.

Meat

LAMB WITH SPINACH AND APRICOTS

Even though lamb is not thought to be aphrodisiac, other ingredients in this recipe are. The combination of the slightly bitter taste of the spinach and the sweet aroma of the apricots is absolutely delicious. This is a perfect catalyst for an intimate discussion of sensual pleasures. It serves two easily and is good with plain white rice.

Ingredients

1 pound lamb, cut in large
 cubes
1 clove garlic
1 tablespoon vegetable oil
1 cup stock
1 pound spinach leaves, washed
 and stems removed
1 tablespoon butter
1 teaspoon flour
1 small can apricots in juice
½ teaspoon grated lemon zest
Salt, pepper, and nutmeg to
 taste
½ cup cream

Preparation

Sauté the lamb and garlic in the oil until lightly browned. Add the stock. Cook in a heavy casserole dish, covered, until tender, 45 to 60 minutes. Remove from the heat and place in a Pyrex baking dish or, even better, a pottery baking dish, and cover with spinach leaves. Melt the butter in a small saucepan or skillet. Add the flour and stir well over low heat. Add the juice from the apricots and cook for 2 minutes. Remove from the heat and season with lemon zest, salt, pepper, and nutmeg. Add the cream, stir well, and pour over the spinach. Decorate with the apricots, cover with aluminum foil, and bake in the oven for 20 minutes.

FILET MIGNON BELLE EPOQUE

Ingredients

2 cups good red wine
½ onion, minced
½ carrot, minced
2 chicken livers
3 anchovy fillets
2 tablespoons cream
Salt, pepper, and garlic powder
 to taste
2 large filets mignon
1 teaspoon olive oil

This sauce is divine and the fillets never fail. Buy the best; in this case it's a good investment that will pay generous dividends.

Preparation

In a casserole, cook the wine, onion, and carrot for 15 minutes. Place in a food processor with the livers and anchovy fillets, and blend. Return to the casserole and cook 15 minutes more, stirring. Lower the heat, add the cream, salt, pepper, and garlic powder, and stir. Keep warm over the lowest possible heat.

In the meantime, in a hot skillet, sauté both sides of the filets mignon in the oil. Try to brown on the outside and keep rare inside. Pour the sauce over the filets mignon and serve immediately.

CHAMPAGNE TENDERLOIN

A bottle of champagne is a lot for two normal lovers. There's always some left over, and once uncorked the bubbles dissipate and the champagne turns to a yellowish liquid with no soul or personality. Use the dregs for this recipe. Since it takes almost no time to prepare, you can have everything ready and—after heating up with caresses, champagne, and assorted hors d'oeuvres—the two of you can whip into the kitchen and make dinner in twenty minutes.

Ingredients

1 tablespoon olive oil
2 lean beef tenderloins
Salt and coarse black pepper to
 taste
2 heaping tablespoons large
 golden raisins
1 garni of assorted herbs
1 clove garlic
½ cup champagne
½ cup peeled and chopped
 tomatoes

Preparation

Heat the oil. Brown the beef on one side. Season with salt and pepper. Turn and brown the other side. Add the raisins, herbs, garlic, and champagne. Cover and cook for 15 minutes. Add the tomatoes, cook 5 minutes more, and serve.

FILLET ORIENTALE

Ingredients

1 pound beef fillet, cut in
 narrow strips
2 tablespoons oil
½ onion
1 clove garlic, minced
½ cup minced celery
6 slices fresh ginger or 1
 teaspoon powdered ginger
½ cup minced red pepper
½ cup minced fresh mushrooms
1 teaspoon chopped sage
1 teaspoon chopped tarragon
5 tablespoons soy sauce
1 teaspoon curry powder (less if
 very hot)

Quick, easy, and infallible. Serve on noodles *al dente* or white rice.

Preparation

Sauté the beef strips in hot oil, then remove from the skillet. In the same oil, sauté the onion, garlic, celery, ginger, and pepper for 6 to 8 minutes. Add the mushrooms and cook for 10 minutes over medium heat. Season with the sage, tarragon, soy sauce, and curry powder. Combine with the meat and serve.

SPICY RABBIT

Don't serve rabbit to cat lovers, they'll faint. This is an old, old recipe from Peru. One whole rabbit, however skinny, is a lot for two people, but it's not usually sold in lesser quantities. This recipe is plenty for four to six people. You can freeze half and serve it on a different occasion or to a different guest (if monogamy isn't your forte).

Ingredients

1 large rabbit, cleaned and
 cut up
Juice of 2 lemons
2 tablespoons lard
2 medium onions, grated or
 minced
Salt to taste
1 teaspoon paprika
1 teaspoon Salsa Picante
 (page 214)
1 cup stock
½ cup sherry and port
½ cup ground walnuts

Preparation

Rub the rabbit with lemon juice and let stand in a vessel with 2 cups of water for 6 hours. Remove and dry well. Sauté the pieces in bubbling lard with the onions, salt, paprika, and salsa picante. When the rabbit is browned, add the stock and sherry. Cover the casserole and cook over low heat for 50 minutes. Add the ground walnuts and cook an additional 10 minutes.

RABBIT HAMBURGERS

This recipe was born of leftovers from wild hare. During a visit in the country, my grandfather went out hunting and came back with half a dozen he had bagged. Once they were skinned and the buckshot picked out, there wasn't a lot left to eat but enough to inspire these hamburgers. They can be made with chicken, duck, turkey, and other aphrodisiac meats, and accompanied with mushrooms sautéed in garlic butter.

Ingredients

3 strips bacon
1 teaspoon vegetable oil
2 cups cooked and ground rabbit
½ cup bread soaked in milk
1 pinch mustard
Salt and white pepper to taste
½ cup cream
2 eggs yolks, lightly beaten
½ cup bread crumbs
2 tablespoons soft butter
1 cup Sherry Sauce (page 220) or Red Wine Sauce (page 223)

Preparation

Cut the bacon in small pieces and brown in the oil. Add the ground meat, bread, mustard, salt, and pepper. Mix the cream with the egg yolks. Add to the mixture in the pan and cook for 5 minutes, stirring, over low heat. Remove and let cool. Shape 4 small hamburgers from this mixture, dip in the bread crumbs, and cook in the butter for 5 minutes on each side. Place the hamburgers in a baking dish and bake in a hot oven 5 minutes more, so they fluff up. Serve with a sauce of your preference.

ROSEMARY VENISON

It's not always easy to find venison—that is, unless you have a friend who's a hunter—but there are times of the year when it appears in the butcher shops. The recipe is for six; don't waste your time preparing less. It will keep several days in the refrigerator. If you want to make an unforgettable impression on your partner, serve stuffed apples with the venison.

Ingredients

2 pounds deer, best cuts, off the bone
3 teaspoons olive oil
3 medium onions, quartered
¼ teaspoon ground cinnamon
1 tablespoon salt
¼ teaspoon ground cloves
1 sprig rosemary (or about 6 leaves)
2 cups red wine
½ cup port
½ cup heavy cream

Preparation

Cut the meat in large cubes and brown in the oil. Add the onions, cinnamon, salt, cloves, and rosemary, and stir until browned. Add the wine and port. Cover and cook over low heat for 30 minutes. (To prevent burning, it's a good idea to set a flame-tamer between the pot and the burner.) Remove and gently add the cream.

If you decide to serve with baked apples, you need 1 green apple per person. Cut out the stem end and remove the seeds with a small spoon, hollowing out the core. Fill the core with a combination of cherry or red currant jelly, a little sweet wine, sugar, cinnamon, and the merest pinch of clove. These apples are great with many meat dishes. Keep them in mind.

KIDNEYS MONTMARTRE

Ingredients

1 pound calf kidneys
4 tablespoons vinegar
2 tablespoons butter
1 clove garlic, crushed
1 tablespoon chopped parsley
2 tablespoons fresh chives
Salt and white pepper to taste
½ cup dry white wine
1 teaspoon Worcestershire
 sauce or meat extract

For anyone who likes kidneys and believes in their erotic properties, this is a quick recipe. Serve with rice.

Preparation

Clean the fat and veins from the kidneys and slice. Soak in water and vinegar for 30 minutes. Drain and dry with paper towels. Sauté in a skillet with the butter, garlic, parsley, chives, salt, and pepper. When barely done, 10 minutes, splash in the wine and Worcestershire sauce (or extract). Don't allow to boil because that makes kidneys tough.

BRAINS ITALIAN STYLE

We've already mentioned that in some countries the brain of certain animals is considered to be very aphrodisiac. This recipe from the south of Italy has the great advantage of your not knowing what you're eating. If you have to buy the whole brain and it weighs more than what is called for here, double the recipe and drum up a small orgy, because this is a dish that won't keep. Serve with rice.

Ingredients

1 pound cow brains
2 eggs
2 tablespoons water
1 tablespoon grated Parmesan
 cheese
½ teaspoon chopped cilantro
Salt and pepper to taste
½ cup bread crumbs
½ cup olive oil
1 lemon, quartered

Preparation

Clean the brains well and boil for 5 minutes. Drain and remove the skin. Cut into slices 2 inches long. Beat the eggs lightly and add the water, cheese, cilantro, salt, and pepper. Dip the brains in this batter and then in the bread crumbs. Fry in the oil on both sides until browned. Serve with rice and the lemon quarters.

ALPINE OSSO BUCO

This is one of the most substantial dishes in world cuisine. Bone marrow is credited with all kinds of nutritional and erotic properties. Serve with boiled potatoes or rice.

Ingredients

6 pieces veal shin bone
2 tablespoons vegetable oil
2 onions, chopped
2 carrots, sliced
1 tablespoon flour
1 cup dry white wine
Salt and pepper to taste
3 tablespoons tomato purée
1 sprig parsley, chopped
1 sprig chervil, chopped
1 clove garlic, crushed
Grated zest of ½ orange
Grated zest of 1 lemon

Preparation

Brown the meat in hot oil. Add the onions and carrots, sprinkle with flour, and cook until browned. Add the wine and enough boiling water to cover the meat. Season with salt and pepper. Add the tomato purée, parsley, chervil, and garlic. Cook over low heat for 1½ hours (45 minutes in a pressure cooker). Shake the pot from time to time to prevent sticking. Set aside the pieces of meat in a deep baking dish and keep warm in the oven. Add the orange and lemon zests to the sauce and cook 10 minutes more. Strain the sauce and pour over the meat.

Vegetarian Dishes

ASPARAGUS AND CAVIAR PASTA

Delicious, extremely attractive, and very aphrodisiac, but not cheap. You don't have to use Beluga caviar; it can be a less costly one. You must not fail to tell your lover how complicated, expensive, and aphrodisiac this dish is and how you expect payment—in carnal tender—for your money and trouble.

Ingredients

2 tablespoons olive oil
Salt
½ pound noodles
6 small asparagus
1 cup Light Dressing (page 212)
1 hard-boiled egg, chopped
1 tablespoon capers
1½ ounces caviar (the best you can afford; it can even be red)
Lemon quarters for garnish

Preparation

Set 8 cups of water to boil with 1 tablespoon of oil and some salt. Cook the noodles *al dente*. As they are cooking, steam the asparagus for 5 minutes (they should be crisp). Cut into pieces of about 1 inch. Sprinkle with the remaining 1 tablespoon of oil. Remove the noodles and drain. Combine with the sauce and asparagus in a baking dish already warmed in the oven to keep from cooling. Sprinkle on the chopped egg and capers. Last of all, place a little mound of caviar in the middle. Garnish with lemon quarters around the dish. Serve immediately.

NOODLES WITH ARTICHOKE

I recommend this one for reconstituting exhausted and ravenous lovers because it is saturated with aphrodisiacs. It's also good as salad the next day and can be prepared in ten minutes.

Ingredients

- ⅓ cup olive oil
- 1 cup bottled marinated artichokes, chopped
- 1 small jar of pimientos
- ¼ cup piñon nuts (optional)
- ½ pound noodles
- 2 large ripe tomatoes
- 6 large black or green olives
- 2 ounces goat cheese, crumbled
- 2 tablespoons minced fresh sweet basil
- Salt and pepper to taste

Preparation

Heat the oil and the liquid from the artichokes and pimientos in a small skillet. And the piñon nuts if using. Cook the noodles *al dente* as you chop the tomatoes and olives. Combine with the chopped artichokes and pimientos. Drain the noodles and return them to the same warm pot. Add all the other ingredients, including the goat cheese and sweet basil, and stir. Season with salt and pepper.

CURRIED ZUCCHINI

Quickly prepared, with exotic results. If you give this dish some Oriental name taken from *A Thousand and One Nights*, you can produce an enormous impression with little effort. Serve with white rice or, for an even more erotic effect, saffron rice.

Ingredients

- 4 medium zucchinis
- 1 tablespoon oil
- ½ onion, grated
- ½ carrot, grated
- 2 tablespoons grated coconut
- 1 teaspoon curry powder
- 4 dates, cut in strips
- ½ cup coconut milk or sweet wine
- ½ cup cream

Preparation

Cut the zucchinis in half lengthwise. Warm the oil and rapidly sauté the zucchinis on both sides. Remove from the skillet. In the same oil, sauté the onion, carrot, coconut, curry powder, and dates for 5 minutes. Add the coconut milk and cook over low heat for 10 minutes. Place the zucchinis in the sauce and cook 10 minutes more. Turn off the heat, add the cream, and serve.

EGGPLANT TO A SHEIK'S TASTE

This is one of those old, old recipes that every good lover should know. It's for two, but I recommend doubling it. Serve with rice.

Ingredients

1 onion
1 clove garlic
4 tablespoons olive oil
1 pinch ground cloves
1 teaspoon sugar
Salt and pepper to taste
1 large or 2 medium eggplants
2 tomatoes
Butter
3 tablespoons grated Parmesan
 or Gorgonzola cheese

Preparation

Mince the onion and garlic, and sauté lightly in the oil. Add the cloves, sugar, salt, and pepper. Cover the skillet and cook over low heat for 3 minutes. Meanwhile, cut the eggplant and tomatoes in thick slices, and preheat the oven to 400 degrees. Arrange the eggplant in the bottom of a buttered baking dish. Cover with half of the onion and garlic mixture and sprinkle with half of the cheese. Place the tomatoes in a separate layer. Add the remaining onion and garlic mixture, and, finally, the remaining cheese. Dot with butter, cover the baking dish with aluminum foil, and bake for 30 minutes. Remove the foil and leave the dish in the warm oven until the eggplant is tender, about 10 minutes.

PUNJAB KEBABS

Inspired by the smells and tastes of India. You can vary vegetables to your taste. This is enough for four large kebabs.

Ingredients

1 small onion
½ red pepper
½ green pepper
1 medium zucchini
6 large mushrooms
Juice of ½ lemon
1 jar (6 or 7 ounces) marinated
 artichoke hearts
4 pieces tofu, cubed
Quick Curry (page 225)

Preparation

Wash, dry, and cut the vegetables into large pieces. Place alternately on skewers, along with the artichoke hearts and tofu, and sprinkle with lemon juice and oil from the artichokes. Heat the oven and bake the kebabs for 20 minutes. Serve covered with the curry sauce.

RISOTTO LORI

Each and every ingredient is aphrodisiac! With this recipe Lori Barra, the woman who did the graphic design for this book (we keep it all in the family), seduced my son, wrenching him from the grip of loneliness following a sad divorce.

Ingredients

3 cups Vegetable Stock
(page 242)
4 tablespoons olive oil
2 tablespoons butter
3 tablespoons minced onion
1 tablespoon grated garlic
1 cup chopped brown
mushrooms
1 cup chopped Portobello
mushrooms
1 cub arborio rice
1 tablespoon chopped rosemary
½ teaspoon grated fresh
nutmeg
½ cup white wine
1 teaspoon truffled olive oil
(optional)
Salt to taste
½ cup grated fresh Parmesan
cheese

Preparation

Warm the stock, then remove from the heat. Put 3 tablespoons of olive oil and 1 tablespoon of butter in a skillet and sauté the onion, garlic, and brown and Portobello mushrooms. Set aside on a plate. In the same skillet, put the remaining 1 tablespoon of oil and 1 tablespoon of butter and lightly brown the rice. Gradually add the rosemary, nutmeg, and 2½ cups of the stock. Cook over low heat, stirring occasionally, for 20 minutes. Return the mushrooms to the skillet, pour in the remaining broth, and cook 10 minutes more. When the rice is tender, not dry, add the wine and truffled oil, and cook a few minutes more. Check the seasoning and add salt if desired. Remove from heat, add the grated cheese, and serve warm.

Desserts

THE HAPPY ENDING

*After an erotic meal
that spoonful by spoonful
has led the lovers
through amorous games and
foreplay to the bed,
there should be a happy
ending: dessert.
Dessert is the crown
of the intimate orgy:
mangos flambé au rhum
or profiteroles
filled with strawberries
and blanketed
with a velvety mantle
of chocolate.*

In deluxe restaurants there is usually a chef whose sole assignment is sweets, a fortunate fellow who spends his days among aromatic spices, whipped cream, fruits, tarts, cakes—that is, doing exactly what I would like to do to earn my living. Desserts are to the table what baroque concerts are to music: a delicate art. But sugar is lethal; it puts on pounds, eats your teeth, and ruins your skin—to say nothing of the dangers of diabetes, cholesterol, and other ills invisible to the eye but, over the course of a lifetime, heart-stopping. Learn to prepare desserts with grace and serve them with feeling, but try not to eat them. Once you have the taste for sugar, it, like caresses, becomes an addiction. Toy with your spoon, moving the sweet around on your plate until it looks like something you threw up, then slyly throw it under the table—this is one of those times it's handy to have a dog—or simply don't give any to yourself and tell your lover you're keeping your serving for some erotic game later on. There's nothing as aphrodisiac as a *mousse au chocolate* on the skin, but try to make sure it's on *you*, because if you get it on the other person, you're the one who will have to lick it off and absorb all those calories. After playing with your dessert in bed, draw a bath for two, nice and hot and with perfumed bath salts, put on some quiet music, light candles, and serve champagne from a single goblet. (All this, so easy to describe, never works for me in real life; my tub gets cold and my partner falls asleep while I'm trying to get the chocolate stain out of the sheets.)

Sweets are a weakness I've fought continually almost from the time I was aware I had teeth. It's a worse vice than alcohol or drugs because it's legal, it's not considered immoral, and it's something people can do in public. Every bite of candy that goes into the mouth cascades directly to the hips and then must be paid for with countless diets and workout programs. I was born at the wrong time. Whatever happened to that wise old saw about "plumpness is the soul of beauty"? I belong on the canvas of some Impressionist painter, at one with the corpulent nude bathers; or in the verses of an Arab poet, among pillowy odalisques nourished on honey and nuts; or in the pages of a Victorian author whose erotic fantasy was that of a complaisant woman whose bombé buttocks he stroked with a peacock feather. I know. Feathers, like incense, have been out of style since the sixties, but nothing has come along to replace them. What the devil am I doing in California at the end of the twentieth century? Here everyone is obsessed with health and beauty; at six in the morning all my neighbors are running

through the streets, even though no one is chasing them, puffing along in shorts and with instruments strapped to their wrists to monitor any lurch of their heartbeat. I think the more palpitations per minute, the more fat is shed and muscle developed, but I'm not sure because even though my heart gallops at full speed, I don't have a visible muscle anywhere on my body.

This section of the book has been the most difficult for me. I dream about desserts at night and spend my days studying recipes while my mother prepares them in the kitchen and the rest of the family enjoys them. It's been months since I tasted a sweet of any kind, but I think about them constantly.

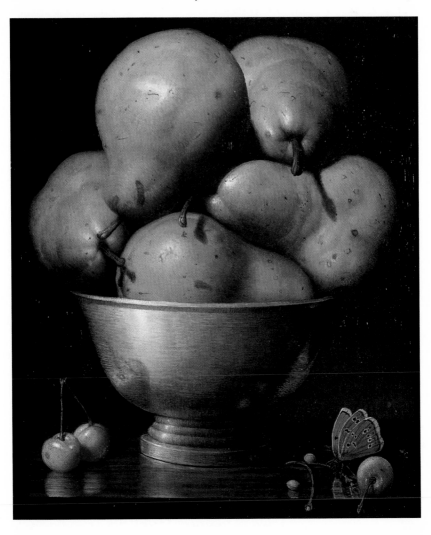

I shouldn't complain: most of my fiftyish women friends go through the same hell in regard to sex. With a little luck, I will soon be admitted into my neighborhood circle of flagellants. (By the way, a few weeks ago an ad appeared in a San Francisco newspaper calling for sadists and masochists to cast for a pornographic film. Four sadists and sixty-nine masochists showed up.)

It seems to me that it's pointless for you to complicate your life fixing desserts—you already have enough with income taxes. Save your strength for making love. Isn't that the point of an aphrodisiac meal? Remember that in the case of desserts, the robes make the monk: the appearance of the dessert is more important than the taste. Anything is improved when soaked in liqueur—even more if you light it—or served in a goblet topped with crème Chantilly. If you're looking for a more audacious effect, think about evocative shapes; for example, a banana with two strategically placed balls of ice cream or two peach halves spiced up with raspberry nipples. I always keep some fresh or canned fruit in my larder, along with ice cream, sorbets, chocolate for making a sauce, and tea biscuits for decoration; with those on hand I can muddle through if I don't have time to make one of Panchita's recipes—which, by the way, are not at all difficult.

Sweet Sauces and Creams

Sweet sauces, in general, are clear and often include among their ingredients Karo syrup or pectin. They are made with fresh or preserved fruits and marmalades, and other aphrodisiac ingredients such as honey, chocolate, coffee, and spices. Tightly sealed, they will keep for several days in the refrigerator. Custards have milk or cream, and often are thickened with egg yolks or cornstarch. When you use eggs, you have to be very careful about the temperature of the liquids; they should be hot but not boiling so the cream thickens without curdling. Sauces with whipping cream can be kept no more than two or three days.

ENGLISH CUSTARD

This cream is the base for many others, so no one with any self-respect can ignore it. It has the silky texture of youthful skin, a beautiful ivory color, and a flavor so delicate that it can be completely altered by adding almond or orange extract, among others, aromas such as coffee or chocolate, or spices like vanilla and clove.

Ingredients

2 cups milk
½ cup sugar
1 piece lemon zest
4 egg yolks
Flavoring to taste

Preparation

Heat the milk, sugar, and lemon zest in the top of a double boiler; do not allow to boil. Beat the egg yolks well. Slowly pour ½ cup of the hot milk over the yolks, stirring constantly. Pour this back into the milk mixture and let cool, continuing to stir until the custard thickens. Remove from the stove, discard the zest, and flavor to taste with extracts, flavorings, and so forth. Let cool, stirring from time to time to prevent skin from forming. This will keep for several days in the refrigerator.

SABAYON

This liqueur sauce is usually served either on ice cream or alone in small goblets with ladyfingers.

Ingredients

5 egg yolks
½ cup powdered sugar
1 cup Marsala or other sweet
 white wine
¼ cup sweet liqueur (kirsch,
 rum, curaçao, or whatever
 you have on hand)

Preparation

Beat the egg yolks with the sugar until nearly white. Continue beating and slowly add the Marsala. Place in the top of a double boiler and continue to beat (an electric hand beater is best) until you have a thick, smooth mixture. It should nearly double in size. Add the liqueur. Beat 5 minutes more and serve immediately in goblets. This will not keep.

CHOCOLATE SAUCE

This is another indispensable sauce. Any ordinary ice cream, served in a goblet, drowned in chocolate sauce, and topped with a nut or maraschino cherry becomes an opulent dessert. It can be flavored with vanilla, fruit liqueur, almond extract, and so on. It is, besides, very aphrodisiac, especially licked from your lover's fingers.

Ingredients

7 ounces (200 grams) bitter-
 sweet chocolate
½ cup sugar
¾ cup water
1 rounded tablespoon butter
Flavoring to taste

Preparation

Melt the chocolate with the sugar and water in the top of a double boiler. Stir, and take care that it doesn't scorch. When you have a thick, smooth sauce, add the butter and flavoring to taste.

MOCHA CREAM

Ingredients

1 egg yolk
¼ cup strong coffee
1 tablespoon sugar
1 tablespoon shaved chocolate
½ cup fresh cream

As with chocolate, you can dress up any dessert with this sauce.

Preparation

Beat the egg yolk with the coffee and sugar. Cook in a double boiler over boiling water until thick. Remove from the heat and add the chocolate, stirring to dissolve well, then add the cream. May be served cool or hot.

RASPBERRY SYRUP

Ingredients

1 cup sugar
½ teaspoon Karo syrup
¼ cup water
2 cups raspberries

Ideal for ice cream or crêpes filled with crème Chantilly or ricotta cheese. Raspberries are sensual, fragile fruit; they should never be boiled except when making preserves.

Preparation
Make a thick syrup of the sugar, Karo syrup, and water. Let cool. Blend the raspberries in a food processor. Add to the syrup.

JAZZY APPLESAUCE

Preparation
Mix all the ingredients together and cook over low heat until reaching a boil. Remove from the heat and let cool.

Ingredients

1 cup applesauce (jar or can, or even processed baby food)
1 teaspoon cinnamon
1 pinch cloves
1 pinch ginger
2 tablespoons confectioners' sugar
Juice and grated zest of 1 large orange

HONEY SAUCE

Ingredients

1 tablespoon cornstarch
1 cup water
½ cup honey
2 tablespoons butter
1 teaspoon grated lemon zest

Preparation
Dissolve the cornstarch in cool water. Add the honey, butter, and lemon zest, and cook over low heat. Beat until a smooth sauce is formed.

BANANA MOUSSE

Ingredients

1 apple, peeled and seeded
1 banana
2 egg whites
3 tablespoons sugar
1 tablespoon lemon juice
2 tablespoons rum

Preparation

Place all the ingredients in a blender and process. Serve immediately on syrup-soaked cake. This cannot sit because the banana turns dark.

RED WINE SAUCE

Different from Sabayon, this sauce is served warm on sponge cake or ice cream, especially vanilla or cinnamon.

Ingredients

½ cup good red wine
½ cup water
4 tablespoons sugar
1 tablespoon cornstarch
1 cinnamon stick
1 piece lemon zest
1 pinch salt
2 tablespoons butter

Preparation

Place all the ingredients except the butter in a saucepan and simmer over low heat for 4 minutes, stirring. Remove from the heat and discard the cinnamon stick. Add the butter and stir until it melts. Serve warm.

APRICOT SAUCE

Ingredients

2 cups canned apricots in
 syrup, drained
½ cup sherry or orange liqueur
1 pinch salt
1 teaspoon lemon juice

This can also be made with peaches or other canned fruit. It goes very well with pancakes, crêpes, cake, French toast, and ice cream.

Preparation

Place all the ingredients in a blender and process. Heat in a double boiler until reaching a boil. Serve hot.

RUM SAUCE

Ingredients

3 eggs plus 1 additional yolk
4 tablespoons water
4 tablespoons sugar
4 tablespoons rum

Invented by the English for their famous plum pudding, a true caloric bomb. You can use it for other less lethal desserts.

Preparation
Place all the ingredients in a double boiler and cook over boiling water, stirring constantly, until the mixture thickens. Serve immediately.

Desserts

These recipes are for two lovers with a sweet tooth who will enjoy a dessert with delicacy and calm. We have tried to offer recipes that are aphrodisiac, easy, and quick, but we couldn't omit examples of crêpes, soufflés, and mousses because no legitimate cook can ignore these masterpieces.

PEACH DELIGHT

Ingredients

1 large ripe peach, peeled
2 scoops lime ice
2 maraschino cherries
1 tablespoon maraschino liquid
1 cup pink champagne

Evocative; they resemble breasts.

Preparation
Cut the peach in half and discard the pit. Place each half in a champagne goblet. Fill each goblet with a scoop of the lime ice, decorate with a cherry and a little liquid from the bottle, fill with champagne, and serve immediately.

SOUSED PEARS

This was the favorite dessert of my sainted aunt Teresa, who despite the purest of souls acquired a coquettish gleam in her eye when served this treat.

Ingredients

1 large ripe pear, peeled and halved
Juice and grated zest of ½ lemon
2 tablespoons ricotta cheese
1 tablespoon honey
1 pinch nutmeg
1 glass red wine
2 tablespoons sugar
½ cinnamon stick

Preparation

Hollow out the core of the pear halves and fill with lemon juice to prevent it from turning dark. Combine the ricotta, honey, lemon zest, and nutmeg, and fill the core with this mixture. Refrigerate. Mix together the wine, sugar, and cinnamon stick, and heat to make a thick, fragrant syrup. Pour over the chilled pear halves and serve immediately.

TROPI-CUP

Quick and exotic.

Preparation

Process all the ingredients in a blender except the raspberries. Freeze for 2 hours. Remove and process again. Serve ice cold in goblets, topped with the raspberries.

Ingredients

1 ripe mango, peeled and cut from the pit
1 banana, cut in chunks
1 cup heavy cream
2 tablespoons sugar
2 tablespoons crème de cassis liqueur
½ cup raspberries

TAJ MAHAL

You already know that saffron is aphrodisiac, but did you also know it's used in desserts?

Ingredients

¼ cup water
1 cup sugar
2 tablespoons orange juice
1 pinch powdered saffron or 3 threads
2 red apples, peeled, seeded, and quartered
2 tablespoons Grand Marnier
4 tablespoons crème Chantilly (whipping cream with powdered sugar and vanilla extract)

Preparation

Heat the water, sugar, orange juice, and saffron until the sugar dissolves and you have a clear, light-colored syrup. Add the apples and simmer over low heat for 10 minutes, turning so that the apples are uniformly colored. Remove, let cool, and sprinkle with Grand Marnier. Spoon the apples into stemmed goblets and decorate with the crème Chantilly.

SPELLBINDING APPLES

Ingredients

2 large red apples, peeled
Zest of 1 lemon
1 tablespoon butter
2 teaspoons sugar
2 tablespoons condensed milk
1 tablespoon lemon juice
Ground cinnamon and clove to taste
1 small glass sherry
2 cherries and 2 cinnamon sticks for decoration

This is a dessert men always like, and it is easily prepared.

Preparation

Soak the apples and lemon zest in cold water for 10 minutes. Butter 2 individual baking dishes and sprinkle sugar in the bottom. Core the apples and place in the baking dishes. Combine the condensed milk, lemon juice, cinnamon, and clove, and fill the apples with this mixture. Moisten with sherry and dot with butter. Cover each dish with plastic wrap. Cook in the microwave for 7 minutes. Remove, cool, and decorate each one with a cherry and cinnamon stick. Don't refrigerate or the butter will harden.

NOVICE'S NIPPLES

The real name for this sweet is Nun's Bosom, but for literary reasons we chose something more suggestive.

Preparation

Beat the egg whites until stiff and slowly add the sugar and vanilla extract. Gently fold in the minced prunes. Place in a buttered mold and bake in a moderate oven for 1 hour. Serve with English Custard (page 301) or with crème Chantilly (whipping cream with powdered sugar and vanilla extract).

Ingredients

4 egg whites
4 tablespoons powdered sugar
¼ teaspoon vanilla extract
1 cup minced prunes

MOORISH BAVAROIS

This is a meringue made from beaten egg whites, syrup, gelatin, and a liquid flavoring (strong coffee, lemon, chocolate) or a medium thick purée of fruits or nuts. The way it turns out depends on the proportions and how stiff you can beat the egg whites (it's always best to use an electric egg beater). It should sit for several hours in the refrigerator. Before being turned out of the mold, the bottom can be whisked through hot water so the Bavarois will slip easily onto the dessert plate. Use your imagination to make a variety of Bavarois; this is but one example.

Ingredients

¼ cup water
1½ cups sugar
Vanilla extract
Rum
3 egg whites
3 teaspoons unflavored gelatin
1 small cup strong coffee
1 tablespoon (½ ounce)
 bittersweet chocolate, melted
½ cup heavy cream, beaten
English Custard (page 301)

Preparation

Make a syrup with the water, sugar, a few drops of vanilla extract and rum. Beat the egg whites until stiff. Gradually pour the syrup into the egg whites and beat gently until it cools. Dissolve the gelatin in the coffee and add the warm chocolate. Strain into the egg whites. Gently fold in the cream. Spoon the mixture into previously oiled molds and refrigerate. To serve your Bavarois, turn out of the molds and top with English custard.

CATALAN CREAM

Of the many variants, we offer the easiest and one that never fails. Make it ahead of time.

Ingredients

2 cups cream
2 level tablespoons sugar
¼ teaspoon vanilla extract
6 egg yolks, lightly beaten
1 heaping tablespoon brown
 sugar

Preparation

Heat the cream with the white sugar and vanilla extract in a double boiler. The water should not reach a hard boil. Add the egg yolks, stirring constantly. Remove when the cream thickens and refrigerate for 8 minutes. When cooled, sprinkle the brown sugar on top to the edges. Set the bowl in a container of crushed ice. Place in a hot oven and broil so that the sugar caramelizes, 2 to 3 minutes. Remove and keep refrigerated until time to serve.

VENUS MOUSSE

A cool summer dessert to get you out of a jam.

Ingredients

1 banana
½ apple
1 kiwi fruit
Juice of ½ orange
Juice of ½ lemon
1 egg white
4 tablespoons sugar
1 tablespoon crème de menthe
2 thin slices lemon

Preparation

Peel the banana, apple, and kiwi, and place them and the remaining ingredients except the lemon slices in a blender. Process at top speed for 3 minutes. Spoon this cream into stemmed goblets and decorate the lip of each goblet with a lemon slice.

CARIBBEAN BOMB

This recipe is very generous for two but may be served at a small orgy.

Preparation

Hollow out the pineapple, cut the edible portion into cubes, and store the shell in a cool place. Combine the pineapple cubes with the mango, mandarin orange, and guava. Then add the banana sprinkled with the lemon juice to prevent its turning brown. Season with the sugar and curaçao. Fill the pineapple shell with vanilla ice cream and top with the cubed fruit. Sprinkle grated coconut over all. Chill until served.

Ingredients

½ fresh pineapple, cut lengthwise, keeping the leaves
1 medium mango, cut in cubes
1 mandarin orange, in sections
½ cup sliced guava
1 banana, sliced
Juice of ½ lemon
3 tablespoons sugar
2 tablespoons curaçao
1 cup vanilla ice cream
2 tablespoons grated coconut

MADAME BOVARY

Flaubert's frivolous heroine inspired this one.

Ingredients

1 heaping cup mixed cherries, strawberries, raspberries, and red currants
3 tablespoons sugar
3 tablespoons cream cheese
1 teaspoon grated lemon zest
4 ladyfingers, crushed
2 tablespoons kirsch
½ banana, sliced

Preparation

Pit the cherries and add to the remaining fruit with the sugar. Cook for 8 minutes. Remove, drain, reserving the juice, and set aside to cool. Beat the cream cheese with a fork and add the lemon zest and ladyfingers. Add the kirsch and juice from the fruit, stirring to a smooth cream. Spoon into goblets and top with the red fruit. Use the banana slices to decorate your dessert.

MOUSSE AU CHOCOLAT

Ingredients

5½ ounces bittersweet
 chocolate
3 tablespoons strong coffee
2 eggs, separated
½ cup heavy cream
1 tablespoon orange liqueur
Several drops vanilla extract

This is the aphrodisiac dessert par excellence, de rigueur in the best restaurants, and a formal invitation to love. There are many versions of this dessert. We offer the simplest. If it falls, don't call attention to it; pretend it turned out exactly as you planned and serve it in goblets. If it isn't presentable even then, use it as a lotion for a sensual massage.

Preparation

Melt the chocolate in the coffee over low heat. Beat the egg yolks and whites separately. Add the egg yolks, stir, and cook for 2 minutes. Remove from the heat, allow to cool, and add the egg whites, cream, orange liqueur, and vanilla extract. Chill in goblets decorated to your taste.

CHARLOTTE FOR LOVERS

Ingredients

1 square (1 ounce) bittersweet
 chocolate
2 tablespoons water
2 tablespoons sugar
2 tablespoons butter
2 eggs, separated
2 tablespoons ground walnuts
½ cup strong black coffee
1 tablespoon cognac
4 ladyfingers or similar cookies,
 crushed
Crème Chantilly (whipping
 cream with powdered sugar
 and vanilla extract)

Saturated with aphrodisiacs: chocolate, nuts, coffee, liqueur, eggs!

Preparation

Break up the chocolate and melt it with the water in a double boiler. Add the sugar and butter, and beat well. Add the egg yolks one by one, continuing to beat well. Cook for 5 minutes and remove from the heat. Beat the egg whites until stiff and fold into the chocolate mixture along with the walnuts. Gently add the coffee, cognac, and cookies to the mixture. Spoon into 2 sherbet goblets and top with crème Chantilly.

CRÊPES

These thin pancakes are so delicate that sometimes they seem transparent. The batter—of the consistency of a light cream—can be flavored with liqueur. They are easily prepared if cooked in a special pan, very hot and barely coated with butter or oil. Use a large tablespoon of batter for each crêpe. As soon as they begin to brown, 1 minute, turn to cook the other side. If the first crêpe is too thick, add a little milk to the batter. It is advisable to double this recipe and keep the crêpes you don't use in the refrigerator, wrapped in aluminum foil, for 4 or 5 days. This basic recipe is for ten crêpes.

Ingredients

1 egg
1 cup milk
3 heaping tablespoons flour
½ level tablespoon sugar
1 pinch salt
½ tablespoon vodka, *pisco*, rum, or other liquor

Preparation

Blend all the ingredients in a food processor until the lumps disappear. Let the batter sit, covered, for 30 minutes. Warm your crêpe maker and add a dab of butter or oil (it's convenient to use a brush). Spoon on 1 large tablespoon of batter and shake to spread. As it begins to brown, in 1 minute, turn and brown the other side.

CRÊPES SUZETTE

Found in all the great international restaurants, these are served flambé, which is itself a stimulating spectacle. Not terribly complicated if everything is prepared in advance.

Ingredients

6 to 8 crêpes (page 312)
¼ cup butter
¼ cup sugar
4 tablespoons cognac
 (Triple Sec)
4 tablespoons Grand Marnier
Juice and grated zest of
 ½ orange

Preparation

Keep the crêpes warm. Heat the butter in a small skillet. Very deliberately, add the sugar, 2 tablespoons of cognac, and 2 tablespoons of Grand Marnier. Add the orange juice and zest. Cook, constantly moving the skillet, on high heat for 1 minute. You will have a thick syrup. Turn the heat to the lowest point. Fold the crêpes twice and dip into the syrup, one by one, until well saturated. Heat the remaining 2 tablespoons of cognac and 2 tablespoons of Grand Marnier, pour over the crêpes, and set afire. Serve after the flame dies. The whole event is fascinating; do it tableside to seduce your guest.

CRÊPES NOËL

Ingredients

3 tablespoons cream cheese
3 tablespoons ricotta cheese
4 tablespoons sugar
1 pinch nutmeg
1 tablespoon grated lemon zest
6 crêpes (page 312)
1 cup canned cherries, with
 liquid
2 teaspoons cornstarch
4 tablespoons kirsch

Preparation

Combine the cream cheese, ricotta, 2 tablespoons of the sugar, nutmeg, and lemon zest. Spread on each crêpe and roll up the crêpe. Heat the cherries with the remaining 2 tablespoons of sugar. Add the cornstarch dissolved in the kirsch and stir well. Keep warm. Heat the crêpes in the microwave for 1 minute. Remove and cover with the warm cherry sauce. Serve immediately.

SYBARITE

Ingredients

2 cups fresh figs, peeled
4 tablespoons confectioners' sugar
4 tablespoons ground walnuts
2 teaspoons cognac
1 pinch nutmeg
6 crêpes (page 312)
6 tablespoons crème Chantilly (whipping cream with powdered sugar and vanilla)

These delicious crêpes are true concentrated aphrodisiacs.

Preparation

Shred the figs with a fork. Combine with the sugar, walnuts, cognac, and nutmeg. Fill the crêpes with this paste and fold into squares. Arrange on a serving plate and heat in the microwave for 1 minute. Remove and top with the crème Chantilly before serving.

ZUCOFF SURPRISE

This is an omelet *flambé au rhum*, which you can vary to taste according to the whims of your imagination and whatever you have left in the refrigerator.

Ingredients

4 tablespoons butter
4 tablespoons honey
2 tablespoons pitted, cut-up dates
2 tablespoons golden raisins, soaked in water
3 eggs, plus 1 additional egg white
1 teaspoon white flour
1 pinch salt
1 small glass rum

Preparation

Cook 3 tablespoons of butter with the honey for 3 minutes. Add the dates and raisins. Cook 3 minutes more, being careful that the mixture doesn't stick. Remove from the heat and keep warm. Beat 4 egg whites until stiff, then add the yolks one by one. Add the flour and salt, and beat for 2 minutes. Heat the remaining 1 tablespoon of butter on high heat in a small skillet. Pour in the batter and stir with a fork from the center toward the edge. Loosen the edge with a spatula and lower the heat. When the bottom is browned, slide onto a plate. Cover with the dates and raisins mixture. Fold in half and take to the table. Just before serving, pour on the warmed rum and set afire.

APRICOT SOUFFLÉ

Every cook fears a soufflé because it tends either to be half raw in the center or to collapse as soon as you take it from the oven. This one is delicately flavored and dependable . . . well, as dependable as we can get in this life.

Ingredients

2 tablespoons sugar
1 rounded tablespoon butter
3 eggs, separated
4 tablespoons apricot preserves
4 tablespoons bread crumbs or crushed cookie crumbs

Preparation

Beat the sugar with the butter until creamy. Add the egg yolks and beat 2 minutes more. Add the preserves and bread crumbs. Finally, add the egg whites beaten stiff to form a meringue. Place this mixture in buttered, individual molds set in a large Pyrex baking dish containing 1 to 2 inches of water. Bake for 15 minutes at moderate heat. Serve warm with apricot sauce.

ARROZ CON LECHE, OR SPIRITUAL SOLACE

Ingredients

½ cup rice
4 cups warm water
10 cups milk
1 cinnamon stick
2 cups sugar
1 piece lemon zest
1 tablespoon cinnamon

Remember my dream about *arroz con leche* at the beginning of this book? I can't imagine a more sensual or delicious dessert. This recipe will serve eight normal people, but in my eyes it's a crime to make less. I'm capable of devouring it at one sitting without blinking an eye, and I don't see why it should be any different in your case, my dear reader. But if you can't finish, you can keep it in the refrigerator, then, should you be in a good mood, you can cover your lover from head to foot with this mouthwatering *arroz con leche* and slowly lick it off. On such an occasion the calories are justified.

Preparation

Soak the rice in the warm water for 30 minutes. Drain. Cook the rice with the milk and cinnamon stick until the rice begins to soften, about 30 minutes. Add the sugar and lemon zest, and simmer over very low heat, stirring from time to time to prevent the rice from sticking. In about 30 minutes the mixture will thicken. Place in a bowl, cool in the refrigerator, and sprinkle with cinnamon just before serving.

Art Credits